THE GILDED PAGE

The

GILDED
PAGE

THE SECRET LIVES OF
MEDIEVAL MANUSCRIPTS

❧

MARY WELLESLEY

Basic Books
Hachette Book Group
1290 Avenue of the Americas, New York, NY 10104
www.basicbooks.com

Printed in the United States of America

First Edition: October 2021

Published by Basic Books, an imprint of Perseus Books, LLC, a subsidiary of
Hachette Book Group, Inc. The Basic Books name and logo is a trademark of the
Hachette Book Group.

The Hachette Speakers Bureau provides a wide range of authors for speaking events.
To find out more, go to www.hachettespeakersbureau.com or call (866) 376-6591.

The publisher is not responsible for websites (or their content) that are not owned
by the publisher.

Print book interior design by Trish Wilkinson.

Library of Congress Cataloging-in-Publication Data
Names: Wellesley, Mary, 1986– author.
Title: The gilded page : the social lives of medieval manuscripts / Mary Wellesley.
Description: First edition. | New York : Basic Books, 2021. | Includes
 bibliographical references and index.
Identifiers: LCCN 2021004832 | ISBN 9781541675087 (hardcover) | ISBN
 9781541675094 (ebook)
Subjects: LCSH: Manuscripts, Medieval—England—History. | Transmission of
 texts—Social aspects—England—History. | English literature—Old English,
 ca. 450–1100—History and criticism. | English literature—Middle English,
 1100–1500—History and criticism | Illumination of books and manuscripts,
 Medieval—England. | Marginalia—England—History.
Classification: LCC Z106.5.G7 W45 2021 | DDC 091.0942—dc23
LC record available at https://lccn.loc.gov/2021004832

ISBNs: 978-1-5416-7508-7 (hardcover), 978-1-5416-7509-4 (ebook)

LSC-C

Printing 1, 2021

For my parents and for Fred

god helpe minum handum

Good syster of your charyte I you pray remember the scrybeler
when that ye may

If you are reading, this manuscript at least will have survived.

MARGARET ATWOOD, *THE TESTAMENTS*

Contents

Introduction

At some point in the sixteenth century a girl named Elisabeth Danes wrote a threat into the pages of her book: "Thys ys Elisabeth daness boke he that stelyng shall be hanged by a croke" (This is Elisabeth Danes's book, he that steals it shall be hanged by a crook [meaning "hook"]).[1] The note appears at the bottom of the manuscript page: defiant, a little naughty, and full of bibliophilic feeling.

I first met Elisabeth Danes through her manuscript when I was doing research in the British Library. I remember reading it and feeling the centuries dissolve. Here were the words of a fellow bibliophile from five hundred years ago; it is a reminder that there have been lovers of books for as long as there have been books to love. Elisabeth Danes treasured her book and the story it contained, and she wanted to protect it. But there was also something else poignant in her words. From her handwriting, she appears to have been young. I wondered how much control she had over the circumstances of her own life. She was a young woman, perhaps a child, in a patriarchal world; threatening potential book thieves might have been one of the few ways she could assert herself. The note has a particular pathos because, as I discovered afterwards, it appears to be all that remains of her. She is otherwise hard to trace in the historical record.

Sometimes medieval manuscripts offer up names, such as "Elisabeth Danes," but more often they only allow us glimpses of anonymous figures. Some three centuries before Danes wrote her threat, a monk in Worcester Priory set about making careful notes in the margins of the manuscripts in the priory's library. This scribe's handwriting was distinctive: shaky, outsized, and left-leaning. Today he is known only as "the Tremulous Hand," as scholars have been unable to discover his name. He was a prolific annotator—writing around fifty thousand glosses (explanatory notes) in as many as twenty manuscripts. The majority of his annotations were in manuscripts containing Old English (the vernacular language of pre-Conquest England), yet he wrote his notes in Latin or Middle English (the language into which Old English had evolved).

The Tremulous Hand was working in the thirteenth century, which means he was part of one of the last generations able to understand Old English without too much difficulty. Old English, a Germanic vernacular, had changed dramatically after the Norman Conquest and its attendant influx of French vocabulary. He seems to have been collecting Old English words, possibly to make a glossary. We might see him as an early linguistic historian of sorts. Nineteenth-century scholars romanticised his work, suggesting that he was an elderly man, one of the last speakers of the dying language.[2] Scholars now believe he had a neurological condition called "essential tremor," which affects one in twenty-five adults today over the age of forty. The Tremulous Hand's work has much to tell us about language change, but whoever he was, I love how he encapsulates so much of what I think is magical about manuscripts. He is anonymous. We know nothing about him except that his hand shook. As with Elisabeth Danes, it's

hard for the manuscript scholar not to feel a kinship with him, intent as he was on ferreting around in the past and decoding its remnants.

To sit in the silence of a special collections reading room and turn the pages of a medieval manuscript is to have tangible, smellable, visual encounters with the past. Parchment manuscripts have a particular scent that is hard to describe: acrid with undernotes suggesting an organic origin. They can feel stiff and buckled, soft and faintly like suede, or so finely worked as to be tracing-paper thin. Up close, ripples and imperfections become visible on a page of parchment—the traces of hair follicles, little repaired holes, and places with discolouration. But the coloured inks and paints remain iridescent, having often been kept safely away from light damage for centuries.

A medieval manuscript is not only a text, but also a collection of human stories. Each manuscript has been made by many different hands and has passed through many different hands throughout its history. Each one bears the traces of the people who fashioned it and loved it, perhaps even of those who disdained it and those who wished to alter it, and often those who found it anew in a more recent time. Many of those who played a role in the creation of the manuscripts remain anonymous—shadowy figures whose work with quills, paintbrushes, and other tools of the trade are all that survive of them. Sometimes they come into sharper focus.

The word "manuscript" itself is a combination of two Latin words, *manus* (hand) and *scribere* (to write). A manuscript is simply a handwritten object. The fact that they are made by hand is what makes manuscripts so compelling. And the handwriting itself tells us a great deal about the people who painstakingly produced these objects. To this day, handwriting remains

a personal expression of the self, perhaps now more than ever before as we ditch our pens in favour of our keypads. Scholars talk about the script in a manuscript as "the hand." A catalogue describing a manuscript might read, "Written in a fourteenth-century hand," and this terminology suggests that "the hand" might extend towards us, might reach out to touch us. This is the magic of the manuscript.

In Geoffrey Chaucer's *The Parliament of Fowls* (written c. 1380), the narrator reflects on what people dream about—he describes the hunter dreaming of the wood, the judge dreaming of the court, the knight of fighting, and the alcoholic of his tipple. Had Chaucer included manuscript scholars in his list, he would have said they dream of hands and folios, pen-lifts and page-gutters, lacunae and palimpsests. To be a manuscript scholar is to worry about tiny, granular details, because a manuscript is like a crime scene—a tissue of minuscule clues to a forgotten history that need to be examined with forensic care. Like forensics jargon, the language of manuscript study can be strange and arcane. I have tried to explain terminology wherever necessary, but I have also included a glossary at the back of the book. Because I love language and language forms, I have chosen, in almost all cases, to quote from original texts alongside modern translations. Consequently, readers will encounter some letters in the Old and Middle English alphabets which did not make it into the Modern English alphabet. These, too, are explained in the glossary.

Manuscripts teem with life. They are the stuff of history, the stuff of literature, the material remains of the writerly act and the reading experience. But, more than that, they are portals. They offer some of the only tangible evidence we have of entire lives, long receded. Manuscripts weren't only made and used and loved by wealthy elites, they were also made by ordinary people.

Manuscripts grant us access to the stories of anonymous artisans, artists, scribes, and readers as well as of people who aren't always celebrated and discussed in our medieval histories—people of a lower social status, women, or people of colour. Without manuscripts, many historical figures would be lost, their voices silenced, their stories erased, and the remnants of their labours destroyed. Sometimes their stories can only be hinted at, while at other times they can be fleshed out more fully.

A manuscript in the National Archives in London contains a marginal image of a man of African descent. The manuscript is a copy of the *Domesday Abbreviatio*—an abbreviated version of the Domesday Book, a census of landholdings in England from 1085.[3] The *Abbreviatio* itself dates from the thirteenth century.[4] The man appears on a page detailing royal landholdings in Derbyshire. Why this marginal image appears we can't be sure, but it's an exciting reminder of a part of British history that is not widely understood and possibly a glimpse of a life now long receded. The man's clothing—his short tunic—suggests he was not a person of elite social status. The artist perhaps intended to depict a servant or a slave. If this man was based on a real person, he may have been forced to come to Europe during the migrations associated with the Crusades.[5] Archaeological evidence indicates that there were people of African descent in England in this period, but it is hard to know how or why they came to be there.[6]

These hints and clues, too, are some of the magic of manuscripts. A charter from a couple of centuries earlier, 1042–1049, records a gift of land to St Alban's Minster. It reads:

> *Her swutelað on ðisan gewrite embe þa land þe Ægelwine swearte geuðe Gode to lofe [&] sancta Mariam & eallan Godes halgan into sancte Albanes mynstre for his sauwlan [&] for Wynflædan*

his wifes & for eallan his yldran saulan þam broðran to fode be
Eadwardes cinges leafe.

(Here is declared in this document about the estates which
Æthelwine the Black granted to God in praise and to Holy
Mary and all God's saints [and] to St Alban's minster for his
soul and for that of Wynflæd his wife and for the souls of all
his ancestors [and] to the brethren for their sustenance with
the permission of King Edward.)[7]

What this description of Æthelwine as "the Black" means
is unclear. It may simply have meant that he had dark hair.
Names describing people by colours, like "red" or "golden"—
colours that do not have the connotations they do today—are
not uncommon in this period.[8] There is also every possibility,
however, that the "Ægelwine swearte" mentioned in this charter
was of African descent. Again, archaeological evidence indicates
that there were people of African heritage in England in this
earlier period.[9] A manuscript made some three hundred years
later, called the "Golden Book of St Albans," recalls the great
donations to St Albans Abbey over time and depicts the major
benefactors. Here we find an image of Æthelwine.

And the image is tantalising. Alan Strayler—the manuscript
artist—has chosen (or been instructed) to depict Æthelwine as
dark skinned, not simply dark haired.[10] The decision might sug-
gest that he had encountered people of a different ethnicity, or
it could simply mean he was familiar with images of people of
colour. For us, it provides a fleeting glimpse of an often over-
looked aspect of British history—a history that is more diverse
and interesting than we give it credit for.[11]

Just as manuscripts offer glimpses of lives in the past, so, too,
they sometimes tell explicit stories of oppression. In the Vatican

Library there is a manuscript copied in the thirteenth century that contains a series of *piyyutim*—Jewish liturgical poems. In it there is a poem that begins with a prayer for a curse:

> *Put a curse on my enemy, for every man supplants his*
> * brother.*
> *When will You [God] say to the house of Jacob, come let us*
> * walk in the light?*
> *You are mighty and full of light, You turn the darkness into*
> * light.*
> *Tear out their hearts—they who brought harm to those who*
> * come in Your Name,*
> *When I hoped for good, evil arrived, yet I will wait for the*
> * light.*[12]

The *piyyutim* in the manuscript are seemingly anonymous, but in one of them the poet has hidden a clue to his identity in an acrostic. It reads: "I am Meir son of Rabbi Elijah of Norwich [Norgitz], which is in the land of the island England [Angleterre]." Nothing else is known of this Meir bin Elijah, but the chilling words of his *piyyut* with the curse should be read against the backdrop of the persecution of Jewish people in England in the thirteenth century, which culminated in their expulsion in October 1290.[13] At the time that Meir was writing, Norwich had a population of fifty or sixty Jewish people, although it had had two hundred at its peak.[14] According to one source, the synagogue in Norwich was burned to the ground in 1286. Archaeological excavations in the nineteenth century uncovered a stone column, glazed tiles, pottery, and—chillingly—a four-inch layer of charcoal at the site.[15]

It is unclear how the manuscript containing Meir's poems came to be part of the Vatican Library's collection, but it could

have been copied from a manuscript smuggled out of England by a Jewish person expelled in 1290. Perhaps this person knew Meir bin Elijah. Perhaps he or she wished to preserve his haunting *piyyutim* as a reminder to future generations of what the Jewish people in England had suffered. I like to imagine this person traversing the border with a manuscript amongst his or her possessions, a message for those of us in later ages seeking to know the human stories contained in handwritten medieval books.

In spite of their role as this essential tether to the past, manuscripts are some of the least accessible artefacts from the Middle Ages. They are kept in research libraries, often available only to scholars. When they are put on public display, what we see of them is very limited. Looking at a single opening of a manuscript is like looking at just one credit-card-sized corner of an Old Master painting—a single opening is far from being the whole picture. The late, great medievalist Michael Camille wrote that "medieval books are . . . of all historical artefacts, the least suited to public display in the modern museum. Behind glass their unfolding illuminations become static framed paintings, cut off from any of the sensations, texture or transport that one gets from turning their pages."[16] But now, for the first time in human history, these previously inaccessible objects can be seen from anywhere in the world in high resolution. We can sit at home in our pyjamas and examine the *Beowulf* manuscript at a level of magnification that would be impossible even if we were in the reading room of the British Library, in clothing more suitable to scholarly study. At last, we all can meet these hidden hands.

———

"In principio erat verbum" (In the beginning was the word). These are the opening lines of the Cuthbert Gospel, an eighth-century manuscript made in the early days of Christianity in Britain, and where our own journey with words begins. Eight hundred years later, the technology of the manuscript was losing ground to the technology of print; as relics of a bygone era, manuscripts became valuable historical curiosities. Yet for all their value to collectors, manuscripts have often been treated carelessly—burned, discarded, or forgotten. Sometimes they were recycled: their pages cut up and reused, often to make bindings for new books. The story of those that remain is one of survival against the odds. The vast majority of manuscripts produced in the medieval era perished through fire, flood, negligence, or wilful destruction. What survived only managed it through serendipitous chance, or because someone, somewhere, thought these books worth saving. The manuscripts discussed here are not just antiquated objects, therefore, but cultural landmarks.

The word "manuscript"—a handwritten object—has a transferred meaning as a book (as opposed to a scroll or a document), and the book is my primary interest, but I've taken the liberty of including a collection of letters. The first chapter begins in the twelfth century with the discovery of a manuscript from the eighth, and the afterword reflects on the emergence of antiquarians and collectors in the sixteenth century. But along the way the story does not march straight through time. Manuscripts, by their very nature, resist neat chronologies, because they often tell simultaneous histories. They might have been written in one age, but contain texts dated much earlier, and they also incorporate the histories of their later owners or readers. The stories collected here are united, instead, by theme.

The opening chapters focus on manuscripts as artefacts and especially on discovery and disaster, demonstrating that the

survival and preservation of manuscripts has always been subject to chance. The chapters that follow in the rest of the book look at specific figures involved in the creation of manuscripts, including patrons and artists, authors and scribes, and their works. And although in the first four chapters I discuss single, monolithic manuscripts, in the final three I move on to more complicated textual remains: multiple books or documents and different versions of texts. These chapters focus on scribes and authors as we look, first, at scribes as people—at their devoted labours and sometimes joyless drudgery—and then explore the relationships between the scribes and the authors, and finally discuss authors long hidden. Throughout I am interested in the relationship between manuscripts and memory—in what manuscripts can tell us about how and why we remember the past. Manuscripts can be tools for remembrance, but—as the opening chapters show—they can also be easily forgotten and destroyed. And manuscripts also remind us that what we remember of the past is uneven. There are some famous figures in this book, but there are also some unfamous ones who might deserve better renown.

Why write about manuscripts? And why *these* manuscripts? Modern printed editions of texts are bald and lifeless things. Manuscripts are, by contrast, rich and messy. Sometimes they are beautifully decorated, sometimes untidy and illegible, but they speak of countless human stories. This book is not a story of manuscripts that changed the world, but about how manuscripts connect us to lives in the past. In attempting to illuminate these human lives, I ask why we value some figures from the past and forget others. *The Gilded Page* is about memory and forgetting, about forms of communication and memorialisation. This book grew out of my own research, so almost all the manuscripts here were created in England, and many of them are

literary. Most of the chapters range across the medieval period, with examples from the pre- and post-Conquest era, but my concern has always been about what manuscripts tell us about their makers, rather than about broad historical narratives.

So many of the manuscripts discussed in *The Gilded Page* were created by anonymous figures. We know nothing about these people—when they lived and died, or where they came from, let alone their names. But we have their work. We have the very parchment or paper they processed, the shapes their letters made, the stitches they sewed, the bindings they fashioned, and the places where they made textual changes or complained in notes of how their backs ached. This craftedness is what makes them so special. A manuscript in the British Library contains the following scribal note:

A man who knows not how to write may think this no mean feat. But only try to do it yourself and you will learn how arduous is the writer's task. It dims your eyes, makes your back ache and knits your chest and belly together—it is a terrible ordeal for the whole body. So, gentle reader, turn these pages carefully and keep your finger far from the text. For just as hail plays havoc with the fruits of spring, so a careless reader is a bane to books and writing.[17]

Manuscripts took many hours to produce. A manuscript (or *codex*, to give it its Latin name) is like a beautiful watch—lift the face, and beneath you find a mechanism of startling intricacy. All the different parts are carefully made, and they work together coherently.

An enormous amount of labour and skill was required to create the magic of the manuscript. This labour began with the preparation of the materials themselves. Until around the fourteenth century, when paper became more common as a writing material, manuscripts in Britain were mainly written by scribes on parchment, which was made from the skin of a domestic animal, usually sheep or calves. (The term *vellum* is sometimes used interchangeably with *parchment*, although it more often refers to calfskin.) Preparing parchment was skilled work, and in the early medieval period, this work would usually have been done close to the places where manuscripts were copied, invariably monastic scriptoria (writing rooms). As time went on, scribal work was increasingly practised less in the monastery and more in secular, commercial contexts, where parchment would have been processed in specialist workshops.[18]

Paper was made from cotton or linen rags, which were soaked and pulverized into a pulp. This pulp was placed into a vat of water and *size* (a glutinous substance). Into the vat a sieve-like wooden frame set with wires was placed to bring the pulp fibres to the surface. The film of sodden fibres was then lifted out of the vat and pressed between sheets of felt. The wires of the frame gave the finished paper ghostly lines on its surface which were only visible when the paper was held up to the light. From around 1300 European papermakers began twisting patterns into the wire to identify the paper as their own. These designs might be, for example, the head of a bull or a bunch of grapes. Known as *watermarks*, they give scholars clues about the origins of particular paper stocks. Medieval and early modern paper made from rags is pretty durable, unlike modern paper made from wood pulp, which tends to wither, discolour, and crumble over time.

But even with the process of making the parchment or paper complete, it was not yet time for scribes to begin their copying work. First, the parchment or paper had to be cut into an appropriate size and shape and folded in half. These folded pieces were called *bifolia*—the Latin just means "two leaves" (the singular is *bifolium*). When the bifolia were ready, they were then prepared for writing. To do this the layout was planned and marked out with ruled lines. To get the lines all in the right place, scribes would first make little holes in the parchment with a knife, an awl (a small, pointed tool), or a *pricking wheel* (a spiked spinning wheel).

In a large scriptorium or workshop, this work might have been done by a junior scribe. Depending on the status and quality of the manuscript, generous margins might be left, along with spaces for illumination, or, for a more economical approach, the folios might be ruled so that there was little space for anything but text. The bifolia were then arranged so that their folded spines slotted into one another such that they could be sewn together into booklets, also called *quires*. (Manuscripts, by and large, do not have pages, but *folios*, or *leaves*. Scholars don't refer to "p. 2," but instead to "fol. 1v." A folio is a single sheet, so "r" stands for *recto*—the front of the sheet—and "v" for *verso*—the back of the sheet.) After the bifolia were prepared, a scribe could finally begin writing. This was done with a quill, which was made from a feather and sharpened with a *penknife* (the origin of this term). The scribe would use ink most probably made from oak galls—round, apple-like growths that develop on an oak tree when gall wasps (from the family Cynipidae) lay their eggs in the tree's developing leaf buds. The galls were ground and mixed with iron salts and tannic acids.

An ink recipe survives in the personal manuscript of a professional scribe from the small Norfolk village of Acle. Robert Reynes was a churchwarden who lived and died in the late fifteenth century, and his manuscript, now known as Bodleian Library Tanner MS 407, is an assortment of literary pieces, legal documents, useful charms, mnemonic devices, itineraries, and prognostications—the medieval equivalent of the "My Documents" folder on someone's personal computer. Amongst its paper folios, it instructs that "Ffor to make blak ynke, take gallys, coporose and gumme of rabyk" (To make black ink, take galls, copperas [iron (II) sulphite] and gum arabic). It advises that the gum arabic should be soaked overnight and "on the morwen take þi gumme-water and þi pouuder of gallys, and put hem togeder, and sette hem ouer the fyer, and lete hem sethen þe space of þis psalme seying, '*Miserere mei, Deus*'" (In the morning, take the gum-water and the powder of galls, mix them together, and put them over a fire and let it simmer for as long as it takes to say the psalm "*Miserere mei, Deus*" [i.e., Psalm 50]).[19] Lacking a pocket watch or clock of his own, he measured time in a highly practical, if also devout, way.

The copying of a manuscript could take a long time, but the type of script used made a difference. The most stately and expensive manuscripts were the most painstaking to produce, partly because they required endless pen-lifts. Later in the medieval period, cursive scripts became more common, and joining the letters of the words together meant scribes could work more quickly. Yet copying manuscripts was still a laborious and time-consuming activity. As an example, the *Moralia in Job* (an important and oft-copied commentary on the Book of Job by Gregory the Great, c. 540–604) took some fifteen months to write out in the fifteenth century. A copy of the entire Bible might take years. It has been estimated that Romanesque scribes

(those working from about 900 to 1200) could copy around two hundred lines of text in five or six hours—a day's work. This meant a scribe might produce about twenty books in his or her lifetime.[20]

Once a scribe's copying was complete, the work would probably be checked by another scribe, and corrections might be made. With parchment manuscripts, incorrect text could be scraped away, although this was impossible with paper. After the text was corrected, then the work of decoration could begin. In manuscripts created on a budget, this might be restricted to occasional touchings in red ink, perhaps a few red initial letters (a practice called *rubrication*). In high-status manuscripts, the work of decoration was a serious enterprise that might take decades. Other forms of extratextual apparatus could be added, such as tables of contents or marginal notes to guide the reader. Sometimes this kind of material could be presented quite beautifully, becoming a form of decoration in itself.

After the copying and decorating was finished, a manuscript might then be bound, with the quires sewn together in evenly spaced *stations* along their spines. To make sure everything was in order, scribes would write *catchwords* at the bottom of the last folio in a booklet. (Such catchwords were the next few words of text appearing at the start of the next booklet. Sometimes these were simple things, but occasionally they became decorative features in their own right.)[21] The top and bottom bands on the spine were given extra reinforcement. Then the covers could be added. Sometimes these were flexible and made of leather, but more often they were wooden boards of a durable wood like oak or beech. Holes were drilled into the wood, and then the boards were laced onto the manuscript's spine before being covered with leather. Parchment inserts called *pastedowns* were often affixed to the inside of the cover. As for the leather itself,

calfskin and goatskin were probably the most common, but manuscripts were covered in all kinds of materials. Recent analysis has identified the furry covers of a number of manuscripts originating in the Cistercian abbey of Clairvaux as sealskin.[22]

Bindings could be considerably more elaborate than leather and wooden boards. Many had decorated covers—perhaps of carved ivory, or they might be covered in metalwork and jewels. These jewelled covers, known as *treasure-bindings*, are extremely rare, as they were often plundered. (No treasure-bindings from England have remained intact, although there are written references to bindings once in existence.[23]) A rare survival is a stunning gospel-book made of silver gilt and jewels in the Morgan Library in New York. It is one of four gospel-books commissioned by Judith of Flanders (d. 1094 or 1095), the wife of Tostig (the brother of King Harold II), who became Earl of Northumbria in 1055.[24]

Beyond the covers, more complex structures could be added. *Chemise bindings* are the "medieval precursor of the modern dust jacket"—a little coat for a manuscript that could be made of leather or textile.[25] Chemise bindings could be simple affairs— unadorned parchment wrappers, for example—or more complicated things made from linen or velvet and trimmed with beads, especially for expensive manuscripts.

The wrappers made the manuscripts easier to carry and, as such, they are akin to *girdle books*, books that could be attached to a belt by a chain or rope. They were especially popular formats for prayer-books, particularly those owned by wealthy women in the fifteenth and sixteenth centuries. The British Library holds a tiny copy of the Book of Psalms owned by Anne Boleyn, second wife of Henry VIII. It measures three by four centimeters and has a gold metalwork binding that was likely attached to a chain so that it could be hung from a belt.[26]

Girdle books were not only easy to carry but also easy to keep safe. For larger books, especially in monastic libraries, more forbidding security measures were used, where books were kept in chains.

———————

All the figures involved in the production of manuscripts were responsible for important acts of textual creation and augmentation. Marginal images could enhance the meaning of a text, rich bindings announced a work's value in unambiguous terms, and the labour of editors, correctors, and annotators might create new meanings in different contexts. Once completed, the books passed through generations of hands, some of whom left their own traces on the pages. Although the names of all these figures are frequently lost, they had a role in fashioning the object we behold and shaping the way we understand that object. There are plenty of splendid manuscripts discussed and pictured in this book, but there are also some unassuming ones, because sometimes it is the unassuming manuscripts that have the most interesting human stories to tell.

Why have we forgotten the names of so many of these figures? Our age values certain kinds of cultural production, forgetting the importance of others. We valorise authors and overlook the role of scribes, who were co-participants, alongside authors, in the creation of meaning. We've forgotten the work of manuscript artists, whose names—if they survive—aren't known beyond the academy. And in our digital age, we've *entirely* forgotten the time-consuming, highly skilled work involved in making parchment, grinding pigments, and stitching gatherings. Manuscripts now command a high price in the sale-room because of their cultural value, but if we consider the intrinsic

value of a manuscript—the cost of replicating the object by employing skilled workers for years to reproduce it—we can reach a new appreciation of their worth.

In *The Gilded Page* I ask what it meant to be an author or an artist. Today, we often think of these figures—if we think of them at all—as people who worked alone, and yet manuscripts remind us repeatedly that making these artefacts was a collaborative exercise. The transmission and preservation of texts down through the centuries was also collaborative. Innumerable figures were involved in their transmission, each shaping it in ways both large and small. Sometimes manuscripts offer us a closer encounter with the scribes whose words we read than with the authors whose work they copied.

History is a story written by the powerful, and the same is true of the literary and artistic canon. The energies of collectors, patrons, churchmen, and regents have had a huge impact not only on what survives, but also—crucially—on what comes to be celebrated and studied. There are ninety-two manuscripts of Geoffrey Chaucer's *Canterbury Tales* in varying degrees of completeness. Chaucer was a government official as well as a poet; he was well connected and had royal patrons. It is not surprising that so many manuscripts of his work should survive. And his place at the head of the English literary canon can be attributed, in part, to the fact that he wrote in a London dialect of English that became the ancestor of Modern English. (He has always been more intelligible to later ages than—for example—the author of *Gawain and the Green Knight*, who was his contemporary.) By contrast, no medieval manuscript of Julian of Norwich's Long Text of the *Revelations of Divine Love*—the earliest work in English written by a woman—survives. We are reliant on copies made by exiled Benedictine nuns in the seventeenth century. This is equally unsurprising: Julian was a

female writer whose unusual theology was sometimes at odds with contemporary church teaching.

That no medieval manuscript of Julian of Norwich's Long Text (a kind of revised edition of this important work) survives is not unusual. Medieval manuscripts that have endured into the present day are survivors of war, fire, flood, and disdain. Most of them were destroyed, those that are left are the exceptions—and so we cannot overstate their value. Some two-thirds of the extant corpus of Old English poetry survives in four physical books. The scholar Roy M. Luizza called "the surviving remains of Old English literature" the "flotsam and jetsam of a vanished world."[27] If later ages had only the flotsam and jetsam of our literary culture—survivals preserved as much by chance as by design—how would they understand our age?

Manuscripts invite us to consider the lives of people who do not always loom large in our histories. And so they invite us, perhaps, to rethink the value we place in certain kinds of authors and particular patrons. You've almost certainly encountered Geoffrey Chaucer and Henry VIII, but have you ever heard of Queen Emma of Normandy, who was twice queen of England, or Leoba of Tauberbischofsheim, the first named female poet from England? Why do some names survive in the historical record while others go unrecorded? Why are some celebrated and others confined to obscurity? Manuscripts, studied in detail, can tell us something about power and collective memory and the making of history. These are some of the richest and strangest objects made by human hands. Let's meet them, and their makers.

Prologue

The Alchemy of Parchment

Many manuscripts started with parchment. Nothing gives you an appreciation of the value of these objects quite like watching the magical alchemy whereby animal hides—hairy, fatty, lumpy things—are transformed into immaculate writing surfaces. In June 2018, I saw this transformation on a visit to William Cowley Parchment Makers—a workshop about fifty miles outside of London.

The work of making parchment is unglamorous, and sometimes it smells like the inside of a boxing glove: like cheese and sweat and hard work. There is only one firm of parchment makers left in the United Kingdom. There are places elsewhere in the world where parchment is produced, but in those places the process is partially mechanized. At William Cowley everything is still done by hand. What happens there is probably not much different from what was done in the Hellenistic city of Pergamon during the reign of Eumenes II (197–159 BCE). Eumenes was an avid bibliophile and built a library to rival that of Alexandria, containing two hundred thousand volumes at its peak. According to Pliny, Ptolemy of Egypt was so enraged by the acquisitive habits of his bibliophilic neighbour that he banned the sale of papyrus. Eumenes instructed his subjects to find an

alternative writing material, and parchment was born. Where papyrus was fibrous, brittle, and prone to breakage, parchment was flexible, durable, and milky smooth. The city gave its name to the material: *pergamenum* is the Latin word for parchment.[1]

The initial stage of making parchment involves working with whole goat or calf hides, which come fresh from the abattoir, covered in hair. They still contain the suggestion of a lopped-off head and the beginnings of a tail. I saw one that had the remnants of some castrated testicles encased in a rubber band. In a storeroom there was a huge pile of these hides, folded up like furry pillowcases waiting to be laundered. After arriving at the parchment-makers, the hides are soaked for around two weeks in a vat of lime (quicklime, not the citrus variety). They come out sodden on the hair side and slippery on the flesh side. The lime breaks down the follicles and loosens the hair. I watched as a hide was fished out and thrown over a wooden stump with a wet thwack. It lay hair-side up, liquid dripping from its brown curled ends.

The stump is a smooth-topped wooden block, which the parchmenter leans over when working on the hide during the next stage. It comes to just below chest height. Once the hide is in place, the parchmenter removes the hair (known as the *nap*) with a long, curved knife (called a *scudder*) with wooden handles at both ends. I had a go at this and the hair peeled off like the skin from a potato—it was satisfying, if disconcerting. What is exposed is unmistakably flesh: faintly translucent, with the suggestion of veins beneath. (Seeing this I thought of *The Silence of the Lambs*. There is something glaring about such a large piece of disembodied skin.) I was reminded, too, of those statues of St Bartholomew—the saint who was flayed alive—with impassive, saintly expression, his skin slung over his shoulder like a shawl.

If I was struck by the skin-ness of the hide in front of me, that wasn't just my modern sensibility interjecting. Several texts from the Middle Ages show a keen awareness of the materials on which they are written. The Middle English poem *The Long Charter of Christ* purports to be a legal document in which Christ grants salvation to mankind. In one version, in a parchment manuscript in the British Library, Christ himself describes the events of the Passion. The extract contains a characteristically medieval anti-Semitic trope:

To a pilour y was pyȝt
I-tugged and towed al a nyȝt
And washen on myn owne blode
And streyȝt y steyned on þe rode
Streyned to drye on a tre
As parchemyne ouȝt for to be
Hyreþ now & ȝe schul wyten
How þis chartre was wryten
Upon my face was mad þe ynke
Wiþ þe Jewes spotel on me to stynke
Þe penne þat þe lettres was with wryten
Of scorges þat I was with smyten

(To a pillar I was tied
All tugged and towed all the night
And washed in my own blood
And stretched and stained on the rod
Strained to dry on a tree
As parchment ought for to be
Hear now and you shall know
How this charter was written
Upon my face was made the ink

With the Jews' spittel on me to stink
The pen used for the letters written
Was the scourges with which I was smitten.)[2]

Imagine the sensation for the devotional reader of reading a text like this, written on parchment—a parchment described as Christ's own face. Imagine the words of John 1:14, "And the Word was made flesh and dwelt among us," thrumming in their ears.

After having their hair removed, the skins are dried and then stretched across a frame known as a *herse*. The word comes from the French *herse*, meaning a harrow (a farming implement with teeth for breaking up clods of soil or removing weeds), and ultimately from the Latin *hirpex*, also meaning harrow. It is a cousin of "hearse," which originally referred to a frame for carrying lighted tapers over a coffin. The funereal connotation seems appropriate. Skins cannot be nailed to a frame because they would rip during the drying process. Instead, the skin's edge is gathered in bunches around balls of newspaper (in the medieval period, this would have been done with pebbles known as *pippins*) and tied with string to pegs at the edge of the frame. Treated in this way, the skin and frame take on the appearance of a rustic trampoline.

As the skin is stretched by twisting the pegs, hot water is applied, and any remaining fat, especially from the meat-side, is removed using a knife shaped like a crescent moon called a *lunellum*, or sometimes a *lunellarium* (at William Cowley they simply call it a *luna*). The process of stretching and scraping is repeated several times before the frame is put into the *oven*, which is a large drying room. I made the mistake of venturing into the oven, which was hot and milky-smelling, in a heady way. My curiosity died in there.

Conrad de Mure (c. 1210–1281) wrote, "Pellis de carne, pelle caro removetur: tu de carne tua carnea vota trahe" (Skin from the flesh, flesh from the skin is pulled: you pull from the flesh your fleshly desires). The meaning is a little obscure here, as *vota* is ambiguous, but de Mure's point seems to be that the labour of preparing parchment makes one purer and closer to God. Despite how unsexy the process was, I didn't feel my fleshly desires leaving me altogether; but I did see how this was a labour of love—the kind of labour that must have taken religious devotion to repeat with any frequency. A similar idea occurs in the late fourteenth-century dream-vision *Piers Plowman*, which compares the cleaning of parchment to the shedding of pride: "Of pompe and of pride þe parchemyn decourreþ" (Of pomp and pride, the parchment denudes you).[3]

After the oven, the skins are ready for the final stage of their processing, when the last layer of skin is shaved off, this time with a slightly larger luna. This removes any dark patches or traces of hair. Again, I had a go. Parchment holes are a common feature of medieval manuscripts. Picking up the knife, I was sure I was about to scrape too hard and break the skin. But the skin is strong; I could have hacked at it without breaking it. It's not surprising, therefore, that one of the main uses for parchment today is drumskins.

Parchment is built to last. In this it is an emblem of a pre-disposable culture. The parchment pages of the Codex Sinaiticus, made nearly 1,700 years ago, in circa 325–375 CE, are still almost pristine. Cheap twentieth-century paperbacks, with glued spines and paper that withers like an autumn leaf, often present a greater challenge to library conservation departments than parchment manuscripts. And parchment, unlike many of the disposable materials we use today, was often recycled. It was cut up to make new bindings, fill holes, or repair other

damage. Sometimes it was scraped clean of its writing and used again, leaving ghostly traces of previous writing on manuscript pages—palimpsests—for scholars to uncover.

Leaving William Cowley, I reflected that it seems like a place from a different time. Plying this ancient trade, these parchment makers disdain disposability and prize what is durable and recyclable. I got the sense that little is thrown away unnecessarily. Instead, everything shows the marks of use and reuse, the wooden handles of tools glossy and smooth from years of handling, the wooden blocks worked on again and again. I wondered what would remain of our culture in 1,700 years.

1

Discoveries

They are ill discoverers that think there is no land when
they can see nothing but sea.

FRANCIS BACON, *THE ADVANCEMENT OF LEARNING*

I n scholarship discoveries are rarely made in an instant. They
often happen through a painstaking process drawn out over
weeks, months, or years. The Egyptologist Flinders Petrie wrote
that "the true line" of research lay "in the careful noting and
comparison of small details."[1] So imagine what it would be
like to discover something and realise that what you have in
your hands is going to change your field. And what would it
be like to discover something by chance, by a "fortunate series
of accidents" (as Walter Oakeshott described one of the most
important discoveries in medieval studies to be made in the
modern era)? Each of the stories here describes people finding
manuscripts quite by chance.

Here I tell the stories of three separate discoveries. They are
all quite different, but they share a striking feature. In each
story, a manuscript made nearly half a millennium earlier is
discovered. The first is about a find made in the twelfth cen-
tury, while the next two are about discoveries made closer to
our own time. The twelfth-century discovery alone was seen as
miraculous, but whether you live in the twelfth century or the

twentieth, uncovering the material remains of a four-hundred-year-old past must feel like an experience of the divine, especially if—as a scholar—you know that the discovery is momentous. Writing about one of these finds, the scholar G. L. Kittredge wrote that it was like hearing "a voice from the great deeps."[2]

———————

In August 1104, the monks of the Durham Cathedral opened the coffin of St Cuthbert (c. 634–687). A new cathedral had been constructed, and it was time to move the saint's body to a new shrine behind the high altar at the east end of the building.[3] On August 24, a group of nine monks waited until nightfall, when they entered the old church and prostrated themselves before the shrine. They had prayed and fasted for several days to prepare themselves for their task. The act of moving their community's most important relic was not to be undertaken lightly. They wept and offered further prayers as they laid their trembling hands on the coffin. Using "instruments of iron," they prised open the lid to discover a chest covered in hides, held together by nails. They hesitated, but the prior exhorted them to continue in their task. Lifting the lid of the chest they discovered an inner coffin, covered in linen. At this point they fell to their knees, weeping and praying, whereupon one of the monks, named Leofwin (whose name in Old English meant "dear friend," or "dear joy," and who was considered very devout and "dear to God"), exhorted them to continue in their task, saying, "He who gave us the will to make the investigation, gives us the hope of discovering what we seek."

They moved the inner coffin from behind the altar to the middle of the choir to make their investigation easier, removed its linen covering, and examined it in the candlelight, hoping to

see its contents through a crack between the lid and the base. Realising it was shut fast, they prised it open. There, on a shelf, they found a gospel-book. It was a tiny red leather thing—so small it could have been held in one of the monks' trembling hands. Thrilled with terror at seeing the miraculously incorrupt body of St Cuthbert, the monks may not have realised how important this book was. It had been made at the start of the eighth century, in the time of Bede (c. 672/673–735), and it had probably been placed in Cuthbert's coffin a few decades after he died in 687. For four centuries, it had lain quietly while Cuthbert's body had taken a wandering course as the members of his community fled Viking raiders.

Cuthbert was initially buried in 687 on the island of Lindisfarne—a tidal islet off the Northumbrian coast. But in 793, just over a century after his death, the island had been attacked by Vikings. These invaders were "like stinging hornets, and overran the country in all directions, like fierce wolves, plundering, tearing, and killing not only sheep and oxen, but priests . . . and choirs of monks and nuns." When the raiders arrived in Lindisfarne, they "laid all waste with dreadful havoc, trod with unhallowed feet the holy places, dug up the altars, and carried off all the treasures of the holy church. Some of the brethren they killed; some they carried off in chains; many they cast out, naked and loaded with insults; some they drowned in the sea."[4]

In face of such savagery, in the spring of 875 the community left the island for the last time, taking Cuthbert's coffin with them. They travelled for seven long years, stopping off at Norham, Whithorn (on the Derwent), and Crayke. In 883 they settled in Chester-le-Street, where they remained until 995. In this year, Bishop Aldun—the leader of the community—"was admonished by a revelation from heaven" that he should flee

"some pirates who were close at hand." The monks moved again, to Ripon, but after three or four months of peace they decided to return to Chester-le-Street. On their journey there they reached a spot near Durham, and "the vehicle, on which the shrine containing the holy body was deposited, could not be induced to advance any further."[5] The cart became stuck in the mud, which the monks took as a sign of divine providence: Cuthbert did not wish to move. It was decided that they should settle there. Perhaps Cuthbert approved of Durham's hill encircled by a river; perhaps it reminded him of the island of Lindisfarne, where he had lived most of his life.[6]

The journey Cuthbert's body had taken was only one consequence of the great destruction wreaked by the Vikings during the era. Generations of monks had to take desperate measures to evade them. In the four hundred years that the little book had remained hidden in the coffin, these incursions had destroyed many important libraries in the north of England. This meant that the manuscript was a precious remnant of an important bibliographic culture that had been devastated by marauding war-bands. Its survival over those centuries was extraordinary. And yet, more extraordinary still, it has survived into our own day. Known as the Cuthbert Gospel, it weighs just 162 grams and measures 10 by 14 centimeters. But its tiny size betrays nothing of its status as a cultural monolith: the Cuthbert Gospel is still in its original binding, making it the earliest intact European book.

The manuscript has had a tumultuous history up to the present day: it has survived not only interment and Viking incursions but also Protestant despoilers and a trip to Belgium. After its discovery in 1104 it was venerated by the monks of Durham Cathedral and seemingly protected by a higher power. Reginald of Durham (d. c. 1190) recounts how, in the twelfth century,

a monk attempted to "grope" the book and died soon afterwards. The same author also describes how one of the Bishop of Durham's officials stole a thread from the strap on the book's satchel. Secreting it in his shoe, he was subsequently afflicted with a terrible swelling of the leg, which was only cured when the thread was returned.

Durham Cathedral Priory was dissolved in 1539, and the cult of Cuthbert suppressed, as part of the Protestant Reformation.[7] Many of the cathedral's relics were destroyed or dispersed. Katherine Whittingham, the dean's wife, removed the stoups (the basins for holy water) and installed them in her kitchen, where she used them to store salted beef and fish.[8] As for the Cuthbert Gospel, what happened to it in this period is a mystery. It probably passed into the hands of an antiquarian. It appears next in the early seventeenth century in the collection of the mathematician and astrologer Thomas Allen of Gloucester Hall, and from there it entered the collection of George Henry Lee, 3rd Earl of Lichfield (1718–1772). Lee's ownership of the book was somewhat incongruous. He was a Tory politician, and one account describes him as "a red-faced old gentleman . . . who had almost drunk away his senses."[9] Lee gave the manuscript to a Catholic priest, the Reverend Thomas Philips, in 1769, who in turn presented it to the English Jesuit College in Liège (which trained Catholic priests). In 1794, the staff and students fled the upheaval of the Napoleonic Wars and moved to Lancashire—to Stonyhurst College, to be precise—just as nearly a millennium earlier the inhabitants of Lindisfarne had fled the attacks of Viking raiders.

In the nineteenth century scholars began to take an interest in the manuscript. Bishop John Milner examined it in 1806 and exhibited it at the Society of Antiquaries. He confessed that he had found the manuscript's story outlandish: "I own I rejected

the story as a fabrication." His description of it is largely accurate, except that he declared the binding to be "of the time of Queen Elizabeth." We can't really blame Milner for this error, because the history of Western bookbinding *begins* with the Cuthbert Gospel, so there wasn't much to compare it with.[10] Milner returned the manuscript to Stonyhurst, but in 1808 it was lent out once more to the society so that a facsimile of its first page might be taken. The manuscript went missing on its way back, and Father Marmaduke Stone, the college president, wrote, "If it be lost God's holy will be done."[11] God's will or not, it was returned, and the Jesuits kept it until the British Library bought it in 2012 for £9 million. It was the largest and most successful fundraising campaign the library had ever mounted.

Today you can see the Cuthbert Gospel (BL Add MS 89000) in full online.[12] It is also often put on display in the British Library's Treasures Gallery and periodically in Durham. Seeing it in person, you could almost be disappointed. It is so slight, and its binding design so simple. The cover is made of embossed red leather with a Celtic interlace pattern surrounding a plant motif. Some faint traces of pale yellow and blue pigment are just discernible in the grooves of the design. But the manuscript was made some 1,300 years ago, and, in subtle ways, it speaks to us across the centuries. It captures a sense of England in the early days of Christianity. It tells us that although we might imagine the British Isles in the period as an outpost at the far edges of the known world, the truth is quite different. The Cuthbert Gospel was made in a flourishing monastery, a monastery with international connections that was celebrated as a centre of learning with an important library.

The front cover of the manuscript shows, in a central panel, an embossed design of a vine sprouting from a chalice. This image recalls the early Christian "fountain of life" motif, which was

common in the period in the Eastern Mediterranean. The motif of the vine sprouting from a chalice can be found, amongst other places, on the doors of the Church of Sitt Barbara in Cairo dating from the fifth or sixth century.[13] At once, the manuscript whispers clues as to its origin and contents. The vine motif recalls John 15:5, "I am the vine, you are the branches," hinting at the contents, the Gospel of Saint John in Latin. Around this vine motif we can see interlacing patterns characteristic of early medieval English and Irish art.

In the design of the front cover we already gain a sense of its origins in an early medieval England that was a place with international connections. If we removed the binding, we would see that the manuscript's folios were bound together using a chain-stitch method that originated in Coptic Egypt. The booklets that make up the manuscript are not sewn onto cords, as was customary in Western Europe, but instead sewn together by two needles working in a figure of eight pattern from booklet to booklet. The effect is that the book opens easily and lies flat.

Although the Cuthbert Gospel's covers are of international significance, for me the beauty of the manuscript is in the pages of its text. The opening words read:

IN PRINCIPIO ERAT VERBUM
ET VERBUM ERAT APUD DEUM
ET DEUS ERAT VERBUM.

(In the beginning was the word
and the word was with God
And the word was God.)[14]

This book—the earliest intact European book—represents the beginning of the word, or rather, a *story* of the written word

in England. It is a story that stretches from the start of the eighth century to our own day. And these opening lines are apposite because each word here has been copied out with a kind of devotional reverence. Each word here is, in a sense, God. The scribe has written out the text entirely in capital letters in a script scholars call *uncial*. The opening letters are picked out in red ink. Although punctuation was uncommon in manuscripts of this period, the scribe has divided the text using line breaks as a kind of punctuation, even though this was not the most economical use of the parchment. The words are written with crisp, clean lines; there are no traces of mistakes. In fact, the manuscript as a whole is remarkably error-free. The entire manuscript contains only five erasures and two instances where letters have been inserted above the line.[15] The words on each folio are generously spaced apart; there are only nineteen lines per page, and the margins are substantial relative to the size of the text-space. These might seem like boring details, but they indicate a book produced with great care, one whose manufacture required an investment of time and resources.

That investment of time and resources was characteristic of the scriptorium where the manuscript was made.[16] The Cuthbert Gospel was written at Wearmouth-Jarrow. This twin monastery (comprising foundations at Wearmouth and Jarrow) once stood on the banks of the river Tyne. It was founded by Benedict Biscop (c. 628–690) in about 672 (for Wearmouth) and in 681 (for Jarrow). Early in its existence, it became a centre of great learning. (It was to produce, a generation later, the Venerable Bede—the greatest historian of the early medieval period in Britain.[17]) Key to this intellectual flourishing was Biscop himself. He went to Rome six times and on three of these occasions acquired manuscripts that he brought back with him over the

North Sea. He also recruited masters to teach liturgy and chant who likely taught the craft of writing as well. It was probably Benedict Biscop who brought back, from one of his trips to Rome, a very accurate copy of the Vulgate, a late fourth-century Latin translation of the Bible. This text would go on to be the exemplar—the source text—for the Cuthbert Gospel.

Given that it bears the name of a saint who preferred seclusion, it is ironic that the manuscript should be a testament to the international reach of early medieval England. Cuthbert spent the latter part of his life as a monk in the monastery of Lindisfarne. Lindisfarne had been founded (possibly in the year of Cuthbert's birth) by Aidan (d. 651), who came from the Irish monastery of Iona. Bede tells us that after "many years" in the monastery Cuthbert opted to live as a hermit on Inner Farne Island, where "he joyfully entered into the remote solitudes which he had long desired."[18] In 685, he was made the Bishop of Lindisfarne, which by all accounts he seems to have disliked, preferring the splendid isolation of his cell. Bede tells us that Cuthbert built a round dwelling for himself that he partially excavated out of the rock. It had a high wall and seemingly no windows, all the better "to prevent the eyes and the thoughts from wandering, that the mind might be wholly bent on heavenly things, and the pious inhabitant might behold nothing from his residence but the heavens above him."[19]

The Cuthbert Gospel today, in the protective dimness of the British Library Treasures Gallery, seems a world away from the saint after whom it was named. It seems almost impossible that it could have been made 1,300 years ago. I can understand the position of Rev. Milner (who thought its leather cover dated from the time of Elizabeth I)—it is miraculous that it should still be in its original binding. From our perspective today, 1104,

the year Cuthbert's coffin was opened, seems a long time ago. But when it was discovered, it was already nearly half a millennium old.

—————

An extraordinary, accidental find was made by a family in search of Ping-Pong balls in the summer of 1934.[20] In a firsthand account, Captain Maurice Butler-Bowdon (b. 1910) of the Royal Navy (then a midshipman) described how he had been playing Ping-Pong with some friends at his family's Georgian house near Chesterfield: "One of us trod on the Ping Pong ball and my father went to the cupboard to get out a replacement and it was soon apparent that he was having difficulty in finding either a ball or even the tube of balls."[21]

At this point one of the Butler-Bowdons' house-guests went over to the cupboard to lend a hand with the ball-hunt. By chance, this house-guest was a certain Charles Gibbs-Smith, who was at the time an assistant keeper at the Victoria and Albert Museum in London. The reason the balls were remaining elusive was that the cupboard contained "an entirely undisciplined clutter of smallish leather bound books." Butler-Bowdon recounted his father's exasperation at this pile of book-clutter: "I am going to put this whole '—' lot on the bonfire tomorrow and then we may be able to find Ping Pong balls & bats when we want them," he said. Gibbs-Smith objected to this idea, asking whether he could invite "an expert . . . acquaintance of mine who knows about these things to come and look through this cupboard, after all there may be something of real interest there which you may not at the moment realise." Captain Butler-Bowdon's father, William Butler-Bowdon, a Royal Navy

lieutenant colonel, insisted that the books were "all old house-hold account books" but remarked, "If your friend thinks his trip would be worth it," he would not mind. So the books were saved from burning and the friend was duly invited to stay.

The friend was Albert Van de Put—a medieval historian on the staff of the Victoria and Albert Museum. This being 1934, he arrived "one evening in time to change for dinner." The next morning, after breakfast, Van de Put began his investigation of the cupboard's contents. Half an hour later he visited the lieutenant colonel in his study, saying, "Thank you very much for your hospitality, I think I will be away now—I think I have found something more interesting than I should have hoped for in my wildest dreams." Van de Put asked to take one of the books with him back to London. It might not have looked very exciting—it had a cover that had been repaired after being "eaten away presumably by a mouse." Butler-Bowdon assented. Not long after this, the text in the manuscript was identified as the lost *Book of Margery Kempe.*

The Book of Margery Kempe is the first piece of autobiographical writing in English.[22] Kempe (c. 1373–1438) was an East Anglian woman who worked variously as a horse-mill operator and as a brewer. She was also the mother of fourteen children. She opens her book by describing how, after the difficult birth of her eldest child, she had become ill and feared for her life. She had called for a priest in order to make her confession. When she confided a particular transgression that had long troubled her, he admonished her for her sinful ways—an experience she appears to have found deeply traumatic. It induced what today we might term postpartum psychosis, which lasted for over six months. During this time, she experienced terrifying visions of devils:

And in þis tyme sche sey, as hir thowt, deuelys opyn her mowthys al inflaumyd with brenny[n]g lowys of fyr, as þei schuld a swalwyd hyr in. Sum tyme ramping at hyr, sum tyme thretyng her, sum tym pullyng hyr and halyng hir boþe nygth and day duryng þe forseyd tyme.

(And in this time she said that she thought she saw, or so it seemed to her, devils with open mouths all inflamed with burning flares of fire, who looked as though they might swallow her up. Sometimes they pawed at her, sometimes they threatened her, sometimes they pulled her, dragging her around both day and night throughout that time.)[23]

These visions occasioned suicidal thoughts: "Sche wold a fordon hirself many a tym" (She would have killed herself many a time). There were bouts of self-harm where Margery tore her own hand with her teeth, causing permanent scarring, and slashed at the skin over her heart with her fingernails. She would have done herself further damage had she had "oþer instrumentys," and had she not been bound and forcibly restrained night and day.[24] She was twenty years old.

After a "long" time had passed, Margery "lay aloone," her "kepars we fro hir" (her "keepers," or "warders," were not nearby), and had a vision of Jesus, who came to sit at her bedside. He appeared in a gorgeous purple robe, looking "most semly, most bewtyvows and most amiable" (most handsome, most beautiful and most affectionate). He asked, "Why hast thow forsakyn me. . . . I forsoke neuyr þe" (Why have you forsaken me? I never forsook you). This vision brought Margery great comfort and she returned to sanity: "stablelyd in hir wyttys and in hir reson" (secure in her wits and in her reason).[25] This was to be the first of a series of visions of Christ, of his mother, and of

other saints that Margery would experience over the course of her eventful life.

After her early visions of Christ—and the failure of two businesses that she ran, which she interpreted as a sign of God's displeasure—Margery sought to live a spiritual life, despite not being attached to any religious institution. She became a *vowess*—a woman who takes unofficial religious vows. After over twenty years of marriage, she persuaded her husband to forswear sexual relations with her. (At this point in the fifteenth century, a husband had the legal right to have sex with his wife whenever he wished; indeed, it took until 1991 for marital rape to be considered a crime in UK law.) Thereafter, she took a vow of chastity, gave up eating meat, and wore only white.

Margery's account of her life is beguilingly down to earth. After her first vision of Christ, she asked her husband "þat sche might haue þe keys of þe botery to takyn hir mete and drynke" (that she might have the keys of the buttery so that she might have food and drink).[26] There is something so charming about a woman who can sit down to what we might imagine was a hearty meal in the immediate aftermath of a mystical experience. It is these kinds of homely details that have captivated readers since the first edition of the text appeared in 1936.[27]

There is also something homely in Margery's expression of her devotion. It is striking that many of her visions centre on Christ as a child and the Virgin as a mother. In the sixth chapter, she has a vision of attending the birth of Christ in Bethlehem. In the vision she provides practical assistance to the Virgin Mary—finding lodgings, "whyte clothys and kerchys for to swathyn in hir Sone whan he wer born" (white clothes and kerchiefs for her to swathe her son in when he was born). Later, Margery herself "swathyd hym [Jesus]."[28] There is great tenderness in this, but it has the mark of a woman who has

been a mother herself—a woman who knows to be comforting as well as useful. We are left to wonder how many of Margery's fourteen children survived and why her visions sometimes focused on the experiences of motherhood. Her visions began in the immediate aftermath of the traumatic birth of her first child; we can only speculate on what psychological effect that experience had.

Margery's book shows the tenderness she felt towards the person of the Christ-child, but her tenderness and compassion is discernible elsewhere as well. There is a moving episode in which she comforts a woman who is mentally disturbed after childbirth. In Chapter 75 Margery is praying in church when she is approached by a man in some distress. She asks what is wrong and he explains that his wife is "newly delyueryd of a childe" (newly delivered of a child) and is "owt hire mend" (out of her mind). You can sense his anguish when he tells Margery that his wife "knowyth not me ne non of hir neyborwys. Sche roryth and cryith so þat sche makith folk euyl a-feerd. Sche wyl boþe smytyn and bityn and þerfor is sche mankyld on hir wristys" (does not recognise me or any of her neighbours. She roars and cries so that folk fear she is evil. She will both hit and bite and therefore she is manacled on her wrists). This description is disturbing, revealing how little mental illness was understood in the fifteenth century.[29]

When Margery visits the woman, she becomes calmer, telling Margery that she is a "ryth good woman" (right good woman), but later, when other people come to visit, she becomes distressed again, weeping and threatening to eat them. After this, she is taken to a room in "þe forthest ende of þe town," where her hands and feet are shackled in "chenys of yron" ("the farthest end of the town," shackled in "chains of iron").[30] Margery, however, visits her every day, speaking to her and praying for

her. The woman recovers and is welcomed back into her community. Of course, it is difficult to know what to make of this story today. But what strikes me is that Margery had also been through a traumatic birth, and she, too, had been scorned and shackled. Perhaps her gentle acceptance of the woman helped her to return to sanity.

Despite these instances of compassion, Margery often experienced derision, scorn, and even threats to her own life. She was repeatedly accused of heresy. Her tendency to weep loudly in devotion drew derision, while her willingness to admonish people on how best to live a good Christian life drew fear from some ecclesiastical authorities. The fifteenth century was an uneasy time for the Catholic Church. A muscular heretical movement centring around the scholar and Bible translator John Wycliffe had begun in Oxford in the late fourteenth century, and by the start of the fifteenth, the church was aggressively cracking down on anyone it perceived to be perpetuating unorthodox views. Unlicensed preaching was banned, and the prospect of a woman preaching was almost unthinkable. Margery was condemned. She was accused of being a heretic several times; interrogated by ecclesiastical authorities at Leicester; and subjected to trials at York, Hull, Hessle, and Beverley while attempting to travel the country on pilgrimage. At one point, she was threatened with being burnt alive in the street.

In spite of all this, Margery continued to travel extensively in England and abroad and went overseas on several pilgrimages. She visited Jerusalem in 1413, not returning to England until 1415. Two years later, she travelled to Santiago de Compostela. And in 1433, after a more sedentary period at home in Lynn, she set off again, travelling to Norway, Danzig, and Aachen. She saw the four holy relics of Aachen Cathedral, which included what were thought to be Jesus's swaddling clothes. She

described these pilgrimages in vivid detail, but also described the scornful way in which others treated her. In Chapter 26, when she travelled to Jerusalem, her fellow travellers bullied her, cutting her robe so that it came just below the knee (a shocking length) and forbidding her from eating at table with them.

Margery's descriptions of her travels are fascinating for what they reveal about her fifteenth-century world. But some of Margery's experiences were timeless. In Chapter 76, she describes how she nursed her husband when he became senile and incontinent. At this point the pair had been living apart because of the vow of chastity she had taken, but she came to live with him again and cared for him until his death. Her husband, whom she had once loved passionately, now had to be tended to like an infant. The book describes how "as a childe [he] voydyd his natural dygestion in hys lynyn clothys" (like a child he soiled his linen clothes). It meant "labowr meche" (much labour) for her, but she felt it was an appropriate divine punishment, as "sche in hir ȝong age had ful many delectabyl thowtys, fleschly lustys and inordinate louys to hys persone" (she in her youth had had many delectable thoughts, lustful urges which centred on him and taken great joy in his body).[31]

Margery's work is extraordinary in many ways, but in some ways its value lies in its *ordinariness*. Kempe was not an aristocratic or gentry woman; she was the daughter of the mayor of a prosperous East Anglian town. Too often it is the voices of a regal or ecclesiastical elite that come down to us from the Middle Ages. This is in part because so few non-elite figures in the medieval period were literate (although this began to change towards the end of the era). And Margery was not unusual—she, too, was illiterate. To record her experiences, she had to dictate the work to an *amanuensis*—a scribe who listened to her words and wrote them down. In fact, three different amanuenses were involved in

the project. The first was an "englyschman." This may have been her son, who lived in Germany but moved to England: "[He] cam in-to Yngland with hys wife and hys goodys and dwellyd with þe foreseyd creatur" (He came to England with his wife and his goods and dwelled with the aforesaid creature—here, as elsewhere in the text, Margery is referred to in the third person, as the "creatur," to advertise that she did not personally write the text). This Englishman died before the work was completed, and thereafter the work was taken up by a priest, who said what had been done to that point was "so euel wretyn þat he cowd lytyl skyll þeron, for it was neiþyr good Englysch ne Dewch ne þe lettyr was not schapyn ne formyd as oþer letters ben" (so ill-written that he could make little sense of it, for it was neither good English nor German and the letters were not written as they should be).[32] At this point, Margery and the priest began the work again from scratch. During the course of the project, the priest was discouraged by malicious gossip he heard about Kempe, and so he delayed for four years. He directed Kempe to a third man, who had at one time been a correspondent of the "englyschman" (the first amanuensis). This scribe could not understand the text that had thus far been written. Subsequently, the priest began to suffer pangs of guilt and prayed to God to be able to understand the work, whereupon he was miraculously able to complete the job. Although hindered at every turn, Margery was dogged in her efforts to preserve her story.

The manuscript itself is not the original one written down by the last of Margery's amanuenses. But for once, we do actually know the name of the scribe who copied it. He calls himself "Salthows" (Salthouse) at the end of the text as part of a conventional phrase often used by scribes: "Jhesu mercy quod Salthows" (Thanks be to Jesus says Salthouse).[33] Exactly who this Salthows was is something of a mystery. There is a village

called Salthouse on the north coast of Norfolk, about thirty-five miles northeast of Lynn, so he may have been from there. Small clues in the book's physical construction tell us that it dates from about 1440 or 1450. The manuscript is written on paper and in this period all paper contained watermarks. Watermarks, which simply denote a place of origin, leave ghostly clues in a manuscript's pages indicating where the paper was made. You can only see them by holding a page up to the light, when they shine through as paler than the rest of the paper. The watermarks in the manuscript of *The Book of Margery Kempe* show that the paper was made in Holland, in about 1440 or 1450.[34] (It's not remarkable to find an English manuscript copied on paper made in Holland, because much of East Anglia's prosperity in this period came from the wool trade, and it had good trade links with the continent and the Low Countries in particular. That's part of the reason the region was so rich.) Other clues in the manuscript help corroborate its date and probable location. At the end of the manuscript we find a document called a *faculty* that records the appointment of a certain William Buggy as vicar in Soham in Cambridgeshire, which is around thirty miles south of Lynn. The document is dated to 1439, so the manuscript was likely not made before 1439—the year after Margery probably died.[35]

The manuscript then made its way to a Carthusian priory in Yorkshire—Mount Grace. On one of its opening leaves there is an inscription that reads "liber mon[n]te gr[ac]e. this boke is of montegrace" in a fifteenth-century hand.[36] From there—it has been conjectured—the book may have made its way to London, where Everard Digby, an ancestor of the Butler-Bowdons, eventually acquired it.[37] After that, its movements are a mystery until it turned up in that untidy cupboard centuries later.

Until the discovery of the only known manuscript of the work in 1934 in the cupboard, the text had only been identified in seven pages of heavily abbreviated extracts printed in 1501 by Wynkyn de Worde (the successor of William Caxton [c. 1422– c. 1491], England's first printer). The text in de Worde's edition is starkly different from the manuscript text. An editor has gone through the original and stripped out all the moments in which Christ addresses Margery in her visions and only printed his words—that is, he silences Margery's voice. Whereas in the manuscript version Margery is a larger-than-life character who roars and wails and boisterously communicates her devotion, in the printed extracts she is a listener, not a speaker. The text focuses on Margery's experiences in the 1420s, leaving out the descriptions of her pilgrimages or the harassment she suffered as a supposed heretic. It is the voice of Christ that dominates the text.

Margery Kempe's story is in many ways one of triumph over adversity and of a woman's determination to be heard. It is appropriate, therefore, that the identification of the text in 1934 was made by a female scholar—Hope Emily Allen, an American who had grown up in a perfectionist "holy community" in Oneida, New York, and attended Bryn Mawr and Harvard.[38] Allen was on a research trip to London at the same time that Albert Van de Put had brought the manuscript to the Victoria and Albert Museum. Van de Put was a historian of medieval Spain and this piece of Middle English devotional prose was outside his area of expertise. He sought the assistance of several scholars, including Eveyln Underhill, who suggested that her cousin, Hope Emily Allen, might be able to help. Allen came to the museum in late July and identified the manuscript as the only known full copy of Kempe's text.[39]

In December, Allen wrote a letter to the *London Times* to announce the discovery.[40] (She is modest, claiming no glory for herself.) As Allen was not interested in transcribing the manuscript or studying its language, she suggested that her colleague Sandford B. Meech be appointed as joint editor alongside of her for an edition for the Early English Text Society. Relations between the two quickly deteriorated and Allen began to suspect that Meech "was seeking, possibly with the support of the manuscript's owner, to force her off the project." As Allen's biographer John C. Hirsch noted, "It is difficult to believe that Meech would have treated a senior male colleague with the irritation, anger and contempt he showed, over many months, to Allen."[41] Unfortunately, much as Margery's own voice was eliminated and reframed by what we can assume was a male editor in the 1501 Wynkyn de Worde edition, so Hope Emily Allen's work was sidelined by Sanford Meech, her coeditor on the first scholarly edition of the text. Allen determined to produce a second book on Kempe, placing her *Book* in the context of late medieval English mystical writers. But through ill health she never completed the project. Allen died in Oneida in 1960.

The Book of Margery Kempe is a powerful document. It often feels open, honest, unvarnished, and unashamed. There is something so moving in the way Margery worked so tirelessly to have her experiences recorded. She had to overcome social stigma, mental illness, and ecclesiastical censure. The opening of the work describes how "euyr sche was turned aȝen abak in tyme of temptacyon lech unto þe reed spyr which boweth with euery wynd [and] neuer is stable les þan no wynd bloweth" (ever she was turned back again in time of adversity, like the reed-spur which bows with every wind and is never still unless no wind blows).[42] In 1976, the feminist thinker Adrienne Rich wrote, "I believe increasingly that only the willingness to share private

and sometimes painful experience can enable women to create a collective description of the world which will be truly ours."[43] Kempe's work, composed some six centuries before Rich's, and largely unknown until the twentieth century, describes the world in a way that makes it just a little bit easier for women to inhabit it. That it is the first piece of autobiographical writing in English makes it important, but the fact that it was composed by an illiterate woman makes it extraordinary. And it might not have come to light for even longer had it not been for that fateful Ping-Pong game.

The year 1934 was an exceptional one in the history of medieval English literary study. In the same year that *The Book of Margery Kempe* was found, Walter Oakeshott, a teacher at Winchester College, stumbled on something equally important. At the time, Oakeshott was thirty-one years old and an "ordinary assistant master."[44] He had become interested in the history of book binding and had been given permission to study sixteenth-century book bindings in the College Fellows' Library. His friend Basil James Oldham suggested he examine some manuscript bindings as well. The manuscripts, however, were kept separately from the books, in a safe in the warden's bedroom. This safe, Oakeshott wrote, had "a legendary reputation with me, since not so many years before a knowledgeable visitor who had made his way into it had recognised, in the bedside mat, a magnificent piece of Tudor tapestry . . . probably woven for the occasion of the christening of Prince Arthur, Henry VII's eldest son, in Winchester Cathedral."[45]

So Oakeshott approached the safe "with some excitement," but on opening it, he felt immediate "disappointment." There

were no medieval bindings. He decided to glance at the manuscripts nonetheless. One of them caught his eye. It was "very fat," made of paper, not parchment, and the text was "clearly about King Arthur and his Knights," but lacked a beginning and an end. Oakeshott "made a vague mental note" of the manuscript and moved on to the next one.

What Oakeshott had stumbled on was the only known manuscript of Thomas Malory's great Arthurian legend, *Le Morte Darthur*—the last major piece of Arthurian literature to be produced in the Middle Ages. It was also the first and only text in Middle English to recount the entire legend of Arthur from his birth to his death. In 1934, the only known copy of the work was an edition dated to 1485 that had been printed by William Caxton. Oakeshott might have forgotten about this "fat" book entirely had it not been for "a fantastic piece of good fortune": a few weeks later, he was preparing for a visit from the Friends of the National Libraries and was due to bring out a few books from the school's collection printed by Wynkyn de Worde. It was necessary, therefore, to do some research on this printer and his relationship with Caxton. He set out to read an article titled "The Introduction of Printing into England and the Early Work of the Press" by the British librarian and bibliographer E. Gordon Duff. While reading the article, Oakeshott later wrote, he "came across a sentence which made my heart miss a beat."[46] Referring to *Le Morte Darthur*, it read, "No manuscript of the work is known, and though Caxton certainly revised it, exactly to what extent has never been settled." It transpired that what Oakeshott had come across in the safe was a manuscript that might settle that debate.

Oakeshott decided to show the manuscript to the delegates from the Friends of the National Libraries. Their secretary, H. D. Ziman, was overawed by the discovery and insisted that

Oakeshott write a column about it for the *Daily Telegraph* the next day.[47] A day or two later, a professor from Manchester, Eugene Vinaver—who was at that very time at work on an edition of the *Morte Darthur*—arrived on Oakeshott's doorstep. He would go on to produce an edition of the text incorporating the manuscript version in 1947.[48]

One of the reasons that the Winchester Manuscript, as it became known, caused such a stir was that, for a long time, there had been some controversy over the identity of the author. Little was known about him. Much of what could be gleaned was from a colophon—a kind of endnote to the reader—in Caxton's edition, which stated that the work was "re-duced in to englysse by Syr Thomas Malory knyght" (condensed into English by Sir Thomas Malory, Knight).[49] In the nineteenth century, the American scholar George Lyman Kittredge pieced together some clues and identified a Thomas Malory of Newbold Revel in Warwickshire (1416–1471) as the likely author of the work. In 1928, another scholar, George Hicks, published a follow-up study in which he pointed out that Thomas Malory was something of a career criminal. He had been accused of extortion, theft, rape, cattle-rustling, robbery of an abbey, deer-theft, horse-stealing, and attempted murder. This Malory had been imprisoned several times and escaped twice—once by swimming the moat of the house in which he was being detained. This image of a thug with questionable morals did not seem to tally with the nature of the text he had supposedly authored. When the Winchester Manuscript was discovered, however, the evidence that it was indeed Sir Thomas Malory of Newbold Revel who had authored the *Morte* began to build. In several places in the text, in the divisions between sections, there were endnotes of a type which scholars call *explicits* that had not appeared in Caxton's text.[50] One, at the end of Book IV, read:

And this booke endyth whereas Sir Launcelot and Sir Trystrams com to courte. Who that woll make ony more, lette hym seke other bookis of Kynge Arthure or of Sir Launcelot or Sir Trystrams; for this was drawyn by a knight prisoner, Sir Thomas Malleorré, that God send hym good recover. "Amen & c."

(And this book ends where Sir Lancelot and Sir Tristram come to court. Those who wish to read on should seek out other books about King Arthur or Sir Lancelot or Sir Tristram, for this [work] was composed by a knight prisoner, Sir Thomas Malory—may God grant him deliverance [release from prison].)[51]

Here was a startling piece of information. While Caxton had simply described Malory as "Syr Thomas Malory knyght," in this note he was described as a "knight prisoner." Oakeshott sent a photograph of this page to Kittredge, and on September 28, 1934, Kittredge wrote back saying, "Nothing that has crossed my path of late, has stirred me so deeply. The colophon, with its spelling of Malory's name, and its 'prisoner[,]' is like a voice from the great deeps."[52] It confirmed Kittredge's suggestion that the Thomas Malory who wrote the work was indeed the Thomas Malory of Newbold Revel who had been imprisoned several times.

Malory appears to have lived a relatively blameless life until around 1450, when—somewhat inexplicably—he turned to a life of crime at the age of forty. But despite the many accusations and imprisonment, he never seems to have been given a trial. The turbulence in Malory's own life tracks the turbulence in the realm at large. In this period, England was wracked by civil war. The Lancastrian king Henry VI (who had come to the throne in 1422 when he was only nine months old) was

afflicted by bouts of mental illness; for long periods during his uneasy reign the country was ruled by a powerful regent, Richard, Duke of York. The situation reached a crisis point in the early 1450s. Henry had failed to produce an heir, and his grip on power became ever more tenuous as factions circled at court. (A son was born in October 1453, but Henry was so mentally unstable he could not be made to understand what had happened.) These developments coincided with a breakdown in law and order in England, and open war between the Lancastrian and Yorkist factions began in 1455.

Malory was held at various prisons in London in the 1450s before being pardoned in 1462. After that he fought in a military expedition against Lancastrian strongholds in the north of England alongside the Earl of Warwick. Later, Warwick switched his allegiance to the Lancastrian cause, and Malory switched with him. This turned out to be a poor decision. In 1462 Malory was explicitly excluded from a general pardon, and sometime after, he was arrested again. The *Morte Darthur* was completed in prison at some point between March 4, 1469, and March 3, 1470 (the final endnote in the manuscript tells us so, saying that the work was completed in the ninth year of the reign of Edward IV). Malory died in 1471, and his remains are buried in the ruins of Greyfriars Church—once an important establishment across the street from Newgate Gaol in London. What is left of the church is now a rose garden.

Le Morte Darthur is one of the great explorations of the culture of chivalry. It is the earliest complete coherent account of the Arthurian story. In a series of individual books, it describes Arthur's life from his birth to his death, and along the way it incorporates the stories of several other famous knights of the Round Table. Malory's text includes the stories of Tristram and Isolde, Lancelot and Guinevere, and the quest for the legendary

Holy Grail. It ends with Arthur's death and the fall of the Round Table. It depicts a world of courtesy, duty, and obligation, and yet it also exposes the dark underside of this same culture. It is tempting to speculate that the accusations laid against Malory might have shaped the way he saw the story of Arthur. Perhaps Malory, more than most, understood that chivalric deeds did not always go hand in hand with chivalric morals.

When Malory sat down to write about the legends of King Arthur, he was only the latest writer in a tradition that had begun some three hundred years before. His great skill as a writer was his ability to blend diverse sources in a crisp and readable narrative. The *Morte* is a story of epic proportions about a pseudo-historical past, but it is also filled with timeless human stories. From the work of the Welsh writer and cleric Geoffrey of Monmouth (c. 1095–c. 1155), Malory took a story of a pseudo-historical Arthur. But he also extensively mined a tradition of French chivalric romance poetry to give us a haunting portrait of Lancelot and his adulterous love for Arthur's wife, Queen Guinevere. The moment that Malory introduces the character of Guinevere, he also introduces the fact that she and Lancelot love each other.

Announcing his intention to marry Guinivere at the start of Book III, Arthur tells Merlin, "I love Gwenyvere, the Kynges doughtir of Lodegrean, of the londe of Camelerde, the whyche holdyth in his house the Table Rounde. . . . [T]his damesell is the most valyaunte and fayryst that I know lyvyng, or yet that ever I coude fynde." This is the first time that both Guinevere and the Round Table are mentioned in the narrative. Merlin warns Arthur "covertly that Gwenyver was nat holsom for hym to take to wyff, for he warned hym that Launcelot scholde love hir, and sche hym agayne."[53] Arthur does not heed Merlin's warning, instead dispatching him to the court of King Lodegrean,

Guinevere's father, to ask for her hand in marriage. Lodegrean proclaims that this is the "best tydynges that ever I herde" and resolves to "send hym [Arthur] a gyffte that shall please hym muche more, for I shall gyff hym the Table Rounde." Thus, the Round Table, one hundred knights, and the princess Guinevere are sent to Arthur. The sense of foreboding is inescapable. Both Arthur's marriage and the Round Table seem doomed to fail.

It's hard to overstate the influence of Malory's version of the Arthurian story for us as twenty-first-century readers. Malory was read by, referenced, and rewritten to varying degrees by Walter Scott and Alfred Tennyson, amongst many others. In the twentieth century many people encountered the tales through T. H. White's influential version of the work, *The Once and Future King*. But it was undoubtedly Malory's clipped and readable prose and the comprehensiveness of his narrative that made his version the most read and readapted version of the story in the post-medieval period.

When Caxton came to print the *Morte*, he chose to remove any references to Malory being a prisoner. We know this because in 1976, the British Library bought the manuscript of the *Morte* from Winchester College, and to celebrate the sale, the library put the manuscript on display next to the only complete copy of Caxton's print edition, lent by the Pierpont Morgan Library in New York. This got the scholar Lotte Hellinga thinking about the relationship between the manuscript and the book, and she discovered something intriguing.[54] On several pages of the manuscript she noticed tiny smudges and blots of a different kind of ink from that used by the scribe. It was a "quick-drying oil-based ink"—in other words, printer's ink.[55] Further investigation revealed that the smudges were in a particular pattern that matched typesets that had been used by Caxton. (You can see the ghostly smudges of the dark, sticky ink on some of the

manuscript's folios when you look at it online.[56]) This meant that the manuscript had been in Caxton's workshop. Scholars were therefore able to get a better sense of the editorial changes Caxton had made, which included not mentioning the fact that Malory had written the work in prison.

At the end of the essay in which he describes his extraordinary encounter with the Malory manuscript, Oakeshott compares his discovery to the biblical story of King Saul, who was sent to seek his father's lost asses:

> We are told that Saul the son of Kish went out to seek his father's asses and found a kingdom. The fate of the literary detective is comparable only in that, if he finds anything at all, he will find something different from that for which he is looking. It is seldom a kingdom. . . . The asses almost always prove obstinately elusive. Certainly I did not, on this occasion, find them. All I could tell Oldham was that there were no bindings on the manuscripts to interest him.[57]

The lesson of 1934—that remarkable year in literary history—for manuscript scholars is clear: you must always keep searching, because you might find something magical, beneath some mouse-eaten cover, while looking for something quite different altogether.

Oakeshott's story is thrilling because it also shows that sometimes discoveries can be made even on well-trodden ground. The Winchester Manuscript had passed through the hands of several generations of experienced scholars before 1934, but it had been miscatalogued: it was never described as being a work

by Thomas Malory.[58] Oakeshott reflected that the "moral seems to be that there are chances for the humblest gleaner even when the harvest has been reaped by experienced hands."[59]

Medieval manuscripts in major libraries are largely now all catalogued and are slowly being digitised, but—despite this—manuscript discoveries are still being made. In 2008 a version of the *Encomium Emmae Reginae*, an eleventh-century work which we'll meet in Chapter 3, was discovered in the Devon Record Office. Produced around two years after the original text, it gives a different account of the last days of the pre-Conquest period in England. Finds like these remind us that there is still land beyond the sea. As an editorial in the *London Times* in 1934 on the discovery of the Kempe manuscript noted, "There is no knowing what treasures may yet be found in private libraries and muniment rooms which have existed for centuries undisturbed by the auctioneer or the bonfire."[60]

2

Near Disasters

In truth infinite are the losses which have been inflicted
upon the race of books by wars and tumults.

RICHARD DE BURY, *THE PHILOBIBLON*
(THE LOVE OF BOOKS)

Ted Hughes's 1997 poem "Hear it Again" expands on
Heinrich Heine's famous observation: "Dort wo man
Bücher verbrennt, verbrennt man auch am Ende Menschen"
(Where they burn books, ultimately they burn people).[1] Hughes
writes:

Fourteen centuries have learned,
From charred remains, that what took place,
When Alexandria's library burned,
Brain-damaged the human race.[2]

Hughes's point is, of course, that the destruction of books
has bleak consequences, but his poem is itself also a monument
to how we value books. This chapter is a story of terrible events
and near misses—of fires and fragments and forgetting. But it is
also a story of survival, a story of the dedicated labours of book
lovers and the efforts they have made to preserve the mate-
rial remains of the past. What follows underlines how precious

medieval manuscripts are. Many medieval literary works, particularly the earliest fragments of English history from the pre-Conquest period, have perished, and many others almost did not survive.

On his death in 1702, Sir John Cotton left his home and its famous manuscript collection, largely amassed by his grandfather, Robert Cotton, to the nation. Since Robert Cotton's time, the house had fallen into a state of disrepair, becoming damp and dilapidated. In 1706, the architect Sir Christopher Wren was consulted on what to do with the building. He recommended that the library be moved to the House of Lords and noted that the collection "may be purged of much uselesse trash, but this must be the drudgery of librarians."[3] Mercifully his advice on the library's contents was not taken and, after some parliamentary dithering, the collection was moved to rented premises—Essex House, near the Strand. Soon after, however, the government got into a dispute with the landlord over the rent. It was claimed that a lower rent should be paid because Essex House was surrounded by other buildings and "therefore in Danger of Fire and in other respects very improper."[4] In December 1729 the officers of the Board of Works wrote to the Treasury. They noted that they had "heard of a House in Westminster by its situation much more safe from fire & more commodious in all other respects belonging to Lord Ashburnham who is willing to let it to his Majesty."[5] This house—Ashburnham House— was in Little Dean's Yard near Westminster School—a fitting choice, as Robert Cotton had been a pupil there. The collection was moved again, but with a grim irony, this "Ash-burn-'em House" was not as "safe from fire" as had been hoped. Some

two years later, on October 23, 1731, a fire broke out in a room on the floor below the library.

In this period the Royal Collection of Manuscripts was stored alongside the Cotton Library.[6] One Richard Bentley was put in charge of caring for the joint collection. The previous librarian had been Bentley's father, also called Richard Bentley. In 1731 Bentley Senior was the Master of Trinity College Cambridge. On the night of October 23, however, he was in London for the night, visiting his son. A contemporary letter reports that "Dr Bentley being expected in Town that Night there was a goode fire made for his reception in a Stove chimney under the Library; The Dr himselfe is not sure whether he did not leave the Blower on the Stove when he went to Bed."[7]

At around 2:00 a.m., a "great Smoak" was detected.[8] A fire had broken out in the apartments on the floor below the library. It began with a wooden mantelpiece and from there it spread along the wainscot. At first it was hoped that the blaze could be stopped at the source, and initial efforts were focused on trying to put the fire out, rather than salvaging the manuscripts on the upper floor. This was an error. In fourteen bookshelves, known as "presses," in the library above were two of the original manuscripts of *Magna Carta*, the largest collection of pre-Conquest manuscripts ever amassed by an antiquarian (including the Lindisfarne Gospels and the *Beowulf* manuscript), the manuscript containing the late medieval masterpiece *Sir Gawain and the Green Knight*, and the state papers of Henry VIII and Elizabeth I, amongst other priceless treasures.

It soon became clear that the fire could not be stopped, and the frantic effort to rescue the books began. The library was long and narrow and was "lined with free-standing book presses made probably of oak, fitted . . . with lockable doors or covers." (On top of each press was a brass bust of an emperor, and the presses

were named after these busts.[9]) We can only imagine how tricky the work of salvaging the books was. The room would have been dark, and lighting candles to aid them, the librarians must have been afraid that the flames would help the fire to spread. There was only a slim crescent moon to aid the rescuers.[10] The room probably contained "a table or cabinet holding the alchemical instruments of the Elizabethan mathematician and astrologer John Dee," and this may have made it difficult to manoeuvre in the semidarkness.[11] Moreover, the doors of the presses were locked, preventing the books from being quickly removed. I imagine the terrified librarians fumbling for the keys of each press as the horrible fire crackled around them. At some point, schoolboys from Westminster arrived at the scene. One account reports that the "scholars being alarmed came and assisted very much both in extinguishing the Fire and saving what they could of the books."[12] We have to hope that the well-meaning efforts of the pupils were a help and not a hindrance in the darkness and confusion.

In November 2018 I went to visit what remains of Ashburnham House, which is now owned by Westminster School. The building has changed a lot since 1731 and it is difficult to work out where the fire began or how it travelled. A few things were clear to me, however. The room was long and cramped. It had two sets of windows at the south and north, and another two on the southwest wall, adjacent to the south end ones. The house now looks out over Little Dean's Yard, a spacious flagstoned courtyard entered from Dean's Yard through a medieval arch. I visited during the pupils' lunchtime and it was full of students, chatting in groups. That yard was not there, however, in 1731. Ashburnham House would have had a small yard in front of it and another small one behind, reached by an entrance (now closed off) through the Westminster Abbey cloisters. Despite

the difficulty of reconstructing the house's original design, what is clear is that there would have been limited room for people to manoeuvre inside the building, and that outside there was also little room for the fire engines—such as they were—when they arrived.

The fire appears to have spread up the walls and ignited the backs of the bookshelves. Several whole presses were then removed, which must have been very difficult. But, according to the official Parliamentary Report, the fire engines were slow to arrive. At this point the bookcases "were obliged to be broke open, and the Books, as many as could be, were thrown out of the Windows." In these vital moments, the librarians had to make instantaneous decisions—and at moments of crisis, personal biases play a role. With hindsight perhaps we feel that different choices could have been made. In the Vitellius and Galba presses, "priority was given to the volumes of sixteenth- and seventeenth-century papers," while the medieval volumes were left longer on the shelves.[13] The Parliamentary Report states that the first press that was salvaged was the Augustus press. The reasons for this are a little unclear. It was a smaller press that contained a collection of maps, papal bulls, and charters. It may have contained drawers that made it easier to remove. Equally, it had fewer items in it, which might mean that it was situated near a door, making it quick to grab and take out. Accidents of geography were key that night.

The next day, the Speaker of the House of Commons, the chancellor, and the lord chief justice visited the scene to ensure that "what had escaped the Flames should not be destroyed or purloined." They found that the surviving books "had suffered exceedingly from the Engine-Water, as well as from the Fire." There had been 958 volumes in the collection.[14] The Parliamentary Report said that 114 volumes were "lost, burnt or

intirely spoiled" and a further 98 were considered defective from damage.[15] Ashburnham House was "a smouldering ruin," and all across Little Dean's Yard were strewn burnt fragments of manuscripts.[16] In the aftermath of the fire some of the pupils from Westminster gathered up the fragments fluttering in the breeze. The British Library still houses boxes of them that have yet to be identified.

The damage to the manuscripts was grave and considerable. Cotton's "pride and joy," the fifth-century Greek Genesis, BL Cotton MS Otho B VI, was reduced to a "pile of cinder-like fragments." The king's great seal on one of the two original copies of the *Magna Carta* had melted into a lump. And over the following days, further damage was done to the manuscripts in the course of some well-meaning "conservation" efforts. Three days after the fire, a committee met to discuss what was to be done about the damaged manuscripts. It was decided that where possible, they should be disbound (taken out of their bindings) and individual leaves hung up to dry, like laundry. The committee decided that the manuscripts should be turned over to prevent the development of mould, and the paper manuscripts—which would have included many of the state papers—should be washed in an alum solution.

Predictably, in the wake of the disaster, rumours about the night's events began to circulate. Sifting through them today feels as tricky as it would have been to sift the charred fragments of the library's manuscripts. According to the Parliamentary Report, deputy librarian Richard Casley's first act was to remove the Codex Alexandrinas—a fifth-century Greek Bible considered extremely important for biblical study. A different report, which may have originated with Bentley Senior himself, describes "Dr Bentley's coming out in his nightgown and large wig, with the Alexandrian Old Testament Manuscript under

his arm."[17] Whether or not there is any truth in this (and it seems a little improbable that in the haste to save the library Dr Bentley would have had time to put on his wig), it conveys a sense of the librarians' hurried distress. Bentley had been at work for ten years on an edition of the New Testament, and his choice of what to salvage may have been coloured by his personal biases, or it may be that this story was one put about by Bentley himself in an attempt to assuage some of his guilt about the tragedy. The Edinburgh *Caledonian Mercury* reported that "this Morning Part of the Lord Ashburnham's near Westminster Abbey, was destroyed by Fire, as also Part of Dr Bentley's fine Library, and also some manuscripts of the Cotton library, but the most valuable called the *Alexandrian Manuscripts* . . . have received no Damage." This story has the whiff of spin, focusing as it does on the saving of the Codex Alexandrinas and mentioning that Bentley's own library had come to harm.

The fire was seen almost at once as a national tragedy. The newspaper reports of the time give us a sense of this. On November 16, 1731, the *Caledonian Mercury* published an account of the fire and concluded with the words, "Such a Treasure of English History was here reposited, that no particular Nation nor Age could boast the like; and the Loss is irretrievable, as few Copies had been taken of the Manuscripts." The fire also elicited poetic responses. The Reverend Thomas Fitzgerald (d. c. 1752), an usher at Westminster school, wrote a poem about the event:

All the past Annals of revolving Time,
The Acts of 'every Age and 'every Clime,
The rich Productions of each studious Mind,
The various Skill and Science of Mankind,
Collected stand, the World's stupendous Boast!
And all in one, one fatal Blaze, are lost.[18]

Fitzgerald's words, although moving, are not entirely accurate. The manuscripts were not "all in one, one fatal Blaze . . . lost." In fact, most were saved. The most recent census notes that thirteen manuscripts were destroyed completely, mainly from the press topped by the emperor Otho. Of course, many manuscripts were damaged beyond legibility, but there are crumbs of hope in this story. The disastrous events of October 23, 1731, led to calls for the creation of a national library that would safely house what remained of these priceless collections. It was partly because of the memory of that disastrous night that, in 1753, the British Museum was created by an Act of Parliament. The combined Royal and Cotton Collections became one of the four founder-collections of the museum's manuscript holdings. (The British Library became a distinct entity from the museum in 1979.)

There were other slivers of hope. Although the *Mercury* lamented that "few Copies had been taken of the Manuscripts," this was not entirely true. Cotton was part of a group of like-minded people who shared manuscripts between them, and some of them *had* made copies of the texts. And, even after the fire, people made transcriptions before the crumbling of fire-damaged folios made the works illegible. We are eternally grateful to these figures, these early lovers of books, without whose energies our sense of these manuscripts and the texts they contained would have been lost completely.

In the library at Ashburnham House, on the first shelf, twelve manuscripts along, in the press under the bust of the Emperor Otho, was a manuscript containing several texts from the early medieval period (BL Cotton MS Otho A XII).[19] It contained, amongst other items, the only known copy of "The Battle of

Maldon"—a poem about a battle between the English and the Vikings on August 11, 991. It also contained the only known copy of a life of the pre-Conquest king Alfred the Great written by the monk Asser. Alfred (849–899; r. 871–899) is the only king in English history to have been afforded the epithet "the Great"—a moniker given him by the Victorians.

Scraps of some of the texts from this manuscript survive in some sad, burnt fragments. The text of Asser's *Life of Alfred*, however, was obliterated in the fire. Mercifully, though, the manuscript was one of a number of codices that was studied by a group of early antiquarian readers. Thus it passed through the hands of some of the most important scholars of the early modern period.[20] Several copies of it were made before 1731, including two printed editions in 1602 and 1722.[21] Were it not for these early scholars and their interest in the text, we would have a much poorer picture of the reign of King Alfred, and we also would have lost one of the great pieces of early Anglo-Latin prose.

Asser (d. c. 909) was a Welshman from St David's, who later became Bishop of Sherborne. He was one of Alfred's closest companions. Alfred mentions "Asser my bishop" in his preface to Gregory the Great's *Pastoral Care*. Asser was clearly a man of learning. He cites a number of sources in the text, but appears to have based his work on a famous *Life of Charlemagne* by the Frankish scholar Einhard (775–840). Asser's *Life* is important for a number of reasons, but one of the main ones is that it shows the human side of Alfred. We gain a sense of his interests, his childhood, and his human weaknesses. The picture that emerges is of a man keen to promote religion and learning, with an interest in justice.[22]

Alfred obviously loved literature. We hear that through the "shameful negligence of his parents and tutors he remained

ignorant of letters until his twelfth year, or even longer. However, he was a careful listener, by day and night, to English poems, most frequently hearing them recited by others, and he readily retained them in his memory." But Asser relates a story suggesting that some of Alfred's thirst for knowledge stemmed in part from sibling rivalry. He describes how Alfred's mother showed him and his brothers a book of English poetry. She promised to give the book to whichever of them was able to memorise it fastest. Asser says that, "spurred on by these words, or rather by divine inspiration, and attracted by the beauty of the initial letter of the book," Alfred immediately took the book away and learnt it by heart. [23]

This love of literature persisted into adulthood. Asser tells us that the king's favourite activity was "reading aloud from books in English and above all learning English poems by heart." (He also found time for "pursuing all manner of hunting; giving instruction to all his goldsmiths and craftsmen as well as to his falconers, hawk-trainers and dog-keepers; making to his own design wonderful and precious new treasures.") Alfred promoted literature and learning by inviting important scholars (including Asser) to his court. Indeed, Asser describes Alfred's "kindness and generosity" towards "foreign visitors of all races," including "Franks, Frisians, Gauls, Vikings, Welshmen, Irishmen and Bretons."[24] Asser tells us that,

> just like the clever bee which at first light in summertime departs from its beloved honeycomb, finds its way with swift flight on its unpredictable journey through the air, lights upon the many and various flowers of grasses, plants and shrubs, discovers what pleases it most and then carries it back home, King Alfred directed the eyes of his mind far afield and sought

without what he did not possess within, that is to say, within his own kingdom."[25]

In this passage and others we see Asser's capacity for lively images and moving metaphors. He is, for a writer and scholar, a sympathetic figure. In Chapter 21 of the work, he admits that he has been distracted while writing: "But (to speak in nautical terms) so that I should no longer veer off course—having entrusted the ship to the waves and sails, and having sailed quite far away from the land . . . I think I should return to that which particularly inspired me to this work: in other words, I consider . . . the infancy and boyhood of my esteemed lord Alfred."[26]

Some fifty-two chapters later, he admits again that the ship of his prose has veered off course again. He promises to "return to that point from which I digressed . . . so that I shall not be compelled to sail past the haven of my desired rest as a result of my protracted voyage." Asser's text is a key document for understanding the reign of the most famous of the pre-Conquest kings, but it also gives insights into the mind of both its subject and its author.

Asser's *Life* has been the source of some scholarly controversy. Alfred P. Smyth argued in 1995 that the manuscript lost in the fire was a forgery and that it did not date from the time of Alfred, but from around a century later.[27] He contended that it was actually by Byrhtferth of Ramsey and was written in about 1000. This debate encapsulates the importance of original manuscripts in historical study.[28] Some questions cannot be answered by copies or surrogates. And when a manuscript is lost completely, many important clues to its provenance are lost with it.

Many other manuscripts nearly succumbed to the flames. One of these horrifying near misses was the only surviving manuscript of *Beowulf*, which is singed at its edges, the fragile ends of its folios a chilling reminder of the fate it might have suffered. *Beowulf* is, of course, the great gem of Old English literature. It was composed at some point between the middle of the seventh century and the end of the tenth. The manuscript itself dates from the late tenth or perhaps the very early eleventh century.[29]

Beowulf, set in a mythic past in sixth-century Scandinavia, tells the story of a hero (Beowulf) from the land of the Geats (in modern-day southern Sweden) who crosses the sea with a band of companions to the land of the Danes. The Danes, under King Hrothgar, are being harried by a hideous man-eating monster named Grendel. Beowulf fights and kills Grendel but is forced into a second encounter with the monster's mother, who comes to wreak revenge for her child's death. Beowulf travels to her watery home and kills her there before returning to Hrothgar's hall (which is called Heorot) as a triumphant hero. At this point, the poem swoops forwards. Beowulf has been ruling his native Geatland for fifty years when his own people—like the Danes fifty years before—begin to be terrorised by a monster. This time it is a dragon, and Beowulf decides to fight the beast. Both of them are killed. The poem concludes with Beowulf's funeral, when his body is burnt on a pyre and his people lament, building a giant barrow to enclose his remains. The final lines of the poem describe how Beowulf was mourned:

Swa begnornodon Geata leode
Hlafordes hryre heorðgeneatas
Cwædon þæt he wære wyruldcyninga
Manna mildust ond monðwærust
Leodum liðost ond lofgeornost.

(Thus the Geat people, his hearth-companions,
Lamented their lord's fall.
They said that of all the earthly kings,
He was most merciful, most gentle,
The kindest to his people, and most eager for fame.) [30]

These lines thrum with resonance. Beowulf is a flawed hero—he was *manna mildust* (most merciful) but also *lofgeornost* (most eager for fame), and that lust for renown led him into an ill-fated fight with the dragon, leaving his people bereft, shorn of their *hlaford* (lord).

Beowulf is a window into an early medieval warrior society quite distinct from our own. As Seamus Heaney, the Irish poet who also translated *Beowulf*, noted, the Geats and the Danes of the poem live in "a society that is at once honour-bound and blood-stained, presided over by the laws of blood-feud." They are "in thrall to a code of loyalty and bravery, bound to seek glory in the eye of the warrior world."[31] But like all great works of literature, *Beowulf* contains much that is familiar to us. The so-called "Father's Lament," for example, in which a father grieves for his son, has a timeless quality. It speaks to a universal human experience of grief for a loved one: "Symble bið gymyndgad morna gehwylce / eaforan ellorsið" (Each morning he awakes, to remember his child is gone).[32]

Beowulf was once a fixture in many an undergraduate English literature course, although it is becoming rarer today. For a long time it was only studied for its language, but since J. R. R. Tolkein published his 1936 essay "The Monsters and the Critics" it came to be seen as a work of unity and artistry. For readers encountering it for the first time, it may seem narratively confusing, as the poet makes frequent digressions into an earlier history. As Heaney observed, "Just when the narrative seems

ready to take another step ahead, it sidesteps. For a moment it is as if we have channel-surfed into another poem."[33] Its complex, interlocking narratives, which loop in and out of one another, are like the zoomorphic designs we find in pre-Conquest jewellery. Initially what we see is a maze of shapes, but these reveal a pattern when viewed as a whole. These historical digressions have a bearing on the world of the poem's present.

To this day, *Beowulf* generates a huge amount of scholarly interest. This is partly because it is a collection of mysteries— the most basic details about its date, authorship, and intended audience remain unclear. What is clear, however, is that it is a work of haunting beauty depicting a strange and mythic past with layered narrative and musical language.

In July 1786 the Icelandic-Danish scholar Grímur Jónsson Thorkelin (1752–1829) visited Britain in search of materials relating to Danish history. He ended up staying in the United Kingdom for six years, extending his research trip so that, among other things, he could procure a British recipe for turning seaweed into potash.[34] Thorkelin travelled widely during his expedition, but when he wasn't travelling, he spent a good deal of time in the Manuscripts Reading Room of the British Museum. On October 3, 1786—a few months into his stay—the Reading Room Register shows that he borrowed one Cotton MS Vitellius A XV.[35] This was the *Beowulf* manuscript. At the time there was no published edition of the poem and its importance to English literature had yet to be recognised. Thorkelin had read a brief description of the manuscript by the antiquarian Humfrey Wanley, who had written, "In this book, which is an excellent example of poetry in Anglo-Saxon, can be seen

fine descriptions in which Beowulf, a certain Dane, originally from the royal line of the Scyldings, performs [in war] opposite the princes of Sweden."[36] Based on this introduction, Thorkelin was keen to learn more about the Danish hero.

The manuscript wasn't the only codex he consulted that day—the register shows he also had several charters on his desk. And we can only wonder at how much attention he gave the manuscript; the register indicates that he did not keep the manuscript on reserve for further study but gave it back the next day. The work of studying the first great epic in English literature could wait. Over the course of the next few years, however, in between trips to Ireland and Scotland, Thorkelin became increasingly interested in the poem and commissioned two transcriptions of the text. It had only been fifty-five or sixty years after the fire, and the singed edges of the poem's folios were in better shape than they are now. Many words and letters now lost were still visible. So the transcriptions, done by a member of the British Museum's staff, preserved readings of the poem that are now impossible to make.

Thorkelin returned to Copenhagen in May 1791 to take up a role as Keeper of the National Archives. He took with him his two transcriptions of *Beowulf* and set about preparing the first ever printed edition of the poem. But disaster soon struck and the project was nearly destroyed. In late August 1807, British naval forces, believing that the Danish would help Napoleon to blockade Britain, attacked Copenhagen. For five days the city was bombarded and over a thousand buildings were destroyed. During this time, Thorkelin's home was devastated, his library ruined, and with it his preparatory work for the *Beowulf* edition wasted. Writing about these events afterwards, he said, "O! Those woeful days (the bitter memory of which brings back my old troubles and ineffable sorrows) that robbed

me of my sumptuous home and all my scholarly tools, which I had assiduously gathered for thirty years or more. My rendering of the Scylding epic, together with its entire scholarly apparatus, perished utterly."[37] Despite this "ineffable sorrow," Thorkelin somehow found the determination to take up the work again, stimulated by what he called *amor patriæ* (love of country). Thereafter, he reported, he "endured a very arduous labor." It took him another eight years, until 1815, to produce *De Danorum rebus gestis seculi II et IV. Poëma Danicum dialect Anglo-Saxonica* (Of events concerning the Danes in the third and fourth centuries. A Danish poem in the Anglo-Saxon Dialect). There has been some debate about how much of the work Thorkelin had actually completed when his house was shelled, but it's fair to say that the destruction of his home and city would have been a terrible blow. The loss would have discouraged the most dedicated of scholars.

In the preface to his edition, Thorkelin wrote, "I have endeavoured to render our poet and his periphrases word for word," but he begged his reader's forgiveness, saying, "For I have had to contend with the greatest confusion of letters and a motley variety of words whose meaning is ambiguous, vague and often wildly contradictory." Today scholars feel that Thorkelin's work is not always accurate, and that at times it is plagued by confusion, ambiguity, and vagueness. He gave credence to a number of theories about the poem that scholars now disregard. He misdated the poem as a work of the third and fourth centuries, for starters, instead of the seventh to tenth. Moreover, he was an unashamed nationalist, and consequently became convinced that the poem was a Scandinavian one translated into Old English. (Thorkelin was not alone here, because in the nineteenth century, as nationalism bubbled up in every quarter, *Beowulf* was also claimed by several German scholars.) He called it the

"divini vatis Danici incomparabile opus" (incomparable work of the divine Danish bard), adding, with disdain, that, "By Hercules!," he was "astounded" that "a song that poured forth from the Danish bard" had been attributed to the English.[38] Linguistic analysis indicates that the poem was indeed composed in Old English, not translated from Danish. But Thorkelin's idea that it was a translation has a kernel of truth in the sense that it was a cultural translation. The stories of the Geats and the Danes may have been passed down in some form through the generations. It's possible that versions of these stories were brought across the sea by the Angles, Saxons, and Jutes who populated Britain after the departure of Roman forces in the fifth and sixth centuries. The poem was very likely to have been composed orally and passed down by *scops* ("poets," pronounced *shops*). The version of the text in the manuscript is a little like an insect trapped in amber. It is simply one form of the poem from a particular moment in time—it probably had a different life before that.

Another of Thorkelin's theories pertained to the Christian aspects of the poem. He thought that Alfred the Great took the work "into his protection" and that it was through his influence that the author introduced the Christian aspects of the poem.[39] The truth is probably more complex—the poem is a mixture of a pre-Christian, mythic sixth-century past and the interventions of a more recent Christianized narrator. It is perhaps best to think of the poem as a fabric, with the different colours of threads representing Christian and pre-Christian elements. The word "text" is, in fact, etymologically linked to "textile." The word comes from Latin *textus*, which means "that which is woven, web, texture." *Textus* itself is derived from *texere*, to weave. *Beowulf* is this textile—artfully woven and iridescently beautiful.

Despite Thorkelin's somewhat unusual opinions on the poem, even the most curmudgeonly of scholars now recognise that his work was vital in recording letters and words that otherwise would have been lost. It is an extraordinary irony that it was British forces who so nearly destroyed Thorkelin's work. Without Thorkelin's efforts, the words at the fragile edges of the first great epic in English literature would have crumbled to nothing. Reflecting on Thorkelin's story, Robert E. Bjork wrote that "it captures the poignancy of a life's work at least in part retrieved from the ruins of war."[40] Bjork's phrase is an apposite one, because Thorkelin's story is a story of a work retrieved from the ruins in several senses.

In his preface, Thorkelin quotes a section of Horace's *Odes* in reference to what he calls the "divina . . . Danici vatis indoles" (the divine genius of the Danish poet). This poet, he says,

Exegit monumentum ære perennius
Regaliqve situ pyramidum altius
Qvod non imber edax, non aqvilo impotens
Possit diruere, aut innumerabilis
Annorum series, et fuga temporum

(Has erected a monument more durable than bronze
Loftier than the royal site of the pyramids
Which neither the destructive shower nor raging wind
Can destroy nor the countless
Series of years nor the flight of time)[41]

There's a chill in Thorkelin's choice of quotation here. There was in fact little that was durable about the only surviving manuscript of the genius poet (who probably wasn't actually Dan-

ish). But Thorkelin's work ensured that a version of the text was able to evade "the destructive shower" and "the flight of time."

Beowulf is especially precious because so little Old English poetry survives. The entire oeuvre stands at around thirty thousand lines, and *Beowulf* accounts for just over three thousand of them—making it one-tenth of the surviving corpus. More extraordinary still, the great majority of this corpus (around two-thirds of what survives) is contained in just four books. The Old English period stretches from around 600 to around 1200. That's equivalent to the space of time between Chaucer's era and our own day. Imagine if only four books survived from that period in English literature—perhaps one work by Chaucer, one by Shakespeare, one by Dickens, and one from the *Harry Potter* series. What picture would that give of our literary culture?

One of these four Old English verse manuscripts is the Exeter Book, which contains some of the most moving and enigmatic literary texts of the medieval period in England. This book was probably made sometime between 960 and 980 (not long before the *Beowulf* manuscript—in fact, each of the four surviving poetic codices were made within a fifty-year period of one another). An eleventh-century list of donations left by Bishop Leofric (d. 1072), dated to 1069–1072, mentions "mycel Englisc boc be gehwilcu[m] þingu[m] on leoðwisum geworht" (a large English book about many things written in verse).[42] In all likelihood, this refers to the Exeter Book.

The manuscript is indeed a mixture of *gehwilcum þingum* (many things). The texts in the manuscript are diverse, and in their diversity they give us a powerful sense of the intellectual sophistication of pre-Conquest literary culture. There are almost one hundred riddles, some gnomic verse, and a body of

elegiac poetry. The Exeter Book is most famous for its elegies and its riddles, however. The riddles—sometimes sombre, but often playful—explore the fabric of the early medieval world through the prism of the everyday. They give voice to inanimate objects. Here disgruntled tools and aging weapons jostle with eloquent animals and euphemistic vegetables. A number of them invite less-than-innocent readings, giving us a sense that early medieval monastic life was perhaps not as solemn as we might expect.

While *Beowulf* presents us with a vision of a heroic warrior culture steeped in glory, the elegies of the Exeter Book complicate that vision, giving voice to its darker consequences: death, loss, and social exile. In one elegy, a sailor, alone at sea, yearns for life onshore. The speaker of the poem may be a *peregrinus*, a wandering recluse who put to sea and placed his trust in God's providence, with no sense of where he was going and whether he would survive. Strikingly, many of the poems meditate on themes of loss and impermanence. One of the more enigmatic of these has been editorially titled "The Ruin" (few Old English poems ever have original titles). This haunting poem describes the forlorn ruins of a once-glorious city. It is often associated with the ruins of Roman Bath:

> *Wrætlic is þes wealstan, wyrde gebræcon;*
> *burgstede burston, brosnað enta geweorc.*
> *Hrofas sind gehrorene, hreorge torras,*
> *hrungeat berofen, hrim on lime,*
> *scearde scurbeorge scorene, gedrorene,*
> *ældo undereotone. Eorðgrap hafað*
> *waldend wyrhtan forweorone, geleorene,*
> *heardgripe hrusan, oþ hund cnea*
> *werþeoda gewitan. Oft þæs wag gebad*

ræghar ond readfah rice æfter oprum,
ofstonden under stormum; steap geap gedreas.

(Wondrous is this masonry, though wasted by fate
The battlements broken: the work of giants perishes.
The roofs have fallen in; the towers have crumbled.
The barred gate is broken; there is frost on the plaster,
The walls are scored, hacked and withered,
Consumed by age. The earthgrip holds
In a harsh embrace, the works of the builders.
Decayed and departed.
Over a hundred generations now have passed.
This wall—red-stained and lichen-coated—
has withstood many a storm, while kingdoms rose and fell.
But now the lofty arch has also fallen.)[43]

The poem makes use of some chilling imagery—the build-
ings, the works of humankind, are described as being held in
the earth's grip—*Eorðgrap*—which the poet renders not two
lines later as a hard embrace or hard grasp, *heardgripe*. Human
life—and the monuments it produces, is transitory—*rice æfter
oprum* (literally, "one kingdom after another" has fallen). With
a strange symmetry, the text itself is a ruin—it is mutilated by
a large diagonal burn across its folio. The next section is almost
unreadable, the fragmentary words and phrases a testament to
impermanence:

Wonað giet se . . . num geheapen,
fellon
grimme gegrunden
. . . scan heo . . .
. . . g orponc ærsceaft

. . . g lamrindum beag
mod mo yne swiftne gebrægd
hwætred in hringas, hygerof gebond
weallwalan wirum wundrum togædre.[44]

This is one of several places where the precious Exeter Book has been damaged. The opening pages are missing from the manuscript, and the current first page has been used as a chopping board and as a resting place for a cup.

Although the damage to the manuscript is disquieting, it seems grimly appropriate. The texts within appear acutely aware of the fragility of their own existence. One of the most iconic of the riddle texts is Riddle 47:

Moððe word fræt. Me þæt þuhte
Wrætlicu wyrd, þa ic þæt wundor gefrægn
Þæt se wyrm forswealg wera gied sumes
Þeof in þystro, þrymfæstne cwide
ond þæs strangan staþol. Stælgiest ne wæs
wihte þy gleawra þe he þam wordum swealg.

(A moth ate words. That seemed to me
A weird happening when I heard of that wonder,
how a thief in the shadows—a worm—
swallowed the words of someone's song:
both its glorious statement and its strong foundations.
Yet, the stealing guest was not a whit wiser for the words he
* swallowed.)*[45]

The most common solution to this riddle is the bookworm. (While Latin collections of riddles from this period often had solutions in the manuscripts, the Exeter Book riddles have

none, so their answers are sometimes a matter of scholarly debate.) Today a "bookworm" is a person who loves reading, but the riddle's composer had in mind the larvae of various different species of insect that are wont to devour books, and have done for centuries. Riddle 47 is a beautiful meditation on impermanence. It is a reminder that so many texts of this period have been destroyed by fire, flood, or invertebrate *stæl-giestas* (the *moððe*, or *wyrm*, is described as a *stælgiest*—literally, "stealing-guest" or "pilferer"). The riddle describes the text that the worm eats as *wera gied sumes* (someone's song), which is *þrymfæstne* (glorious) but also, ironically, stands on *strangan stapol* (strong foundations). More importantly, the riddle makes clear that the *wyrm* does not become *gleaw* (clear-sighted, wise, skilful, sagacious, prudent, good), despite the fact that it has consumed the *gied* (song, lay, riddle; i.e., the text it has eaten through). The image is clever. Early medieval monastic readers were encouraged to practise *ruminatio*, from the Latin for "chewing the cud." This practice meant reading with care, as if chewing over the words. The riddle is a reminder that such *gied* are impossibly precious. They need to be read with care to extract their meanings, and carefully protected because they are susceptible to manifold destructive forces.

In November 2018, 287 years after the fire, I called up the remaining fragments of Cotton MS Otho A XII, which had once contained Asser's *Life of Alfred*. The manuscript had originally comprised several texts alongside each other. Nothing of Asser's biography is left, but a few fragments of the other texts that were once bound with it survive into our era. I had recently discovered, in the course of my research, that these fragments

had actually been burned *twice*. In the nineteenth century the Keeper of Manuscripts at the British Museum, Frederic Madden, set about trying to sort the fragments left over from the Cotton fire. During this time some fragments of Otho A XII had been identified and gathered together and then sent to the museum's bindery to be bound as one. On July 18, 1865, at 9:00 p.m., Madden was writing letters in his apartments when, as he noted afterwards in his diary,

> we were alarmed by a report brought up by the manservant that Mr Panizzi's house was on fire! It was the work of a few moments to fly downstairs, put on my boots & overcoat, get out the Museum keys, and rush into the Court. The first thing I saw was a column of black smoke, followed by flames, rising apparently out of the corridor leading to Mr P.'s house, but on approaching closer, I perceived that the fire was not in the corridor, but in Tuckett's (the binder's) workshops! The sight was terrible, for I knew many MSS [Manuscripts] of value had lately been sent down to him![46]

One of the "MSS of value" was what remained of Cotton Otho A XII. To burn a manuscript once may be regarded as a misfortune, but to burn it twice looks like carelessness. Madden's account gives a powerful sense of the chaos that ensues in the event of a fire: "There was a great deal of confusion! Policemen running to and fro and shouts for the 'key' of the door of Mr P's garden and Tuckett's house and for the hose." Madden refers to particular local problems that night, to important people being on leave and how, "instead of the two trained policemen <appointed> in such cases of fire, two ignorant fellows were sent who had never handled a hose in their lives!" I reflected that the pandemonium of that night was probably not dissimilar to the

night of October 23, 1731. Madden concludes, "Such a want of organisation . . . I never beheld in my life." Perhaps most chilling in Madden's account is the sense that, had the wind been in the east, the fire might easily have spread to the Manuscripts Department. Madden wrote, "I feared greatly that the rooms of my Department (my study, my sorting rooms etc) could have caught fire. Indeed, had there been an east wind, I do not think anything could have saved them and probably the whole of my Department, from destruction! As it was the sashes of the windows were charred and blackened, and the glasses cracked!"

When I called up Otho A XII, what arrived from the stacks of the British Library was something that looked like a school ring binder. Inside there were a series of plastic wallet pages, and within these the fragments were mounted onto yellowed Victorian paper pages. The vellum fragments are black-burnt in places, and in others the colour of milky coffee. The script is just about discernible, if not easily legible. Letters can be made out, but the heat of the fire has shrunk the vellum, and the script is only a few millimetres tall. In the surrounding area, on the paper mounts, there are penciled notes by Edward Maunde Thompson (who joined the British Museum staff in 1861) identifying sections of text.[47] The edges of the vellum pieces are ragged. Most of the fragments are about ten centimeters high and six centimeters wide, but some are no bigger than a thumb. They come in a variety of shapes—some roughly triangular, like what I imagine a dinosaur tooth might look like, others a sort of D-shape. Turning the plastic pages, I started to see faces in the shrivelled scraps that reminded me of medieval gargoyles. Occasionally, red initial letters appeared, surprisingly clear and crisp amidst the burntness. Although these letters have shrunk significantly from their original size, the red ink has survived well. I felt as though I were looking at an evidence bag in a TV

crime drama. It's hard to process the sadness you feel looking at the remnants of such destruction.

I had a similar sensation in October 2018, when the British Library put on an exhibition of pre-Conquest manuscripts and artefacts, entitled "Anglo-Saxon Kingdoms." The star of the show, for me, was the Codex Amiatinus, which was made in the early eighth century in the monastery of Wearmouth-Jarrow (where Bede was from and the Cuthbert Gospel was made). The manuscript is a single-volume Bible—a beast made from many beasts. Its spine is half a metre tall, it weighs 34 kilograms, and it has 1,030 leaves, which means it was made from some 515 calf skins. We can only wonder at the investment of time and resources necessary for the manuscript's production.

In 716, Ceolfrith, abbot of Wearmouth-Jarrow, set off from Northumbria bound for Rome, taking the Codex Amiatinus with him. The anonymous *Life of Ceolfrith* describes how the monks sang and wept as his boat set sail on the river Wear. The book was intended as a gift for the shrine of St Peter in Rome, but it never made it. Ceolfrith died en route, and the Bible ended up in the monastery of Monte Amiata in Tuscany (hence its name). Ceolfrith's abbey was a centre of learning and its scriptorium produced works of great quality. The inky sweeps of the Bible's script are crisp and clear and its illumination sophisticated. Until the nineteenth century it was thought that the manuscript could not have been made in England. The assumption was bolstered by some dedicatory verses explaining that the manuscript was a gift from "Petrus Langobardorum" (Peter of the Lombards) to "Cenobium Saluatoris" (the monastery of the Saviour). But, as the Italian scholar Giovanni Battista de Rossi noted in 1888, these words are later additions. Some wily person had sought to claim the Bible for Italy. According to the *Life of Ceolfrith*, the words should have described how

the book was a gift for the shrine of St Peter from "Ceolfridus, Anglorum extimis de finibus abbas" (Ceolfrith, abbot from the faraway lands of the Angles).

The *Life of Ceolfrith* also tells us that the abbot originally commissioned *three* of these giant single-volume Bibles (known as *pandects*). One of these is lost, and the third survives in three sets of sad fragments—a few leaves were discovered being used to wrap legal documents in the sixteenth century; others came to light in a shop in Newcastle in 1882; and a third fragment turned up amongst estate papers in Kingston Lacy in 1982. In the exhibition, one of these fragments was displayed alongside the monumental Bible, a chilling reminder of the fate it might have suffered. Looking at these sad remains I thought about a line from the ruined "Ruin" in the Exeter Book: "Brosnað enta geweorc" (The work of giants perishes).

The works of giants have perished. But sometimes they have survived, often because of the dedicated labours of particular people. The Codex Amiatinus is a giant itself—a hefty marvel of a thing, and one that has been loved over the centuries. One person loved it so much they wanted to claim it as an Italian manuscript. That person was not so dissimilar from Grímur Jónsson Thorkelin, who sought to claim *Beowulf* for Denmark but in the process saved parts of the first epic in the English language. And it was probably largely a love of books that brought the pupils from Westminster school running across Little Dean's Yard on the night of October 23, 1731. It was love of books that made the librarians break open the doors of the presses and throw the manuscripts from the windows. Whatever their motives, these people valued the books they encountered, and were it not for this, many manuscripts, and the crumbling texts within them, might never have survived.

3

Patrons

The praise of the Queen is evident at the beginning, thrives in the middle, is present at the end and embraces absolutely all of what follows.

ENCOMIUM EMMAE REGINAE

Forty folios into the British Library's Royal MS 17 D VI there is an image of a man in russet robes kneeling in front of a king. The king is comically oversized by comparison with the kneeling figure, his stature a metaphor for regal majesty. The kneeling man is presenting a book to the king, who stands resplendent in a lapis coat lined with ermine. Beneath the image, a stanza of verse addresses the king:

Hye and noble myȝty prince excellent,
My lord the prince <o> my lord gracious,
I humble servaunt and obedient
Unto your estate hye and glorious,
Of whiche I am full tendre and full ielous,
Me recomannde unto your worthynesse,
With hert entier and spirite of mekenesse.[1]

The text here is Thomas Hoccleve's early fifteenth-century *Regiment of Princes*, which is addressed to Henry, Prince of

Wales (later Henry V). Both the text and the image tell us something important about the system of patronage in the Middle Ages. Throughout the medieval period and beyond, patronage remained key to the production of texts and manuscripts. It was most often royal or ecclesiastical. (That is not to say that other kinds of patronage did not exist—they did, as aristocrats, and, later in the period, the gentry and mercantile classes, were patrons of literature and the arts.) The manuscripts we encounter here, however, are products of royal patronage. They reflect paradigm shifts, embodying the hopes and fears of their commissioners in a time of change.

Opening British Library Add MS 33241, known as *Encomium Emmae Reginae* (In praise of Queen Emma), the first medieval folio you come to is a blank page with a brief descriptive ownership inscription on it: "Gesta Cnutonis [. . .] Lib[er] S[an]c[t] i Aug[ustini] Cant" (The deeds of Cnut, [this] book [is from] St Augustine's, Canterbury).[2] The inscription was right in one sense only—the book did come from St Augustine's. But on the subject of the text, the inscription is revealingly inaccurate, if not sexist. The folios are not strictly the deeds of Cnut (d. 1035), but of his wife, Queen Emma. Cnut is a key player in the narrative, but the work was commissioned by Emma herself. And it's one of the most important sources for our understanding of the Danish invasion of England in the early eleventh century and the fractious environment of the royal court in the generation before the Norman Conquest.

Although few people have ever heard of Queen Emma, she was a crucial—if not pivotal—figure in early medieval English history. She was crowned Queen of England twice, and she was

the mother of two English kings and the great-aunt of William the Conqueror. It was her relationship to William that partially legitimised the invasion in the Conqueror's eyes. She was a key political player—some might say the axis on which English politics turned in around the year 1000. Unlike so many other medieval queens, who remain in the shadows, Emma is a more fully fleshed out figure. The *Encomium Emmae Reginae*—a poem written for her by a monk from St Omer in northern France—gives us unprecedented insight into her life and world. Written in about 1041, it is a brilliant piece of political propaganda. The *Encomium* illustrates the delicate balance of power in the English court during a period when factionalism was rife and monarchs held power on a knife-edge. It is a highly political work, commissioned by a shrewd operator.[3]

BL Add MS 33241 was copied shortly after the text was composed in the mid-eleventh century. It was not the original copy made for the queen, but appears to be a close cousin of that manuscript, which is now lost. After turning the page from its dubious opening inscription, the reader is greeted with an image.[4]

Here we see Emma, a crown on her head, wearing a gown made from a splendid patterned fabric. Her figure dominates the image. Framed by a Romanesque arch elegantly draped with curtains, she appears to be sitting not so much on a throne as an architectural edifice. The work's tonsured author kneels before her, reverently presenting the book. Behind him, two figures peer through the side of the arch. They have little fuzzy beards and are also wearing crowns. They are her sons, Harthacnut and Edward. The image encapsulates the fault-lines in Emma's life. Her story was one of intrigue, scandal, and major reversals of fortune.[5] You would have no idea, looking at this image, that the two benign-looking figures in the background

were competing claimants for the English throne, or that the kneeling man in the foreground had produced an audacious piece of propaganda.

Emma was born in Normandy in the early 980s (her exact date of birth is not recorded). She was the daughter of the Duke of Normandy and one of nine children, although we don't know which child she was; her early life is obscure. She was probably in her early teens when she was sent across the English Channel to marry Æthelred the Unready in 1002.[6] (Æthelred's modern epithet comes from the Old English word *unræd*, which means "ill-advised.") This was a period of high tension between England and its Scandinavian neighbours, when England was savaged by a series of Viking raids. The marriage was political—clearly part of a policy to strengthen links between England and Normandy as a buffer against Viking incursion. It was the first wedding of an English king to a foreign bride for over a century and a half.

Emma disembarked from Normandy in the spring of 1002. On her arrival she was given a new name—Ælfgifu, which means "elf-gift," after Æthelred's sainted grandmother, which was evidently an honour. That said, it was also the name of his previous wife. We can only wonder at what life was like for her in this new court, with a new (or recycled) name and in a new language. Emma likely spoke both Norman and Danish, but not the form of English used at the time. And within months of her arrival an event occurred that illustrates the fragile political environment in which she found herself, as reported in the *Anglo-Saxon Chronicle*:

> *& on þam geare se cyng het ofslean ealle þa deniscan men þe on Angelcynne wæron, ðis wæs gedon on Britius mæssedæg, for ðam*

þam cynge wæs gecyd þæt hi woldon hine besyrewan æt his life, &
siþþan ealle his witan & <habban> siþþan ðis rice.

(And in this year the king ordered to be slain all the Danish-
men that were in England; this was done on St. Brice's day
[November 13], because it was made known to the king that
they wished to deprive him and all of his council of their lives,
and have thereafter his kingdom.)[7]

This act of near-genocidal brutality illustrates Æthelred's
weak and anxious hold on power. We know little about Em-
ma's marriage to Æthelred. Writing one hundred years later,
William of Malmesbury tells us that Æthelred "was so offensive
to his own wife that he would hardly deign to let her sleep
with him."[8] Malmesbury's account is neither firsthand nor un-
biased, but it's possible that the marriage was not a happy one.
Whether their marriage was harmonious or not, it is striking
that after her arrival at court "she was immediately accorded
a prominent place in the witness-lists of the king's charters."[9]
(These charters—legal documents—give us an insight into the
court's power structures.) Whether as a result of her own ma-
noeuvring or because of her status as the daughter of Rich-
ard I, Duke of Normandy, Emma appears to have exercised
some power in her new court. Perhaps she had already learnt
how to be a political operator—a skill that would stand her in
good stead throughout her life.

Emma's life in this period is largely obscure, but it was likely
"dominated by marriage and children"; she had three—Edward,
Alfred, and a daughter, Godgifu.[10] But larger political concerns
threatened in the summer of 1013 when King Swein of Den-
mark invaded England. Æthelred fled with Emma and her sons

to Normandy. Swein died on February 3, 1014, and Emma and Æthelred returned to England, where they remained until his death on April 23, 1016. Edmund—Emma's stepson, Æthelred's son from his first marriage—was proclaimed king, but the country was soon attacked by Cnut—Swein's son. London was besieged twice in 1016, and on October 18 Cnut decisively defeated Edmund at the Battle of Ashingdon. Thereafter, Cnut became the ruler of all of England except Wessex (a kingdom in southwestern England). On November 30, Edmund died.

Mercifully for Emma, her son Edward had already fled England, because Cnut was ruthless with Æthelred's remaining heirs. He sent Edmund's young sons to the king of the Swedes to be executed, and he ordered exile for Edmund's brother Eadwig before murdering him upon his return to England. We are not sure where Emma was in this period—she may have been captured during the siege of London. But at some point soon afterwards, in 1017, Cnut ordered Emma "to be fetched" so that he might marry her. This looks like a brazenly political move to "to draw her away from the cause of her exiled sons in Normandy."[11] Cnut may have wanted to use her as a means to maintain continuity between Æthelred's administration and his own. We don't know where Emma was "fetched" from; she may not have had a choice. The *Anglo-Saxon Chronicle*'s language here is bald: "& þa toforan kalendas Augusti het se cyng feccean him þæs oðres kynges lafe Æþelredes him to wife, Ricardes dohtor" (And before the first day of August, the king commanded that King Æthelred's other heirloom—Richard's daughter—be fetched such that he could make her his wife). Emma is defined in terms of her relationship to men, as "Ricardes dohtor" and Æthelred's wife. The word *lafe* can mean

"leavings, remains, legacy, heirloom."[12] But the language of the chronicler is clear: Emma was chattel to be claimed. In an Old Norse poem by Hallvarðr Háreksblesi, composed during Cnut's reign, England is figured as feminine, and Cnut as the masculine conqueror; as one scholar has put it, the depiction recalls "earlier pre-Christian eulogies in which the conquest of a territory is expressed in sexual terms, as a forced 'marriage.'"[13] Cnut may have seen his marriage to Emma as another form of conquest.

Emma was married to Cnut until his death on November 12, 1035. She had two children by him—Harthacnut and Gunhilda. By the time he died, she had been queen for thirty years at a court first presided over by Æthelred and then Cnut. She might have felt secure in her status, but in the closing weeks of 1035 Harold Harefoot (Cnut's son by his first wife) seized all her estates and effectively disinherited Harthacnut. Emma tried to secure a position for Harthacnut (who was at the time in Denmark), but she was not successful. Desperate to protect her own interests as well as those of her children, she then tried to secure positions for Edward and Alfred (her sons by Æthelred the Unready), who were in exile in Normandy. Harold Harefoot was formally chosen as king in 1037, and Emma went into exile. When Harefoot died in 1040, Emma returned to England, and it was then that she commissioned the *Encomium.* These are the bones of Emma's story, and they help us to grasp not only the story she wanted to tell in the *Encomium,* but also the stories she did not want to tell.

As the thumbnail sketch of Emma's biography makes clear, hers was a precarious political position. She was the mother of three separate claimants to the English throne, and the throne was claimed by several others—for each of her sons, there was

a rival stepson. Her sons by her first and second marriages were in direct conflict with one another for the kingship of England. The *Encomium* therefore presents "a particular picture of past glory and present peace as part of a deliberate attempt to intervene, on Emma's behalf, in the politics of the Anglo-Danish court," as the scholar Elizabeth M. Tyler has put it.[14]

The text opens with a prologue ("Incipit Prologus") in which the anonymous author addresses Queen Emma: "O regina, que omnibus in hoc sexu positis prestas morum eligantia" (O Queen, who excel all those of your sex in the in the admirable example of your life). Strikingly, the prologue addresses the responsibilities of the historian, writing (in the translation by Alistair Campbell): "The historian should greatly beware, lest, going against truth by falsely introducing matter, he lose the very name which he is held to have from his office."[15] In the rest of the text, these words are resonant. There are so many places where the author—the *encomiast*, one who praises someone—appears not to have adhered to his own words.

After the prologue, we find the "Argument"—a short summary of the text's story. The story begins not, as we might imagine, with Emma, but with an account of Swein Forkbeard (the father of Cnut) invading England. The author takes pains to deny that this means the text is not entirely in praise of the queen, and he does so with a striking image:

> You are aware that wherever you draw a circle, first of all you certainly establish a point to be the beginning, and so the circle is made to return by continuously wheeling its orb, and by this return the circumference of the circle is made to connect itself to its own beginning. By a similar connection, therefore, the praise of the Queen is evident at the beginning, thrives in the

middle, is present at the end, and embraces absolutely all of what the book amounts to.[16]

In other words, his text is a perfect O, looping back in reverent, circular praise of its queen like the "O" in the "O Regina" of the prologue. In the Argument, the encomiast also signals his debt to Virgil—a debt we see throughout the text: in places he even quotes Virgil directly.[17] (He also name-checks Horace, and the influence of a host of other writers is also discernible in the work.)[18] The *Encomium*, like Virgil's *Aeneid*, legitimises "the claims of a contemporary ruler by recounting the foundation of her dynasty."[19]

When the main text begins, the self-consciously literary style of the work is instantly apparent.[20] The author's description of the fleet of ships that set off to conquer England is pointedly Virgillian. This is no threatening war fleet intent on the murderous suppression of a neighbouring nation, but a beautiful and noble flotilla. He describes the vessels as decorated with "lions moulded in gold," birds, and golden "dragons of various kinds." Elsewhere, there were "glittering men of solid gold or silver nearly comparable to live ones," and "bulls with necks raised high and legs outstretched . . . fashioned leaping and roaring like live ones."[21] The encomiast tells us that the king was as beautiful as his vessels and that beneath them "the blue water, smitten by many oars, might be seen foaming far and wide." These ships are so gorgeous that the sea beneath them is foaming in excitement. (Shakespeare would use a similar image centuries later in his description of Cleopatra's barge as having silver oars "which to the tune of flutes kept stroke, and made / The water which they beat to follow faster, / As amorous of their strokes.")[22] Such overwrought descriptions don't seem out

of place from an author with an avowed love of Virgil, but there are other aspects of the *Encomium* that are not so much poetic license as wilful perversion of fact.

The text describes the events of 1016 and 1017, leading up to Emma and Cnut's marriage, as follows: "The king lacked nothing except a most noble wife ['noblissima coniuge']; such a one he ordered to be sought everywhere for him, in order to obtain her hand lawfully . . . and to make her partner of his rule."[23] As the text continues, it explains that Cnut sent his agents to "realms and cities" and that the imperial bride was "found within the bounds of Gaul." Having identified the appropriate bride, "royal gifts were sent, [and] furthermore precatory messages were sent." In other words, Cnut wooed Emma because she was a woman "of the greatest nobility and wealth" ("stirpe et opibus ditissima"). There is no suggestion that marrying Emma was a political move, because nowhere does it mention that she had been married to Æthelred.[24] It is a startling omission. And the *Encomium* goes further, attributing agency to Emma herself. It says she refused "to ever become the bride" of Cnut "unless he would affirm to her by oath, that he would never set up the son of any other wife." The impression we get from the *Anglo–Saxon Chronicle* is that Emma—a woman defined in terms of her relationship to men—was an object to be left by one king and fetched by another. But the *Encomium* describes a woman in charge of her destiny. It paints a picture of a woman who well understood that her status was contingent and that rival claimants to the throne were a threat to her and her sons. It is startling that the text mentions Cnut's "other sons" (the encomiast says that Emma had received "information that the king had sons by some other woman"), but does not mention Emma's marriage to Æthelred.

It is clear that questions of succession were some of the stickiest for Emma. And the text finds deft ways to reframe the complicated threads of paternity that threatened her position. Describing the birth of Harthacnut—Emma and Cnut's son—the *Encomium* says that the two parents were happy in an "unparalleled love for this child." But it also says that they sent "their other legitimate sons to Normandy to be brought up." This is the first mention of Emma's other children. Predictably her daughters are not mentioned, and revealingly, Edward—Emma's son with Æthelred—is described as one of "their other legitimate sons," that is, the child of Cnut, not Æthelred. Seemingly under Emma's direction, the encomiast has redescribed Emma's son from her first marriage as a son from her second.

There were other complicated threads of paternity to deal with. Emma was evidently concerned with furthering the interests of her children alone, and not Cnut's from *his* first marriage. Nevertheless, after Cnut's death, a faction of nobles installed Harold Harefoot (Cnut's son from his previous marriage) as the king. The *Encomium* describes him as "one Harold, who is declared, owing to a false estimation of the matter, to be a son of a certain concubine of the above-mentioned King Cnut." The encomiast describes Ælfgifu of Northampton—Cnut's first wife—as a "concubine," but more damningly, describes Harold as the child of a servant, not even the son of this "concubine": "The assertion of very many people has it that the same Harold was secretly taken from a servant who was in childbed, and put in the chamber of the concubine." The words of the prologue— where the encomiast says "the historian should greatly beware, lest, going against truth by falsely introducing matter, he lose the very name which he is held to have from his office"—have

a particular resonance here.[25] The extraordinary claims about Harold are all the more surprising given that there are moments elsewhere in the text where the encomiast acknowledges the outlandishness of his story. In an episode in which he is discussing a magical raven banner carried into battle, he says, "I believe that it may be incredible to the reader, yet since it is true, I will introduce the matter into my true history."[26]

The concluding section of the work describes how Edward (Emma's son by Æthelred) asked Harthacnut (her son by Cnut) to "come and hold the kingdom together with himself." The encomiast assures us that "the mother and both sons, having no disagreement between them, enjoy the ready amenities of the kingdom."[27] In the final lines of the work, the author offers up thanks to "Him, who makes dwellers in a house be of one mind, Jesus Christ, the Lord of all, who, abiding in the Trinity, holds a kingdom which flourishes unfading." Just as the work concludes with an image of the Trinity, so, too, it enshrines a trinity of Emma, Harthacnut, and Edward, united by shared parental love. The parallelism is plainly intentional. And it is indeed this very trinity that appears in the manuscript's opening image. The encomiast insists that his praise of Emma may be seen at the beginning, the middle, and the end of his story, but his larger purpose—the projection of a harmonious family unit—is perhaps more visible.

The moment of glory that the *Encomium* describes was brief, however. Her son Harthacnut died in June 1042; Emma was deprived of her treasures by Edward the Confessor and demoted from her former status. She lived the rest of her life in "retirement" and died in 1052. She was buried at Winchester near the graves of Cnut and their son Harthacnut.

In 2008, a different version of the *Encomium* came to light.[28] It was preserved in a manuscript copied later—in the fifteenth

century—and presented a variant ending of the text written in the time of Edward the Confessor (the son of Æthelred and Emma). The text's new conclusion is an intelligent response to the original version:

> Now, o watchful reader, let your careful attention show itself and bring back to recollection what I said in my preface about the circle. I indeed recollect that I said that in making a circle there must be a returning to one and the same point so that the circle may attain the orbit of its round form. So likewise it was brought to pass in the arranging of the rule of the English kingdom. Æthelred, the foremost king—foremost because of all those of his time the most outstanding—commanded that monarchy.[29]

In a brilliant move, the reviser—or perhaps the original author, under new instruction—has taken a key image from the opening of the text and reframed it. Whereas in the original text Æthelred is unmentioned, here he is *returned to*, as though he had been there all along, underlining Edward's royal English lineage. (It might also suggest that a new ending was quickly slapped on once Edward became the sole ruler of the kingdom.) The discovery of the variant text is a reminder that historical texts are susceptible to change and alteration. Political agendas underpin the writing of history and the weaving of stories.

In 2012, a conservation project was begun at Winchester Cathedral to examine the contents of six of the cathedral's mortuary chests.[30] The chests were supposed to contain the bones of fifteen people, including eight kings, two bishops, and one queen, all from the late pre-Conquest and early Norman period. The chests are labelled, but during the Civil War, they were broken open and the bones scattered. A Royalist churchman,

Bruno Ryves, described how Parliamentarian forces, "monsters of men," were seen to "violate these Cabinets of the dead, and to scatter their bones all over the pavement of the Church." Ryves was undoubtedly a biased informant, but the latest research supports some of his accusations. He wrote about the soldiers "spurning and trampling on the bones of all" and subsequently using the bones as "passive Instruments, of more than heathenish Sacrilege, and prophanenesse [profaneness], those Windowes which they could not reach with their Swords, Muskets, or Rests [musket supports], they brake to pieces, by throwing at them, the bones of Kings, Queenes, Bishops, Confessors and Saints."[31]

After this, local people gathered up the bones and placed them back into the mortuary chests, but in the process the different skeletons got mixed up. In 2012, a team of biological anthropologists at the University of Bristol began work to sort the bones—reassembling dispersed skeletons and radiocarbon dating them. They found that several had been broken in a way consistent with Ryves's account. Radiocarbon (C14) dating on selected bone fragments by the Radiocarbon Accelerator Unit at the University of Oxford revealed in 2015 that the bones were indeed—as was suspected—from the late pre-Conquest and early Norman period. This finding accorded with the information on the outside of the chests. Using other techniques, the researchers were able to assess each skeleton's sex, age at death, and physical characteristics. They also used the "marine reservoir effect" to determine the social status of the individuals. (In the medieval period, high-status individuals generally ate larger amounts of both freshwater and seawater fish, which affects the radiocarbon dating of their bones.) Collating all of this information, the researchers were able to identify several specific

individuals. They sifted through 1,300 bones and discovered the skeletons of twenty-three individuals rather than the expected fifteen. Amongst them were the bones of a mature female of a high social status. It seems very likely that these are the bones of Queen Emma.

Like her bones, Emma's story has been dismembered and scattered. Reconstructing the facts of her life is a complicated business. It's intriguing to speculate on whether she knew how stories, especially women's stories, become obscured over time. Perhaps she commissioned the *Encomium* in part to ensure that later ages would know something about her. This is the striking feature of the *Encomium*—it is so rare to find historical accounts from this period featuring women, let alone commissioned by women. But what adds to the wonder of the *Encomium* is that its author is acutely aware of how stories are contingent, easily altered and reframed. The encomiast acknowledges that parts of the story might seem unbelievable. And the discovery of the different, later version of the text shows how stories can become broken, scattered, and reconstituted.

Queen Emma is almost completely unknown beyond academia. The contrast with our next patron could not be more marked. British Library Royal MS 2 A XVI is still in its original binding. This binding would once have been a luxurious, fluffy red velvet, but is now threadbare. Several elegant silver corner pieces and gilt edges remain, however, as do the suggestion of clasps, providing a sense of the book's former sumptuousness. One of the first images in the opening folios is of a plump and bearded king—one of the most famous of England's kings, King Henry VIII—sitting

in his bedchamber. Henry was the book's owner and commissioner. He looks a little sturdy here, but otherwise the image is an uncompromising display of royal power.[32]

The room—airy and neoclassical in design—is decorated with expensive fabrics and furniture. The king is reading a manuscript in a red velvet binding with golden clasps—undoubtedly the very manuscript in which the image appears. Beside him on the floor are two similarly sumptuous volumes. Beneath the image, the opening text of the Book of Psalms appears. It reads (in Latin), "Blessed is the man who has not walked in the counsel of the ungodly, nor stood in the way of sinners, nor sat in the chair of pestilence." Henry's seated position may be intended to suggest that he does not sit in the chair of pestilence. The second verse of the psalm exhorts readers to meditate on the word of the Lord day and night. Henry is shown in his bedchamber, but not asleep. It is daylight outside, but the scholar-king has retreated to his chamber to study.

The text of the psalms is written in an elegant script with perfectly straight ascenders, enclosed in a neoclassical architectural surround and decorated with an opulent initial depicting flowers and insects. Henry sits in a chair adorned with a lion's head. (The chair may have been observed from life. It is remarkably similar to a chair described in his personal inventory.[33]) This folio is striking for a number of reasons. It was common to find an image of the biblical David—the supposed author of the psalms—at this point in a psalter, but what is surprising is that here Henry is identified, iconographically, with David. Equally striking is the fact that beside the opening words of the psalm, Henry has himself written "nota quis sit beatus" (note who is blessed). This annotation, beneath an image of the king himself, is a potent display of Henry's belief in his own blessed

status, which is appropriate for a man who broke with Rome and established himself as the head of the English church.

BL Royal MS 2 A XVI was Henry's private prayer-book. It was a personal commission and has a clear political agenda, embodying the desires and fears of its patron. Its images provide ample evidence of Henry's vanity, while its annotations provide an unparalleled insight into the mind of the tyrant-king whose personal marital wrangles influenced the politics of Europe.[34] A remarkable commission, the manuscript brings us to the human heart of one of the most radical shifts in English cultural life in the premodern period.

The prayer-book was written and illustrated by the French scribe and book-artist Jean Mallard in around 1540. It is small and would have been easy for the king to hold in his hands, unlike some of the other works that Mallard produced for him, which required a writing desk or lectern to read.[35] It is written in an incredibly clear hand, which Henry may have favoured because of his failing eyesight. In 1535, when he was forty-four, Henry had written that he favoured a printing style that was "easier to read."[36] (The script—called *humanist* script—originated in Italy and was modelled on the script of the Carolingian era, meaning the era of Charlemagne, c. 748–814, and his descendants. It symbolised a revival of antiquity and ancient learning for Renaissance humanists.) Alongside its clarity, the manuscript has exquisite decorative details. The opening initial of Psalm 79, for example, shows a ladybug clambering over a plump cucumber.[37] Indeed, some of the most magical parts of the manuscript are its decorative details—tiny features easily missed. In the opening initial, a tiny frog can be seen crouched amid briar roses. Elsewhere Mallard's initials contain snails, blackberries, butterflies, beetles, plants, a mouse chewing on

an ear of corn, a parakeet, sweet-peas, fruit covered in caterpillars, a grasshopper, and, rather alarmingly, two gutted rabbits, hanging up.[38]

But the manuscript is most extraordinary for its large images and its annotations. The book is more heavily marked up than any of Henry's other surviving books.[39] The annotations happened in stages—in pen, pencil, and red crayon. Sometimes Henry drew symbols in the margin—including the distinctive "tadpole" sign which is a hallmark of his work. In some places he underlined pieces of texts, while in others he wrote short notes in the margin. It was not unusual to gloss books in this period, but it says something of Henry's lavishness that he should have used the margins of so sumptuous a book to write notes in.[40] The annotations do not appear throughout. As in other books he owned, he did not annotate the complete book, suggesting he had a rather short attention span.[41] After Psalm 111, the margins are unmarked—a testament to regal boredom. In spite of this, Henry evidently knew much of the text well; he engaged with it thoughtfully, if not comprehensively. Erasmus—a scholar with whom Henry corresponded—wrote that "it is generally agreed that among all the books of Holy Scripture, none is so full of such recondite mysteries as the book of Psalms, and no other book is wrapped in such obscurity of words and meaning."[42] This was plainly thought to be a text that should be studied with care.

The historical background to the prayer-book's production is key, as the events of the previous decade—and, to some extent, the decade before that—directly informed the psalter's decoration and annotations. Henry was born in 1491 and came to the throne in 1509. He married his brother Arthur's widow, Katherine of Aragon, on June 11 that year. The wedding was followed by a spectacular joint coronation thirteen days later.

Their marriage was to last nineteen years, but it failed to produce the son and heir Henry so passionately desired. In her first pregnancy, Katherine suffered a miscarriage; the second pregnancy resulted in a son, Prince Henry (born on New Year's Day 1511), but he survived for only a few days. Katherine was to have six pregnancies in all in ten years, but only one of the babies survived—Princess Mary, born in 1516. In 1519 Katherine was pregnant again, but again miscarried. It must have hurt her deeply that in that year Henry's mistress Elizabeth Blount gave birth to a healthy son, whom Henry acknowledged (and created Duke of Richmond in 1525). Both Henry and Katherine were thirty-four years old in 1519, and Henry's grandfathers had died at the ages of twenty-six and forty-one. Henry probably no longer saw himself as being in the prime of his youth, and Katherine was entering the twilight of her fertile years according to the standards of the time.

Henry abandoned intercourse with his wife in 1524, increasingly concerned that his lack of a male heir was proof of God's displeasure with him. He had become concerned with a particular verse from Leviticus 20:21, which stated that if a man had sexual relations with his brother's wife, he would be childless—and Katherine had previously been married to Henry's brother Arthur. At some point in early 1526, Henry began to pursue Anne Boleyn, and in August 1527 he petitioned the pope to have his marriage annulled so that the two of them could marry. They likely expected the annulment to come through in a matter of months, but it would take another five and a half years.

After much legal wrangling, the pair married in January 1533. On May 23, Thomas Cranmer, Henry's newly appointed Archbishop of Canterbury, declared that Henry's marriage to Katherine had been invalid. This legitimised his marriage to Anne and rendered the Princess Mary illegitimate; Katherine

was demoted to Dowager Princess of Wales. Rome responded forcefully, ordering Henry to take Katherine back. The king formally denied papal jurisdiction in England and in November 1534 Parliament passed the first Act of Supremacy to break with Rome. Henry thereby became "the only Supreme Head on earth of the Church of England"—not only king of the nation, but also head of its new religion.[43] It was a theocratic model of kingship.

The sweeping change in the new religion mirrored reformist movements in northern Europe. Between 1535 and 1540, under Thomas Cromwell, Lord Privy Seal, the government carried out a policy known as the "Dissolution of the Monasteries," seizing monasteries and pilgrim shrines. Vast swathes of church land and property passed into the hands of the Crown and ultimately into those of the nobility and gentry. A host of practices were banned, including the worship of icons, the use of candles, the veneration of saints, and the performance of pilgrimage. But this great change did not achieve one of its original aims. Henry had reshaped the English religious landscape and declared himself head of a new English church in order to marry Anne, in the hope of having a son, but no son was forthcoming. He turned against his second wife, and she was executed in 1536.

Henry was betrothed to Jane Seymour the next day. They were married ten days later, on May 30, 1536. Jane gave birth to a coveted male heir on October 12, 1537, but died twelve days later of complications related to the birth, possibly from a retained placenta. Two years later, in January 1540, Henry married Anne of Cleves. It was in this year that the psalter was produced. The marriage was not to be the most momentous event of that year; it was annulled not long after; his trusted adviser, Cromwell, was executed; and Henry married again. This fifth wife was Catherine Howard. Exactly when Mallard's

commission was delivered and how long he worked on it is unclear, but the weight of the previous decade's events is discernible throughout the manuscript.

The prayer-book reflects Henry's status as the Supreme Head of the Church of England. In his dedicatory epistle at the start of the book, Mallard addresses Henry as "Defender of the Faith, King of England and France" (this fawning dedication is somewhat surprising from a Frenchman). Henry's status as the head of the church can be seen throughout the book, most obviously in the way it identifies him with the biblical David. David's story was used to justify and define Henry's supremacy. But it had other quite striking resonances as well. David had been the king of Israel and Judah. He was a young shepherd famed for his skill as a musician. He had fought the giant, Goliath, and had become a favourite of King Saul and Saul's son, Jonathan. Saul had then turned on David, and both Saul and Jonathan had been killed in battle, paving the way for David to become king. David conquered Jerusalem and brought the Ark of the Covenant to the city, reorganised the priesthood, and created a new spiritual order. These parts of the story evidently resonated with Henry, who had established a new church and saw himself as battling against great evil.

But there are other parts of the story that have inadvertent resonances. When David became king, he was walking on the roof of his palace when he saw a beautiful woman, Bathsheba, bathing. Enquiring about her identity, he was told that she was married to Uriah the Hittite, who was off fighting David's battles. So "David sent messengers, and took her, and when she came to him, and he slept with her: and presently she was purified from her uncleanliness" (2 Samuel 11:4). When Bathsheba became pregnant, David hoped to pass off the child as Uriah's. But when Uriah declined to sleep with his wife, even when

David called him home (ostensibly to report on the battle), out of sympathy for his fellow soldiers still out in the field, David arranged for him to be killed upon his return to the front lines. One wonders whether Henry identified with both parts of this story of a murderous adulterer. No doubt Henry was more focused on the image of David as an ideal king, a musician, the supposed author of many of the psalms, and the prefiguring forefather of Christ. But the underlying resemblances with the darker side of David's character are striking.

Henry's fascination with David had begun even before passage of the Act of Supremacy in 1534. He had acquired a ten-piece set of tapestries depicting a "riche historye of king david" in 1528.[44] But it was after the Supremacy that royal iconography became particularly Davidic. In the frontispiece of the Great Bible—the English translation that all English parishes were required by law after 1538 to purchase—Henry appears enthroned at the top alongside a quotation from Psalm 118:105: "Lucerna pedibus meis verbum tuum" (Thy word is a lamp to my feet). And it was not only royal iconography that associated Henry with David. A number of writers also made the comparison, in ways both subtle and unsubtle.[45]

After the striking opening image in BL Royal MS 2 A XVI, Henry's prayer-book, several other illustrations also link Henry with David—and, more subtly, with Christ himself as heir to the House of David. One of the first large images in the manuscript appears alongside Psalm 26 and shows David pitted against Goliath.[46] Like the earlier image, it appears in a gold frame. The detail is gorgeous, even in the text border: Mallard has drawn two golden chain links below the frame; from these hang two trompe-l'œil knotted blue ribbons, to which bunches of cucumbers, pears, and cherries are attached. The ribbons hold up the lower border, a kind of golden ox-yoke decorated with

a man's head, which is horned and bearded. This is a virtuoso piece of painting—three-dimensional and textured, conveying the weighty heft of the chains, the succulence of the fruit, and the delicate flutter of the ribbon-ends. This becomes a motif, with the same blue ribbons and horned male head adorning the text borders of other major images in the book.

But one could so easily miss the border details, and indeed, I wonder if Henry did. In this case, his attention was most likely attracted to the image above. There, the two figures of David and Goliath are fighting against a backdrop of elegant striped tents, green fields, and a distant city. Mallard has made artful use of aerial perspective. And David has the face of Henry, as well as the distinctive black velvet cap we saw in the earlier image. Goliath—an awkwardly oversized figure in neoclassical golden armour, towers over him. David is in the act of drawing back his slingshot, ready to devastate Goliath, whom Henry no doubt saw as a metaphor for Pope Paul III—the pope who had decreed the second and final excommunication of the king in 1538. The *titulus*—the small, explanatory gloss written out by Mallard in the margin at the start of the psalm, reads, "Christi plena in Deum fiducia" (Christ's full trust in God). Next to this Henry has made one of his characteristic "tadpole" annotations, apparently denoting a particular interest in the text. He seems to have felt that his complete trust in God would be rewarded.

This is something that recurs in several places in the annotations, revealing that Henry thought himself to be protected by God. In the margin two psalms later, next to the words "Exaltabo te, Domine, quoniam suscepisti me, nec delectasti inimicos meos super me" (I will extol thee, O Lord, for thou hast upheld me: and hast not made my enemies to rejoice over me), he has written, "de gratiarum actione" (concerning

thanksgiving). He seems to have been thankful that God had not made his enemies rejoice over him. In another annotation, next to Psalm 10:7, we sense that Henry expected those very enemies to be punished. He "notes well" (*nota bene*) that God will rain snares, fire, brimstone, and storms upon the wicked, and at the end of the psalm he writes "nota de iusto" (note concerning the just). Henry evidently did not think that he himself would be punished by God, however. Psalm 17:26–27 describes how "God will be holy with those who are holy, but with those who are perverse, He will be a hard judge," and next to this, Henry wrote "de confortio" (of comfort).[47]

The annotations in the prayer-book suggest that Henry hoped the Psalms of David could teach him important lessons about his new role as Supreme Head of the Church of England as well as about how to be a king. He highlighted Mallard's titulus, "exortatio ad principes" (exhortation to princes). And he aligns himself with David again and again, as in an annotation attached to Psalm 88:20, where, next to the words "I have laid help upon one that is mighty, and have exalted one chosen out of my people," he has written "Promissa David facta" (The promise made to David), seemingly seeing David and himself as chosen ones.[48]

The manuscript's next major image, depicting a battle, appears at the start of Psalm 38.[49] The scene is crowded with knights on horseback. They wear early modern armour and are armed with a forest of spears. In the foreground a man lies dead or dying; another, on foot, stands to the right. But our eyes are drawn to a pair of figures in armour and white stockings who are engaged in one-to-one combat. The relevance of the image isn't immediately apparent, but the scene may be a reference to the death of Uriah, sent to his death by King David.

Henry's self-identification with the biblical David is even more explicit in an illustration several folios later. Here, above Psalm 52, which contains the line "The fool hath said in his heart, there is no God," Henry is depicted with a harp—the traditional symbol of David.[50] Next to him is a man wearing a green hooded jacket and blue stockings. This man's hands are folded in front of him and his face is rather scowly. He can be identified as Henry's jester Will Sommers, with whom the king enjoyed a close relationship for over twenty years. Sommers was born in Shropshire and brought to court in 1525 by Richard Fermor, a senior merchant in Calais. He remained at court for the rest of his life, not retiring until the reign of Elizabeth I. In Henry VIII's later years, when he was suffering from a variety of medical conditions, it was said that only Sommers could cheer him, and it is possible that this is why he was included in the psalter's imagery. (Sommers also appears in a painting in the Royal Collection at Hampton Court Palace.)[51]

Another image, accompanying Psalm 68, which begins "Salvum me fac" (Save me, O God), depicts an episode in 2 Samuel 24:13–25 where David was forced to choose between three terrible punishments.[52] David could choose three years of famine, three months of flight from his enemies, or three days of plague for his sin of carrying out a census of Israel when God had not directed him to do so, a violation of the Law of Moses. David chose the plague, and thousands died. The image in the psalter shows Henry VIII as a penitent King David kneeling among the ruins of a neoclassical building. He is dressed in armour, but also wears the distinctive black hat with a white feather that he wears in several other images. Henry's crown appears on the ground beside him, and his eyes are raised in the direction of an angel, who appears in the sky in the upper-left corner of

the picture. The angel is holding three symbols to represent the three punishments: a birch scourge (three years of famine); a sword (three months of flight); and a skull (three days of plague). Overleaf, Henry has highlighted some verses with the tadpole sign:

> *In the multitude of thy mercy hear me, in the truth of thy salvation.*
>
> *Draw me out of the mire, that I may not stick fast: deliver me from them that hate me, and out of the deep waters.*
>
> *Let not the tempest of water drown me, nor the deep swallow me up: and let not the pit shut her mouth upon me.*
>
> *Hear me, O Lord, for thy mercy is kind; look upon me according to the multitude of thy tender mercies.*
>
> *And turn not away thy face from thy servant: for I am in trouble, hear me speedily.*
>
> *Attend to my soul, and deliver it: save me because of my enemies.*

The titulus reads, "Christus in angustia mortis inuocat Deum" (In his distress Christ invokes God). This phrase suggests how David's torment prefigures Christ's in the Garden of Gethsemane. The image, the titulus, and the annotations thus link Henry with Christ as well.

One of the final images of the manuscript reflects not Henry's personal iconography, but instead a change brought about by his religious policies. Next to Psalm 97, where in a pre-Reformation manuscript you might usually find an image of a group of monks in song, we find instead a group of plump-faced *putti* (young boys depicted as angels).[53]

They appear in a historiated initial and are wearing fetching robes in dark purple, deep red, and burnt orange. They have ruddy cheeks, chubby feet, and boyish curls and are singing from a manuscript very like the one in which they appear. Perhaps their youth was intended to signal the promise of the new era—a new Church of England, no longer populated by monks. And it is not only the manuscript's images that reflect the changes in religious practice brought about during Henry's reign. Some of Henry's annotations reflect these changes, too, especially where he made notes next to verses related to the use of religious icons and the role of confession in religious practice.[54]

Thomas Cromwell was executed for treason and heresy in 1540, and Henry's marriage to Anne of Cleves was annulled in the same year. But we can only speculate on a *nota* mark Henry added to Psalm 11:3, which describes how the lips and tongues of flatterers and braggarts will be cut off. Had Henry come to see Cromwell as a flatterer or braggart? His court was certainly a place where people jostled for advancement; amidst such cutthroat political manoeuvring, a wrong move could be fatal. We get a sense of these dangers in a play called *Magnyfycence* written by Henry's childhood tutor John Skelton, which describes a ruler surrounded by fawning courtiers. The allegorical characters have names such as "Counterfet countenance" (Counterfeit countenance), "Crafty conueyance" (Crafty guidance), "Courtly abusyon" (Courtly abuse), and "Clokyd colusyon" (Cloaked collusion).

Alongside the glosses in the psalter, which point out issues of faith and practice and hint at the environment of the court, there are also annotations that reflect more human concerns. The first half of verse 25 of Psalm 36 reads, "I have been young and now I am old." Henry, who was between forty-nine and

fifty-six years old when he made his note by the line, seems to have felt that his time on earth was drawing to a close. He comments, "Dolens dictum" (A painful saying). And, near Psalm 26:4, he wrote, "Apt petition"; it is next to a passage describing a desire to "dwell in the house of the Lord all the days of my life." He also added *nota* signs next to Psalm 89:9–10, which reads, "Our years shall be considered as a spider: the days of our years in them are threescore and ten years." Seventy years was thought to be the average span of a human life. Henry may have been wondering if he would live that long. We see his concern for how his days might be numbered again in the way he has drawn a line in the margin and added the tadpole sign next to Psalm 38: "Notum fac mihi, Domine, finem meum, et numerum dierum meorum quis est, ut sciam quid desit mihi" (O Lord, make me know my end. And what is the number of my days: that I may know what is wanting to me).[55]

One of the last of the annotations in the manuscript appears next to Psalm 108, which describes the punishment of the sinner: "May his posterity be cut off; in one generation may his name be blotted out."[56] The events of the previous decade had been shaped by Henry's concern for "his posterity" and an anxiety that "his name may be blotted out." He highlighted the entire psalm in ink in the margin. But at some point, he underlined a specific verse, relating to sinners, in pencil and added the tadpole sign in the margin:

Fiant contra Dominum semper, et dispereat de terra memoria eorum: pro eo quod non est recordatus facere misericordiam.

(May they be before the Lord continually, and let the memory of them perish from the earth: because he remembered not to shew mercy.)

Henry seems to have wanted the memory of his enemies to perish from the earth. The exhortation not to show mercy, doubly annotated in Henry's hand, is a chilling one. But to the historian, the idea of how memory might perish from the earth is a pertinent one, especially when we consider the two very different patrons we've met here and how the memory of one, Henry VIII, has lived on in the cultural memory, while the other, Queen Emma, has nearly perished.

Henry died some seven years after the psalter was made, on January 28, 1547. After lying in state, his body was moved on February 16 to the vault of St George's Chapel, Windsor, where he was buried next to the grave of Jane Seymour. In September, formal instruction was given for an inventory to be made of his moveable property. It took eighteen months to complete, and in its printed edition, it stretches to just under eighteen thousand items. Item 3527 describes a "Booke of Psalmes covered with crimson vellat and garneshed with golde." This is probably Henry's prayer-book.[57]

The inventory is strangely compelling. The extensive list of Henry's books, tapestries, armour, and furniture give a sense of regal opulence, but there are also parts of it that remind us of his human frailty. I paused over the two silver ear-picks, feeling a thrill of disgust at the thought of the royal earwax. To see a life laid out like this, in an itemised list, makes Henry simultaneously close and distant—a spoiled tyrant and a weak man. Enough of Henry's possessions survive today to make his presence still accessible to us, just under five hundred years later. I wonder if, in Henry's day, anything survived of Emma, who had died just under five hundred years earlier again. None of her possessions survive today. Even her skeleton was dismembered and has only recently been reassembled. It is impossible to know if she had any conception of how her story would

live on, but she made a bold attempt to have her very selective version of events recorded. Like Henry, she commissioned a work that reflected her personal fears and biases, enshrining a particular narrative of her life. Few women in history have had this power to record their stories.

4

Artists

It is typical of medieval achievement that we should
find the work of one great artist so closely bound up
with that of another, that the names of both should
be unknown, and their personalities distinguished only
because the hand of a master is almost always individual.

WALTER OAKESHOTT,
THE ARTISTS OF THE WINCHESTER BIBLE

I n some ways, the title of this chapter is anachronistic. The
word "artist" did not appear in the English language until
after the medieval period. Its arrival as a word—and concept—
was concurrent with the emergence of early modern thinking
that elevated painters from the status of craftsmen. In the medi-
eval period, manuscript artists were called often "limners." (The
word is an altered form of *luminer*, meaning "illuminator," from
the Latin *lumen*, meaning "light." Medieval artists were—in a
literal sense—bringers of light.) Much like scribes, limners were
often attached to monastic institutions, particularly early on; as
the medieval era progressed, they increasingly became secular
professionals. (The Stationers' Company of London, a guild of
scribes and limners, was formed in 1403.)[1] The examples I dis-
cuss here are a mixture of monastic and lay artists.

So these artists wouldn't have called themselves artists. Nor were they individual creative geniuses working alone in the pursuit of fame or new modes of self-expression. Instead, works were typically produced by *groups* of artists engaged in a collaborative enterprise. This is a key difference between our understanding of the "artist" and medieval practice. The names of the people who created and decorated medieval manuscripts, even those of the very highest status, rarely survive in the historical record. But although their names and individual stories are lost to us, their strange and beautiful works still captivate us today.

Who were these limners? Part of the answer comes from the findings of a microscopic analysis of dental calculus found on a medieval skeleton. Dental calculus, or tartar, is a hardened buildup of dental plaque. The teeth of a middle-aged woman buried in a church-monastery complex at Dalheim, Germany, radiocarbon-dated to 997–1162 CE, was found to contain "lazurite and phlogopite crystals, in the form of powder consistent in size and composition with lapis lazuli–derived ultramarine pigment."[2] In the Middle Ages, ultramarine was very expensive. It came from Afghanistan or Iran and was used in the painting of manuscripts, and frequently it was used for painting the robes of the Virgin Mary. Its high price was a kind of reverence in colour form. The little particles in this woman's dental calculus suggested that she was a manuscript artist. She probably got the particles in her mouth when she sucked her paintbrush to bring it to a point, for more precise line filling.

We know almost nothing about who this woman was: we have neither a name nor her dates of birth and death. But we do have these little particles—tiny pieces of evidence to show that, contrary to popular belief, women did work as manuscript illustrators in the medieval period. She worked with the most precious materials in the trade. But this pattern—no name, no

dates—is common for artists of the period, whether male or female.

———————

At some point around the middle of the twelfth century, a scribe set about work on a commission that was both hefty and spectacular.[3] This scribe was probably the most senior scribe in the scriptorium of St Swithun's Benedictine Priory in Winchester—only someone with many years of experience as a copyist could be trusted with the task he was about to undertake.[4] He was, in all likelihood, a Benedictine monk, which meant that copying manuscripts was an important part of his daily routine. He likely worked at it every morning.[5]

In front of him was a great bifolium of animal skin, probably calf hide, that had already been carefully pricked and ruled, probably by a more junior member of the scriptorium. The parchment was of high quality—such high quality that it must have been made in a specialist shop, rather than in the priory itself.[6] This bifolium was to be one of many—in the end the work he was beginning would comprise some 234 huge pieces (23 x 31¼ inches) made from whole hides, totalling 936 pages of text. These hides would eventually make up the magnificent two-volume Winchester Bible. Copying the text probably took around four years.[7] The scholar Christopher de Hamel has called it "a candidate for the greatest work of art produced in England."[8] It belongs to a group of large Bibles made for religious houses in England (and on the Continent) in the twelfth century, but of this group, it is the largest English example and possibly "the finest," as Walter Oakeshott wrote.[9] Its size and scale were physical manifestations of the power the biblical text had for the community that made the manuscript.

Today the Bible can still be seen in Winchester Cathedral, which in the twelfth century was the church of St Swithun's.[10] The cathedral had a long tradition of producing lavish illuminated manuscripts—particularly Bibles, liturgical books, and charters.[11] The Winchester Bible was likely completed by 1161 and may have been commissioned by Bishop Henry of Blois (1129–1171). Henry was Bishop of Winchester from 1129 until his death and was one of five sons of Stephen II, Count of Blois, by Adela of Normandy (daughter of William the Conqueror); he was the younger brother of King Stephen. He had earlier commissioned another Bible (Bodleian Library MS Auct. E inf. 2) for Winchester and was responsible for a number of changes in the cathedral, including the renovation of the east end of the choir to give pilgrims better access to the relics of St Swithun.[12]

The Winchester Bible is now displayed in a room in the cathedral's South Transept. A mural (from a later period) on the south wall shows a scribe at work, suggesting that this became the priory's scriptorium. The area is traditionally known as the Calefactory (a heated place), heated perhaps to prevent the scribes and artists from getting cold hands. (Cold hands were something of an occupational hazard for scribes.)[13] I sometimes wonder whether the Bible's artists were afflicted by cold as they laboured to decorate its folios.

The work is now bound in four volumes owing to conservation work done since 2014. In its original form, it was not intended for individual study but for ceremonial use by the monks of the priory. After the text was copied, it was carefully corrected, and at some point accents were added to aid in reading the text aloud. And only when the text was completed did the work of decoration begin. The Winchester Bible is an endlessly absorbing artefact, because it provides us with an unrivalled opportunity to see medieval illumination *in progress*. The work

of decorating it took around fifteen years but was never completed.[14] The plan seems to have been to have some ninety-three large historiated initials—initials decorated with human figures or particular scenes. Only forty-two completed initials survive.

We might imagine that when manuscripts were decorated, an artist would draw, gild, and paint an image and then move on to the next one. But the Winchester Bible shows us that sometimes these stages in artistic production were separated by many years and could be the work of several artists. Because it is unfinished, we still have a series of written instructions telling us about how the manuscript was made: there are sections of text for the *rubricator* (who added text headings in different coloured ink), colour instructions for the decorated initials, and notes on the folio sequence in each quire.

Sometimes the instructions are simple, as on a folio near an unfinished initial for the Second Book of Chronicles, where it is noted that Solomon should be depicted in the Temple, in keeping with the biblical story.[15] In other instances, the artists are given free rein. A note next to a space by the preface to the Book of Maccabees reads "ad placitum" (as you like).[16] The manuscript allows us to lift the bonnet and see the workings of the artistic engine.

Every stage in this process is represented—from the simple lead underdrawings to the rich, shimmering colours of the completed initials. We see that the creation of a painted initial happened in stages. First, a drawing would be made using a stick of lead alloy called a *plummet* (sometimes these were inserted into holders—the forerunner of the pencil). The lead drawing would next be filled in with ink to prevent particles of lead from showing through in the subsequent painting. The gilding stage followed. To apply the gold, a layer of gesso first had to be added as a ground. Gesso was a thick white substance

usually made from chalk or plaster mixed with an adhesive. It created a raised surface onto which gold leaf could be applied (sometimes the gesso was coloured red so that a warm glow showed through the gold, although this only appears twice in the Winchester Bible).[17] After application, the gold leaf was then burnished. Gilding was a messy activity and sometimes the gilded areas had to be trimmed with a knife. It was for this reason that it was done before the paint was applied. Some of the initials in the Winchester Bible have been gilded but not painted. These initials, although perhaps not as beautiful as the completed ones, show the meticulous care that was taken in the decoration of the manuscript. It is as if we have happened on a moment in time when, after painting, pressing, and burnishing, the artist sat back to consider what would come next.

After the gold leaf was burnished, the coloured paints were applied. The paints were made from a mixture of animal, vegetable, and mineral pigments mixed with egg yolk or gum arabic.[18] The rarest of the pigments—rarer and more costly even than the gold—was the ultramarine, the very particle found in the teeth of the limner from Dalheim.[19]

The Winchester Bible reveals not only the many stages involved in manuscript decoration, but also a sequence of different artistic hands toiling in its folios. Like all the manuscripts discussed in this chapter, the Bible was decorated by a group of artists, and untangling the relationship between them and their work is a tricky business.

Their work is entwined, like the interlacing patterns we find in the manuscript's folios. Often initials were drawn by one artist and painted by another. In some places, it seems the artists worked alongside one another; in others it looks as though earlier work was taken up and modified by later hands. The manu-

script also holds in its pages evidence of changes in artistic styles over the period in which it was produced, as new artistic fashions arrived as a result of exchange and collaboration between English and European artists.

Two artists appear to have begun the ambitious programme of decorating the Bible in around 1160. Although all the artists who worked on the Bible are anonymous, Walter Oakeshott in the 1940s identified six different figures involved in the manuscript's artistic production. He gave them names describing their roles in the project, and these names have largely been accepted by later scholars. The six artists were probably lay professionals who had been brought into the priory specifically to work on the initials. The differences in their styles suggest that they encountered diverse influences on their travels as they moved from job to job.

The first of the artists is known as "the Apocrypha Drawings Master." He may have come from St Albans Abbey, because a manuscript made there bears a striking resemblance to his style. It's possible that he was first trained in western France or Normandy. The second artist, "the Master of the Leaping Figures," may have been the manuscript's "primary designer."[20] His work is characterised by its "energetic mannered poses and gestures."[21] He was probably English, and he perhaps even trained in Winchester itself.[22] His style resembles the Winchester Psalter, which may have been commissioned by Henry of Blois. His figures are painted in a characteristic "Byzantine dampfold style," which means they look as though they have just emerged from water and their clothes are sticking to them. This distinctive style came to England in the 1130s, probably first at Bury St Edmund's. As the artist's name suggests, he created dramatic poses and leaping movements. Much of his work was painted

over by later artists, in the period from 1170 to 1190, but his dramatic, fluid underdrawings remain. The initials he created that were not overpainted demonstrate how he got his name.

The initial for the Book of Exodus is a tangle of figures, foliage, and interlace. The episode depicted is one in which Moses kills an Egyptian who has been tormenting a Hebrew slave (Exodus 2:11–12). In the upper part of the image, the Egyptian can be seen grasping the arm of the Hebrew man and poking a finger in his eye.[23]

The Egyptian's knee is bent, his body intruding into the space occupied by the slave, who seems about to topple over. Below we see Moses delivering the fatal blow to the abuser and the little pile of sand under which he will hide the Egyptian's body. These are images of fluid, colourful movement, with interlacing patterns that are different from the decorative patterns we find in the work of the other artists.

The Master of the Leaping Figures may have worked on the Bible for a long time, and his style may have changed and been influenced by new artistic fashions over the years. But at some point, a new set of artists took up the project. While the Apocrypha Drawings Master and the Master of the Leaping Figures appear to have had connections with England, working there and perhaps partially training there for some time, the next four artists named by Oakeshott appear to have been "European travellers."[24] Oakeshott called them "the Master of the Morgan Leaf," "the Master of the Genesis Initial," "the Amalekite Master," and "the Master of Gothic Majesty." (The work of the last two is less impressive than that of the others, and they may have been assistants.) These four artists use more of a Byzantine style (i.e., a style related to the artwork of the Byzantium—the continuation of the Roman Empire in its

eastern provinces through the late antique and medieval periods). This style may be derived from Italian models.

Many of the later images in the Bible are painted onto a gessoed gold ground that shimmers like the mosaics of Cefalù Cathedral and the Cappella Palatina in Palermo, Sicily.[25] Sicily was a notable centre of Byzantine art in the period. Henry II's daughter, Joan, married King William of Sicily in 1177, when she was twelve years old. Three years before the marriage his envoys visited her in Winchester, and it was from Winchester that she subsequently embarked on the journey to meet her husband in August 1176 (she arrived in February the following year). Perhaps she had English artists in her retinue who brought a Sicilian style back to England's rainy shores in their luggage. Her marriage was part of a larger pattern of Anglo-Sicilian relations in the period: the Archbishop of Palermo was an Englishman, and several members of the courts of Henry I and II visited Sicily in the twelfth century.[26]

The Master of the Morgan Leaf appears to have worked on manuscripts for the monasteries of St Albans and Westminster.[27] He takes his name from a single leaf of the Winchester Bible that is now held by the Pierpont Morgan Library in New York. The leaf, which contains scenes from the life of David, was painted separately but never sewn into the manuscript.[28] And although the Master of the Morgan Leaf painted it, it is based on drawings by the Apocrypha Drawings Master. Figures by the Master of the Morgan Leaf are solemn creatures with sombre expressions. They lack the writhing movement that characterises work by the Master of the Leaping Figures. The Master of the Morgan Leaf invested in his work an emotion not seen in the more stylised poses of some of the other artists; in one scene, in which David covers his face in grief upon

learning of the death of his son Absalom, he used "a softer, yet still intense, color palette."[29]

Intriguingly, the work of the Master of the Morgan Leaf (as well as later artists who worked on the Bible) shows an affinity with some surviving wall paintings in Winchester Cathedral's Holy Sepulchre Chapel, suggesting that he was trained to work on frescoes as well as manuscript images.[30] This might seem strange to us—that artists of this period worked across such diverse media—but the Winchester Bible is endlessly informative about how medieval artists operated. Even more excitingly, there is evidence that one or more of the later group of artists—perhaps the Master of the Morgan Leaf himself—also worked on a series of wall paintings in the Chapter House of the Royal Monastery of Santa María de Sigena in northern Spain.[31] There are details in the Sigena paintings that only find parallels in English art, making it likely that they were created by English artists. The case is further strengthened by a number of striking stylistic similarities between the Winchester Bible and the frescoes.[32]

There is a popular misconception that medieval people rarely travelled, but the Winchester Bible and the Sigena frescoes put paid to this idea. Travel was, of course, arduous and time consuming—it was not to be undertaken lightly—so it is thrilling to imagine the artist (probably accompanied by assistants) making the journey from England to Aragon. Why he went remains unclear—it may have been a diplomatic mission or the result of international royal connections. It has been suggested that he may have visited Sicily on the same trip, although opinion is divided on whether the frescoes pre- or post-date the Winchester Bible, and not all scholars accept this theory.[33]

The Master of the Genesis Initial painted an extraordinary initial for the opening of the Book of Genesis.[34] This artist's

palette is immediately distinguishable from, say, that of the Amalekite Master. Here the only warm colour is a deep coral red; there is no purple or bright orange in the Genesis image. The greens and blues that form the roundel borders predominate alongside the gilding. This artist's figures are sturdier than some of the others and their faces wear fearsome frowns. Like many of the Winchester Bible's artists, the Master of the Genesis Initial had a talent for conveying narrative, even within the confines of an initial. In his image of Noah's Ark, we can see both the dove and the raven that Noah sent out after the flood receded.[35] Genesis 8:6–9 tells us that Noah sent forth the raven after forty days, but it did not return. Afterwards, he sent forth the dove, "but she, not finding where her foot might rest, returned to him into the ark: for the waters were upon the whole earth: and he put forth his hand, and caught her, and brought her into the ark."

Christian commentaries traditionally figured the dove and the raven in opposition to one another, the dove symbolising virtue and the raven vice. Some commentators held that the raven did not return because it was feasting on the corpses of the sinful who had been killed in the flood.[36] The Master of the Genesis Initial therefore shows the corpses of the damned floating in the waters of the flood; Noah, on the Ark, reaches out to gather the dove into his arms, while the raven bends its head to its feasting. The medallion captures within its round orbit the drama of the great flood, which was thought to wash away the sins of mankind. In the roundel above, we see an image of sin being created in the person of Eve.

We do not know why the decoration of the manuscript was never finished, although it may have been due to the death of its likely commissioner, Henry of Blois, in 1171. Regardless, it has remained in Winchester Cathedral ever since, apart from a

brief period after the English Civil War when Oliver Cromwell gave it to Winchester College. The Bible was returned to the cathedral in 1669 following the restoration of the monarchy.[37]

The Winchester Bible has not always been treated well in its long history. Nine initials have been cut from the manuscript since its creation. These removals occurred at different points. A date of 1626 appears next to one hole—a depressing note, as though the vandal wanted to record the date of the crime for posterity. Other thefts were more recent. A report on the Bible written in Winchester in 1907 describes an incident where a church official was offered a bribe to look away while a "souvenir" was taken from the Bible.[38] And, more chillingly, a letter dating from August 16, 1927, thanks the canon librarian for an hour's "consultation" of the Bible that concludes with a dastardly "P.S.": "That initial 'S' now ranks as the cornerstone of my possessions. . . . But mum mum as to this!"[39] One of the nine missing initials was identified in 1948, bought back with the assistance of the National Art Collections Fund, and thereafter resewn into the manuscript.

Tragically, the frescoes in Sigena monastery were largely destroyed by fire in 1936 during the Spanish Civil War. (Thankfully they were photographed before their destruction.) The Winchester Bible has fared better by comparison, giving us a unique insight into the artistic making of a medieval manuscript. Its folios reveal the collaboration of many hands whose work with brush and gilding knife tell us about the international journeys they took. They also tell us something of their individual characters in the decisions they made as they realised the drama of the biblical story in shapes and colours.

Sir Geoffrey Luttrell (1276–1345), a wealthy Lincolnshire land-owner, commissioned a spectacular psalter (BL Add MS 42130) in the early decades of the fourteenth century. It is a weighty thing, with around four hundred decorative borders.[40] Sir Geoffrey may have intended for it to be used for ceremonial purposes both during his lifetime and after his death.[41] The Book of Psalms contained much of the material used in the Divine Office in the Middle Ages. From our modern viewpoint we might imagine that such a manuscript would be decorated in a manner befitting the solemnity and power of the text it contained. And parts of the manuscript meet our expectations—they contain images of the life of Christ, a sequence of saints, and other aspects of the biblical story. Other parts owe a debt to the book's commissioner. There are idealised images of the feudal hierarchy—peasants labouring in the fields; Sir Geoffrey at his feast table, surrounded by family and servants; repairs being carried out to the parish church. It is, seemingly, a vision of parochial English life in which localised communities cluster around their lord.

But the Luttrell Psalter, as it is now known, also contains imagery that we do not expect. In fact, it doesn't simply defy our expectations, it sets fire to them. Alongside its religious scenes and its images of rural life the psalter depicts a different reality: a comedic and surreal world. The manuscript's margins portray people from the social margins, such as beggars, entertainers, and pedlars.[42] This strange borderland is also home to bizarre creatures—with faces where their buttocks should be, or with human torsos and animal legs. This is a world where knights tilt against snail-dragons, where monkeys drive carts drawn by teams of horses, or ride goats, out hawking with owls. The world is turned upside down, a place of anarchy and rupture.

The surreal monsters and comedic scenes adorning the psalter's folios are not uncharacteristic of manuscripts produced in this period—the so-called "Gothic" period in manuscript art (roughly 1200–1350). And it is not impossible to find images fantastic, profane, or scatological in the borders of sacred manuscripts produced for important patrons.[43] So the Luttrell Psalter is not an outlier, but the scale and scope of its imagery does set it apart. It often seems as though the marginal imagery will overwhelm the text it surrounds, spilling riotously into the text's space. But we should approach with caution. There are some images in the manuscript that look strange to us but would have made perfect sense to a medieval audience. One such image is that of a bishop in purple robes who is pinching the nose of a bear-like creature using a pair of tongs; the creature has a second face protruding from its belly.[44] A medieval viewer would most likely recognise this as St Dunstan, who was said to have tweaked the nose of the devil with a pair of blacksmith's tongs.[45] An image like this reminds us that we should always be wary of how we—as moderns—interpret a manuscript's images. They may bamboozle and delight in equal measure, but rarely do they offer neat explanations of their meaning.

Like the Winchester Bible, the Luttrell Psalter was made by several figures, and the collaborative nature of the enterprise perhaps explains some of its uniqueness. We can almost imagine the group of artists working together, delighting in outdoing one another with their strange and comic imagery. Sometimes the manuscript's images feel like a long sequence of in-jokes, what the scholar Paul Binski has called "small-group humour."[46]

The Luttrell Psalter was produced in one or two workshops, but the exact nature of that workshop is unclear. It was likely a secular workshop based in a major urban centre. Geoffrey Lut-

trell lived in the village of Irnham in Lincolnshire, so a number of nearby towns have been proposed as possible places of production. Peterborough was a day's walk from Irnham, but there is not much evidence for Peterborough being a centre of book production. Stamford, a growing university town half a day's walk from Irnham, is another contender. But Lincoln looks most likely, as there is good evidence of it being a place where booksellers and illuminators worked.[47] The artists were probably laymen supervised by a churchman, probably, in this case, a Dominican; Geoffrey Luttrell had a Dominican chaplain in his household. It might seem strange to us that a churchman would sanction the creation of such strange images, but the medieval audience appears not to have felt that such images detracted from the solemnity and importance of the texts they surrounded. In fact, our modern distinctions between "sacred" and "profane" would probably have made little sense to a medieval person. The scholar Michael Camille cites a Book of Hours—a prayerbook—held in Trinity College Cambridge that contains an image of a man defecating and then presenting his faeces to a lady. It appears beneath the text of Psalm 7, and, as Camille notes, "Because we have so cleanly separated faeces from everything else in our lives, its medieval status, interwoven with the sacred text, makes us uneasy. Instead of turds being just what they are—matter—they become mysterious signs that we are unable to read, savour and enjoy with the gusto of our ancestors."[48]

The Luttrell Psalter, like other important medieval texts, was created in stages. First, the Latin text was written out by a single scribe. The perfect, architectural lines of his letters were likely formed with a single, thick quill, and it made precise,

angled sweeps. He added gossamer-thin flourishes to some of the letters with a different, thinner nib, or perhaps with the angled point of his thick nib's edge. The result is a work that conveys weighty importance with touches of delicate beauty—appropriate for the place of the Book of Psalms in medieval culture. The work would have taken the scribe months or perhaps years to complete.[49] After this, the images and decoration were added by some half a dozen artists.[50] There were four distinct phases in the decoration project, which was done booklet by booklet (that is, quire by quire). Although a sense of the personalities involved in the manuscript's creation can be discerned in its folios, the different artists again worked collaboratively, and their work is enmeshed.

The manuscript's decorators largely worked in teams. The first booklet was actually decorated later than the rest, so the sequence of events begins with Booklet 2. Booklets 2–9 are a mixture of the sombre and the comic and were the product of at least two artists working together. They contain bar borders and line-fillers populated by human figures, animals both real and magical, and hybrid monsters (sometimes called *grotesques*). The monstrous creatures appear to have been designed by "Hand C," but at the bottoms of the pages narrative religious scenes appear, including moments from the New Testament and Apocryphal material. Here we see a narrative arc from the Annunciation (the moment the angel Gabriel visits the Virgin) to the Last Judgement. There are also scenes from the Apocryphal Death of the Virgin. These images were painted by an artist termed "Hand D," who mainly painted religious subjects.[51]

The next phase, Booklets 10–12, have no figural elements. There, spaces were left for scenes to be painted, but they were left unfilled, for reasons that are unclear. But at the start of the thirteenth quire we get to the book's justly most famous section.

What follows are six full quires painted by a single hand. The scenes are a marked departure from the earlier, more overtly religious ones. The work here was carried out by a single person whom Michael Camille named the "Luttrell Master," otherwise known as "Hand A." Camille called this artist a "highly individualistic illuminator."[52] The Luttrell Master used a softer, more naturalistic palette than the creators of the religious scenes, which include shades of bright blue and vermillion. The hybrid monsters that here populate the borders of the manuscript, wrote Backhouse, "achieve astonishing new dimensions of ingenuity, imagination and scale."[53] They are "greasy, slimy, hairy, subcutaneous, phosphorescent, rubbery, metallic, velvety, and vegetal— they exhibit every possible malformation, often on one page," Camille said.[54] This artist tended to design the pages himself, leaving the floral borders to be completed by "Hand B" and doing the figural work himself after the borders were finished.[55]

These quires, more than any others, show the identity of the manuscript's commissioner. They contain frequent images of its patron as well as a sequence of images of farming and feasting. What is magical are the places where the Luttrell Master has painted minute details observed with forensic care. In a scene depicting a water-mill, we can see the eel traps tied in the current.[56]

Overleaf from the water-mill, a stately carriage pulled by five horses makes its way across the *bas-de-page* (the bottom of the folio).[57] The details of the horses' tack—halters, bridles, bits, cruppers, and girths—are meticulously rendered, and they differ from the simpler equipment depicted on the horses on another folio, which are pulling a cart loaded with bushels of wheat from the harvest.[58] These images are alive with narrative and movement. At the bottom of an earlier page, a man is sowing seeds in a field, scattering them from a basket hitched

to his body.[59] It would appear to be a cold March day: he is wearing both a hood and a hat. In front of him, his dog chases away a crow, but behind him, out of sight, another crow feasts on a sack of seed.

Turning the pages, we sometimes feel we have happened on a private moment. At the foot of one folio we find an image of three friends presumably playing a game, which seems to require one of them to lift a pole over a molehill while the other two stand at each end.[60] These observations of agricultural life are stylised, portraying a seemingly cheerful bucolic existence, but the small details lend touches of realism. In a scene of harvest on a double-page spread, we see women with sickles bent forward to cut wheat stalks.[61] Behind them, a man looks (perhaps lasciviously) towards their upturned bottoms. Another woman stands up to stretch, her back sore from the work. Across the page, one of the men piling the bushels of wheat together has taken off his gloves and tucked them into his belt. Perhaps he is warm from his efforts.

We should be wary about reading the psalter images too literally. However, its carefully rendered details offer insights into the trappings of medieval rural life, life contingent with that of the patron, who is paying for the work and is depicted frequently in its pages. Towards the end of the Luttrell Master's stint, we find one of the manuscript's most famous images.[62] It shows a knight on horseback. He wears heraldic colours, as does his horse. Beneath him stand two women, who are passing him his shield and helmet. The knight is, of course, Sir Geoffrey Luttrell, and the women have been identified by their heraldic surcoats as Agnes Sutton (d. 1340) and Beatrice Le Scrope—his wife and daughter-in-law.

This is the *dedication miniature*, an image depicting a manuscript's patron. But it is an unusual one. Dedication miniatures

most often depict a patron kneeling in reverence before the image of the Virgin or a patron saint; here we see Luttrell resplendent in armour on horseback. At the point of the manuscript's production, Luttrell was "well past his prime[,] and this specially commissioned image shows him in the glory days of his youth."[63] The image appears next to the text of Psalm 109, which includes the line "I make thine enemies thy footstool" (the first psalm of Sunday Vespers), but this image, which is "closer in feeling to a knightly tomb," depicts martial strength rather than reverent prayer.[64] It is an unambiguous display of wealth and power, and it was probably produced on specific instructions from Sir Geoffrey.

Some five folios on, we find a double-page spread along the bottom showing Luttrell and his family at a feast.[65] On the left-hand page, the food is being prepared. Here the "Master of the Kitchen" wields a large knife to dismember a suckling pig and a fowl. At the same table another servant is filling salt cellars. (Salt was a prized commodity in the period, and this scene is an indication of Luttrell's wealth and status.) Two other servants carry platters into the hall (seemingly across the page gutter). There, on the opposite folio, Sir Geoffrey appears at the centre of his table. Behind him is a hanging decorated with his heraldic colours—silver martlets on a navy-blue ground. His wife, Agnes, sits to his right, flanked by Dominican or Austin friars. To his left sits his daughter-in-law, Beatrice; his son, Andrew; and another man, likely one of his other sons, Guy or Robert.

This is the last major image in the manuscript. After this, the quality of the work decreases. For reasons that remain unclear, these initial phases of work were stopped prematurely, and the manuscript was completed in a different workshop or by different hands. One scholar has argued that the project languished

for at least ten years before being finished.[66] It seems that a different artist took over the work and completed the last eight quires as well as the calendar of saints' days (which now appears at the start of the manuscript, in its usual place). After the feasting scene, the work was done "cheaply and in haste," and the initials and line-fillers are in the "crudest of styles."[67]

Towards the end of the century, the manuscript was in the hands of new owners. These owners added obituary notes—the names of deceased family members and their dates of death—to the calendar. Under their direction, corrections and additions were made in the style of the earlier artists.

It is hard to know how many of the Luttrell Psalter's images were designed by the artists themselves and how many were the result of some kind of intervention by Sir Geoffrey, or perhaps by the Dominican friar in his household. We do not have any surviving notes as we do for the Winchester Bible, which might give us more of a sense of the artists at work and the decisions they made. It is hard to know how—if at all—we should interpret the manuscript. To a modern audience, the juxtaposition of the real and the surreal on its folios is strange. Clearly the images delineate the facts of medieval life: birth, death, marriage, and the harvest alongside the words of the psalms, all pointing to the inexorable, repeating pattern of the liturgical year. In one folio, a swaddled baby appears as a line-filler, while in another, a wayward youth steals cherries—his shoes discarded at the bottom of the tree.[68]

Elsewhere, the inevitable conclusion of this cycle of life is represented by a shrouded corpse lying in an open coffin.[69] Yet alongside these images depicting the nitty-gritty of human life,

we find a topsy-turvy world, such as a scene where a monkey, wearing a cap, is driving a cart pulled by three horses.[70] Its expression is angry and it wields a huge whip. More surreal still are the hybrid creatures populating the psalter. In the image of the monkey driving the cart, the horses, the cart, and the monkey are all recognisably creatures or objects from the real world—the strangeness lies in their conjunction. But the psalter's hybrids are unmoored from reality. Some have features that are half-recognisable—such as a bird's beak and wings—but these features are wont to appear on a beast with blue fur and a snail's shell atop its head.[71]

What to make of the manuscript, its conjunctions and contradictions? What is the relationship—if any—between the world of the margins and the text of the psalms? At times, the marginal images appear deaf to the words of the text. The end of Psalm 30 reads, "O love the Lord, all ye his saints: for the Lord will require truth, and will repay them abundantly that act proudly. Do ye manfully, and let your heart be strengthened, all ye that hope in the Lord." The words appear next to a marginal image of a man climbing an oak tree to gather acorns for his pigs.[72] One of the pigs can be seen looking expectantly into the branches of the tree, while another feasts on acorns below. The text promises punishment for pride and exhorts the faithful to trust in the Lord. Are the acorns a metaphor for the fruits promised those who trust in the Lord? The marginal image appears at the end of Psalm 30 and the beginning of Psalm 31, which reads, "Blessed is the man to whom the Lord hath not imputed sin, and in whose spirit there is no guile" (v. 2). Might the pigs represent sin (pigs being symbols of sinfulness in the story of the Prodigal Son)? Might the man in the tree be a lost soul serving his sins? If there is a relationship between the words and the images, it is not altogether clear.

There are other places, however, where text and image appear to be in conversation with each other. The famous farming sequence appears at the foot of the folios for Psalms 94 and 95. Psalm 94 opens with, "Come let us praise the Lord with joy. . . . Let us come before his presence with thanksgiving." It continues, "For he is the Lord our God: and we are the people of his pasture and the sheep of his hand." Psalm 95 says, "Let the heavens rejoice, and let the earth be glad, let the sea be moved, and the fullness thereof. . . . The fields and all things that are in them shall be joyful." These words of thanksgiving for God's bounty appear above images of the sowing of seeds and ploughing of the earth.[73]

In other places, the marginal imagery responds to the text it surrounds in ways that are *both* playful and sombre. On a folio containing part of Psalm 87, in the left-hand margin, there is an image of a naked man seemingly being drawn into an open Hell-mouth beneath him.[74] Underneath this is an open coffin containing a shrouded corpse. Meanwhile, the psalm reads, "For my soul is filled with evils: and my life hath drawn nigh to hell" and, "I am counted among them that go down to the pit: I am become as a man without help . . . like the slain sleeping in the sepulchres" (vv. 5–6). The final words on the folio are, "Thy wrath is strong over me: and all thy waves thou hast brought in upon me. Thou hast put away my acquaintance far from me" (vv. 8–9). Further marginal decoration hangs from the word *notos* (acquaintance). Here, hanging by three threads from the first "o" of *notos*, is a glass vessel that two young men are apparently using in a drinking game. One of the men lies underneath the open-glass vessel, while the other pours liquid into it. What seems to be happening is that a piece of fruit has been placed at the bottom of the open-ended vessel, and the game is to drink some of the liquid without getting drenched.

This little scene of youthful japery hangs from the text like a hammock, as if mocking the words it is attached to. Yet on the same folio, in the left-hand margin, we see the image of the hell-mouth and the shrouded corpse. Taken together, the scenes act as a *memento mori*—a reminder that life is brief, the joys of youth short, and the spectre of death and judgement ever present.

The margins of the psalter are playful and strange, resisting neat interpretations, or rather, resisting modern modes of interpretation. In places they present conventional religious imagery and images of the manuscript's patron. But elsewhere they show strange events and outlandish beasts. You could be forgiven for thinking that the artists produced some of their paintings on a wild whim, perhaps beginning the outline of a snail's shell and then deciding to add the feet and body of a long-billed bird. Despite the curious juxtapositions, and the sense that sometimes the text and images are in conversation, we have to acknowledge that parts of the manuscript are resistant to interpretation. Opening the Luttrell Psalter, we feel as though we have walked in on a group of friends making jokes and conversational references we struggle to understand.

———————

The Luttrell Psalter is puzzling at times and a bit unruly. The Sherborne Missal, by comparison, is a highly ordered and meticulously produced book. It does not convey the mad spontaneity that characterises the Luttrell Psalter; instead, the scenes depicted in its borders almost always enrich and complement the text. Its allusions are subtle, and the decoration, which is extensive, follows a precise programme. It is a monumental manuscript—not only in its size but also in the amount of

decoration it contains.[75] And yet even here there are sometimes disruptive images that pose more questions than they answer. At a later stage in the manuscript's production, in a central portion of the book, one of the manuscript artists added forty-eight images of birds to the folio margins. They appear oversized by comparison with the scale of the illustration around them, and each one appears with a label giving its name in Middle English. The significance of this manuscript aviary is a perplexing mystery. Were these images a specific commission from the manuscript's patron(s), or were they added on the personal whim of the artist? Do they have a symbolic meaning, or are they merely decorative?

The Sherborne Missal was made sometime around the beginning of the fifteenth century (c. 1399–1407) for Robert Brunyng, abbot of the Benedictine abbey of Sherborne, in Dorset. A missal is a book containing all the Masses to be celebrated in the liturgical year.[76] The Sherborne manuscript is both vast and beautiful, weighing over 44 pounds (20 kilograms), measuring about 2 feet by 1 foot (53 by 38 centimeters), and running to 347 folios. It likely took years to produce.[77] Inside, alongside the crisp lines of its text, it is decorated with a riot of floral, scroll, and leaf designs, twisting colours, decorative sprays, and roundels depicting worthy saints, royal benefactors, and strange beasts. Each page—with its complex, interrelated programmes of image and decoration—demands to be examined and reexamined.

It is difficult to convey the scale and artistry of the missal. Its pages are dizzying in their beauty and intricacy. One scholar has noted that a description of all the images and decoration in the manuscript could make it sound "grossly overburdened," and yet it is "delicate in impression."[78] The manuscript represents a late manifestation of what is termed "Gothic" style,

which is characterised by its use of rich, warm colours, its impressive architectural designs, and its delicate, painterly use of human figures.

The missal appears to be the work of five artists and one scribe.[79] They have been termed Hands A, B, B1 (an assistant to Hand B), C, and D by the scholar Kathleen Scott.[80] Hands A and B appear to have worked together closely. Hand C's style is slightly different from the others; Scott has suggested he may have been influenced by Dutch artists.[81] Highly unusually, one of these hands is actually named in the manuscript. Hand A's name was John Siferwas, and—also very unusually—he depicted himself in self-portraits in several places.[82] He often appears alongside the scribe John Whas and two other figures, Brunyng (the abbot) and Richard Mitford, Bishop of Salisbury.[83] Although Siferwas's name survives, and thus he is more visible than other artists of the time, his name is not widely known today. The names Brunelleschi, Donatello, and Fra Angelico—who all worked in Italy at the same time that Siferwas was at work in England—might ring a bell for people instead. The names of artists whose work is tucked into the folios of medieval manuscripts have remained unknown beyond the academy.

Siferwas's self-portraits show a man with a tonsure, a slightly beaky nose, and rather serious eyes. He painted himself in ten different places. The first is on a page that contains the Mass for the first Friday of Lent.[84] Looking at the whole page you could miss the little portrait; it is tucked into a roundel beneath an image of a swan (the emblem of the Prince of Wales). Siferwas is looking somewhat wistfully to his right, his expression unreadable. In his final self-portrait, he appears to be unfurling a scroll. It reads, "Soli deo honor et gloria secula seculorum amen" (Only to the honour and glory of God, for ever and

ever).[85] Siferwas (fl. 1380–1421) was one of the most important manuscript artists of late medieval England. His work survives in three manuscripts—the Sherborne Missal and two others.[86] He can probably be identified as the "John Cyfrewas" of the Dominican community in Guildford.[87] There has been some debate about his origins, but elements of his style suggest the influence of northern Germany.[88] Some scholars believe he may have been from the Rhineland or Bohemia.[89]

Siferwas depicts himself in Dominican robes while painting the scribe, John Whas, as a Benedictine. Whas probably belonged to Sherborne Abbey, while Siferwas may simply have resided there while working on the manuscript. The two must have planned the work in tandem, although it is hard to know who planned which aspects of the manuscript. Were smaller decisions about the scenes in the roundels left up to Siferwas, or were those decisions Brunyng's province? In any case, like the Winchester Bible and the Luttrell Psalter, the manuscript was clearly a collaborative enterprise.

Perhaps the most famous image in the Sherborne Missal is the full-page crucifixion image, which Siferwas painted.[90] It appears on the inner face of an independent bifolio (i.e., a separate sheet with a blank recto that wasn't part of a quire), which separates it from the text: when turning the pages of the missal, the reader would come across an anomalous blank page and discover the crucifixion painting following it. When the missal was used during the Mass, this meant that the crucifixion image would not have been visible at the moment of the consecration, but would have been symbolically revealed during the Mass.[91]

Having been kept safely within the pages of the manuscript, the colours in this image are perfectly preserved. It has a rectangular shape and is enclosed in an architectural border that looks like carved stone. At the four corners are eight-pointed

rosettes depicting the Four Evangelists. Four other roundels depict Old Testament scenes that prefigure the crucifixion. The crucifixion image itself is one of extraordinary detail and colour. There are twenty-five figures in the composition, which depicts Christ crucified alongside two others and surrounded by a crowd of onlookers. In the background, men in armour and elaborate, gold-decorated headdresses, some on horseback, press in towards the cross shafts, gawping at the torment. The Roman soldier Longinus extends his spear into Christ's emaciated side, which gushes with blood. Mary Magdalene, her blond hair plaited elegantly around her head, looks towards Christ's shins, as if gazing upon his face would be too much to bear. A striking feature of the image is that the iridescent crush of people does not, in fact, draw the eye. Instead, the viewer's focus is pulled towards the figures of three women in the foreground. The Virgin, in an ultramarine robe, looks not at Christ, but down and away. Mary Cleophas and Mary, mother of James, hold her up in a sisterhood of grief. On the whole, the image is busy, sumptuous, and colourful, covered in gold and scarlet. But Mary, in her flowing blue gown, provides an oasis of calm, a focus for grief amidst the crush.

The crucifixion image gives us a sense of the scope and ambition of the missal. It was an artistic achievement almost unparalleled in the period in which it was produced. As with the Luttrell Psalter, some of its smallest details are the most exquisite. In a historiated initial in the "Sanctorale"—the sequence of Masses associated with particular saints—we see an image of Luke the Evangelist painting the Virgin.[92] (According to legend, St Luke created the first icons of the Virgin; the idea gained currency and spread as the cult of Luke spread, and he became the patron saint of painters.) Unlike in conventional images of the scene, here Luke kneels in the space of the initial

and extends his paintbrush to the Virgin, who appears next to him in an architectural frame in the page's border. She is the same size as Luke, and both she and the Infant Christ are looking at him. There is a certain tenderness in the way his paintbrush gently sweeps the line of her robe; he looks in reverence towards her face as if hoping to see how she will react to being painted. There is nothing visually, besides the paintbrush itself, to distinguish the painted from the painter. Kathleen Scott attributed the image to the work of Hand B1—the third artist to work on the Missal.[93]

Perhaps the most beautiful and perplexing details in the Sherborne Missal are the images of birds that grace the borders in a central section of the manuscript. Scholarly opinion is divided over which of the manuscript's artists painted them, and their function is something of a mystery.[94] As Janet Backhouse noted, "No comparable series appears in any known European manuscript of the period."[95] Many of the birds are accompanied by labels identifying them in Middle English. Indeed, this is the earliest and most comprehensive collection of Middle English bird names in existence. In some places, the choice of birds bears a relation to the rest of the manuscript page. Alongside the *Communicantes*—the prayer in the Mass in which important early saints are recalled—we find the robin, labelled as a "ruddoke robertus."[96] (The suffix "-ock" is a diminutive, as in "hillock," so "ruddock" just means "little ruddy one.") It's been suggested that this was an "oblique compliment" to the manuscript's commissioner—Robert (Robin) Brunyng, abbot of Sherborne.[97] The goldfinch was a common iconographic trope in images of the Virgin and Child, especially in Italy, with its blood-red head taken as a symbol of Christ's passion.[98] Similarly, the skylark—traditionally associated with the celestial realm—appears above a tiny image of the Ascension of Christ.[99]

But, for the most part, the birds do not seem to relate to the text around them and don't seem to follow a particular order.

It is also striking that all of the birds in this particular section are wild: there are no domesticated birds, such as chickens; nor, for that matter, are there any birds used for the aristocratic pastime of falconry. In several places in the manuscript where we find images of its commissioner, Robert Brunyng, he is accompanied by elegant hunting dogs, so, by the same token, we might expect images of hawks and falcons. But instead we find more prosaic birds: a dusky juvenile gannet and a plain-plumaged quail.[100] The collection feels a little like a bird-watcher's compendium. Intriguingly, many of the birds are coastal species. One scholar has suggested that as the birds are mainly northern coastal species, they may have been painted by a "northerner who carried his sketches with him."[101] They are observed with great care. The woodpecker is stretching out his long tongue to gather insects, while the heron gulps down a fish or worm.[102]

Another striking feature of the birds in the collection is that many of them have local Dorset names, such as "bergandir" for the shelduck and "waryghanger," a variant of "wariangle," for the shrike or butcher bird. It is possible that the birds may have "been labelled as an afterthought by a specifically local hand."[103] That said, it is also possible that the birds were painted afterwards too. Their scale in the context of the decoration they surround is outsized, unlike other decorative details in the manuscript. In the page for the Christmas Mass, the robes of the angels at the top of the page have been carefully plaited in and out of the border at the page head.[104] Some of the birds, by contrast, sit on top of the rest of the decoration rather than appearing to be integrated into it. At times the birds are integrated into the details around them, but they still appear to be

overpainted afterthoughts.[105] It's as if the manuscript's ordered design has been disrupted by these marginal images: in amongst the opulence of its pages there is something so delightful about the presence of the hungry heron or the homely thrush. Their appearance makes us wonder about the hand that added them and why.

We have no idea who the artists were who made the Winchester Bible. Similarly, while the name and the image of Sir Geoffrey Luttrell have been preserved, the artists who created the bizarre and topsy-turvy world at the edges of his psalter have left nothing of themselves but the sweeps of their paintbrushes. Although we can name John Siferwas, he was only one of a group of artists who toiled to realise the Sherborne Missal's majesty.

In the Bibliothèque nationale in France, there is an image in a fifteenth-century manuscript depicting Tamaris—a painter who lived in the fifth century BCE.[106] According to Giovanni Boccaccio, Tamaris was the daughter of Micon the Younger, who "scorned womanly tasks and practised her father's craft."[107] In the image, Tamaris is at work in what looks like a workshop. A man can be seen grinding pigments at a table next to her. It's so rare to find images of manuscript artists at work, and this one is obviously not a "portrait" in the way we would normally think of it. But I like the image of the man in the corner, his head bent, his gaze fixed on the work in front of him. His presence is a reminder of all the hidden hands that worked to produce medieval manuscripts.

5

Scribes

Is am fuar toirsech and cen tene, cen tugaid.

(I am cold and weary, without fire or shelter.)

SCRIBAL NOTE, AN LEABHAR BREAC
(THE SPECKLED BOOK)

In his *Institutiones*, Cassiodorus (c. 485–c. 585) wrote that the work of scribes and illuminators is

felix intentio, laudanda sedulitas, manu hominibus praedicare, digitis linguas aperire, salutem mortalibus tacitum dare, et contra diaboli subreptiones illicitas calamo atramentoque pugnare. Tot enim vulnera Satanas accipit, quot antiquarius Domini verba describit.

(a blessed purpose, a praiseworthy zeal, to preach to men with the hand, to set tongues free with one's fingers and in silence to give mankind salvation and to fight with pen and ink against the unlawful snares of the devil. For Satan receives as many wounds as the scribe writes words of the Lord.)[1]

He thinks of the work of the scribe and the illuminator as sacred work, but in a martial vein. Each of the scribe's words harms the flesh of the devil. Geoffrey Chaucer wrote a wry

injunction to his own scribe, Adam (sometimes identified as Adam Pinkhurst), some nine hundred years later.[2] Chaucer—whose works include translations of Boethius's *Consolation of Philosophy* and his own *Troilus and Criseyde*—berates Adam, threatening the curse of scabs ("scale") on his head, should he not copy the work more correctly ("more trewe"). He complains about having to "rubbe and scrape" the parchment folio in order "to correcte" Adam's work:

Adam scryveyn, if euer it þee byfalle
Boece or Troylus for to wryten nuwe,
Under þy long lokkes þowe most haue þe scalle,
But affter my makyng þowe wryte more trewe;
So ofte adaye I mot þy werk renuwe,
It to correct and eke to rubbe and scrape,
And al is thorugh þy neglygence and rape.

(Adam scribe, if ever it falls to you
Boethius or Troilus to write anew,
Under your long locks you must have the scale,
Unless you make my words more true;
So many a day I must your work renew,
Correct it and also rub and scrape,
And all that is from your negligence and haste.)[3]

What we have here are two contrasting visions of the work of the scribe. Cassiodorus was a Roman Christian. He wrote his *Institutiones* from the monastery he founded at Vivarium in the sixth century, and his texts were likely copied by fellow monks who saw their work as in the service of God. Chaucer was a fourteenth-century London-based bureaucrat and poet, and his texts were largely copied by professional scribes working

in commercial workshops in and around Chancery (in London). The twin poles that they represent illustrate how scribal work changed during the medieval period. With the emergence of the professional scribe, the work was increasingly done in secular, commercial contexts rather than in monastery scriptoria. In whatever context they worked, when we—as readers, centuries later—encounter the works of these scribes, we have an intimate connection with the figures who shaped the words on the folios we see. In this chapter we will encounter individual scribes and try to reconstruct something of their lives.

On the final page of the Lindisfarne Gospels (BL Cotton MS Nero D IV), a note has been added. It is in a later hand—small, spiky, and cursive rather than bold and stately like the letters of the main text. In eccentrically unstraight lines, the annotator has recorded something of the manuscript's history:

Eadfrið biscop lindisfearnensis æcclesiæ
he ðis boc aurat æt fruma gode & sancte
cuðberhte & allum ðæm halgum gimænelice ða ðe
in eolonde sint.

(Eadfrith, bishop of the Lindisfarne church,
originally wrote this book, for God and for St.
Cuthbert and—jointly—for all the saints whose relics
are in the island.)[4]

The note was added by a monk named Aldred. Aldred goes on to explain—in Old English—that the manuscript had been bound by "Æthelwald, bishop of the Lindisfarne-islanders,"

and then bejewelled by "Bilfrið, the anchorite." (The jewelled binding was lost in the post-Reformation period, before the manuscript came into the hands of the collector Robert Cotton.) Elsewhere in the manuscript Aldred added a continuous interlineal Old English gloss to the Latin text—his work is the earliest translation of the Bible into the English vernacular. For this he is beloved of linguistic historians. But his annotations are also important because without them we would have no idea who made the Lindisfarne Gospels, which has been described as "a landmark of human creative achievement."[5]

The manuscript was probably made in a monastery on the island of Lindisfarne in Northumbria. Surprisingly, it was the work of a single brilliant scribe-artist. (This manuscript might just as easily have been discussed in the previous chapter, on "Artists," because it contains beautiful artwork, but I have decided to include it here because in the Lindisfarne Gospels word becomes visual masterpiece, and letters artworks.) Many medieval manuscripts were collaborative enterprises, but in this case the collaboration appears to have been confined to the manuscript's now lost jewelled binding. It was copied in the first centuries of Christianity in Britain (Christianity arrived in the south of England in 597 but had been brought to the north by Irish missionaries some time earlier). If the note at the end of the manuscript is to be believed, it was made at some point between 698 (when Cuthbert began to be venerated as a saint by his community) and 721 (when the scribe Eadfrith died).[6]

The details of Eadfrith's life are hard to reach. We know nothing of him from before he became bishop, but he was probably already a monk in the Lindisfarne community when he was named to the position. Once he became bishop, we know he promoted the cult of St Cuthbert—restoring Cuthbert's hermitage on Inner Farne Island and commissioning Bede and

another writer, who remains anonymous, to write accounts of his life.[7] The gospels may have been part of this project of veneration. As well as promoting the monastery's own saint, Eadfrith also appears to have helped and encouraged the leaders of other nearby monasteries. According to another medieval text, a poem by a monk named Æthelwulf, Eadfrith gave advice and instruction to an abbot named Eadmund at one of these monasteries (Æthelwulf does not say exactly where). And in this monastery there was a gifted scribe named Ultán, who "could ornament books with fair marking." Æthelwulf reports that Ultán "made the shape of the letters beautiful one by one, so that no modern scribe could equal him. . . . [T]he creator spirit had taken control of his fingers, and had fired his dedicated mind (to journey) to the stars."[8]

Eadfrith may have perceived his role along these lines. That is, he may have understood himself to be "a channel between God and humanity" as he fired his dedicated mind and journeyed to the stars.[9] (It's also important here that Ultán is described as forming his letters "one by one." This painstaking method is characteristic of early medieval scribal work.)

Debate rages over whether Eadfrith would have had time to copy the manuscript while he was bishop. Alan Thacker contends that the manuscript took at least around two years of full-time work to complete and therefore could not have been written after 698.[10] On the other hand, some of the book's artwork is incomplete, suggesting that he died while still working on it. If the book was a long-term, continuous project, perhaps it became a kind of meditative retreat for the bishop as he sought to leave his administrative cares behind. If so, the manuscript may have been copied over a longer period of years, perhaps from 710 to 721.[11] It's been suggested that he may have retreated to a hermitage on Cuddy's Isle, a tidal islet to the

north of Holy Island, to work on his project during the season of Lent, the forty days preceding Easter.[12] The idea is attractive. The Lindisfarne Gospels manuscript is a work of painstaking intricacy; it feels like devotion in book form. It seems fitting that Eadfrith would have withdrawn to a hermitage to carry out this spiritual labour over a period of years.

Opening the manuscript, the reader is first greeted by a *carpet page*—a densely complex array of patterns covering the entire folio. The multifaceted decoration reveals new shapes at every glance. There are five of these carpet pages in the manuscript.[13] Four of them appear before the start of each gospel. Embedded in each of these four is an image of the cross—each one in a different form: Latin, Greek, Celtic ring-head, and the Coptic or Ethiopic tau cross. In this way, the manuscript testifies to Lindisfarne's international connections, showing that its designer was familiar with the iconography of religious cultures far from England's shores.

The opening carpet page is followed by an *incipit page*—from the Latin word meaning "here begins." This page marks the start of a prologue introducing the canon tables that follow. The incipit pages, of which there are also four, are some of the most famous pages in the manuscript.[14] Here letters become devotional icons—no longer simply alphabetical shapes but exquisite pictures. Birds and beasts writhe in a complex interlacing pattern set on a shimmering red-dotted-ground. These tiny red dots, each placed with exquisite care, remind us of the words of Cassiodorus: "Satan receives as many wounds as the scribe writes words of the Lord." It is as if every dot is a tiny wound in the back of the devil.

After the first incipit page, we come to the canon tables.[15] These tables of information, common in gospel-books, were devised in the fourth century by Eusebius, Bishop of Caesarea,

Elisabeth Danes' threat to potential book
thieves, BL Harley MS 5272, fol. 42r.

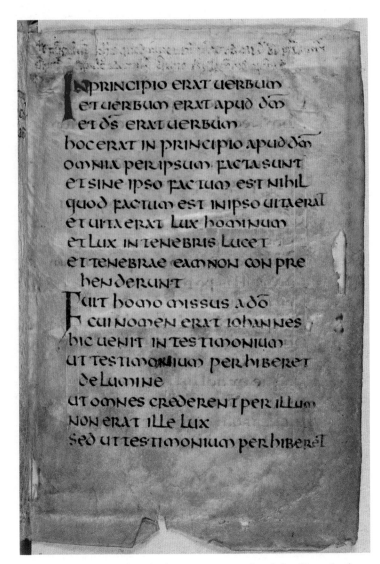

'In principio erat verbum': the opening words of the Gospel of
John in the eighth-century St. Cuthbert Gospel, BL Add MS
89000, fol.1r.

The opening of the Gospel of Luke from the Lindisfarne Gospels, with a cat chasing birds in the border design, BL Cotton MS Nero D IV, fol. 139r.

In a note almost hidden in the page gutter, Aldred, the tenth-century annotator of the Lindisfarne Gospels begs to be remembered alongside the book's makers (BL Cotton MS Nero D IV, fol. 89v).

CREDIT: BRITISH LIBRARY

The opening of *Beowulf* from BL Cotton MS Vitellius A XV (fol. 132r), showing the singed edges of the folios.

CREDIT: BRITISH LIBRARY

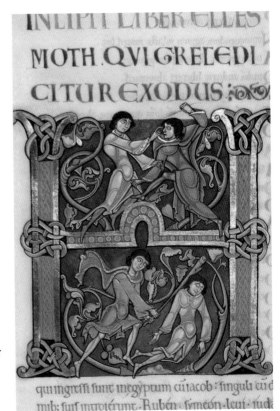

The nun Hugeburc's secret code identifying her as an author, München. Bayerische Staatsbibliothek, Clm 1086, fol. 71v.

The young Moses slays the Egyptian in retribution for the tormenting of the Hebrew, Master of the Leaping Figures, The Winchester Bible, fol. 21v.

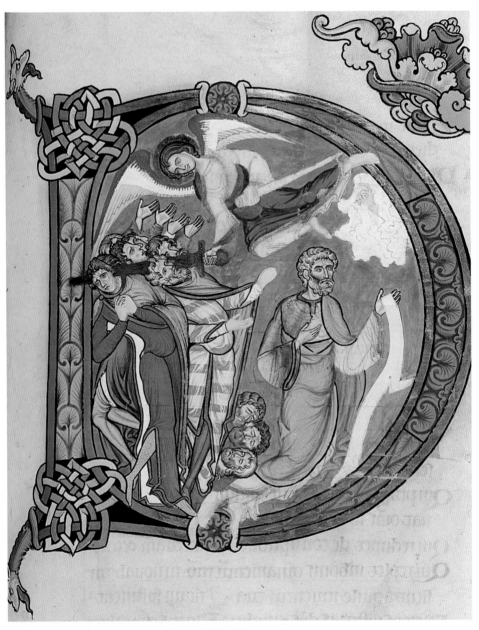

Initial for Psalm 101 by the Master of the Morgan
Leaf over a design by the Master of the Leaping
Figures, drawn, gilded and partially painted, the
Winchester Bible, fol. 246.

Opening for the Book of Genesis: 'In Principio' showing Noah's Ark, The Winchester Bible, fol. 5r.

Æthelwine the Black (Egelwynus ye Swarte) and his wife Wynflæd, who gave land to the abbey of Saint Alban in the eleventh century: BL Cotton MS Nero D VII, fol. 89v.

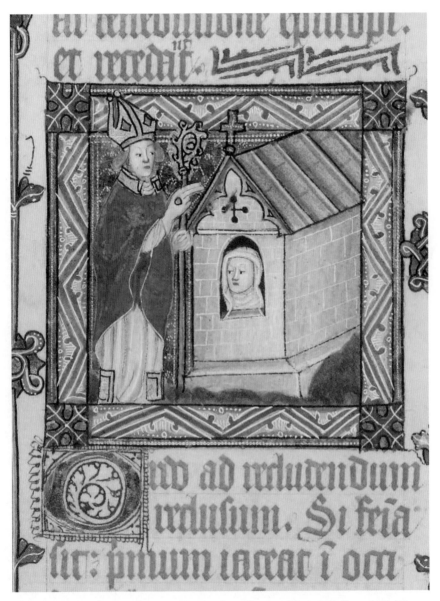

The enclosure of an anchoress, Cambridge, Corpus Christi College MS 79, fol. 96r.

A man sewing seed on a cold Spring day: his dog chases away a crow, while another feasts behind his back, detail, the Luttrell Psalter, BL Add. MS 42130, fol. 170v.

s super omnes

A carriage pulled by horses conveys a group of ladies and their pets (including a squirrel), *bas-de-page* double-page spread from the Luttrell Psalter, BL Add. MS 42130, fols. 181v–182r.

Dominus in celo parauit sedem su
am : 7 regnum ipsius omnibus do
minabitur

Benedicite domino omnes angeli
eius potentes uirtute facientes uer
bum illius : ad audiendam uocem
sermonum eius

Benedicite domino omnes uirtu
tes eius : ministri eius qui facitis
uoluntatem eius

Benedicite domino omnia opera
eius : in omni loco dominacionis
eius benedic anima mea domino.

Enedic anima mea domi

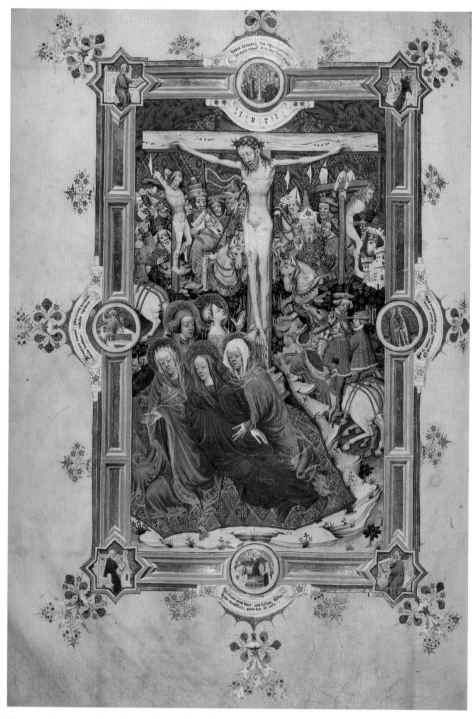

The whole-page Crucifixion from the Sherborne Missal, BL Add. MS 74236, p. 380.

St. Luke, patron saint of painters, painting the Virgin Mary, detail, from the Sherborne Missal, BL Add. MS 74236, p. 573.

Self-portrait of John Siferwas, the principal artist of the Sherborne Missal, BL Add. MS 74236, p. 81.

The artist Tamaris and her assistant in *De Mulieribus Claris (On Famous Women)*, Bibliothèque nationale de France, MS Français 12420, fol. 86r.

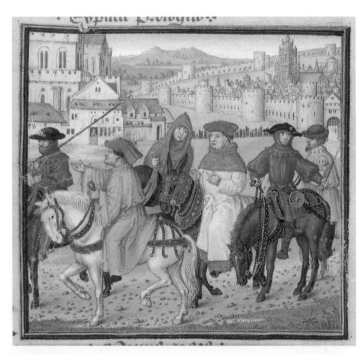

The Canterbury Pilgrims from the *Siege of Thebes*, BL Royal MS 18 D II, fol. 148r.

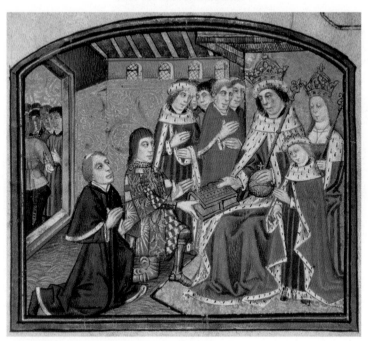

In a manuscript copied from a printed book, Anthony Woodville is shown presenting the *Dictes and Sayings of the Philosophers* to Edward IV. Lambeth Palace Library MS 265, fol. vi verso.

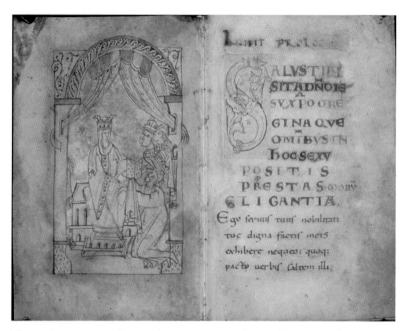

The author presents his work to its patron, Queen Emma, as her sons, Harthacnut (d. 1042) and Edward the Confessor (d. 1066), look on from the *Encomium Emmae Reginae*, BL Add MS 33241, fols. 1v–2r.

CREDIT: BRITISH LIBRARY

'The fool hath said in his heart: There is no God', the opening of Psalm 13 in the prayer-book of Henry VIII depicting the king and his fool, Will Sommers. BL Royal MS 2 A XVI, fol. 63v.

CREDIT: BRITISH LIBRARY

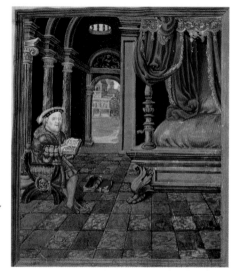

'Note who is blessed', king Henry in his bedchamber reading, BL Royal MS 2 A XVI, fol. 3r.

CREDIT: BRITISH LIBRARY

to help readers find parallel passages in the gospels. Rendered simply as a list of references, the tables could be dull creatures, but in the hands of Eadfrith, the Lindisfarne Gospels canon tables are sixteen folios of intricate iridescent architectural arches. The tables appear in pairs, with folios of similar decoration appearing on each double-page spread. Here we find—as in the opening incipit page—entwined birds, knotted beasts, and braided designs "cleverly moulded to fit an awkward space."[16] As elsewhere, the use of alternating colours creates a shimmering, rippling depth. Another striking aspect of the tables is that, unlike some of the models Eadfrith may have seen and used, the arches are not classical in form but instead distinctively "Insular." (The term derives from the Latin for "island" and refers to the art of early medieval England and Ireland, which often features complex interlacing patterns.)

Perhaps the most spectacular of the incipit pages is the "Chi-rho" page marking the start of the Gospel of Matthew.[17] "Chi-Rho" (that is, XP) is an ancient symbol for Christ—a monogram of the first two Greek letters of ΧΡΙΣΤΟΣ (*Christos*). It's almost hard to make out the shapes of the letters amidst the teeming, eddying beasts and knots of Eadfrith's design.

The complexity of his work is dazzling—Eadfrith plotted some of his designs mathematically.[18] But, for all the complexity of the beast imagery, there is also sometimes something playful in the incipit pages. The decorated borders for the Gospel of Luke, for example, are filled with cormorant-like birds, but the whole series of birds terminates in what looks like a cat's head. Is the cat hunting the birds?

The decoration of the book is not restricted to ornamental designs. The opening page of each of the gospels—Matthew, Mark, Luke, and John—is preceded by an image of the corresponding evangelist accompanied by his symbol: Matthew with

a man, Mark with a lion, Luke with a bull, and John with an eagle.[19] Matthew is also attended by a mysterious haloed figure holding a book, who peeps out from behind a curtain. Each image depicts its evangelist at work on his holy labour, writing out the words of his gospel. We can only wonder at what Eadfrith felt as he drew these figures who, like him, bent their heads to realise divine words on the empty page.

The text of the manuscript is a good copy of St Jerome's fourth-century translation of the Bible into the Latin Vulgate (the version most widely used in the medieval West). It is written in a stately script called *half-uncial*, which has thick, round letters terminating in neat little points. It would have been very time consuming to write because it requires so many lifts of the quill (in contrast to the quick, cursive scripts we will meet at the end of this chapter). The name of the script derives from its half similarity to the Greek uncial script that was used in manuscripts such as the Codex Sinaiticus (an important Bible manuscript dating to c. 330–360). Jerome criticised it "for being so luxurious and costly of materials and effort," noting that "its letters might be an inch high."[20] The Lindisfarne Gospels demonstrate luxuriousness in their script alone.

Eadfrith's copy-text, or "exemplar," was most likely a good Italian one, akin to the copy-text of the Cuthbert Gospel (from Chapter 1), and was probably derived from a manuscript brought to Bede's monastery of Wearmouth-Jarrow. The Lindisfarne Gospels were most likely intended for ceremonial use in church—to be carried in procession and used for reading on special festivals. The book's beauty, as Janet Backhouse

observed, was therefore "in keeping with the status of a book enshrining the Word of God."[21]

—————

Although we know little of Eadfrith, the process he followed to make the manuscript can be partially recovered. He probably wrote the text of the manuscript first before coming to the illumination. He appears to have kept the work of the illumination and the text-writing quite separate. Three of the five carpet pages (preceding Matthew, Luke, and John) are not part of the original gatherings and were copied on different sheets before being sewn into the existing folios.[22] For the main text he used a black ink called *iron gall* made from oak-galls and iron salts. Once the text was complete, Eadfrith would have begun to plot the illuminations. The manuscript contains many prick-marks—small punctures in the parchment to mark out the patterns on the carpet and incipit pages. These are ghostly traces of the careful planning involved in the manuscript's creation. Having marked out his designs with graphite and pricking, Eadfrith would have begun to paint the illuminations themselves.

An illumination was created using animal, vegetable, and mineral pigments. Some of these were available locally, but some had to be imported. Eadfrith would have mixed the pigments with an adhesive made of beaten egg whites, called *glair*. For the black of the illuminations he used *lamp black* made from soot (or, more scientifically, carbon particles). Rich yellows were created using a pigment called *orpiment*.[23] The greens were probably either from *verdigris*, made with copper and vinegar, or from *vergaut*, a blend of blue and yellow pigments.[24] The purples, crimsons, and blues came from lichens and plant

extracts such as woad and *folium* (turnsole), and the reds and the orange shades were from toasted lead. The flashes of gold were from gold leaf and powdered gold ink.[25]

Eadfrith probably applied the colours using reeds and quills. Holy Island is today renowned as a bird sanctuary, and the feathers of the various goose species visiting the island would have made for perfect quills. (One of St Cuthbert's miracles involved an uncooked goose, which suggests that live geese were available locally.[26]) The preparation of all these pigments and quills was just another part of the investment of time and resources that were necessary to create a manuscript.

In all their beauty and intricacy, the Lindisfarne Gospels, created perhaps in silent retreat and contemplation, still feel like an act of devotion in book form when viewed today. But Aldred's note at the end of the manuscript gives us a sense of the community of devoted artisans who created the book and its binding. It also connects us in a powerful way to the scribe who laboured to create this masterpiece. Given that so many scribes from the Middle Ages remain anonymous, even the little we know about Eadfrith gives us a tantalising glimpse of life in northern England in the earliest days of Christianity on the British Isles.

Many people assume that it was only men—particularly monks—who worked as scribes in the medieval period. But this popular assumption is wrong, on two levels: first, many manuscripts were written by secular figures, not monks, and second, many were written by women (and this always seems to surprise people). In around 732, St Boniface (c. 675–754), a Christian missionary in Germany, received a letter from a nun named Leoba. It was a

kind of eighth-century Cover Letter. She requested that he pray for her parents, to whom he was related, and included a poem which she excused as "exercising little talents and needing your assistance."[27] Leoba added that she had learnt to write poetry "under the guidance of Eadburga," likely the abbess of Thanet.[28] This makes Leoba the first named English female poet. Her letter is just one of a number of indications that early medieval English nuns could be highly learned—not just literate, and not just writing letters, but also composing poetry.[29] Leoba's letter was successful: later she joined Boniface in his missionary work in Germany and became abbess of Tauberbischofsheim. When she wrote the letter, however, she was part of the Benedictine double-monastery of Wimborne, in Dorset. Such an institution would probably have had a bustling scriptorium, perhaps even two of them—one for the male house and one for the female.[30] It's likely that Leoba copied manuscripts there. Her work may have been prized both inside and outside the institution. The abbess Eadburga, whom Leoba mentions in her letter, was a scribe so skilled that Boniface wrote to her in about 735 to ask for a particular text: "I beg you further to add what you have done already by making a copy written in gold of the Epistles of my master, St Peter the Apostle, to impress honor and reverence for the Sacred Scriptures visibly upon the carnally minded to whom I preach."[31]

As Boniface's request makes clear, the value of a manuscript was not only in the text it contained but also in the visual beauty of its folios. (Later, Eadburga received a gift of a silver stylus from Boniface's successor, Lul, perhaps in recognition of her skill as a scribe.)[32] It is striking that Boniface does not want just any copy of the Petrine Epistles, but specifically requests Eadburga's penwomanship. A manuscript was not simply a repository of text but an embodiment, in visual and physical form,

of the sacral power of Scripture. Such an artifact could not be created by just anyone.

Tragically, Eadburga's manuscript does not survive. As ever in manuscript study, patchy survival is a problem, and hunting for the work of female scribes is a challenging business. There is a larger body of evidence for the work of medieval female scribes on the Continent; most of the equivalent material in England perished in Viking raids, the Norman Conquest, and the Dissolution of the Monasteries.[33] Moreover, because scribes, of whatever gender, did not often sign their work, it goes unattributed (although signatures became more common in the later medieval period). Female scribal hands are indistinguishable from male scribal hands. Particularly when the place of production for a medieval manuscript is uncertain, there is always the possibility that it is the work of an unidentified female scribe.

Sometimes, however, a manuscript will give us clues that it was made by a female copyist. The Book of Nunnaminster, BL Harley MS 2965, is one of these.[34] Textually, it is made up of gospel extracts as well as a variety of prayers. There is a prayer against poison, for example.[35] It also contains the oldest known copy of the "Lorica of Laidcenn," an Irish "breastplate prayer" for protection of the body.[36] This prayer requests blessings on a long list of body parts, over one hundred in all, including the skull, the tongue, the teeth, "hams," and "spleen with winding intestines," as well as the "joints, fat and two hands."[37] The prayer's anxious catalogue of body parts is a very human reminder of the terror of disease that its readers must have felt in a time before medical conditions were well understood and often could not be effectively treated. Arguably the most intriguing aspect of the manuscript, however, is that it contains prayers in Latin using nouns with feminine endings, which may suggest it was made by, or for, a woman.[38]

The manuscript's small size suggests that it was made for personal use—it could easily be held in one hand. The text was written by a single scribe in a clear round hand, and it is delicately decorated with soft colour wash infills in some of the initials and dotting patterns around certain letters. Headings appear in red ink, and some letters have animal heads in an interlacing pattern that is characteristic of pre-Conquest English and Irish artwork.

The Book of Nunnaminster was probably created in the kingdom of Mercia (in the Midlands of England) in the late eighth or early ninth century, but by the tenth century it had made its way to the Benedictine abbey of St Mary's Nunnaminster in Winchester. At this time someone added further prayers in Latin with grammatically feminine endings. Tantalisingly, inscriptions were also added in Old English describing the boundaries of a plot of land donated to Nunnaminster by Ealhswith (d. 902), wife of Alfred the Great.[39] This could be a clue that the book had originally belonged to Ealhswith, who was Nunnaminster's founder. Although the evidence is only suggestive, Asser—Alfred's biographer (from Chapter 2)—describes Alfred's children Ælfthryth and Edward the Elder as studious and bookish, mentioning that they read "the Psalms, and books in English, [and] especially English poems."[40] Asser describes Alfred himself being given a book of English poems by his mother. It would seem likely, therefore, that Ealhswith shared Alfred's love of learning and promoted it to their children, as Alfred's mother had to him. A bequest of a personal prayerbook to the convent she had founded would be in keeping with our picture of her.

The Book of Nunnaminster may suggest it had a partially female audience, provide suggestive clues to a female scribe, and hint at a female owner. But the evidence is frustratingly

piecemeal. Very occasionally, however, a manuscript speaks to us in more unambiguous terms. Bodleian Library MS Bodl. 451, from the early twelfth century, contains an anonymous moral treatise, a collection of sermons, and a text on the monastic life called *Diadema monachorum* (The crown of monks) by Smaragdus of Saint-Mihiel.[41] It was all written by a single scribe in Nunnaminster (St Mary's Abbey Winchester), which appears to have had a flourishing scriptorium in the early medieval period.[42] This scribe added a colophon at the end of the text that reads, "Salva et incolomis maneat per secula scriptrix" (Save the scribe, may she remain unharmed forever). The manuscript is written in a clear, neat hand with elegant "rustic capitals" and rubrication, meaning that the text would have been easy to navigate. It was a carefully produced volume, with tiny thread page markers— which acted as bookmarks—traces of which can still be seen. Unlike the Book of Nunnaminster, it seems to have been used for public instruction rather than private devotion.[43] The *Diadema monachorum* was intended to supplement the Benedictine Rule (the instructional manual that Benedictine monks and nuns lived by). Smaragdus, the author of the *Diadema*, suggests that one chapter of the text should be read aloud at each evening meal. There are drips of wax and wax stains in the manuscript, showing it was likely used for this very purpose.[44] It would seem that the scribe came back to her work, decades after it was finished, to add a note at the start of the manuscript concerning the genealogy of St Edburga—the granddaughter of Nunnaminster's founder, Queen Eahlswith, who may have owned the Book of Nunnaminster.[45]

There is something compelling about her added note. It shows the book was retained by the abbey and likely read by generations of nuns. The manuscript appears to have been well cared for. When one of its leaves was lost or went missing,

another scribe—probably another female scribe—replaced the leaf and copied the missing text in a hand approximately contemporary with the main hand. And the book went on being read and used for some time. Readers added forms of punctuation in the sermon collection to help them read the text aloud; one scribe added a portion of a now lost text describing a miracle associated with St Edburga.[46] Later notes and pen trials from the thirteenth century testify to several generations of (most likely female) readers.[47]

In the tiniest of details—in traces of thread, drips of wax, the three letters of a feminine word ending, "scriptrix" [female scribe]—we can begin to glimpse a lost world of female scribes and readers. Both of the manuscripts—the Book of Nunnaminster and the collection of sermons—testify to female patrons and owners, reminding us that women were involved in the production of texts in many different ways. These manuscripts offer a corrective to the popular perception that medieval manuscripts were "all written by monks." Our imagination of the past is delineated by patriarchalism infused with prejudice. If we were wrong in imagining that all scribes were men, what else might we be wrong about? The past is, as ever, richer and more intriguing than we imagine.

The scribes described thus far were all attached to religious institutions, but as the medieval period progressed, book production increasingly moved out of the monastery and into the lay world. The rise of universities in England from around the twelfth century created a demand for books outside of religious institutions. (Students were being taught in Oxford in some form in 1096, and something approximating a university developed

after 1167, when Henry II banned English students from attending the University of Paris.) The growth in the number of lay scribes meant that by the end of the twelfth century "monastic houses tended to acquire new books from professional scribes rather than relying on their monks to produce them."[48]

These changes are reflected in the appearance of the scribal hands. Eadfrith's letters are straight, careful, stately beasts, created with many painstaking pen-lifts. The Nunnaminster scriptrix's letters are more interconnected and look to have been made much more quickly. But by the time we get to the scripts of the late medieval period, the scripts are cursive, that is, the letter forms are linked together, with single words written in one fluid movement, rather than the individual letters being formed as separate entities. These scripts are quick and functional and, especially in lower-status manuscripts, have none of the meticulous character of the scripts of the earlier period. It takes quite some time to learn how to read the cursive hands. (Many students learn from a palaeography textbook called *English Cursive Book Hands*, known informally by palaeography students as "English Curséd Book Hands.") As we move into the late medieval period, the devotional or religious scribe begins to fade away and we start to meet the secular scribes. There were several who worked for a single family in the fifteenth century, and these scribes often wrote in rushed, slightly messy hands. But when deciphered, their words open up a world of family politics and social history.

———

What's under the microscope here is not a single manuscript but a collection of letters from several generations of the Paston family in a village twenty miles north of Norwich. The surviving

correspondence, dating from 1422 to 1509, traces the hopes, fortunes, loves, and trials of William Paston and his descendants. Although the letters prodominate, other documents created for the Pastons also survive, including inventories and legal documents such as petitions, indentures, and wills. Through both the letters and the other documents we gain insights into the civil strife caused by the Wars of the Roses as well as about more intimate aspects of the Pastons' lives. And remarkably, the family's lives were often entwined with those of their scribes. In these papers, we see scribes becoming people rather than just names—their loves, losses, and financial hardships, too, are traced by the documents that they and their employers left behind. The family's relationships with its scribes can be mapped in some detail—it is a story that evolved over decades, and it gives us a richer understanding of the lives of scribes than could be gained by a single manuscript.

The first member of the family to appear in the documentary record was Clement Paston (d. 1419), a yeoman. His wife, Beatrice (d. 1409), was said to be a "bond woman" (a female slave). Their son, William (1378–1444), was able to attend grammar school and train as a lawyer through the generosity of his uncle (Beatrice's brother). William's life was very different from his father's, and his children grew up in a world dissimilar in turn to their father's. William had a successful legal career; later in life he married Agnes Barry (d. 1479). Agnes was from a well-known gentry family—she was the daughter of Sir Edmund Barry (d. 1433). She brought William three manors and a degree of social standing he had not previously possessed. Agnes and William had five children who survived into adulthood; the eldest of these was John Paston (1421–1466), who married Margaret Mautby (c. 1422–1484). Margaret was also from a prominent local family; she brought with her nine

manors, located in Norfolk and Suffolk. Crucially, however, she was—like her mother-in-law—well connected. She was related to Sir John Fastolf of Caister (1380–1459), a relationship that would come to shape the Pastons' fortunes. Margaret and John had seven surviving children: John II, and then—confusingly—John III, Margery, Edmund, Anne, Walter, and William III.

Through these canny marital alliances and professional successes, the family's ascent through the social ranks might have been assured. Two events took place in 1459, however, which shook the family. In this year civil war broke out and Sir John Fastolf died. John Paston claimed that Fastolf had made him his sole heir in an orally dictated will. Fastolf had owned the manor of Caister, "one of the most desirable contemporary houses in the country."[49] Unsurprisingly, John Paston's fellow executors disputed the will. What ensued was the so-called "war of Fastolf's will," which cost the family dearly. John Paston I died in 1466 with the will still in dispute. In 1470, after some ten years of conflict, the matter was referred to William Waynflete, Bishop of Winchester, who awarded Caister to the Duke of Norfolk. In a strange turn of events, however, at the unexpected death of the fourth Duke of Norfolk, and through some political manoeuvring, the family did eventually acquire the manor.

The letters offer unique insights into the family's day-to-day existence. Much of the correspondence is of an administrative nature, but there are also moments of intrigue and fear alongside family squabbles and local gossip. At times we glimpse a life where mundanity and danger sat side by side. Margaret Paston wrote to her husband in 1448 asking him to buy almonds, sugar, "some cloth for gowns," "two or three short poleaxes," and "some crossbows."[50] The family's manor of Gresham was in danger of being attacked, and Margaret wanted the resources to

defend it—yet this comes alongside a request for material for the children's clothes.[51]

What intrigues me most about the collection is that although sometimes the Pastons wrote the letters themselves, they often employed scribes. Perhaps the most famous letter in the collection is a love letter from Margery Brews to John Paston III (a son of John and Margaret). Written in the hand of Thomas Kela, a clerk to Margery's father, Sir Thomas Brews, it is thought to be the first Valentine's letter in the world.[52] What was it like for Margery to dictate her declaration of love to an intermediary? The letter gives new meaning to our sense of scribal work, raising questions about the relationships between scribes and their employers. In this sense Margaret Paston is one of the most interesting figures in the collection. She was able to read, but appears to have been unable to write, meaning she had to dictate everything to an amanuensis. She authored 104 of the letters, but all of them were written by scribes—29 different scribes, in fact.[53]

Other members of the Paston family used scribes for a variety of reasons, not simply because they weren't able to write themselves. Writing was time consuming, and the Pastons were busy people. They usually had servants write their letters. One letter survives in the hand of a professional scribe named William Ebesham. Dated to April 1469, it is from William Paston II (the brother of John Paston I) and is addressed to his sister-in-law, Margaret.[54] Ebesham seems to have found employment with William in Norwich. We have to hope that William treated him fairly, because it would seem that other members of the family did not. A letter from Ebesham to John Paston II (William II's nephew) describes all the work he has done and the outstanding payments owed to him. He opens by commending the ungrateful John, "besechyng you moost tendirly to see me

sumwhat rewardid for my labour in the grete booke which I wright vnto your seide gode masitirship" (beseeching you most tenderly to see me somewhat rewarded for my labour in the Great Book which I wrote at your request, good master).[55] The "grete boke" he refers to also survives. It is now BL Lansdowne MS 285—a collection of English, French, and Latin texts "including descriptions of ceremonial occasions governing war and judicial combat," an English translation of a treatise on warfare by the fourth-century writer Vegetius, and a verse version of an Arabic text that purports to be a letter from Aristotle to his student Alexander the Great.[56] In short, it is a compendium ideally suited to a medieval would-be nobleman—a mix of the martial, educational, and entertaining in the languages of the court, the church, and the street.

In the letter, Ebesham describes how he has "often tymes" written to Paston's employee John Pampyng requesting funds; he had also put his case to an associate of the family, Sir Thomas Lovell, but to no avail. He describes how he has been forced to seek "seintwarye" (sanctuary), presumably from creditors, at "grete coste" to him. Later in the letter he itemises the work he has done. There were seven jobs—and in each case he notes whether he had to use "parchemyn" (parchment), an expensive material. It's important to note that he would have been paid (in theory) for his work and not his time.[57] The letter, rather tragically, concludes with a request that John at least send him one of his "olde gownes."

The picture of William Ebesham begging for some clothing to keep him warm is a long way from our image of Eadfrith, Bishop of Lindisfarne, retreating to Inner Farne Island to carry out his devotional labour, plaiting snakes and beasts together on the parchment folios of the Lindisfarne Gospels, and making the pages shimmer with tiny red dots, like wounds on the back

of the devil. What we can gather of Ebesham's story shows how precarious the life of the professional scribe could be in the later medieval period.

Ebesham is an unusual case. None of the other writers identified in the papers were professional scribes; they were family servants, in differing roles, who sometimes were called upon to perform tasks involving writing. The Pastons also sometimes wrote for themselves. One of the few surviving letters by Agnes Paston contains a note at the end that reads, "Wretyn at Paston in hast þe Wednesday next after *Deus qui errantibus*, for defaute of a good secretarye .& c." (Written at Paston in haste the Wednesday next after *Deus qui errantibus*, for want of a good secretary etc.). (*Deus qui errantibus* means the third Sunday after Easter by way of reference to the first words of a prayer said on that day—it's a small reminder of how medieval people measured out their lives by liturgical markers.) The letter is written in a clear, even hand—it would seem that Agnes trusted none of her servants to improve on her writing. The letter can be dated to April 20, 1440, and it is addressed to her husband. It is largely administrative, but with flashes of human detail. She reported that "yowre stewes [fish ponds] do weel" and asked that he bring her more gold thread for embroidery.[58] She also mentioned that

> þe furste aqweyntaunce be-twhen John Paston and þe seyde gentil-woman, she made hym gentil chere in gyntyl wyse and seyde he was verrayly yowre son. And so I hope þer need no gret treté be-twyxe hym.

(the first acquaintance between John Paston and the said gentlewoman, she made him gentle cheer in gentle wise [i.e., they got on well] and said he was truly your son. And so I hope

there need [be] no great treaty [i.e. no difficult negotiations]
between them.)

The "gentilwoman" in question was Margaret Mautby, who
became Margaret Paston not long afterwards. As noted above,
all of Margaret's letters are in the hands of others, unlike Ag-
nes's letters.[59] For this reason, Margaret is one of the most in-
triguing figures in the collection. I have wondered often what
the experience of composing her letters was like for her. Re-
covering their original tone is difficult, and because so many of
them were dictated, it becomes especially hard to read between
the lines. On December 14, 1441, Margaret opened a letter to
her husband of eight months, John I, by enquiring about his
"wylfare" before getting down to more pressing matters. She
begs that he buy her some cloth for a new gown, as he had
promised, because "I haue no govne to werre þis wyntyr but
my blake [and] my grene [one] . . . and þat ys so comerus þat
I ham wery to wer yt" (I have no gown to wear this winter but
my black and my green [one] . . . and that is so cumbersome
I am weary of wearing it). She goes on to request a new girdle
as well. The reason for her sartorial anxiety soon becomes clear:
"I ham waxse so fetys þat I may not be gyrte in no barre of no
gyrdyl þat I haue but of on" (I have grown so elegant/shapely
that I can no longer get any of my girdles round me except one).
Indeed, Margaret was pregnant, and in her next paragraph she
reports that the local midwife has been ill, but has reassured
her that she will be able to attend the birth even if she has to
be pushed "in a barwe" (in a wheelbarrow).

In these lines we glimpse Margaret's sense of humour. In
her description of herself as "fetys" ("elegant" or "shapely"), can
we detect a bit of facetiousness? And perhaps she is playing on
her husband's anxiety by joking that the midwife might need to

come in a wheelbarrow. But her words have a darker tinge as well: it is worth remembering that pregnancy was very dangerous in this period and that as many as one in three women died in childbirth.[60] A contemporary text called *Instructions to Parish Priests*, by John Mirk (or Myrc, c. 1380–1420), an Augustinian canon regular, contains an unsettling reminder of these hazards. Mirk encourages priests to warn the pregnant members of their flock that death could be imminent, particularly as their due dates approached, so that they could prepare themselves accordingly by confessing their sins: "Wymmen that ben wyth chy[l]de [. . .] Theche hem to come [and] schryue hem clene, [. . .] For drede of perele that may be-falle" (Women that are with child . . . teach them to come and clean themselves through confession. . . . For they should be aware of the peril that may befall them). Later there is a chilling instruction to midwives: "[If] þe chylde bote half be bore" ([If] the child is but half born), then the midwives should quickly "crystene hyt and caste on water" (christen it and cast on water).[61] In other words, if the child is about to die, it must receive baptism of some kind to have a chance of salvation. Mirk goes on to say that if the child cannot be born and the mother dies, the midwife must cut the mother open with a knife in order to administer baptism to the infant.

Margaret Paston was facing a potentially fatal ordeal, both for herself and for her child. Her letter concludes with a request:

I pre yow þat ye wyl were þe reyng wyth þe emage of Seynt Margrete þat I sent yow for a rememrav[n]se tyl ye come hom. Ye haue lefte me sweche a rememrav[n]se þat makyth me to thynke vppe-on yow bothe day and nyth wane I wold sclepe.

(I pray that you will wear the ring with the image of Saint Margaret that I sent you for a remembrance till you come home.

You have left me with such a remembrance that makes me
think about you both day and night when I am trying to sleep.)

We can only wonder whether there is affection, and possibly
sexual longing, in the assertion that she "thynke vppe-on yow
bothe day *and* nyth," particularly on those sleepless nights of her
pregnancy.[62] The gift of the ring bearing St Margaret's image
was not simply intended as a reminder of her: Margaret was
the patron saint of childbirth. Expectant mothers were known
to wear amulet scrolls containing texts related to St Margaret
around their stomachs during labour.[63] So Margaret Paston was
also asking her husband to invoke the intercessory power of the
saint for her ordeal ahead. Thankfully, St Margaret appears to
have looked kindly on Margaret Paston. John Paston II—the
first of seven children—was born some time before April of the
following year, 1442.

This context gives Margaret's letter layered meaning. Her
words thrum with humour, affection, perhaps some veiled inti-
macy, and also probably beneath it all, fear. What was it like for
her to tell an intermediary that she had grown so big in preg-
nancy, that she longed for the intercessory power of St Mar-
garet, that the midwife was ill and might have to be pushed in
a wheelbarrow to attend the birth? The scribe of this letter is
unidentified; it comes from a cluster of letters that were written
around this time by different unidentified hands.[64] Who was
this scribe, and what was his or her relationship with Margaret?

In other cases, the scribal hand can be identified, and we
see something more of the relationship between the scribe and
the letter's author. Nearly thirty of the Pastons' letters are in
the hand of James Gloys, the family chaplain. He appears in the
records for the first time in 1448 and seems to have been in the
family's service until 1473. He wrote seven letters—in total or

in part—for John Paston I, and twenty—in total or in part—for Margaret. As she was unable to write, she was especially reliant on those who could do her writing for her, and Gloys appears to have been close to her. For complex reasons, her sons came to resent him. It is possible that after the death of her husband she came to rely on him more and more, and that this development was not to her sons' liking.

On July 8, 1472, John Paston III wrote to his brother, John Paston II, in his own hand. The letter discusses a number of matters, which John III lays out as a list, beginning each point with "item." The fourth item speaks of James Gloys:

> *The prowd, pevyshe and evyll dyposyd prest to vs all, Syr Jamys, seyth þat ye comandyd hym to delyuer þe book of vij Sagys to my brodyr Water, and he hathe it.*

(The proud, peevish and evil-disposed priest to us all, Sir James, says that you commanded him to deliver the book of the Seven Sages to my brother Walter, but he has it.)[65]

After writing the letter, he came back to it and added in a hasty hand, evidently as an afterthought: "I prey brenne thys by[ll] for losyng" (I pray you burn this letter in case you lose it).[66]

Later in the same year, John III's sense of disquiet about Gloys appears to have grown. On October 16, he wrote again to his brother, again on several matters, but including Gloys:

> *Syr Jamys is euyr choppyng at me when my modyr is present, ywith syche wordys as he thynkys wrathe <me> and also <cause> my modyr to be dyspleaseid wyth me. . . . And when he hathe most vnsyttyng woordys to me, I smylle a lytyll and tell hym it is good heryng of thes old talys.*

(Sir James is ever snapping at me when my mother is present, with such words as he thinks anger me and also cause my mother to be displeased with me. . . . And when he has the most offensive words for me, I smile a little and tell him it is good hearing of these old tales.)[67]

The family's relationship with Gloys suggests that those who were employed to write the Pastons' letters were often trusted intimates, perhaps too intimate for the liking of other family members. And Gloys was not the only employee whose familiarity with certain family members elicited concern.

Six of Margaret Paston's letters were written by Richard Calle, who was the bailiff of the Paston lands from around 1455.[68] He was evidently well trusted by the family, in part because he had been recommended to their service by the Duke of Norfolk. A sense of how important it was to be able to trust the people in their employ is conveyed in a short postscript at the end of one of the letters Calle wrote for Margaret, addressed to her husband.[69] It reads, "Yf it plese yow to send aney thing by the berer herof, he is trusty jnough" (If it pleases you, send anything you wish with the bearer of this letter, he is trustworthy enough). Calle was not the bearer of the letter as well as its scribe; the note nonetheless illustrates a sense of anxiety about how written information could be used or misused.

Calle wrote letters for John Paston I as well as for Margaret. On July 28, 1460, he took dictation from John, writing a letter to Margaret in his clear, cursive hand.[70] It is businesslike and full of administrative detail. It appears that after he finished writing it, he handed the letter to John to read, and Paston amended the language in several places, crossing out words and replacing them. In the top margin, Paston added a more

personal note: "I requer yow be of god cu[m]ffort and be of not heuynes if ye wil do owth for me" (I ask you to be of good comfort and be of not sadness if you will do anything for me). John was able to give the letter a more personal and private touch in a way that Margaret could not. She had to entrust her feelings to her scribes.

Calle's familiarity with the members of the family came to be his undoing. On April 3, 1469, Margaret Paston dictated a letter to James Gloys. The letter was addressed to her son John II and is a mix of administrative detail and maternal advice. She sends updates on the manor of Caister and encourages John II not to rush into marriage. Then she makes a special request:

> *Also I wuld ye shuld purvey for your suster to be wyth my lady of Oxford or wyth my lady of Bedford or in summe othere wurchepfull place where as ye thynk best, and I wull help to here fyndyng, for we be eythere of vs wery of othere. I shall telle you more whan I speke wyth you. I pray you do your deveyre herein as ye wull my comfort and welefare and your wurchep, for diuerse causes which ye shall vnderstand afterward, & c.*

(Also I would like you to arrange for your sister to be with my lady of Oxford or with my lady of Bedford or in some other reputable place, as you think best, and I will help with her maintenance, for we are both of us weary of each other. I shall tell you more when I speak with you. I pray you do your duty herein, for my comfort *and* welfare *and* your reputation, for many reasons which you shall understand afterwards, etc.)[71]

Despite her somewhat guarded language, it was clear that Margaret was having a difficult time with her daughter and

wanted her out of the house. (The daughter must have been Margery [b. 1448], as later letters reveal.) As Margaret hinted, it wasn't simply a question of a strained relationship, but "diuerse causes which ye shall vnderstand afterward." Gloys—the scribe and chaplain—would no doubt have been privy to all the information here. It was probably this very familiarity that would enrage John II in the letter quoted three years later.

It is unclear whether Margery indeed found employment with "my lady of Oxford or wyth my lady of Bedford," but a letter written a month later explains the cause of the difficulty between Margery and her mother. It is written in John Paston III's own hand and is addressed to his brother John Paston II.[72] Margery, it turns out, had fallen in love with Richard Calle, the family's trusted employee. The Pastons were newly socially elevated and evidently very keen to preserve their status. Calle was from a family of shopkeepers in Framlingham. The affair was a scandal. Calle, evidently unsure about how to broach the subject of a possible marriage, had asked an intermediary to sound out John III, and the conversation had not gone well. John III's words are cruel. He refers to his "vngracyous sustyr" (meaning she was wicked and miserable, literally without God's grace) and reports what his response was:

> *I answerd hym þat dan my fadyr whom God asoyle wer a-lyue dan had consentyd ther-to and my modyr and ye bothe, he shold neuer haue my good wyll for to make my sustyr to selle kandyll and mustard in Framly[n]gham.*

(I answered him that if my father—whom God absolve—were alive and had consented to this and also my mother and you both, he should never have my good will to make my sister sell candles and mustard in Framlingham.)

Despite this strong opposition, the pair made solemn vows to each other in secret (effectively a wedding) late in the summer of 1469.[73] They may have tried to choose their moment strategically. The rest of the family was consumed with a threat to the disputed manor of Caister from the Duke of Norfolk, who stormed the manor in late August.[74] But when she heard of the secret marriage, Margaret was incensed. She had the pair kept apart and set about trying to have the union dissolved by the Bishop of Norwich. Her distress comes through in a letter dated to September 10 or 11, 1469. Addressed to John II, it is written in the hand of Edmond Paston—the fourth of her children, who was nineteen at the time.[75]

This private matter clearly had to be written by only the most trusted of scribes. The letter is much more open than the previous one that Gloys wrote for her, and it makes for chilling reading. The depth of Margery's feeling was of little consequence to Margaret, whose primary concern was the family's reputation:

I pray ʒow and requere ʒow þat ʒe take yt not pensyly, fore I wot wele yt gothe ryth nere ʒowr hart, and so doth yt to myn and to othere but remembyre ʒow and so do I þat we have lost of here but a brethele.

(I pray you do not take it too badly, because I know well that it goes right to your heart, as it does to mine and to others, but you should remember, as I do, that we have lost in her nothing but a worthless thing.)

The word Margaret uses here, "brethele," means "a worthless person, a wretch; a pauper."[76] (It is related to the word "brothel.") Later she writes that even if Calle died, Margery would never return to her affection.

The tone of the letter could not be more different from what we find in an extraordinary surviving letter that Calle wrote to Margery. He opens by addressing her as "myne owne lady and mastres and be-for God very trewe wyff" (my own lady and mistress and before God very truly my wife). His distress that "we þat ought of very right [to] be moost to-gether ar moost asondre" (we that have the most right to be together are the most apart) is palpable. Calle speaks of his faith and loyalty to Margery's mother and how upset he is to displease her, begging Margery to tell the truth about their union. He concludes with:

> *Mastres, I am aferde to write to you for I vndrestond ye haue schewyd my letters þat I haue sent you be-fore thys tyme but prey you lete no creatur se this letter. As sone as ye haue redde it lete it be brent for I wold no man schulde se it in no wice. Ye had no wry-tyng from me this ij yere, nor I wolle not sende you no mor therfor I remytte all this matre to your wysd<om>.*

(Mistress, I am afraid to write to you because I understand that you have shown the letters I have sent you before this time, but pray you, let nobody see this letter. As soon as you have read it, let it be burnt, for I do not wish any man to see it in any form. You have had no writing from me these last two years, nor will I send you any more, therefore I surrender this matter to your wisdom.)

The final line is perhaps the most poignant: "This letter was wreten wyth as greete peyne as euer wrote I thynge in my lyfe" (This letter is the most painful thing I have ever written in my life).[77] The tone is striking, and the letter has a particular significance because the voices of ordinary people like Calle rarely survive from the Middle Ages.

In the end, Margery and Calle's marriage went ahead and the family ostracised them. Still, competent and trustworthy employees were hard to find. Calle did eventually find his way back into the family's service—there are letters in his hand from after the scandalous marriage.[78] It is unclear whether Margery, who had disgraced the family, was ever welcomed back.[79] She appears to have died after only ten years of marriage, perhaps in childbirth.

Calle wasn't the only figure whose relationship with the family was viewed with suspicion. On November 22, 1473, some four years after the affair between Calle and Margery had shocked the family, John Paston II wrote about a delicate matter to his brother John Paston III. He wrote in his own hand, perhaps feeling that these words could not be trusted to an intermediary:

> *Item, as towchyng my sustre Anne I vndrestand she hathe ben passing seek, but I wend þat she had ben weddyd. As fore Yeluerton, he seyde but late þat he wold haue hyre iff she had hyre mony, and ellis nott; wherffor me thynkyth that they be nott very esewer. But amonge all other thyngys I praye yow be ware þat þe olde love off Pampyng renewe natt. He is nowe fro me I wott nat what he woll doo.*

(Item, as to my sister Anne, I understand that she has been passing sick, but I hope she will be wedded. As for Yelverton he said lately that he would have her if she had her money and otherwise not, which makes me think it is not very sure. But among all other things I pray you be wary that the old love for Pampyng does not renew. He is not with me now and I do not know what he will do.)[80]

With an extraordinary symmetry, it seems that Margery's younger sister Anne (1454–1494) had developed an affection

for John Pampyng—another man in the family's employ. Pampyng had written over twenty letters for the family and appears to have been in John I's service.[81] The letter indicates that the Pastons saw marriage predominantly as an economic transaction. Three days later, on November 25, he wrote again, once more stressing his concerns: "I pray yow take good hedde to my soster Anne lesse the olde love atweyn hyre and Pampyng renewe" (I pray you take good heed of my sister Anne lest the old love between her and Pamyng renew).[82] Not long after this, Pampyng left the Pastons' service permanently, having been separated from Anne.

The interwoven stories of the Pastons and their scribes demonstrates that scribal work could sometimes be intimate work, bringing the writer into the orbit of the author. Sometimes, of course, it was not. Poor William Ebesham, who begged for some clothing to keep him warm, had little intimacy with his supposed patron, despite having copied a "grete boke" for him. But for the others—for Calle, for Pampyng, for Gloys—the words they copied were emblematic of the familiarity they had with their employers, a familiarity that was sometimes viewed with suspicion. And today we feel a certain intimacy in reading those words. To be a scribe was to eavesdrop on an author's thoughts, and we, in turn, eavesdrop on the scribes when we read their work.

This feeling of intimacy is especially poignant when we encounter the work of the types of people whose voices are not often heard from the Middle Ages. There is a thrill when we read the eloquent words of Richard Calle—the much-maligned shopkeeper's son—expressing his love for his would-be wife. There is a thrill when we see the words written by the Nunnaminster scriptrix, and see the notes she added later, as well as

the wax stains and lection marks that testify to the generations of (female) readers who benefitted from her words. And there is a thrill when we read the words written by Eadfrith, who perhaps felt a kind of intimacy with God as he formed the letters on the page with what Cassiodorus called "felix intentio" (blessed purpose).

At the end of the Gospel of Matthew in the Lindisfarne Gospels, almost hidden in the page gutter, is a note: "Remember Eadfrið & Æthilwald & Billfrið & Aldred, a sinner; these four with God, were concerned with this book."[83] Aldred—the enigmatic annotator of the Lindisfarne Gospels—begs that he and the book's scribe and binders be remembered. And we hear him, a millennium later.

This almost hidden note allows us to attach names and partial stories to the people who wrote the script before our eyes. We so nearly did not have the name of William Ebesham—he did not sign the "grete boke" that he copied for John Paston III. We only know his name by connecting his hand to the letter in which he begs for money. And of course the name of the Nunnaminster scriptrix is lost. Her story, like so many women's stories from the past, is now irrecoverable.

On the final folio of the Lindisfarne Gospels where Aldred's postscript appears, near the page's right-hand edge, the following words appear:

Lit[er]a me pandat
sermonis fida
ministra
Omnes alme
meos fraters
uoce saluta

(May the letter,
faithful servant of speech,
reveal me;
salute all
my brothers
with thy kindly voice)[84]

Aldred invokes the power of the letter—the "faithful servant of speech"—asking that the letters themselves salute his fellow monks with a kindly voice. And yet his letters did more than that. The letters written by Aldred, and by Bishop Eadfrith before him, and later by the nuns of Nunnaminster and the Pastons' scribes, salute *us* with their kindly voice.

6

Authors and Scribes

Ælc gelæred bocere on godes gelaðunge ys gelic þam hlaforde
þe forlæt simble of his agenum goldhorde ealde þing & niwe.

(Every scribe in the kingdom of God is like the lord who
continually brings out of his gold-hoard old things and new.)

ÆLFRIC, "ON THE OLD AND NEW TESTAMENTS"

A fter a day in the office, working as a clerk of the Privy Seal
(the bureau that issued royal warrants), Thomas Hoccleve
(c. 1367–1426) was wont to spend his evenings—like many a
modern office worker—getting drunk, flirting, gossiping, and
spending too much money. In between, he sometimes wrote
poetry. And in about 1406 he wrote a witty account of his dis-
solute youth in London. Today it is known as *La Male Regle*
(The Bad Regimen).

The outward signe of Bachus & his lure,
Þat at his dore hangith day by day
Excitith folk to taaste of his moisture
So often þat man can nat wel seyn nay.
For me, I seye I was enclyned ay
With-outen daunger thidir for to hye me,
But if swich charge vp on my bake lay,
That I moot it forbere as for a tyme;

[. . .]
Of him þat hauntith tauerne custume,
At shorte wordes the profyt is this:
In double wyse his bagge it shal consume,
And make his tonge speke of folk amis;
For in the cuppe seelden fownden is,
Þat any wight his neigheburgh commendith.
Beholde & see what auantage is his,
Þat god his freend & eek him self offendith.

(The street sign and the lure of Bacchus
[Which hangs outside his door every day]
Entices people to take a sip of his liquid
So often that they can hardly say no.
As for me, I say that I was always inclined
To rush there without a second thought
Unless such a burden lay upon my back
That I must decline it for a while,
[. . .]
For he who haunts the tavern habitually,
To speak briefly, the "profit" is this:
It will use up his money-bag twice over
And make his tongue speak wrongly about people;
For it's seldomly found at the bottom of a glass
That anyone compliments his neighbour.
Look and see what he gains, he who
Offends God, his friend and also himself.)[1]

A copy of the poem appears in Huntington Library MS HM 111. Reading these words in the Huntington manuscript gives one a particular thrill, because there they are written in Hoccleve's

own hand, and we can imagine the poet forming these gently self-mocking words.[2]

We might imagine that this kind of manuscript was a common thing—that many medieval literary manuscripts survive that were written by the authors themselves. But author *holographs*, or *autographs*, as they are termed, are actually surprisingly rare. The vast majority of medieval literary manuscripts contain the hands of scribes, not author-scribes.

When we open a modern printed book, we invariably see a title page, which gives us a whole set of clues about what to expect. We have a title, at least, which is something many medieval texts did not have. (A large number of the titles of medieval works are actually later editorial inventions: William Caxton came up with the title for Malory's *Morte Darthur*, for example, and it's an awkward title at that, given that the *Morte* covers more than simply Arthur's death; the title of the poem in the Exeter Book that we call "The Ruin" is a modern editorial invention.) And in modern books, except in rare circumstances, we also have the name of the author, and often this name will mean something to us. We can even Google the name and find out what other works the author has written, along with some personal details. For modern authors, we might be able to go to YouTube and watch the author in an interview, or peruse the author's website. But when medieval readers came to a manuscript, their experiences were very different from our own. Often there would have been no title, and no author would be listed. Even if there was, probably very little would have been known about this person. And there would have been nothing like a publisher or a place of publication to guide the reading of the text. Indeed, opening a medieval manuscript and encountering its text might have been slightly disorientating—something

akin to a dream-vision. The reader might have felt like he or she had fallen asleep and woken up in a strange land. (And the "dream-vision" form, when a narrator falls asleep and wakes up in an unknown place, was an extremely popular literary genre in the Middle Ages.) But this strange land—this textual world—was presided over by an obscure but powerful figure: the scribe.

Medieval texts were malleable things, malleable in a way that printed texts are not, and as such they were often refashioned and reframed by the scribes and editors who worked on them. Scribes often had an important role in shaping the meaning of a text—for example, they might change the wording of a text being copied, select particular texts to copy, or place particular texts alongside each other in a manuscript, practices that could radically alter the way a work was understood. Sometimes, texts only survived because of what feels like the whim of the scribe.

When I was an undergraduate, I began to realise that texts—and the manuscripts that contain them—are infinitely richer and more complicated than printed editions would lead you to believe. There is a huge disparity between the texts that appear in manuscript form and the sanitised, ordered blandness of the modern, edited text. The traditional understanding of the role of the modern editor held that they were vested with an important power, that they should act a bit like the author's holy representative on earth. Their job was to filter out the white noise created by scribes and return texts to some kind of original form intended by the author. But recovering what this "original form" may have been is often tricky. Many scholars are now shifting away from this earlier view, seeking to faithfully record the decisions of the scribes themselves, and recognising that these decisions are often just as interesting as the decisions of authors. By taking this approach, we gain fascinating insights into what a text meant in a particular time.[3]

We've seen that manuscripts are portals that connect us to lives in the past. But sometimes it seems that manuscripts get us closer to the authors we seek, but never quite close enough. And sometimes, the encounter brings us closer to the scribe than to the author. We've already caught glimpses of scribes' hopes and terrors, their devoted labours and their joyless drudgery. Now we'll explore scribes as active agents, masters of their art making literary decisions and influencing how we come to see the authors whose work they copied.

———————

At some point in around the 740s—perhaps as early as 737—a scribe from the monastery of Wearmouth-Jarrow set about copying a version of Bede's *Historia ecclesiastica gentis Anglorum* (*Ecclesiastical History of the English People*). Bede was the first great historian of Britain, and he was himself from Wearmouth-Jarrow. The *Historia* details the conversion of the inhabitants of early medieval England to Christianity and charts the establishment of the English church. It was Bede's last major work. He completed it in 731 and would die only a few years later, on May 25, 735. The earliest surviving copy of the work, called the Moore Bede, was written by a single scribe using a type of script called *Insular minuscule*. This script was cursive and easier to write rapidly than some other kinds of more formal scripts—such as the script of the Cuthbert Gospel—that required frequent pen-lifts and generous spaces between the words. Sometimes the spaces between the scribe's words are hard to make out and the manuscript can be tricky to read.

When the scribe got to the end of the text, he wrote out an explicit in red ink stating that it was the end of the work.[4] This

left a space at the bottom of the page. I sometimes imagine what this was like—when a scribe realised they had a pristine piece of parchment to fill, or take instruction on how to fill—at the end of text. Using the empty space, the scribe wrote out a mini-chronicle describing the events of 731–734. It includes new information on King Ceolwulf, to whom the *Ecclesiastical History* was dedicated; the last entry records an eclipse of the moon on 30 January 734. This still left him with a blank space on the other side of the folio. He turned it over and, at the top of the next page, in smaller script, and with slightly paler ink, he wrote out what looks like another section of prose. But here he switched languages, taking up Old English—a vernacular that was probably his mother-tongue. He wrote out three lines in Old English, cramming the text, with almost no word division, into a compact space at the top of the page. Despite looking like a concertinaed piece of prose, that text is now thought to be one of the earliest surviving poems in the English language.[5] English literature, it would seem, had cramped and inauspicious beginnings. It is known as Cædmon's "Hymn." The three lines, simply transcribed, read as follows:

Nuscylun hergean hefaen ricaes uard metudæs maecti end his
 modgidanc uerc uuldur fadur
sueheuundragihuaes ecidrin yctin or astelidæ heaerist scop
 aelda barnū heben til hrofe
halegscepen· thaminddun geard moncynnæs uard ecidryctin
 æfter tiadæ firum foldu frea allmectig

Wrestling a poem out of this squished sequence of words by breaking them into lines is a little tricky. But, the words can be reformatted to give us this:

Nu scylun hergan hefaenricaes uard
metudæs maecti end his modgidanc
uerc uuldurfadur sue he uundra gihuaes
eci dryctin or astelidæ
he aerist scop aelda barnum
heben til hrofe haleg scepen.
tha middungeard moncynnæs uard
eci dryctin æfter tiadæ
firum foldu frea allmectig

(Now [we] must honour the Guardian of Heaven,
the might of the Creator, and his purpose,
the work of the Father of Glory
as he, the eternal lord, established the beginning of wonders;
he first created for the children of men
heaven as a roof, the holy creator
Then the guardian of mankind,
the eternal lord, afterwards appointed the middle earth,
the lands for men, the Lord almighty.)[6]

As a devotional text, this little hymn is a masterpiece of formal economy and musical alliteration. Its opening invocation "Nu" (Now) grabs our attention and suggests that we are to participate in a communal act of praise. The poem's DNA is God—he appears in every line: he is "hefaenricaes uard" (the Guardian of Heaven) in line 1; "metudæs" (God/Creator) in line 2; "uuldurfadur" (Father of Glory) in line 3; "dryctin" (Lord) in line 4; "scepen" (Creator/Maker) in line 6; "moncynnæs uard" (mankind's Guardian) in line 7; "dryctin" again in line 8; and "frea allmectig" (Lord almighty) in line 9. In line 5—the central line of the hymn—God appears more obliquely: "he aerist scop

aelda barnum" (He first created, for the children of men), but there's a clever little pun in this line. "Scop" can also mean "poet," so the heart of the poem draws our attention to acts of both verse and universe creation. (This short list shows the richness of Old English vocabulary relating to God—a plethora of words are used here which are often translated as the same word in Modern English.)

The scribe concluded the poem with the Latin words "Primo cantauit Cædmon istud carmen" (Cædmon first sang that song). And after that, as if finding something useful to fill the space, he wrote out three Latin words that perhaps he had difficulty with: "arula," "destina," and "iugulum," alongside their Old English translations, "hearth," "feur-stud," and "sticung," which translate as "altar," "buttress," and "piercing/pig-killing." The Latin words do not crop up frequently in Bede's text (the first two only appear once each). After this, he added some information on Northumbrian history, including a list of the kings from 547 to 737 (and it is this information that helps to date the manuscript). The final section of the page was copied later by a scribe in Europe.

These three small, squished lines have an important place in English literary history. Reformatted, they often appear in anthologies as one of the earliest English poems. They've been treated with a degree of reverence that might have puzzled the scribe.[7] But one reason the passage has come to be so revered in modern times has to do with a story that Bede told in the *Ecclesiastical History*.

Bede, in fact, tells us about a poet named Cædmon who was active in around 670, which makes him the earliest named English poet.[8] But this Cædmon was not—as we might perhaps expect—a famous author who lived in a royal court. He was not of noble birth. And he did not leave an important *oeuvre*

behind him. Cædmon was a cowherd who lived at the Abbey of Whitby in the north of England.[9] He was an ordinary man living in an extraordinary time: Christianity had been in Britain for less than a century. Bede says that Cædmon was one of the greatest poets of his age, although you wouldn't have guessed this from his early life. Because, according to Bede, he was so shy about singing or speaking in public that when people began to sing at social gatherings he would leave "as soon as he saw the harp approaching him."[10]

Bede describes how one night, Cædmon saw the harp being passed in his direction and he slipped out. He went to the cattle byre (*stabula*), as it was his turn to take care of the animals that night. I picture him alone there, the sounds of laughter and song from the abbey drifting across the night air, mixing with the low rustles and murmurs the cows made, their feet stamping the straw. Perhaps Cædmon enjoyed their gentle warmth. My image of the scene is undoubtedly coloured by Christmas carols. And yet Bede probably intended this connection—because a divine event would occur in the stable that night. Bede wanted us to see Cædmon's story as in some way akin to the Nativity. He tells us that Cædmon stretched himself out in the byre and went to sleep.

And as he slept he had a dream, in which someone came to him and made a request: "Canta mihi aliquid" (Sing something to me). Cædmon protested that he was not able to sing, which is why he had left the feast. The visitor in his dream replied, "Nevertheless you must sing to me." Cædmon queried, "What should I sing?" And the messenger replied, "Sing of the beginning of creation." After this, Cædmon "straightway began to sing verses to the praise of God the Creator, which he had never heard before." Bede then gives a description of Cædmon's song in a Latin paraphrase. Then he cautions, "This

is the sense but not the order of the words which he sang as he slept. For it is not possible to translate verse, however well composed, literally from one language to another without some loss of beauty and dignity." Although Bede was describing a miraculous event—the divine gift of sacred song to an illiterate cowherd—he probably did not think it was worth recording the vulgar, vernacular text of the song.

In the morning, recounts Bede, Cædmon went to the steward (his monastic superior) and reported his dream. The steward took him to the abbess, Hild, who said he should be examined by "learned men." (This is one of the many ways that Bede subtly sidelines the contributions of women in the early English church—it is only the authority of learned *men* that can affirm the miracle that has occurred, despite the fact that Hild is the abbess.)[11] Bede stresses that Cædmon "had never learned anything of versifying," noting that "he did not learn the art of poetry from men, neither was he taught by man, but by God's grace he received the free gift of song."[12]

The learned men confirmed that the song Cædmon had received was indeed a gift from God. It becomes clear that Cædmon was illiterate, because to test him further the learned men "expounded to him a passage of sacred history or doctrine" (the implication being that he could not read it for himself), and the next day he returned, having rendered it "in most excellent verse." At this, the abbess instructed him to take monastic orders. Bede says that Cædmon, "giving ear to all that he could learn, and bearing it in mind, and as it were ruminating, like a clean animal, turned it into most harmonious verse." Here Bede is figuring Cædmon as an ideal monastic learner. Medieval monastics were encouraged to practise *ruminatio* when reading a text—that is, they were to read deeply, to chew over the words

of what they had read (as we saw with the ironic book-moth riddle in Chapter 2). In this way, Bede makes the illiterate cowherd a fitting model for his monastic readers. And the reference to the "clean animal" subtly reminds us of the humble origins of the saintly Cædmon, who received a revelation in the *stabula*.[13]

Bede's point in this story about Cædmon is that poetry is transformational, mystical, and God-given. The implication, as one pair of scholars put it, is that this is the "moment the native (Germanic) traditions of oral song-making are allied with the subject of Christianity and harnessed for the faith."[14] It is a conversion story that maps neatly onto Bede's larger story about the establishment of the English church. But for literary historians today, it is also perfect as a foundation myth for English literature, as Cædmon is the first named English poet. Distilled down to its basic parts, you could perhaps render this event as "Long ago, in a stable, a miraculous genesis occurred, and written English poetry was born." Except that the story is more complex than that.

Apart from Bede's account, almost nothing else of Cædmon is recorded. None of the marvellous songs he composed are extant. And the hymn that Cædmon sang in the cattle byre that night might only have survived in Bede's described form, as an echo of a text, had it not been for the scribes who began adding an Old English version of the poem into the spaces around Bede's Latin text. The scribe of the Moore Bede added the vernacular text in amongst some annals and a few random Latin words. Another very early copy of the text is found in the Saint Petersburg Bede held at the National Library of Russia.[15] This manuscript is roughly contemporary with the Moore Bede, and like that manuscript it was also produced at Wearmouth-Jarrow, Bede's own monastery. In this manuscript a scribe has

added Cædmon's "Hymn" to the space at the bottom of the folio containing the text that describes his divine dream.

After the eighth century, many more scribes added the "Hymn" to the spaces in and around the Latin text of Bede's *Ecclesiastical History*. It survives in twenty-three manuscripts dating from the eighth to the fifteenth centuries, and in four main *recensions* (essentially branches of the textual family tree).[16] There has been some debate about the nature of the different versions of this little poem. Some scholars have suggested that the added Old English texts were simply translations of the Latin paraphrase Bede provided, back-formations without any sense of Cædmon's original poem. But the scribes who copied the "Hymn" may have had access to something like the original vernacular poem. Were you to translate Bede's version of the "Hymn" into Old English, the version you would arrive at would be different from the early marginal versions added to the copies of Bede's Latin *Ecclesiastical History* or a later version produced under the reign of King Alfred.[17] This suggests that the versions we have of the "Hymn" predate Bede's text—that they existed in some form before Bede came to write his *Ecclesiastical History*.

Cædmon has probably become famous today in part because he is one of the few vernacular authors from the early medieval period who has anything that approaches a life story. Bede told the story of Cædmon as evidence of a miracle, but for modern scholars its significance lies in the way it provides an identifiable authorial biography for such an early figure. And the text—in its different versions—has taken on a life of its own, appearing in anthologies as a kind of foundational text of English literature. But it is a problematic work—textually a little confusing, and of uncertain genesis. How much is Bede's story to

be trusted? How much can we truly say that the "Hymn" was authored by Cædmon?

In spite of these difficulties, Cædmon's "Hymn" is a beautiful metaphor for what is ephemeral, for the importance of manuscripts as tangible witnesses to a lost literary past, and as a reminder of how fragile that past is. And it's appropriate that the vernacular version of the poem should have been recorded as it was—unobtrusively tucked into the spaces around the Latin text, a bit like the shy Cædmon who hid from the harp.

A "miscellany" manuscript is a concoction of works written for different purposes and in different genres—perhaps poems, fables, musical works, and medical texts—all thrown together in one volume. BL Harley MS 978 is one such manuscript. It dates to the thirteenth century. In it you can find a dialogue on falconry, a glossary of herbs, a recipe for improving eyesight, a legend relating to the parents of Thomas Becket, a poem on the Battle of Lewes in 1264, a selection of verse, and a famous early English song.[18] The diversity of the manuscript's texts is mirrored by the diversity of its languages. Here there are texts in Latin, English, and Anglo-Norman (the language of the educated elite in England after the Norman Conquest of 1066). This grab bag of material is not unusual for medieval manuscripts, which are often more like a modern bookshelf than a modern book—they might hold several unrelated works together in a single place.

Some forty folios into the manuscript we find an explanatory rubric at the top of the page that reads, "Ici cumence le Ysope" (Here begins the Aesop).[19] The text is in Anglo-Norman and

would appear to be a translation of Aesop's *Fables*. The final lines of the text command our attention:

> *Al finement de cest escrit*
> *Que en romanz ai treité e dit*
> *Me numerai pur remembrance*
> *Marie ai num, si sui de France*
>
> *(To end these tales I've here narrated*
> *And into Romance tongue translated,*
> *I'll give my name, for memory:*
> *I am from France, my name's Marie.)*[20]

These words mean that the text is the work of the earliest named female writer of secular literature in the European tradition: Marie de France. And yet we know almost nothing about her. Thus there is an irony in her words: although Marie names herself "pur remembrance," very little can be remembered, as little can be gleaned about her apart from the assertion that Marie was her name and she was from France. It is thought that she was active from around 1160 to 1215, and she is generally accepted to be the author of three other works. One, simply called "The Lais of Marie de France," is a collection of short lays, or tales, about love, loss, and *aventure*. (This word *aventure* has a rich semantic range. It can mean a happening, an event, or a piece of good fortune, but it can also mean a misadventure or an accident.)[21] Another is called "The Fables," and it consists of tales based loosely on the works of Aesop. The third is *L'Espurgatoire Seint Patriz* (Saint Patrick's Purgatory), and it is the story of an Irish knight's visit to a pilgrimage site named for St Patrick, where he enters Purgatory and is tested by demons.

The only reference to Marie from her time period comes from an English monk, Denis Piramus, who refers to a "Dame Marie" and her popular "lays in verse," beloved of both men and women, which he noted were "not all true."[22] Although she was "de France," Marie probably lived in England and wrote in Anglo-Norman. Her poetry reveals her to be highly educated—it appears she was fluent in Latin, Anglo-Norman, English, and Breton. In the prologue of the "Lais" she writes that she has composed the work "En l'honur de vus, nobles reis, / Ki tant estes pruz e curteis" (In your honour, noble king, / who are so brave and courteous).[23] Scholars have long speculated on who this "noble king" might be; it is sometimes assumed to be Henry II of England (1133–1189), but Marie leaves us guessing.

In the "Fables," the tales are often pithy and dryly witty, with flashes of cynicism. Marie takes a misogynistic form and makes it her own. Although she made use of a long Latin fable tradition, she altered the texture of her source material.[24] As the scholar Karen Jambeck has pointed out, Marie "raises women from a position of moral inferiority to one of greater equality."[25] Yet some of the scribes who copied Marie's text had other ideas, introducing new lines to her verse and giving the texts a misogynistic ring. One of Marie's fables, for example, is called "Del lu e de la troie" (The wolf and the sow). It describes how one day a wolf came across a sow who was pregnant and about to give birth. The wolf tells the sow he wants her to deliver the piglets quickly so that he can take them from her. The sow responds:

Sire, cument me hastereie?
Tant cum si pres de mei vus veie,
Ne me puis pas deliverer;
Tel hunte ai de vus esgarder.
Ne savez mie que ceo munte?

Tutes femeles unt grant hunte,
Si mains madles les deit tucher
A tel busuin ne aprismer!

(My lord, how can you hurry me?
When you, so close to me I see,
I cannot bear my young outright;
I'm so ashamed when in your sight.
Do you not sense the implication?
All women suffer degradation
If male hands should dare to touch
At such a time, or even approach!)[26]

The wolf therefore retreats, and the sow escapes, her piglets unharmed. Coming to the fable, we might expect a cunning wolf and a stupid pig. But the heavy, lumbering, pregnant sow is more than a match for the wolf, who thinks he can outwit her. Her quick thinking allows her to escape and to protect her piglets, as she claims that to be seen or touched would make her unable to give birth. In BL Harley MS 978—considered to be the best text of the "Fables"—the end of the fable provides a bit of advice:

Ceste essample deivent oïr
Tutes femmes e retenir:
Que pur sulement mentir
Ne laissent lur enfanz perir!

(All women ought to hear this tale
And should remember it as well:
Merely to avoid a lie,

They should not let their children die!
[Or, literally: "All women should hear this example and
 remember it: they should not let their children die for
 want of a lie."]) [27]

Marie's point seems to be that a woman should not be afraid to lie if it will protect her children. The scribe of a fourteenth-century copy of "The Fables" in Cambridge changed this, however, turning the line "Que pur sulement mentir" (Only for want of a lie) to "Por soulement lor cors garist" (Only to protect themselves). The change refashions this story of a protective mother into a suggestion that mothers might prioritise their own safety over that of their offspring.[28] This is only one example: we see a pattern of misogynistic alterations in the manuscripts of Marie's "Fables."[29]

It's intriguing to speculate on whether Marie knew how her work could be susceptible to change and co-optation. In the epilogue to the "Fables" she hints at this:

Put cel estre que clerc plusur
Prendreient sur eus mun labur.
Ne voil que nul sur li le die!
E il fet que fol ki sei ublie!

(It may be that several clerks
Will claim this work as their own labour
I'll not have any make this claim
A fool is one who is forgotten.) [30]

It is as if Marie knew that "clerks" would seek to claim her work and reframe it. But there is a sad irony in these words as well.

Apart from a few small snippets of information in some of her texts, almost everything about Marie's life has been *ublie* (forgotten), and her work was indeed reclaimed and reinterpreted by scribes.

BL Harley MS 978 is often used as the basis for editions of the "Lais" and the "Fables." It is the only version to contain both texts in one manuscript, and the only one with all twelve of her lais, which appear in an order that seems close to the original authorial arrangement. BL Harley MS 978 also contains an important verse prologue to the text. And yet this manuscript is several removes from Marie. It was probably put together between 1261 and 1265, around sixty years after we believe she died. It was written by multiple scribes, apparently in Oxford, and may have been the product of professional book producers there.[31] A note in the manuscript hints at its commissioner: it reads, "Ord.li. W. de. Wint," which may be an abbreviation for "Ordo libri William de Wint" (The list of the books of William of Wint).[32]

Scholars have identified the note in various ways. Some have suggested that it means the book belonged to one William of Wycombe (fl. c. 1275), a music copyist and Benedictine monk. He composed polyphonic alleluia settings and held the position of precentor—the most important position for a church musician—at Leominster Priory, one of the dependencies of Reading Abbey. (Elsewhere there are clues that the manuscript belonged to Reading Abbey, probably in the 1260s, as it contains notes recording the death of some of its abbots.[33]) William may have composed a song that is in the manuscript, "Sumer is icumen in, Lhude sing cuccu" (Summer is coming in, Loudly sing cuckoo).[34] Others suggest, however, that "W. de. Wint" could be William of Winchester, who—like Wycombe—resided at

Leominster Priory.[35] This William has been called "something of a latter-day Abelard."[36] He was accused of having an improper relationship with Agnes of Avenbury, an Augustinian nun of Limebrook (nine miles northwest of Leominster). In 1282, Thomas de Cantilupe, Bishop of Hereford, lodged a formal complaint against him for scandalous misbehaviour. He failed to appear in court, sent a proxy, and was duly excommunicated and dismissed from office. Whichever of these two candidates it was (or indeed another), it is a great irony that we know more about these putative owners or commissioners than we do about the author of the "Lais" and the "Fables."

Bede's story of Cædmon has the contours of a biography—it is a pleasing creation story that details the transformation of a pious cowherd into a divine poet. Yet all but one of Cædmon's texts are lost. And the versions of the "Hymn" that survive have a complicated history. Marie de France is a different case—with her we have a body of texts, in which she carefully embeds her name to signal her authorship, but we have nothing of her biography that isn't conjecture, and her texts have been subjected to alteration by scribes.

In the prologue of her "Lais," Marie writes,

Ki Deu ad duné esciënce
E de parler bon' eloquence
Ne s'en deit taisir ne celer,
Ainz se deit volunters mustrer.

(He to whom God has given knowledge
And the gift of speaking eloquently
Must not keep silent or conceal the gift
But he must willingly display it.)[37]

There is something almost tragic in these words, because the shadowy Marie had spoken up, did not conceal her gift, but almost everything of her life has been lost. And over time, she receded from view—the best manuscript of her two most famous works dates to around sixty years after she probably died, while other versions have often been altered by scribes with their own agendas. Happily, unlike some of the authors we will encounter in the next chapter, Marie's work has never completely disappeared from view. It was known to later figures, including Chaucer, and subsequently studied by antiquarians and historians. Marie's "gift" then has not been completely obscured.

BL Royal MS 18 D II contains an image of an assembled group of men on horseback in brightly coloured clothing. You may recognise this image and associate it with the pilgrims from *The Canterbury Tales*—Geoffrey Chaucer's most famous work. The late fourteenth-century *Tales* is a collection of stories held together by a framing device: it describes a group of thirty-one pilgrims who meet while travelling to the shrine of Thomas Becket in Canterbury. While at an inn, at the start of the journey, the innkeeper suggests that to pass the time they should each tell two tales, one on the journey there and another on the way home. If you own an edition of the *Tales*, it may have just such an image of pilgrims on its cover. However, the image isn't from a manuscript of *The Canterbury Tales*, but from a manuscript of *The Siege of Thebes* by the fifteenth-century poet John Lydgate (c. 1370–1450), who was a devoted follower of Chaucer. It dates from around fifty years after Chaucer died.[38]

Lydgate's text has a framing device, too. The poet imagines himself meeting Chaucer's pilgrims on the road to Canterbury

and telling his own tale to pass the time on the road. (His tale is about the struggle between the two sons of Oedipus for control of the city of Thebes.)

This portrayal of the Canterbury pilgrims reflects a larger pattern. Today we often view Chaucer through the prism of later ages. He is frequently hailed as the "father of English literature," and many students in the English-speaking world read at least part of his delightful masterpiece as part of today's educational journey. But Chaucer's place at the supposed head of the English literary canon owes much to the generation of poets who came after him, who created what one scholar, Seth Lerer, has termed a kind of "cult," in part as a way to advertise their own claim to his mantle.[39] In positioning themselves as heirs to Chaucer's legacy, they vested themselves with literary power. Successive editors, antiquarians, and collectors did much to cement Chaucer's position as a dearly loved author. And, in a very literal sense, we see him through their eyes, because, it seems, none of Chaucer's surviving manuscripts date from his lifetime.[40] The Chaucer we know, wrote Lerer, is "the product of his fifteenth-century readers and writers."[41]

These facts sit in stark contrast to the surviving documentary records relating to Chaucer's life. We know that he worked for many years in the service of the crown, and we know how much was paid in ransom for his release (£16) when he was taken prisoner in France in 1360; we also know that he was accused of *raptus* (possibly rape) in 1380, and that he was robbed on a highway in Deptford a decade later. And yet, of the nearly five hundred "life-records" that survive relating to Chaucer, "not a single one gives him the title of poet or links him with any kind of poetic activity."[42]

Understanding Chaucer as a poet is made all the more difficult by the fact that several of his works are unfinished and

the manuscripts of his work often present messy versions of incomplete or divergent texts.[43] Of the seventeen surviving manuscripts of *Troilus and Criseyde*—his great exploration of love and loss set during the Trojan War—only two of them name him as the author.[44] Indeed, the word "anonymous," to describe a literary text, only appears in the sixteenth century.[45] Our age cares much more about authorship than Chaucer's age did.

The Canterbury Tales was written towards the end of Chaucer's career and is perhaps his defining achievement. The poem is, however, apparently unfinished. The manuscripts of the *Tales* often differ in the number of tales they contain, and the ordering of the tales also differs. Although the poem survives in ninety-two manuscripts, of varying levels of completeness (some no more than fragments, others complete codices), no manuscript is in Chaucer's own hand.[46] A Google search for "Chaucer" and "manuscript" is likely to bring up the Ellesmere Manuscript held in the Huntington Library in San Marino, California; switch to Google Images, and you get a plethora of folio images in beautiful script. The Ellesmere is handsomely produced—the writing is neat and upright, with elegant flourishes, and the leaves are decorated with fine border illumination. It has twenty-two images of pilgrims in its borders, including an iconic one of Chaucer himself. It would be wonderful to imagine this was a portrait of Chaucer taken from life, and that the author had overseen the production of the manuscript, but this is not the case.[47] Nor does this expensive, star item give a true impression of the manuscripts of the *Tales*—manuscripts which are as diverse, messy, surprising, and delightful as the text of the *Tales* itself.

The scholars John Manly and Edith Rickert embarked on a project in 1924 to examine all the manuscripts of the *Tales* and produce an authoritative edition of the text. (Rickert had earlier translated Marie de France's "Lais."[48]) Hitherto every published edition had used particular manuscripts rather than examining them all. What they probably hoped to find was a definitive manuscript—perhaps not Chaucer's own version, but something closely resembling one. They thought the project would last "several years."[49] In the end, it lasted for sixteen.

Their task was truly daunting. It required them to identify and photograph all the manuscripts, research their provenance, transcribe the texts, and compare each textual variant word for word. The variants were compared on sixty thousand collation cards.[50] Although dealing with large bodies of complex information was something they had experience with, from their time working as code breakers for the American War Department during World War I, the eventual eight-volume work exacted a heavy toll on them both. Rickert died a few months before the first volume was published, and Manly died six months afterwards. (Predictably, Rickert's work was undervalued then and still is today. In the introduction to the edition, Manly praised her for having a "woman's capacity for enormous drudgery." To this day, Manly has an entry in *American National Biography*, a compendium of biographies for over nineteen thousand notable figures from American history, but Rickert does not.)[51]

Manly and Rickert's task was made all the more complicated by the fact that after Chaucer died, he was put to many uses. The scribes who copied his work prodded and poked him, they squished him into moulds and fashioned him in their own image. A small, unglamorous manuscript held in the British Library exemplifies how this process was enacted. BL Harley MS

2382 is a small paper manuscript that was copied by a single unnamed scribe.[52] Paper was, of course, a much cheaper writing material than parchment. The scribe wrote in a cramped, cursive script (meaning the writing is speedily "joined up"), and the manuscript is a plain thing. Its only decoration is the occasional use of red ink (for the underlining of rubrics, running titles, and highlights for the first letters of poetic stanzas). The manuscript contains several texts, which are split up over the codex and crammed into the available space. One text breaks off midway and is followed by a new text before the scribe returned to copying the earlier one. The overall impression is one of economy and slightly haphazard planning.[53] Manly and Rickert suggested that this was "a book which a country parson might have written for himself."[54] Another scholar called it "a labour of love, evolving as the scribe worked on it."[55] Throughout the manuscript, the texts are glossed with heavily abbreviated Latin annotations. The annotations are written in a cramped and scrawled cursive script that is difficult to decipher, which probably means the scribe was producing this gloss either for himself or for a group of readers who were similarly Latinate.

Unlike the Ellesmere Manuscript, a showy parchment manuscript that may have been made for an elite patron, BL Harley MS 2382 appears to have been made by a scribe, probably working in a provincial location, who was making it for himself or for circulation amongst a group of friends or acquaintances. And it is different from the Ellesmere not only in its cost and appearance but also in the version of the text it contains. It is emphatically not a complete copy of the *Tales*, but instead a devotional compilation of religious and moralising material. It contains a number of saints' lives, devotional texts, and miracle stories as well as two other texts, labelled "Fabula monialis de sancta maria" (Fable of the nun of Saint Mary) and "Vita Sancte

Cecilie virginis" (The life of Saint Cecilia the Virgin). These two texts are in fact two of the tales from *The Canterbury Tales*—the ones we know of as the "Prioress's Tale" and the "Second Nun's Tale."[56] What is striking is that nowhere is Chaucer named as the author of these tales, and they have been stripped from their original context in the *Tales* as a whole.[57]

These tales are unlikely to be the ones that people study at school today, in part because they are some of the most overtly religious of the tales. The "Second Nun's Tale" tells the tale of St Cecilia—a virgin martyred for her faith in a boiling bath, which she survives miraculously unharmed before ascending to heaven. (The Second Nun is not one of the pilgrims described in the prologue of *Tales*.) The "Prioress's Tale" is an altogether more disturbing story. It tells of a young Christian boy who lives in a city in Asia that contains both a community of Christians and a community of Jews. The boy grows up to revere the Virgin Mary, and he sings the "Alma Redemptoris Mater" (Nurturing Mother of the Redeemer) every day, although he does not understand the words. But some Jews in the city are incited by the Devil, "that hath in Jues' herte his waspe's nest" (that hath in Jews' heart his wasp's nest), to murder the boy and dump his body on a dunghill.[58] Later, when the boy's body is found, he is still miraculously singing the "Alma Redemptoris." His Jewish murderers are drawn by wild horses and hanged; the boy finally stops singing, but not until he tells a local abbot how Mary had placed a miraculous grain onto his tongue to enable him to sing past death. The abbot removes the grain, and the boy is buried.

The way the scribe has reframed the tales is problematic for modern readers. The scribe clearly admired the stories for their devotional content, as he annotated passages that could be used as prayers. Modern scholars have often pointed to the frame of the *Canterbury Tales* to assert that the narrator of the whole is

not the one relaying this grim account—it is the Prioress who is to blame, and we can understand her to be a provincial person despite her intellectual and courtly pretensions. It seems we are being invited to see this disturbing story as a feature of the Prioress's ridiculous, small-minded view of the world. But the scribe of BL Harley MS 2382 has stripped the tale from its original context, and the sense that the story is *ironic* has been lost. It becomes instead a straightforwardly anti-Semitic text. The scribe has selected a very particular kind of Chaucer for his collection.

Today, the Chaucer whom we value is the writer of secular verse, a writer who is bawdy, witty, and self-referential. The scribe of BL Harley MS 2382 did not care for the Chaucer we would recognise. He wanted a sober, devout moraliser who fully accepted the very medieval tropes of anti-Semitism that we find troubling today. (And indeed, he did not even care to name Chaucer as the author of these poems.) The manuscript shows how scribes were not mere copyists—that many of them, for better or for worse, made important literary decisions.[59] As the scholar Michael Johnson observed, scribes were "interpreters of literary texts and . . . co-participants, along with authors, in the creation of meaning."[60]

Early printed editions of Chaucer's work continued this trend, refashioning the texts to suit the agendas of editors. William Thynne, a courtier and antiquarian, published the first "complete works" of Chaucer in 1532. For his second edition, in 1542, he included, amongst the texts attributed to Chaucer, a work entitled *The Complaint of the Plowman*. This text was written at the end of the fourteenth century by a Lollard author. Lollardy was a movement associated with the religious reformer John Wycliffe, who sought ecclesiastical reform, changes in sacramental practices, and access to the Bible in

the vernacular. Considered heretical at the time, it is some-
times seen as a proto-Protestant movement. And the spurious
tale that Thynne published sought to reframe Chaucer as a re-
formist, which likely satisfied the appetites of readers in post-
Reformation England.

These two examples of Chaucer's work—one printed, the
other in manuscript form—illustrate how he has been refash-
ioned for different audiences across time. Sometimes, reading
Chaucer's work, I sense he might almost have enjoyed how
his texts were altered. And maybe he wouldn't be too worried
about how several of his texts were left unfinished, or how they
came to be lost. His work seems to invite us to not take the
idea of the author too seriously, and he was probably aware that
his texts would be subject to alteration. His famous injunction
to a scribe, Adam, which I quoted at the start of the previous
chapter, is worth revisiting here:

Adam scryveyn, if euer it þee byfalle
Boece or Troylus for to wryten nuwe,
Under þy long lokkes þowe most haue þe scalle,
But affter my makyng þowe wryte more truwe;
So ofte adaye I mot þy werk renuwe,
It to corect and eke to rubbe and scrape,
And al is thorugh þy neglygence and rape.

(Adam scribe, if ever it falls to you
Boethius or Troilus to write anew
Under your long locks you must have the scale
Unless you make my words more true
So many a day I must your work renew,
Correct it and also rub and scrape
And all that is from your necgligence and haste.)[61]

As ever, Chaucer's tone is playful. The poem is also important because it suggests that Chaucer knew his texts were out of his own hands and in the hands of someone else. It should be noted, however, that this little poem only survives in one manuscript from the medieval period, written between twenty-five and fifty years after Chaucer's death. The scribe, named John Shirley, wrote chatty snippets of introduction at the start of the poems he copied to supply information on their authorship and the circumstances of their creation. This poem appears with a rubric that reads, "Chuauciers words a Geffrey vn to Adame his owen scryveyne" (Chaucer's words, he Geoffrey, unto Adam his own scribe).[62] These introductory remarks, or *rubrics*, are often assumed to be trustworthy, but Shirley seems to have copied his manuscripts for commercial purposes, apparently creating a little circulating library of manuscripts. The rubrics might contain only a pinch of truth—and the ascription of the poem to Chaucer might be a marketing strategy, adding to the prestige of Shirley's collection.[63] This much beloved self-characterisation that is supposed to be by Chaucer himself may not, in fact, be genuine. If the work is Chaucer's, then we can say he showed an awareness of how his works could be altered by scribes. And, if it isn't, then the text is emblematic of the problems of attribution and reliability that we encounter reading his work.

In Chaucer's work more generally, however, there is still a playfulness in the way he presents himself; indeed, there is playfulness in how he presents the idea of authorial fame. His extraordinary dream-vision, in the *House of Fame*, exemplifies this. Here, the narrator falls asleep, wakes up in a temple made of glass, and finds a brass tablet depicting the story of Dido and Aeneas. He steps outside the temple, hoping to work out where he is, only to be gathered up in the claws of a giant eagle. This eagle, who has been sent by Jupiter, addresses the narrator as

"Geffrey" and teases him, telling him he is heavy to carry ("thou art noyous [difficult/troublesome] for to carye").[64] He chides him for his habits:

> *For when thy labour doon al ys,*
> *And hast mad alle thy rekenynges,*
> *In stede of reste and newe thynges*
> *Thou goost hom to thy hous anoon,*
> *And, also domb as any stoon,*
> *Thou sittest at another book*
> *Tyl fully daswed ys thy look.*
> *And livest thus as an heremite*
> *Although thyn abstynence is lyte.*

> *(For when thy labour done all is*
> *And hast made all thy reckonings*
> *Instead of rest and new things*
> *Thou goes home to thy house anon*
> *And also dumb as any stone*
> *Thou sittest at another book*
> *Til fully dazed is thy look*
> *And live thus as a hermit*
> *Although thy abstinence is light.)*[65]

The eagle accuses "Geffrey" of liking nothing more than to return home after a long day of "rekenynges" and sit down "domb as any stoon" with yet another book to read until he looks "daswed." ("Alle thy rekenynges" presumably refers to Chaucer's job as comptroller at the Port of London, where he was responsible for the import and export taxes on wool, skins, and leather.) "Geffrey" appears to prefer the company of books to people, living "thus as an heremite," but in another jibe,

at his weight, the eagle remarks that his "abstinence is lite." These moments show Chaucer in a playful, self-mocking mode, blurring the boundaries between the narrator and his authorial persona. And unlike the injunction to Adam, there is no doubt about attribution. His playfulness is apparent throughout the poem, which is a wider reflection on the nature of authorial fame. The eagle takes "Geffrey" to the house of the goddess Fame, and when they arrive, he sees it is built on top of a huge mound of ice. On this ice is engraved the names of famous people, but they are slowly melting away and becoming "unfamous."[66] Literary fame is fleeting.

Time and again, Chaucer asks us to think about what an author is and suggests—perhaps—that we should not take them too seriously. And the scribes who copied his work, as well as the work of Marie de France, sought to reframe and refashion the words they copied, treating these authors with varying degrees of reverence. This contrasts with the scribes who copied Cædmon's "Hymn," who seem to have had a certain reverence for the ephemeral, vernacular text—a reverence not shared by Bede, who only thought it worth recording in a described form.

Today we deify great authors from the past and we are fascinated by their biographies. This modern attitude has complex origins, but we can see the seeds of it in the period immediately after Chaucer's death, when a generation of poets began to talk about him in gilded terms. John Lydgate referred to Chaucer in his *Fall of Princes* as "my maistir Chaucer" (my master Chaucer), and said he was "ded, allas, cheeff poete off Breteyne" (dead, alas, chief poet of Britain). Lydgate exhorts his readers, "Lat us yiue hym laude & glory / And putte his name with poetis in memory" (Let us give him praise & glory / And put his name with poets in memory).[67] In so doing, Lydgate, and others who made similar statements, were strategically situating themselves

within an important literary tradition, figuring themselves as heirs to the now dead master poet. This deification of Chaucer was reflected, however, only in the work of *some* scribes—such as John Shirley, who copied the poem purportedly addressed to the scribe Adam. Other scribes seem to have been indifferent to the cult of the author, such as the one who stripped out the "Prioress's Tale" and the "Second Nun's Tale" for his own devotional anthology, and didn't attribute them to Chaucer.

Chaucer is buried in Westminster Abbey in what is now called "Poet's Corner." It was not called that in 1400, when he was buried there. His body was placed in the abbey not because he was a poet, but because he had been clerk of works for the Palace of Westminster. The antiquarian Nicholas Brigham paid in 1556 for the erection of a splendid tomb into which Chaucer's remains were transferred. The poet Edmund Spenser was buried nearby in 1599, and the tradition of "Poet's Corner" was born. Chaucer's tomb is a monument to him, of course, but it is also a monument to the way later ages have come to valourise "the author."

Today, we have very particular ideas about what an author looks like. We like single, identifiable figures, preferably with lives that we can read into their works. But medieval texts disrupt many of these notions. Many medieval texts have no authors, while others have multiple authors. And when authors are identified, they may have no biography. Perhaps most disruptive of all, the manuscripts that preserve medieval texts are complex, messy things, shaped by the whims, political ideologies, devotional feelings, or commercial interests of scribes.

7

Authors Hidden

The struggle of man against power is the struggle of
memory against forgetting.

MILAN KUNDERA,
THE BOOK OF LAUGHTER AND FORGETTING

Aldhelm, abbot of Malmesbury, dedicated a treatise to Ab-
bess Hildelith and her nuns at Barking Abbey in around
the year 705. In the prologue, he remarks on the lively corre-
spondence he had with the Barking community. He describes
the "rich verbal eloquence and the innocent expression of sophis-
tication" in their letters. He imagines the abbess and her nuns
"roaming widely through the flowering fields of scripture" and
"scrutinizing with careful application the hidden mysteries of the
ancient laws."[1] But Aldhelm's words have a tragic note. Only one
side of the correspondence survives: the work of the nuns is lost.

To sift the remains of the past is to be aware of such loss. Were
it not for the discovery of Margery Kempe's *Book* in 1934, we
would have lost a unique text—a work of openness and honesty
relaying the experiences of an ordinary woman from fifteenth-
century Lynn in Norfolk. And as we've seen, manuscripts are sus-
ceptible to many dangers: fire, flood, and unthinking bookworms
(which the Exeter Book describes as *stælgastas*—stealing-guests).
But in some cases, material does not survive for ideological reasons.

Most of history is, after all, a story written by the powerful. Certain voices have been excluded and erased from the literary canon and the historical record. This chapter is about some of those voices nearly silenced and biographies nearly or completely lost.

Much of the discussion in previous chapters has been about single manuscripts. Here, by contrast, we look at sources on female authors that are spread across several codices. Recovering something of their lives is an exercise in uniting fragments (not unlike the burnt fragments of the Cotton Library that fluttered in the breeze on the day after the fire at Ashburnham House). We are reliant on scraps of information—brief references and partial and corrupted textual witnesses. This is a chapter devoted not so much to single, monolithic manuscripts as to the gaps between them, and to the ghosts of those we have lost.

At some point between 776 and 786, an English nun in the Bavarian monastery of Heidenheim hid a secret code in the space between two texts. Transcribed as it appears on the folio, it reads as follows (the lines over the words, which appear in the original, indicate abbreviations):

Secdg quar̄. quīn. npr̄i.spr̄imx quar̄. nter̄
cpr̄i.n quar̄. mter̄. nsecun. hquīn. gsecd
bquīnrc. qar̄r.dinando h secdc. scrter̄.
bsecd. bpr̄im²

With the expansion of the abbreviations, the text reads:

Secundum g quartum. quintum. n primum. s primumx
quartum. n tertium

cprimum. n quartum. mtertium. n secundum. h quintum. g
 secundum
b quintum rc. quartum r. d inando h secundum c. scr
 tertium.
b secundum. b primumm

This code was not deciphered for some 1,200 years, until the scholar Bernard Bischoff untangled it in 1931. Bischoff realised that the code-writer had replaced all the vowels with abbreviations for ordinal numbers. That is, "Sgd" stood for "secundum" (second), meaning the vowel *e*. Once he'd had that insight, the code could be cracked as follows, with the words in bold indicating vowels:

Secundum *g* **quartum.** **quintum.** *n* **primum.***s* **primum***x*
 quartum. *n***tertium**
*c***primum.** *n* **quartum.** *m***tertium.** *n***secundum.** *h***quintum.**
 *g***secundum**
*b***quintum***rc.* **quartum***r.d***inando** *h* **secundum***c.* *scr***tertium.**
*b***secundum.** *b***primum***m*

Which gives you: **Ego una saxonica nomine Hugeburc** ordinando hec scribebam. This translates as, "I, a saxon nun named Hugeburc, composed this."[3] This Hugeburc was the author of both texts—accounts of the lives of Saints Wynnebald and Willibald—but had left her authorship anonymous, describing herself at the start of one as no more than an "indigna Saxonica" (unworthy Saxon woman). We know that Hugeburc was a missionary who travelled from England to Germany to assist Bishop Boniface in his proselytising work in the region. The survival of her work is startling—an early copy of the text from about 800 is held in Munich (Bayerische Staatsbibliothek, MS

Clm 1086).[4] I like to think she stitched this code into the space between the texts because she had some inkling of the way authors' names were often lost in manuscript transmission. When manuscripts were copied and recopied, there was no guarantee that an author's name would survive the process, especially if that name was a female name. As the scholar Diane Watt observed, "Medieval texts most often circulated anonymously, or were ascribed or re-ascribed (regardless of who actually wrote them) to renowned figures from the past, who were almost invariably male. No matter how powerful they were in religious or political terms, medieval women were perceived by others—and perceived by themselves—as lacking the authority to be described as authors."[5]

The word "author" is a cousin of the word "authority," and in the Middle Ages, authors were called *auctores*. An *auctor* was thought to have *auctoritas* (authority). As the scholar Alistair Minnis noted, "In a literary context, the term *auctor* denoted someone who was at once a writer and an authority, someone not merely to be read but also to be respected and believed."[6] Watt's point is that women were often deemed not to have the *auctoritas* that would make their texts worthy of preservation. It was only by embedding a clue to her identity in a cipher between two of her texts that Hugeburc's name survives. But precious little else is known of her "except the sketchy information to be gleaned from her writings."[7]

Still, Hugeburc's texts are something of an exception. A number of anonymous works survive from the medieval period that are clearly female-voiced, and it's possible that some of them were written by women. But their names have been erased, either by accident or design. The Exeter Book, a tenth-century manuscript collection of poems in Old English, contains two female-voiced elegies (with feminine grammatical endings indi-

cating that the speaker is female). These texts have no titles in the manuscript but came to be called "Wulf and Eadwacer" and "The Wife's Lament" by editors.[8] They are complex works that invite multiple interpretations. The poems appear in the manuscript alongside a section of riddles in a placement that may be intentional: the female-voiced elegies are tiny, emotional riddles describing the pain of loss, and both poems describe their narrators being separated from loved ones. Yet who these loved ones were and why they were separated has elicited much scholarly debate, in part because both poems use polysemous language (in the opening line of "Wulf and Eadwacer," for example, we find the Old English word *lac*, which can mean "battle," "sacrifice," or "gift," and each translation lends a different meaning to the line). "The Wife's Lament" appears to describe a woman who is separated from a lover or husband. The lover had earlier set out over the "tossing waves," and after his departure she was made an outcast by her beloved's kin. She was forced to live under an oak tree in an *eorðscræfe* (earth-cave) amid dark valleys tangled with briars, where she meditates on loss.

In "Wulf and Eadwacer," the speaker is separated from "Wulf," whom she addresses as "Wulf min Wulf" (Wulf, my Wulf). The identity of this Wulf remains unclear, though we are told that he goes on long journeys, and that the rareness of his visits has made the speaker ill. The speaker is on an island and guarded by "bloodthirsty men." In the final lines of the poem she asks, "Gehyrest þu, Eadwacer?" (Do you hear me, Eadwacer?). *Eadwacer* means "property-watcher," and it could be a name, or perhaps a nickname. Is this the woman's husband, who is set up in opposition to the lover, Wulf? Or is it the same person as Wulf, who could be her husband? Or is Wulf her child? The poem ends, enigmatically, "þæt mon eaþe tosliteð þætte næfre gesomnad wæs, / uncer giedd geador"

(That may be easily separated which was never bound, / the song of us both together).

Can we say these texts were authored by women? It's impossible to say so conclusively. And we have to be wary that the definition of "author" in this context is a slippery one. These vernacular texts likely circulated orally for some time before they were copied down, perhaps centuries later, in a very different cultural context—likely by monastic scribes. Authorship in the premodern period was often collaborative, and scribes and revisers altered texts over time.

The female-voiced elegies of the Exeter Book encapsulate many of the difficulties inherent in searching for women's writing and female authors in the premodern period. We can make educated guesses on the authorship of texts, but often we lack definitive proof. The nature of authorship itself is complicated. These problems also beset a group of texts produced in the West Midlands region of England in the thirteenth century.

Mi druð, mi derling, mi drihtin, mi healend, mi huniter, mi hali- wei, swetter is munegunge of þe þen mildeu o muðe.

(My dear, my darling, my lord, my savior, my honey-drop, my balm, sweeter is the memory of you than honey in the mouth.)[9]

These are the opening lines of a meditation appearing uniquely in a British Library manuscript. The narrator here is a woman; a later line reads, "Yif that I wile ani mon for feirnesse luve, luve I wile the, mi leve lif" (If I will love any man for beauty, I will love you, my dear life).[10] And although the prayer

is anonymous, it's not unreasonable to assume it was written by a woman. It is a work of passionate love and longing, describing Jesus as "mi lives luve, min herte-swetnesse" (my life's love, my heart's sweetness).[11] The speaker compares Christ to different kinds of worldly men—men famed for their nobility, virtue, largess, wit, power, honour, or beauty. Each worldly virtue is itemised, and each time the speaker concludes that such men are no match for Christ, with the refrain, "A, Jesu, swete Jesu, leove that te luve of the beo al mi liking" (Ah, Jesus, sweet Jesus, grant that love of you be all my pleasure).[12]

These are words of romantic love: "A, swete Jesu, thu oppnes me thin herte for to cnawe witerliche and in to reden trewe luve-lettres, for ther I mai openlich seo hu muchel thu me lu-vedes" (Ah! sweet Jesus, you open your heart to me, so that I may know it inwardly, and read inside it true love-letters; for there I may see openly how much you loved me).[13] The language throughout is quasi-sexual: "Hwen thu for me swa rewli-che hengedes on rode, ne hafdes in al this world hwerwith that blisfule blodi bodi thu mihtes hule and huide" (You so pitifully hung for me on the cross, in all this world you had nothing with which to cover and hide that blessed bloody body).[14] The focus on the physical body of Christ is striking. Contemplating Christ on the cross, the speaker says, "A, that luvelike bodi that henges swa rewli, swa bodi, and swa kalde" (Ah! that lovely body, that hangs so pitifully, so bloody and so cold).[15] The text is written in a sing-song alliterative style. Some of the best alliteration comes in pairs and triplets, such as "blisfule blodi bodi" and "hule and huide."

At the end of the text, the speaker says, "Broht tu haves me fra the world to bur of thi burthe, steked me i chaumbre" (You have brought me from the world to the bower of your birth, locked me in a chamber).[16] And, a little later: "Mi bodi

henge with thi bodi neiled o rode, sperred querfaste withinne fowr wahes, and henge I wile with the and neaver mare of mi rode cume til that I deie" (My body will hang with your body, nailed on the cross, fastened, transfixed within four walls. And I will hang with you and nevermore come from my cross until I die).[17] This reference to being locked in a chamber—figured as a cross—is one of several indications that the speaker of the text is an anchoress. An anchoress ("anchorite" is the male form) was a person who permanently enclosed herself into a cell to live a life of prayer and contemplation. The word comes from the Greek, ἀναχωρεῖν (anachorein), meaning "to retire or retreat." In the Middle Ages in England, as elsewhere in Europe, the practice was relatively widespread—there were around one hundred recluses across the country in the twelfth century, and by the thirteenth there were around two hundred. Strikingly, women outnumbered men in this vocation—there were around three times as many female recluses as male recluses in the thirteenth century and twice as many in the fourteenth and fifteenth centuries.[18] Anchoritism emerged in the late eleventh century in tandem with a monastic reform movement and a growth in spiritual enthusiasm that has been dubbed the "Medieval Reformation."

And although the narrator of this meditation, called Þe Wohunge of Our Lauerd (The Wooing of Our Lord), is evidently an anchoress, it is also possible that it was actually authored by an anchoress too. The text appears in a manuscript alongside several texts associated with a group of anchoresses who lived in the West Midlands region of England in the thirteenth century. They are all written in a distinctive style, sharing similarities of dialect, theme, and imagery. The longest is a haunting work known as the Ancrene Wisse (Anchoress's Guide).[19] This anonymous work, likely written by a Dominican friar, is addressed

to three sisters. The author tells them, "You are much talked about, what well-bred women you are, sought after by many for your goodness and your generosity, and sisters from one father and one mother, [who] in the bloom of your youth renounced all the joys of the world and became anchoresses."[20] Here, it is clear that they were genetic sisters, not spiritual ones. But although the text is addressed to three sisters, soon after it was composed it was modified in a later manuscript to address "the anchoresses of England, in such a large group . . . twenty now or more."

Between 1225 and 1250, the text was copied at least five times into manuscripts that were probably produced for anchoresses. Alongside the *Ancrene Wisse*, the scribes also added other texts suitable for the edification and instruction of an anchoritic audience. These texts—appearing in different combinations across a key group of manuscripts—included female saints' lives, a text on the value of virginity, and a series of meditations. One of the meditations was *Þe Wohunge of Our Lauerd*. We know nothing of the group of anchoresses associated with these texts. We have no names or biographies or knowledge of when—exactly—they lived and died. Even the three sisters to whom the *Ancrene Wisse* was first addressed are anonymous, despite the fact that the text was popular. (It survives in nine manuscripts.) But we can get a sense of their lives and the life of the possible author of the *Wohunge* from the extensive body of advisory literature produced for anchoresses throughout the medieval period in England.

Life as an anchoress began with a death. The liturgy of the enclosure ritual is theatrically macabre. In places it is indistinguishable from a funeral service; once enclosed a recluse was dead to the world. When the moment for the enclosure arrived, the *recludendus* (would-be recluse) would process with

the celebrant, choir, and others out of the church and into the graveyard as the choir sang "In paradisum deducant te angeli" (May angels lead you to paradise)—usually sung when a body was conveyed to a grave. The procession would travel to the cell, which was built onto the side of the church—usually, in England, on the north side, where the wind was most biting and the least sun shone. Some *ordines* (liturgical directions) state that the *recludendus* should pause at the opening of the cell while the bishop said, "Si vult intrare, intret" (If he/she wishes to go, then allow him/her to go in).[21] An antiphon drawn from the Book of Tobias was sung. It concluded with, "Be of good courage, thy desire from God is at hand." Upon entering, the *recludendus* would climb inside a grave dug inside the cell. Lying there, the new anchoress would be sprinkled with earth—ashes to ashes, dust to dust—as the antiphon "De terra plasmasti me" (You have created me from earth) was sung. The door of the cell would then be bolted. Once inside, she was to be enclosed for the rest of her life. A thirteenth-century record for a church in Frodsham, in Cheshire, shows that an anchoress named Wymark was enclosed there for around fifty years.[22]

It was not only during the moment of enclosure that anchoresses were invited to meditate on their death to the world. The *Ancrene Wisse* instructs that this grave should be daily enlarged, that recluses should use their bare hands to "scrape up the earth every day from the grave in which they will rot."[23] The text also prescribes the daily recitation of two psalms from the Office of the Dead, noting elsewhere that there is no difference between "a smiret ancre" (anointed anchoress) and an "ancre biburiet" (buried anchoress), because "Hwet is ancre-hus bute hire burinesse?" (What is an anchorhold but her grave?).[24] It was not uncommon for anchoresses to be buried in their cells after they died. At St Anne's in Lewes, an anchoress was buried in a grave

positioned in the exact place where she would have knelt at her *squint*—a window that faced into the church sanctuary—in order to see the high altar, meaning, as the scholar Roberta Gilchrist put it, "she would have had to kneel daily in her own grave."[25]

A would-be anchoress would have had to apply to her local bishop in order to be enclosed. Her application had to demonstrate that she was of good character, that she was suited to the contemplative life, and that she was of independent financial means or had a patron or patrons. Recent scholarly work on anchoritic patronage has shown that anchorites and anchoresses were supported by people from almost every level of society.[26] And this patronage could take various forms. Wills and household accounts reveal that often it was money that was bequeathed that supported the recluse. In other cases, gifts of bread or books were given. One William Fylham, canon of Exeter Cathedral, left twenty shillings and "three canonical loaves" per week in 1435 to an anchorite at the church of St Leonard.[27] A decade earlier, Thomas Dunham, rector of Little Torrington, left a book of Sunday sermons to an anchoress in Exeter named Alice.[28]

Anchoresses were required to remain continuously in their cells, which, on average, measured only twelve square feet. The cells typically had three windows. Besides the squint, there would be another window that looked onto either the graveyard or a street, and a third that connected to a servants' parlour. Recluses were tended to by a servant, or sometimes two, who brought food and took away waste through the servants' window. Some anchorites and anchoresses had access to walled gardens or adjoining rooms, but most of them remained inside a single room. When not in use, their windows were covered by a thick black curtain. They were encouraged to fast frequently and to maintain silence as much as possible, resorting to sign

language if necessary. Even sleep was seen as an unnecessary luxury.

The thirteenth-century *Walter's Rule* says that recluses should vary where they slept in their cells—sometimes they should sleep standing up, other times on the floor. They were advised to sleep on nothing softer than a rush mat and to use an arm in lieu of a pillow. This was a life of sensory deprivation, with limited conversation, laughter, or touch, and even limited light and air. The squint became a conduit of sensation. If their other windows were covered by curtains, the light from candles on the altar, glimpsed through the squint, might at times be the only source of illumination inside the cell. Through the squint, they might hear the sounds of the sung liturgy, smell incense, and, importantly, receive the Eucharist. I imagine they got used to their own smell. *Walter's Rule* says that recluses should shake out their clothes "when required," but says nothing of washing.

Anchoresses' contact with the outside world was limited. They might receive visitors at their windows, and it seems their counsel was often sought, but several texts exhibit concern for what such visits might entail. The thirteenth-century *Dublin Rule* recommends that before speaking to visitors, recluses should cross themselves upon their mouths, and they must not look too long upon the faces of visitors, lest they be tempted to some kind of sin by the encounter.[29] Walter Hilton's *Scale of Perfection*, which was addressed to an anchoress, advises her to receive visitors with grace and humility, offering them words of comfort. But should their talk turn to idle chatter, she should "give little answer," and if the visitor was a man of the church, she must only ask questions and never instruct him, for "it is not your place to teach a priest."[30]

The *Ancrene Wisse* prescribes a life of privation predicated on the idea that the recluses were inherently sinful creatures.

They were forbidden to touch anyone from the moment of their enclosure. It stipulates a virginity so totalising that even the intrusion of a hand into the anchoritic cell was considered a sinful penetration. The anchoresses' bodies became one with the cell, and being one with the cell, became organs of the church that could be controlled and contained. Their lives were regulated by bizarre restrictions: they were not allowed to cross their legs, affect a lisp, arch their eyebrows with moistened fingers, do certain kinds of embroidery, own gloves, wear pleated garments, or write without the permission of the confessor. They also had to seek permission to wear a belt made of *irn* (iron), *here* (hair), or *ilespiles felles* (hedgehog skins). The text says that the anchoress should "ne beate hire þer-wið, ne wið scurge il-eadet, wið holin ne wið breres, ne biblodgi hire-seolf . . . ne binetli hire, ne ne beate biuoren, ne na keoruunge ne keorue" (not beat herself with them [meaning the aforesaid belts], nor with a scourge weighted with lead, with holly, or with brambles, or draw blood . . . nor should she sting herself anywhere with nettles, or scourge the front of her body, or mutilate herself with cuts).[31] These self-inflicted tortures were apparently like treats to be rationed, and permissible only with authorisation. Bodily mortification was seen as a form of *imitatio Christi*—a way to experience Christ's suffering and thereby commune with him. Indeed, anchoresses were thought to be mystically married to Christ.

———————

Knowing what we know about the realities of the enclosed way of life, reading the *Wohunge* and the other texts associated with it pulls us in different directions. The texts are beautiful—richly allegorical works full of sonorous language and rhetorical

flourish. They were "written with unexpected skill and elegance" at a time when great works of literature were generally in Anglo-Norman (the language of the educated elite in post-Conquest England) rather than English—though their style is redolent of the rhythms and patterns of Old English literature.[32] Reading them, we feel a thrill at their artistry, but awareness of the lives of their intended audience can crush the delight we take in the texts. The *Ancrene Wisse*, like the *Wohunge*, is a sensuous reading experience. It is written in a rhythmic, alliterative language. As with the *Wohunge*, some of its best alliteration comes in pairs, such as "swete ant swote" or "woh of word" in these lines:

> *Mine leoue sustren, alswa as ӡe witeð wel ower wittes utewið,*
> *alswa ouer alle þing lokið þet ӡe beon inwið softe ant milde ant*
> *eadmode, swete ant swote iheortet, ant þolemode aӡein woh of word.*

(My dear sisters, just as you guard your senses well outwardly, see to it above all that you are kind inwardly, even-tempered and modest, gentle and good-hearted, and patient with offensive remarks that are made to you.)[33]

The imagery is rich, allegorical, and unforgettable. The rhythmic language delights the ear and contorts the tongue when read aloud. In other words, it glorifies in its own aesthetic, revels in its sound and sense. In one passage, the author, always alive to sonic play, riffs on the dual meaning of the Middle English word *ancre*, which means "anchoress/anchorite" and also "anchor":

> *For-þi is ancre "ancre" icleopet, ant under chirche iancret as ancre*
> *under schipes bord forte halden þet schip, þet uþen ant stormes hit*

*ne ouerwarpen. Alswa al Hali Chirche (þet is schip icleopet) schal
ancrin o þe ancre, þet heo hit swa halde þet te deofles puffes, þet beoð
temptatiuns, ne hit ouerwarpen.*

(The anchoress is called an "anchor," and anchored under the
church like an anchor under the side of a ship to hold the ship,
so that waves and storms do not capsize it. Just so, all Holy
Church [which is described as a ship] should anchor on the
anchoress, for her to hold it so that the devil's blasts, which
are temptations, do not blow it over.)[34]

This is a rhetorical pirouette—playing not only on the differ-
ent meanings of the word "ancre," but also on use of the word
"chirch" as both a physical building and the global church. It
moves from particular, local detail (an anchor, a building) to
the cosmic battle between good and evil. The language makes
the tongue take several trips: the *cr-*, *cl-*, *ch-*, and *sh-* sounds
half-echoing each other while the repetition of "ouerwarpen"
loops the sentences together.

The use of metaphor here is typical of the text as a whole.
The author is fond of animal and bird metaphors, in particular,
describing the angry anchoress as a pelican that kills its own
chicks (figured as good works), and with a beak of sharp an-
ger.[35] In the fourth part, he warns against the lion of pride, the
serpent of envy, the bear of sloth, the rhinoceros of wrath, the
sow of gluttony, and the scorpion of lechery. Each beast has
offspring that are varieties of these sins. The sow's piglets have
names like "To Frechliche" (Too Greedily) and "To Ofte" (Too
Often).[36] You can't forget the snouting, scuttling, slithering,
and slouching creatures of this sermon.

The *Wisse*'s tone is also unsettling to modern ears. Read one
way, it is veined with hatred of women. But it is also a work

suffused with love: "Godd hit wat as me were muche deale leouere þet Ich isehe ow alle þreo, mine leoue sustren, wummen me leouest, hongin on a gibet forte wiðbuhe sunne" (God knows I would rather see all three of you, my dear sisters, women dearest to me, hanging from a gibbet in order to avoid sin).[37] These words are intimate, affectionate, but the image of three sisters hanging from a gallows sticks in the mind.

It takes a tremendous intellectual leap to understand these texts. It is difficult for twenty-first-century readers to inhabit the thought-world of the anchoress. But for those women, enclosing themselves was an act of love. And the *Wohunge* is plainly a work of love: "A, Jesu, swete Jesu, leve that te luve of the beo al mi liking" (Ah, Jesus, sweet Jesus, grant that love of you be all my pleasure).[38] The *Ancrene Wisse* is filled with the imagery of love as well. There is a famous passage about a lady who lives in a castle beset by enemies. A powerful king comes to her aid, giving her protection and showering her with gifts. And yet she treats him with contempt. He is "of alle men feherest to bihalden" (the handsomest of all men in appearance), speaks tenderly to her, and offers to make her his queen.[39] But she continues to treat him with contempt. He tells her she is in mortal danger, that she will be captured and put to a shameful death, and vows that he will die to protect her. He does, in an act of great sacrifice. It could be the plot of a romantic novel, except that the king is a metaphor for Christ.

We cannot be sure if the *Wohunge* was written by an anchoress. The idea first emerged in the nineteenth century and was given currency in 1958, when the scholar W. Meredith Thompson agreed with an earlier scholar that the text had a "preponderance of enthusiasm and fantasy over thought," which he felt indicated that its author was female.[40] Some more recent scholars have argued that the work wasn't actually written

by an anchoress, claiming that anchoresses were required to practise a "strenuous passivity" that would have precluded them from writing.[41] This dilemma is hard to assess. In their cells, anchoresses followed a regime of prayer. When not praying, guidance literature advised that they occupy themselves with reading, writing, or engaging in other kinds of activities suitable to the enclosed life, such as mending church vestments or making cloth. The fifteenth-century *Speculum Inclusorum* (*Mirror for Recluses*) instructs that the moment a recluse's "taste for prayer or delight in meditation decreases" she should "immediately" read or perform some kind of manual work.[42] If she was unable to read Latin, she was to read in English, French, or her vernacular language. But one manuscript of this work, specifically addressed to a female audience, advises recluses to engage in the "writyng of holy and edificatif thynges of deuocyoun" (writing of holy and edifying things of devotion).[43] The *Speculum* is from around two centuries after the *Wohunge*, but it does not seem unreasonable to imagine that writing works of devotion could have formed a part of the anchoress's regime of prayer and contemplative activity.

Reading the *Ancrene Wisse* and the *Wohunge* side by side raises other complex questions. The *Ancrene Wisse* is a didactic work, written by a male author, which prescribes a life of extreme privation for its female addressees. The author of the original work no doubt thought he was offering kindly instruction to the three sisters ensuring their eternal salvation. The *Wohunge* is likely a female-authored work—a work of passionate love and longing that suggests a wholehearted desire to be enclosed in the confines of a dark cell. Or, more troublingly, might the *Wohunge* be the work of a man, imposing a vision of the cell as the "bower of Christ" on its addressee? I confess I want it to be the former, I want the work to be authored by an anchoress. So

little survives of the women associated with these texts. Even the names of the original three sisters to whom the *Ancrene Wisse* is addressed are not recorded. All we have of these women are the texts composed to regulate their lives.

If the text was written by an anchoress, we are able to glean a few details about the kind of person she might have been. The addressees of the *Ancrene Wisse*—the original three sisters—appear to have been from a well-to-do gentry family. Some recluses may have been of humble origin, and there are accounts of aristocratic women being enclosed, but many seem to have been from the burgess and gentry classes. The three sisters would have had a male patron. The text says they had "no worries about food or clothing, either for [themselves] or for [their] maids." They had "from one friend all that [they] need[ed]," who would hand out provisions to their maids "at his hall."[44] I've wondered if their patron was their father, brother, or another family member, but I suspect they left their family— such as it was—behind. Perhaps they had no immediate family left. There are several accounts of women becoming enclosed in widowhood.[45] Grief could drive you to seek a living death.

The three sisters may have been enclosed together—there are accounts of anchoresses sharing cells—but that seems un- likely.[46] According to the text, the permission of the confessor had to be sought before they could receive visits from friends or relations. A later version of the text says, "Tendre of cun ne limpeð nawt ancre beonne" (An anchoress ought not to be too attached to her family).[47] With "the door of their cell bolted and the window covered with a black curtain, they lived as if at the gates of heaven."[48]

From my own twenty-first-century perspective I struggle to understand the author of the *Wohunge*. What might have made her want to rend her own skin with a lead whip? How could

she desire to get inside her own coffin for decades? Sometimes I think the *Ancrene Wisse*'s three sisters were trapped in an abusive relationship with Christ. But their choices look more reasoned when you consider what their other options were. Becoming an anchoress was a way of avoiding the dangers of childbirth and the misery of a forced marriage. To be an anchoress was to gain a position of authority and social standing. Margery Kempe, the most boisterous of the late medieval English mystics, described how she sought the counsel of the anchoress Julian of Norwich, spending "many days" with her—which likely means she visited Julian at the window of her cell over several days. (What Julian felt about this is unrecorded.)[49] In an all-male church, Julian's position was unusual. It is no small irony that one of the few ways women could achieve autonomy and social standing in this period was by imprisoning themselves.

————————

There is only one text from medieval England that we are sure was written by an anchoress—Julian of Norwich's *Revelations*. On May 8, 1373, Julian lay in bed, believing that she was shortly going to die.[50] She had been ill for six nights. On the fourth night her condition had worsened and she had received last rites, but somehow she had "lingered on" for another three days. On the morning of the seventh day, dead to sensation from the waist down, she felt a desire to sit up in bed so as "to have the mare fredome of my herte to be atte Goddes wille" (to give my heart more freedom to be at God's disposition).[51] Those who were gathered around her bed sent for the priest, who came with his assistant. When he arrived, she was no longer able to speak and her eyes were fixed in a stare. To offer her comfort, the curate—the priest's assistant—held a crucifix out in front of

her. At this point her sight failed her and the room grew dim. It seemed to her that night had fallen, but the cross in front of her appeared illuminated. Everything around it, in fact, was hallucinogenic terror—the room was full of fiends. She felt the upper part of her body begin to die. Her hands fell down at her side, and her head lolled to one side, her neck no longer able to support it. And then, suddenly, all pain left her. At this moment, Julian experienced a series of fifteen extraordinary visions of God. Thereafter she recovered from her illness and lived for about another forty years.

Soon after this terrifying experience, Julian composed a text describing the visions. The first work in English that we can be sure was authored by a woman, it is known as the "Short Text" of her *Revelations of Divine Love*.[52] Over the next twenty years, Julian meditated on the meaning of her experiences and produced a longer version. In the expanded account, "she *'reads'* her memories of these showings [as she termed the visions] over and over again, as if they formed a treasured book," in the words of the scholar A. C. Spearing.[53] The "Long Text" represents Julian's transition from visionary to learned theologian.

At some point after the events of 1373, Julian decided to become enclosed as an anchoress at St Julian's Church in Norwich. Little can be gleaned of her life before this point. Some have suggested she may have been a nun beforehand, but in her description of the deathbed terrors, she wrote, "My modere that stode emangys othere and behelde me, lyftyd uppe hir hande before me face to lokke myn eyen, for sche wenyd I had bene dede or els I hadde dyede" (My mother who was standing with the others watching me, lifted her hand up to my face to close my eyes for she thought I was already dead or else I had that moment died).[54] This suggests that she was not at that point part of a monastic order; she was surrounded

by people, including her mother. One compelling suggestion is that she composed the "Short Text" as part of her application for enclosure.[55] Whether or not that theory is correct, the application was approved. Bequests made to her show that she was an anchoress for at least twenty years, and perhaps longer.[56] The exact date of her death is unknown.

Julian's text (in its two versions) is important not simply because it is the first text in English definitively authored by a woman, but also because she was a writer of exceptional quality. Her prose is characterised by its elegant rhetorical structure, but in spite of this it never feels scholarly or obtuse: instead, it is a work of clarity and empathy. Many of her metaphors are domestic, and they seem familiar despite the gap of centuries between her age and ours. Even when describing divine revelations, she uses an accessible register. In a vision of the blood running from Christ's crown of thorns, for example, Julian writes that the droplets were as plentiful as "the dropys of water that fallen of the evys after a great showre of reyne" (the drops of water which fall from the eaves after a great shower of rain). She adds, "For the roundhede, it were like to the scale of heryng in the spreadeing on the forehead" (As for the roundness of the drops, they were like herring scales as they spread on the forehead).[57] Later, when Julian is describing how she saw the devil's face, she says the "color was rede like the tilestone whan it is new brent, with blak spots therin like blak freknes, fouler than the tilestone" (the colour was red like newly fired tiles, with black spots on it like black freckles, fouler than the tiles themselves).[58] In these vivid details we can hear echoes of Julian's experience. In the busy trading and manufacturing city of Norwich where she lived, herring would have formed a staple of the diet. The catch was probably landed at Yarmouth or some other nearby place and brought along the river Wensum to the city. Her cell was nestled

in a "highly industrial location . . . near the busy quays of King Street Conesford," as the scholar Carole Hill noted.[59]

These images are also homely—in the British sense of the word, meaning something domestic and familiar. Indeed, "homely" is a word Julian used often to describe what she saw as the intimate love of God for humankind:

> *In this same time . . . oure Lord shewed to me a ghostly sight of his homely loveing. I saw that he is to us all thing that is good and comfortable to our helpe. He is our clotheing, that for love wrappith us and wyndeth us, halsyth us, and alle beclosyth us, hangeth about us for tender love, that hee may never leave us. And so in this sight I saw that he is al thing that is gode, as to myne understondyng.*

(At the same time . . . our Lord showed to me a spiritual vision of His homely loving. I saw that He is to us everything that is good and comfortable to our help. He is our clothing, that for love wraps us, winds us, embraces us and encloses us, hanging about us for tender love, so that he can never leave us. And so in this sight I saw that he is everything that is good, as I understand it.)[60]

Here the use of the word "homely" indicates a gentle, familiar Divine love. This passage precedes one of the most famous of Julian's images:

> *Also in this he shewed a littil thing, the quantitye of an hesil nutt, lying in the palme of my hand as me semede; and it was as round as a balle. I lokid thereupon with eye of my understondyng and thowte, "What may this be?" And it was generally answered thus, "It is all that is made." I mervellid how it might lesten, for methowte it might suddenly have fallen to nowte for littil. And I was answered*

in my understondyng, "It lesteth and ever shall, for God loveth it;
and so all thing hath the being be the love of God."

(Also in this He showed a little thing the size of a hazelnut in
the palm of my hand, and it was as round as a ball. I looked at
it with my mind's eye and thought, "What can this be?" And
the answer came to me, "It is all that is made." I wondered at
how it could last, for it was so small it might suddenly have
disappeared. And the answer came to me, "It lasts and ever
shall because God loves it; and everything exists in the same
way by God's love.")[61]

Her hazelnut image is justly famous. It conveys simultane-
ously Julian's sense of God's omnipotence and his gracious love
of mankind. The universe is as small as a hazelnut, a thing so
small that "it might suddenly have fallen to nowte." Presenting
the universe as so fragile a thing conveys Julian's feeling for the
omnipotence of her God—that God might hold the universe
in the palm of his hand. In her vision, she fears for this tiny
nut of a thing, but she is reassured that it "lesteth and ever
shall, for God loveth it." The image—domestic and "homely"—
is instantly comprehensible. And the style of her description is
effortless. Julian's writing often has this "fluidity of talk"—it is
sinuous but comprehensible.[62]

In this particular revelation, we see the different modes of
Julian's visions. Sometimes they are sensory or visual (as in the
image of the hazelnut), but sometimes she receives revelations
directly in her mind ("And I was answered in my understond-
yng"). At still other times she receives insights that transcend
the sensory or the verbal—in these moments, Julian will some-
times acknowledge the difficulty of conveying in language the
nature of her experience.[63]

Elsewhere, Julian acknowledges her weaknesses as she sees them. She calls herself a "simple creature that cowde [knew] no letter."[64] The exact meaning of this phrase is unclear. She may have meant that she could not read Latin, or perhaps that she was illiterate, and dictated her work to an amanuensis. But in her text she makes reference to the alphabet: "I have techyng with me, as it were the begynnyng of an ABC," which makes it seem unlikely that she could not read.[65] Beyond that, what the scholar Barry Windeatt called her "detailed and meticulously phrased" revisions to the work make it seem impossible that she could not write.[66]

The task of refining and recomposing this text was evidently Julian's life's work. She may have still been revising it when she died. At its conclusion she writes, "This booke is begunne be Gods gift and his grace, but it is not yet performid, as to my syte" (This book was begun by God's gift and his grace, but it seems to me that it is not yet completed).[67] Although she worked on her text while she was enclosed, she was in no sense intellectually limited by her confinement. Julian's learning is apparent throughout her work, although she never directly cites her source-texts. Her biblical references convey the sense but not the wording of the Scriptures.[68] Her work only contains one direct quotation, but is veined by biblical allusion and imagery and contains many oblique references to other forms of theological writing.[69] This lack of direct citation is intriguing. Did she feel confident enough in the validity of her work that she did not need the intellectual buttressing of citation? Or had she encountered the majority of her source material aurally—through sermons, readings of Scripture from the pulpit, or discussions with spiritual advisers—and thus did not have physical texts from which to cite?[70]

The advisory literature on the enclosed life—such as the *Ancrene Wisse*—gives us a powerful sense of the privations of

anchoritic existence. Yet Julian's "Long Text," which she appears to have worked on after her enclosure, is free of references to the realities of her way of life. At one point she writes, "This place is prison and this life is penance," but she was likely referring to her life on earth rather than the confines of her cell.[71] She probably saw her life as no more than a waystation on the road to heaven. Given the restrictions of the lifestyle she chose, her text is strikingly hopeful, almost radically so. She insists, "In al thing I leve as holy church levith, preachith, and teachith" (In everything I believe what the Holy Church believes, preaches and teaches).[72] Yet her most famous line, "All shall be well and all shall be well and all manner of things shall be well," which encapsulates her generous vision of God's love, appears at odds with some of the church teaching of the era.[73] The description of purgatory in an anonymous text from the same period, which may also have been written by an anchoress (although the attribution is not entirely secure), reads like a low-budget horror film.[74] In this text, provisionally dated to 1422 and entitled *A Revelation of Purgatory*, sinners are boiled in barrels, pierced with hooks, forced to drink poison, and have their lips cut off. If that was purgatory, what was hell like? I wonder what Julian, with her generous view of God, would have made of the text.

Across her two texts, we see Julian refining her theology and altering the way she presents herself. The "Long Text" is very different from the "Short Text" in tone—for example, many of the personal references have been removed. The person of Julian recedes, such that the "shewings"—as she calls them—are foregrounded. The description of her deathbed experience is rewritten, with its domestic, human details stripped out. In the "Short Text" there is a striking passage in which Julian defends her authority to write as a woman:

Botte God forbede that ye schulde saye or take it so that I am a techere, for I meene nought soo, no I mente nevere so. For I am a woman, leued, febille and freylle. . . . Botte for I am a woman, schulde I therfore leve that I schulde nought telle yowe the goodenes of God, syne that I sawe in that same tyme that it is his wille that it be knawen?

(God forbid that you should ever say or take it that I am a teacher, because I do not mean to be, nor did I ever mean to be, for I am a woman—ignorant, weak and frail. . . . But just because I am a woman, must I therefore believe that I should not tell you about the goodness of God, when I saw at the same time both his goodness [and] his will for it to be known?)[75]

In the "Long Text," this passage has been removed, as has any reference to her gender. It is hard to know why she made this change. Did she feel more confident in her authority, perhaps, by dint of having been enclosed? Or perhaps she was aware that writing as a woman made her a more peripheral voice, and, wishing to be read by the widest possible audience, removed references to her gender in order not to alienate readers. Reading the manuscripts of the "Long Text" today, we know Julian's gender, because it is announced in an introductory rubric. But the imprecise nature of manuscript transmission means that when texts were copied, they might lose this kind of extratextual material. Medieval readers could come to a text "blind," knowing nothing of its authorship or title. Without these rubrics it would be possible to read the "Long Text" and not know that the author was a woman.

Not all of Julian's changes were deletions. The main change between the "Short Text" and the "Long Text" is an expansion of Julian's meditations on her visions. But there are episodes in

the "Long Text" that do not appear in the "Short Text." Perhaps the most striking is her image of Christ as a mother. This is an extraordinary identification. She writes, "And our savior is our very moder, in whom we be endlesly borne and never shall come out of him" (And our saviour is our very mother, in whom we are endlessly borne and never shall come out of him). Here Julian figures the womb as a safe space where humankind is held and protected. It is a generous and "homely" vision of Divine love. It also prompts the question of whether Julian had been a mother herself. We cannot know, as so little survives of her biography. All that we know about her is what we can glean from the "Short Text" and a collection of wills and documents attesting to her enclosure. There is a 1394 will that bequeathed money to "Julian anchorite" (Julian the anchoress). There was a further bequest in 1404, and another in 1415. John Plumpton, a Norwich citizen, left forty pence to Julian and twelve pence each to her maid, Sarah, and former maid, Alice.[76] Julian seems to have still been alive in 1416, because in that year Isabel Ufforde, the Countess of Suffolk, left twenty shillings to a "Julian, recluse at Norwich." Julian would have been seventy-three; she had been enclosed for decades. But for these scant references, nothing remains of her life—except her text.

Julian's text, in its two versions, has a complex manuscript history. The "Short Text" survives in a single copy, which is held at the British Library.[77] The text appears in a collection of Middle English devotional material that may have been assembled by a Carthusian scribe, whose mysterious monogram, "I.S.," occurs throughout.[78] It appears to have been copied when Julian was still alive. The rubric at the start describes the text as "a vision" received by "a devoute woman and hir name es Julyan that is recluse ate Norwyche and ʒitt on lyfe" (a devout woman and her name is Julian, she is a recluse in Norwich and is alive).

The rubric dates the manuscript to 1413, and it appears to have been in Carthusian hands during the fifteenth century. There are annotations in it made by James Grenehalgh (b. c. 1465/1470), a Carthusian monk of Sheen.[79] The manuscript passed into the hands of antiquarians in the post-Reformation period.

A complete version of the "Long Text" does not survive in a manuscript dating from the medieval period. Some extracts of it appear in a manuscript held in Westminster Cathedral dated to about 1500, but the earliest full versions of the text were copied at various points between the end of the sixteenth and eighteenth centuries. Five copies appear to have been made by a community of exiled Benedictine nuns in Europe. In 1670 the first edition of Julian's work, based on a manuscript likely copied by the nuns, was produced by the Catholic convert Father Serenus de Cressy.[80] The work was dismissed in some quarters. Edward Stillingfleet, Bishop of Worcester, called it "blasphemous and senseless tittle tattle."[81] Other editions followed in the nineteenth century. But it was only through the work of the scholar Grace Warrack that Julian's text became better known. Warrack's 1901 edition was more accessible than earlier ones—she modernised spellings and punctuation, added paragraphs, and translated obscure words.[82] It is appropriate that the Revelations—such an important work by a female writer—was preserved by devoted female scribes and made accessible in the modern era by a female scholar.

The Ancrene Wisse and the Wohunge articulate a life of severe restriction. But we should not imagine that all the literature produced by female writers from medieval Britain was bound by stricture. The Welsh poet Gwerful Mechain (c. 1460–1502)

wrote in a gloriously unrestricted way. Her surviving work is varied. She wrote the kind of religious verse common to her era—the late fifteenth century—but she also wrote about topics that few, if any, medieval women writers discussed: unambiguous sexual desire, bodily functions, domestic violence. Her work circulated in manuscript form for centuries, but upon being rediscovered in the twentieth century, it was long dismissed as profane and excluded from poetry anthologies and textbooks. It is only recently that it has come to be better known. As with the work of Julian of Norwich or the *Wohunge*, the manuscript evidence is sometimes confusing and the author's voice from the past is hard to reach.

"Every drunken fool of a poet is quick / In his pompous vanity," one of her poems begins, "To sing of the girls of the lands / In fruitless praise all day long."[83] The poem's tone is raucous, dismissing the fatuousness of fellow poets. But as it unfolds, the text reveals itself as a brilliant, unabashed work about the female body. As this poem, "Cywydd y gont"—variously translated as "Ode to the Vagina" or "Poem of the Cunt"—continues, it states that poets too often praise a girl's "hair," "the eyebrows above the eyes," and the "bare breasts, soft and smooth," as well as the "hands." But, the poet complains, they leave other body parts neglected:

> *the middle without praise,*
> *That palace where children are conceived,*
> *The snug vagina, clear hope,*
> *Tender and lovely, open circle strong and bright*
> *The place I love, delicate and healthy* [84]

Mechain goes on to compare the vagina to a page of musical notation with red staves, a "Dabl y gerdd â'i dwbl o goch"

(Table of song with its double in red). The association is clear, as musical notation of this kind would have appeared in service books used in church. The image is irreverent—conjoining the sacred and the profane—but Mechain's use of the metaphor is strategic. In the next line she takes aim at the hypocrisy of the contemporary church, noting that "bright saintly men of the church / Don't abstain . . . to give it a good feel." Despite directing a jibe at "men of the church," she closes the poem with an invocation to God: "Berth addwyn, Duw'n borth iddo" (Noble bush, may god save it).

"Cywydd y gont" is Gwerful Mechain's most famous poem, and the evidence of surviving manuscripts suggests that it was also one of her most popular—it survives in thirteen copies.[85] Perhaps part of its shocking, witty, joyous appeal was the way it took a familiar form and refashioned it. The poem is likely a response to Dafydd ap Gwilym's famous "Cywydd y Gal" (Ode to the penis). Scholars have noted that "Ode to the Vagina" is "a challenge both to the established literary tradition and to accepted social mores."[86] It's unusual to find medieval British literature discussing female sexuality so unashamedly; it's even more unusual to find such a work written by a woman. When female writers of the period do deal with sexuality or sexual desire, it is almost always sublimated into a desire for Christ, as in the *Wohunge*.

Mechain is the only female medieval Welsh poet from whom a substantial body of work is known to have survived. We know precious little about her biography. She appears to have lived in Mechain in Powys, in northeastern Wales, close to the border with England. She was the daughter of Hywel Fychan and apparently had brothers and sisters. She married John ap Llywelyn Fychan and had at least one daughter, Mawd.[87]

Although "Ode to the Vagina" is now her most famous poem, it does not characterise her oeuvre, which, as the scholar Ceridwen Lloyd-Morgan pointed out, "varies from light-hearted to *angst*-ridden, from biting satire and anger to gentle fun-poking, from the passionate to the devotional."[88] To modern readers it may seem strange that a poet who wrote so unabashedly about her sexual organs could also be a poet of devotion and admonition. And this is perhaps all the more surprising given the medieval church's anxiety about human sexuality, as exemplified by the *Ancrene Wisse*. But the fact that Mechain was a laywoman may have given her more freedom to express herself than a woman who had taken religious vows would have had. Although the details of her biography are scant, it is clear she was part of a lively coterie of poets who exchanged verse, and that their verse was often combative, could be profane, and was sometimes ideological. She was not an isolated figure creating verse for herself—like, say, Emily Dickinson—but an active participant in a dynamic milieu. She was part of a wider network of poets whose inner circle was clustered around the male Welsh poet Dafydd Llwyd of Mathafarn (c. 1395–1486), who was best known for his works concerning Welsh prophetic lore but also wrote poems both religious and profane. Through her husband, John ap Llywelyn Fychan, Mechain was related to the poet Llywelyn ab y Moel (d. 1440), who became an outlaw for fighting against English rule.[89]

Welsh poetry has a fiendishly complicated metrical system. It conforms to the conventions of *cynghanedd* (which literally means "harmony") and "strict-metre." *Cynghanedd*, in the words of M. Wynn Thomas, is "a stunning edifice of aural architecture." It uses a combination of rhyme and stress in particular patterns, and there are twenty-four different forms of metre in the tradition.[90] Understanding *cynghanedd* is almost impossible for a non-Welsh

speaker. But it is enough to understand that the system is highly complex, and that Mechain's work was a high-wire act with language. It was said to take nine years of training just to master the art.[91] In *cynghanedd*, each verse line is broken down into two half lines (much like Old English poetry). But, as the modern Welsh poet Gwyneth Lewis explained, the "Welsh tradition makes this patterning even more complex by insisting that the sequence of consonants in one half of the line follows the order in the other."[92] Unlike Old English poetry, which has no end rhyme, Welsh poets had to find both internal rhymes and end rhymes. The mind-boggling complexity of the genre has its advantages, especially for oral performance: *cynghanedd*, as Lewis said, "is an excellent mnemonic device." As she noted, "If you can't remember the second half of a given line, all you have to do is fit in the words needed according to the pattern in the first half."[93]

Strict-metre verse was patronised by and performed for Welsh nobles and gentry in the medieval period. It was part of a professionalised bardic tradition from which women and low-born men were excluded.[94] Mechain and other poets left out of such occasions would have had to learn their craft by hearing strict-metre poetry declaimed by poets in formal and informal settings at home. She and other female poets, in particular, may have learned the craft from their fathers, husbands, or other male relatives.[95] Some of Mechain's most famous works, including "Ode to the Vagina," appear to have been composed in response to works by male poets. Works like this are "in the tradition of adversarial poetry—*canu ymryson*—where one poet challenges the other."[96] Another of Mechain's works, "I wragedd eiddigus" (To jealous wives) is, like "Ode to the Vagina," a refashioning of a familiar form. It accuses wives of being "too jealous," of being women who would rather

give away the houses and land
And mind you, even her own good cunt,
Than give away her [husband's] penis.[97]

As Mechain dryly noted, "Byd caled yw bod celyn / Yn llwyr yn dwyn synnwyr dyn" (It's a hard world when a penis / Leaves a woman bereft of her senses). The poem is "a response to a male-dominated poetic tradition" where male poets attack "the jealous husband for guarding his nubile young wife so closely that young men cannot have a share of her."[98] I read the poem as heavily ironic and feminist in its outlook: the wives' "ownership" of their husbands' sexual organs is satirical. Mechain is drawing attention to the way *women's* bodies are most often controlled by men in a patriarchal society. The poem ends with the following disclaimer: "Ni chenais fy nychanon . . . I neb . . . a fyn gal fwy no'i gilydd" (I did not sing my satire . . . to anyone . . . who wants a bigger than average cock.)[99] The poem is clearly addressed to women, so the disclaimer is a witty jibe at any males in the audience.

Mechain's adversarial poetry is not always comic. In "I ateb Ieuan Dyfi am gywydd Anni Goch" (A response to Ieuan Dyfi's poem on Red Annie), she takes the Welsh poet Ieuan Dyfi to task for his misogynistic description of his lover Annie Goch.[100] Ieuan Dyfi's text is a "highly conventional and a deeply personal complaint against women," wrote Katie Gramich, who translated Mechain's work into modern English.[101] It is in the tradition of a whole subgenre of *querelle des femmes* (complaints against women) that present a sequence of examples intended to show that women are dishonest.[102] (Several writers wrote rebuttals to this popular form; these include Christine de Pizan's *Book of the City of Ladies* and Geoffrey Chaucer's *Legend of Good Women*.)

Mechain's response combines the personal with the historical. She catalogues worthy women from history, scripture, and mythology, including the legendary queen Gwendolen, who raised an army against her husband after he spurned her in favour of his mistress, and Dido, whom Mechain calls "graceful and good."[103] Strikingly, all the women are chosen for their achievements in a "non-domestic context, not for motherhood or for conventionally feminine, passive virtues."[104] Some of Mechain's examples, however, are women whom society scorned or ignored. She mentions the wife of Pontius Pilate, who was reported to have had a prophetic dream, and attempted to persuade her husband not to have Christ crucified (but, of course, was ignored). Pontius Pilate's wife appears alongside Susanna from the apocryphal portion of the Book of Daniel, who was spied upon by two lecherous judges as she bathed. They attempt to rape her, threatening to accuse her of adultery if she does not acquiesce. She refuses to be blackmailed and is sentenced to death, only to be released after the intervention of the prophet Daniel. Alongside these mythical and biblical stories, Mechain criticises Ieuan directly:

> *Dywed Ifan, 'rwy'n d'ofyn*
> *Yn gywir hardd, ai gwir hyn?*
> *Ni allodd merch, gordderchwr,*
> *Diras ei gwaith, dreisio gŵr.*

> *(Tell me, Ifan, I'm asking you,*
> *Truly and nicely, is this true?*
> *No woman could, fornicator,*
> *Ever rape a man, your doings are wicked.)*[105]

Later she calls on Ieuan to "stop your attacks, adulterer, / Calling a lovely woman a whore." The poem is "particularly poi-

gnant," because records in the Hereford Consistory Court show that Annie alleged Ieuan had raped her.[106] The pair were lovers, but Annie was married, and they were summoned to court more than once for the sin of adultery. Ieuan was punished with six lashes, but Annie pleaded not guilty. Later she was accused of plotting to kill her husband, and she subsequently changed her plea, arguing that her husband had sold her to Ieuan Dyfi.[107]

Many of Mechain's poems are lengthy and make use of the quintessentially bardic device of *dyfalu* (literally, "to compare"), where she layers descriptions on top of one another. But in other places, her work has an elegant economy within a clipped form. Mechain was masterful in her use of the *englyn*—a crisp three- or four-line poem that uses varying and highly complex metrical patterns. One of the more memorable is "I'w gŵr am ei churo" (To her husband for beating her):

Dager drwy goler dy gallon—ar osgo
I asgwrn dy ddwyfron;
Dy lin a dyr, dy law'n don,
A'th gleddau i'th goluddion.

(A dagger through your heart's stone—on a slant
To reach your breast bone;
May your knees break, your hands shrivel
And your sword plunge in your guts to make you snivel.)[108]

Katie Gramich—the poem's translator—has noted the "physical emphasis" of the poem, which discusses the man's "heart, breastbones, hands, knees and guts."[109] We cannot know, of course, whether Mechain was ever a victim of domestic violence. But there's an undeniable force to this work. It conveys the sense of a speaker who has fantasised, in detail, about returning the

violence done to them. In another poem (of somewhat uncertain authorship, but likely by Mechain), the use of the *englyn* has something of the quality of a Japanese haiku—brief and elegant with the sensation of transience. In "Yr eira" (The snow), Mechain uses a four-line *englyn* over two stanzas:

Gwynflawd, daergnawd, du oergnu—mynydd,
Manod wybren oerddu
Eira'n blât oer iawn ei blu
Mwthlan a roed i'm methlu

Eira gwyn ar fryn fry—a'm dallodd,
A'm dillad yn gwlychu;
O, Dduw gwyn, nid oedd genny'
Obaith y down byth i dŷ

(White flour, earthflesh, black mountain—with cold fleece
Cold, black, snow-laden horizon;
A plate of snow, feathers frozen,
A soft snare to trip me all of a sudden.

White snow on a high peak blinded me,
And my clothes were soaked;
I really thought I'd never manage,
Oh dear God, to reach the village.) [110]

Mechain's work appears to have circulated orally both in her lifetime and long after her death. There is evidence that it was still being transmitted in this way as late as the nineteenth century.[111] Crucially, however, very few of her poems appeared in print.[112] Instead, copies were often made from memory, and the

texts were corrupted by the people who copied them.[113] Scholars differ in their thinking about how many poems should be attributed to her.[114] What makes Mechain's verse tricky is that we can't be sure when it made the transition from oral to written text. All the surviving manuscripts of her work date from after her death.[115] Recovering what might have been her original versions is difficult. Authorial attribution is often scattershot and imprecise in manuscript culture, especially in works that were written down after circulating orally, and Mechain's work was sometimes misattributed.[116]

In the centuries after Mechain's death, her work spread, appearing in the personal manuscripts of generations of readers. But in more visible, printed forms, it was long marginalised. She has been "deliberately and consistently excluded from anthologies, scholarly editions and textbooks."[117] Although the reasons are complex, it is clear that from the eighteenth to the twentieth centuries the nonconformist movement in Welsh Christianity—so important to Welsh culture in that period—played a role in her marginalisation. As translator Katie Gramich noted, "in the wake of the notorious 'Blue Books Report' of 1848 (a study of state education in Wales commissioned by the Westminster government, which alleged that the Welsh were poor, ignorant, and unchaste), indignant Welsh people took it upon themselves to display to the world that they were a people of the Book: moral, upright, and industrious."[118]

The legacy of this attitude can be seen in the scholarship on Gwerful Mechain, who was long dismissed as profane and artless. The scholar Leslie Harries edited her verse for his master's thesis in 1933, but omitted her work from his subsequent book, *Gwaith Huw, Cae Llwyd ac Eraill* (The work of Huw of Cae Llwyd and others).[119] Indeed, he wrote that she produced

"pornographic songs" and was "nothing more than a whore."[120] Even comparatively recent scholarship has described Mechain as "salacious" and "technically lax."[121]

———————

In January 2019 I visited one of the few remaining intact anchorholds (anchorite's cells) left in Britain, attached to the church of St Nicholas, Compton, in Surrey. The space was the size of a large cupboard. There wasn't enough room to lie down. As I'd come late on a winter afternoon, the light was seeping away and the cell was dim. The only light came through the squint. This window onto the church sanctuary was cruciform in shape, and through it I could see a single candle standing on the altar.

I turned on my phone's torch. In front of the squint was an oak shelf. A dark circle on its edge marked a spot where some of the wood had been rubbed away. Above it was a notice that read, "Please put nothing on the ancient sill. This was the prayer-desk of the anchorites for several centuries." I knelt in front of it. If the floor level had been the same in the medieval period, it would have been too high for an anchoress to rest her elbows there. Perhaps the indentation had been made by pairs of hands gripping the edge of the desk's ledge. I wondered at those pairs of hands. This cell had been a coffin to its inhabitants—once inside, they were never to come out. They may have been buried beneath my feet.

I came out of the church and into the churchyard in what remained of the light. I could hear cars on the nearby B-road sighing past; the churchyard was empty. Over the graveyard hedge was a care home. It was a Saturday, but there were only one or two cars in the carpark.

It didn't seem to be a busy time for visiting. But for the indifferent passing cars on the road, I was alone. The anchorites or anchoresses who'd lived in the cell probably rarely felt the same kind of aloneness. They withdrew from the world in one sense, but they were anchored to their church, and in that sense at the centre of community life. Anchorholds often appeared in prominent places in medieval English towns—in some they appeared along the routes of liturgical processions.[122] In London, there were once many cells along the old city walls; indeed, they formed "a ring of prayer" encircling the capital.[123] But this anchorhold had now become as lonely, to me, as the care home and the carpark. I wandered back to my car. I had come to Compton hoping to understand something of the possible author of the *Wohunge of Ure Lauerd*, but instead I couldn't help feeling that her life was closed off to me.

I had a similar feeling about Gwerful Mechain when I called up one of the manuscripts of her startling *englyn*, "I'w gŵr am ei churo" (To her husband for beating her), in the British Library. There are five other manuscripts of this work, and the earliest dates from about 1600. The one I viewed, BL Add MS 14990, is a late one. It was copied in the eighteenth century for the Gwyneddigion Society—a London-based Welsh literature and culture society formed in 1770.[124] Written in a clear eighteenth-century hand, it appears on a page with some other *englynion*, carefully and neatly ruled. While medieval manuscripts are often economical with space, aware of the preciousness of parchment or paper, the lines of text in this manuscript are generously spread out. Looking at this manuscript, I reflected that the gaps between the lines were apposite. To reach Mechain we have to search in the spaces between the lines.

This manuscript was copied centuries after her death, for an antiquarian society in London. It is several removes from

a moment of oral composition in the late fifteenth century, a moment of composition perhaps occasioned by a moment of intense personal pain. So often, medieval manuscripts give us a tangible connection to the past, but this is not always the case, as I found with the figures described in this chapter. Each is obscured in a different way. For the author of the *Wohunge*, we have no name and no secure attribution. We have a wealth of contextual information that can tell us what kind of person the author may have been, but ironically, most of it comes from guidance literature prescribing the controls imposed on anchoresses. For Julian, we have a name, along with two versions of a fascinating text. But there is precious little sense of a biography. And for Gwerful Mechain, we have a smattering of evidence, but no manuscripts to connect us to her directly. In each case, the manuscripts get us a little closer. But they never get us quite close enough to the women in question, about whose worlds we can only hazard our guesses in the spaces between the lines.

Epilogue

The Death of the Manuscript

W hen Enea Silvio Piccolomini, who would later become Pope Pius II, wrote to Cardinal Juan de Carvajal on March 12, 1455, his tone was breathless: "It seems that everything I had been told was true," he wrote. "I have not seen entire Bibles, but I have seen signatures of five folded sheets."[1] It is hard to imagine today how radical those folded sheets must have seemed. Piccolomini was discussing the work of a *vir mirabilis* (admirable man), Johannes Gensfleisch zur Laden zum Gutenberg, and in particular his printed Bible. It had been produced using moveable metal type. The invention was a landmark in European culture.

Printing with moveable type was already taking place in Korea and China before Gutenberg developed his press. But for Europe, his press was a great innovation, enabling the mass production of texts as never before. Gutenberg printed 180 Bibles in two years. During that time a single scribe would have barely put a dent in the work of copying a Bible manuscript. Yet despite this mechanized production, each copy was bespoke. They were printed on parchment, signalling their cost and luxuriousness; headings in red ink (rubrication) were added by hand. The Bibles were sold unbound and undecorated,

allowing owners to have them customized with hand-painted border decoration. (Around 49 Gutenberg Bibles survive, but each one is unique.) This marriage of new technology with individualized design made the Bibles sought-after objects; when Piccolomini wrote to Cardinal Carvajal there was already a long waiting list for the Bibles. It would take time for the technology to become available to ordinary people.

Printing arrived in England in 1476. It was brought by William Caxton—an enterprising merchant who had lived most of his adult life in the Netherlands.[2] Born in Kent at some point between 1415 and 1424, as a young man Caxton had been an apprentice in the Mercer's Company (a cloth merchant in London). He had then moved to the Continent and embarked on a successful career trading textiles. He appears to have learnt how to print in Cologne, and thereafter he began printing books in various locations in the Low Countries. When Caxton returned to England in 1476, he set up shop in Westminster, near the seat of government and next door to the Benedictine foundation of Westminster Abbey. Westminster was also outside the jurisdiction of the City of London—which gave him freedom from guild restrictions.

We might think of Caxton as the fifteenth century's equivalent of a Silicon Valley tech entrepreneur. But his skill lay not simply in the introduction of a technical innovation, but also in his careful engagement—as an editor, designer, and translator—with the texts he produced. While he was still on the Continent (in Ghent) he produced his first book in English. It was an edition of *Recueil des Histoires de Troye* by Roaul Lefèvre, a collection of stories relating to the *Iliad*, that Caxton had translated himself. This was to become a pattern: in his career he translated and produced more than twenty different works. He printed his 1485 edition of the *Morte Darthur* after

his return to London, having made changes to the manuscript exemplar he worked from to improve the reading experience. Caxton divided the text into books and chapters to make it easier to navigate, and in some places he updated the language.

Like Gutenberg, Caxton strove to make his editions visually attractive, often having rubrication added by hand. Although he did not print on parchment, he did add decoration. One of the first books he printed, in 1476, was Geoffrey Chaucer's *Canterbury Tales*. The work was popular enough for him to produce a second edition in 1483. In the "Prohemye"—a kind of preface—to this edition, he stated that after the release of the first edition, "one gentylman cam to me / and said that this book was not accordyng in many places unto the book that Gefferey chaucer [*sic*] had made" (one gentleman came to me and said that this book did not accord with the book that Geoffrey Chaucer had written). So he had borrowed another copy of the text from this man's "fader" so as to print a new version more "trewe and correcte."[3] This charming story may have been marketing speak. The textual differences between the two editions are relatively minor. The second edition was printed in a smaller type, allowing more words to fit on each page and reducing the cost of production by decreasing the number of pages overall.[4] But Caxton also added a new feature for aesthetics: a sequence of twenty-six woodcuts of Chaucer's pilgrims on horseback.

What Caxton brought with him from Europe wasn't simply a printing press; it was a new culture—and, as some have argued, a new way of thinking. In just the same way that when it arrived, the Internet radically changed the way we received, transmitted, and distributed information, so printing heralded a huge transformation. This change did not happen overnight, however. Opening Lambeth Palace Library MS 265, you'd have

little idea that the text in front of you was actually copied in 1477 *verbatim* from a text printed by William Caxton.[5] This is a sumptuous manuscript. It is on parchment, and it features elegant decorated initials in an Italian fashion with white vine stems. One of its opening folios contains a presentation miniature (depicting the moment the manuscript was presented to its recipient). It shows Anthony Woodville, 2nd Earl Rivers, bestowing the book on Edward IV, who is surrounded by his wife, Elizabeth, and sons, Edward and Richard.

Woodville was the translator of the text, which is known in English as the *Dictes and Sayings of the Philosophers*. (His work was based on a French translation of an Arabic text by the eleventh-century Syrian scholar al-Mubashshir ibn Fatik. As a text, it reminds us of the importance of Arabic learning in Western Europe in the medieval period.) Lambeth MS 265 illustrates how manuscripts retained their value as high-status objects, but it also has the feeling of a doomed technology. It is a potent metaphor for how things were to change irrevocably. This beautiful book—so laborious to produce—would soon be rendered extinct by Caxton's cheaper, more streamlined production process. It is an irony that this manuscript was copied from one of these printed editions. But this pattern, of manuscripts being copied from printed editions, was actually common.[6] The scholar Curt F. Bühler, commenting on the practice, wrote, "Experience has taught me that every manuscript ascribed to the second half of the fifteenth century is potentially (and often without question) a copy of some incunable" ("incunable" means a book printed before 1500).[7] At the end of Lambeth MS 265, the scribe has dutifully reproduced Caxton's endnote, which reads, "Here endeth the book namede the dictes and sayenges of Philosophres emprinted by me William Caxton at Westmynst the yere of our lorde m cccc lxxvij." The words

themselves were eventually to become the death knell of this very kind of book.

In much the same way that ebooks and traditional books are used today in tandem, so the two technologies of manuscript and print culture continued to exist, side by side, long after printing was introduced into England. Manuscripts had uses that printed books did not. Henry VIII read both printed books and manuscripts, expressing a preference for particular kinds of type that were more readable than others in his later years. But, for his personal prayer book, now the "Henry VIII Psalter" (Chapter 3), he commissioned a sumptuous manuscript, replete with personalised images of himself as the biblical David. And manuscripts were malleable in a way that printed texts were not. The only literary manuscript containing the hand of William Shakespeare—*The Book of Sir Thomas More*—is a playscript partially authored by Shakespeare. It is the acting company's final draft, a kind of backstage copy from which players' parts could be copied. The manuscript contains notes showing that it had been sent to the censor, Edmund Tilney, Master of Revels, who had prevented the play from being performed. Later, after the death of Elizabeth I, the manuscript had been taken up again and prepared for performance. Manuscripts had this important malleability, but they were also more private—suitable to personal, devotional reading, or the circulation of potentially scandalous material. Manuscripts allowed poets—such as John Donne—to circulate their work amongst a coterie of friends and acquaintances. But, by Shakespeare's time, although manuscripts still had important uses in particular contexts, they were being produced less and less, and medieval manuscripts were increasingly being collected as objects of historical interest.

Afterword

The Use and Misuse of the Past

John Leland styled himself King Henry VIII's "antiquary." He received a commission from the king in 1533 "to serche and peruse the Libraries of hyse realme . . . before their utter destruccyon."[1] But the fruits of Leland's search were not published until 1549, when John Bale, Leland's friend and associate, released a version of Leland's notes under the title of *Laboryouse journey*. In the intervening years, Henry VIII had died, John Leland had lost his mind, and the monastic libraries of the realm had been destroyed, their collections dispersed as part of the English Reformation.

The sad figure of Leland on his "laborious journey" is a harbinger of the end of an age and the start of another. It was in this period that manuscripts began to be valued as vestiges of an earlier time. Manuscripts, as we have seen in the case of Henry VIII's psalter, did not suddenly disappear when William Caxton set up shop in Westminster. But their uses did begin to change, and eventually they came to signify something different from what they had been before.

While perusing the libraries of the realm, one of the places Leland visited was Lincolnshire.[2] But by the time he arrived, the king's agents had already been there, looking for specific

books that Henry wanted. British Library MS Royal Appendix 69 is titled "Tabula liborum de historiis antiquitatum ac diuinitate tractancium in librariis et domibus religiosis" (A list of books treating ancient histories and divinity in libraries and religious houses). It is a list of nearly one hundred titles, with notes in the margins in Henry VIII's hand. Thirty-six titles have been marked with a small "x." Most of these marked titles ended up in the Royal Library at Westminster Palace. Three of Henry's palaces—Hampton Court, Greenwich, and Westminster—were remodelled and reordered in this period to incorporate newly acquired books. MS Royal Appendix 69 was something of a shopping list.

Since 1527 the king had been wracked with doubt about the validity of his marriage to Katherine of Aragon. So in 1529 he dispatched agents to Europe to search continental libraries looking for material that might buttress his case for divorce. A similar search was ordered for English libraries. Henry hoped to find in old monastic books the justifications for a divorce from his wife—which set in motion a series of events that would ultimately lead to the destruction of many of those books.

Henry began weaponizing the past for his own agenda. He married Anne Boleyn in January 1533 without papal approval, thereby dissolving his marriage to Katherine of Aragon. In April, Parliament approved the Act in Restraint of Appeals—the legal foundation of the English Reformation for transferring power from the Catholic Church to the king. The wording of this legislation is telling: "By diverse sundry old authentic histories and chronicles it is manifestly declared and expressed that this realm of England is an empire, and so hath been accepted in the world, governed by one supreme head and king having the dignity and royal estate of the imperial crown of the same."[3]

That is, Henry had assembled "old authentic histories and chronicles" to confer power on himself. Anne was crowned on June 1, 1533. The day before, she had participated in an elaborate coronation procession through London, visiting a number of pageant stations where actors spoke laudatory verses composed by the king's antiquary, John Leland, and Nicholas Udall, a playwright.[4] Further legislation followed, including the Act of Supremacy in 1534, and in 1536 Parliament passed a bill suppressing all religious houses in England with an income of less than £200 (around £94,000 in today's money). Thus began the Dissolution of the Monasteries—and the dispersal of their libraries. The process would continue until 1539. It was, as the historian James Simpson put it, "the largest transfer of power in England since the Norman Conquest."[5]

The scale of the destruction was vast. The intention was to demolish England's monastic buildings so thoroughly that they could never again be restored as sites for the old religion. John London, one of the king's agents, wrote in 1538 that he had so thoroughly "pullyd down" and "defacyd" a series of friaries that "they shuld nott lyghtly be made Fryerys agen."[6] The work of destruction was highly organized. London, under the direction of Thomas Cromwell, sent an Italian military engineer, Giovanni Portinari, to oversee the demolition of Lewes Priory, for example.[7] Portinari took with him a team of seventeen men, including "carpenters, smiths, plumbers and a furnace man."[8] They undermined the foundations, installed timber props, and set them on fire.[9]

With the destruction of buildings came the destruction and dispersal of their contents, including books. Although some books were saved, many were used for ignoble purposes: stuffing for scarecrows, mending material for wagons, or wrapping

paper.[10] John Bale described these uses in the *Laboryouse journey*, condemning the "horryble infamy" of the destruction:

> *A great nombre of them whych purchased those superstycyouse mansyons, reserved of those lybrarye bokes, some to serve theyr iakes, some to scoure theyr candelstyckes, & some to rubbe their bootes. Some they solde to the grossers and sope sellers, & some they sent over see to ye bokebynders, not in small nombre, but at tymes whole shyppes full, to the wonderynge of the foren nacyons.*

(A great number of those who purchased those superstitious mansions [i.e., monasteries] used those library books: some for use as toilet paper, some to scour their candlesticks and some to rub their boots. Some they sold to the grocers and soap sellers and some they sent overseas to the bookbinders, not in small number, but at times whole ships full, to the wonderment of foreign nations.)[11]

For Bale, the level of destruction was a national shame.

The only literary manuscript to contain the hand of Shakespeare, *The Book of Sir Thomas More*—a much revised script of a play that may never have been performed—is wrapped in the fragments of a late thirteenth-century legal text with a later marginal commentary. We can only wonder which medieval monastic library the leaves likely came from. The disregard for the original purpose of the leaves is evident. They are stained and scribbled on and have been turned upside down. In a blank space at the new top of the folio, someone has added the title, "The Boke of Sir Thomas More"—the medieval past here upended and repurposed. Sometimes books escaped total destruction and were simply defaced. Royal proclamations of June 9, 1535, and November 16, 1538, decreed that the old religion

should be expunged from old books. In the Sherborne Missal (from Chapter 4), the words "pape" (pope) and the name of St Thomas of Canterbury have been erased.[12]

The scale of the bibliographic loss during the Reformation is hard to estimate, but it is clear that what survives of England's "medieval textual heritage represents a small fraction of the medieval books that existed before 1536."[13] Of the more than six hundred volumes in the medieval catalogue of the Augustinian Friary in York, only five books have survived the Reformation. And of the three hundred volumes that the bibliophile benefactor Duke Humfrey gave to the University of Oxford, only two remain.[14]

We can only wonder what poor John Leland felt about the dispersal of the monastic libraries. According to a later source, he wrote to Thomas Cromwell in 1536, expressing concern for their fate: "Now the Germanes perceiving our desidiousness and negligence, do send dayly young Scholars hither, that spoileth them, and cutteth them out of Libraries, returning home and putting them abroad as Monuments of their own Country."[15] In other words, the remnants of the English past were being snatched up by Germans and heralded as German treasures (and there is an irony in this, as Germany was the cradle of the Reformation that precipitated the destruction of the books of which Leland speaks).

Henry VIII died in 1547, the same year that, according to John Bale, John Leland lost his mind. Bale worked on Leland's unpublished notes and published *Laboryouse journey* two years later. There are a number of theories about what prompted Leland's mental collapse. There is a sense, surveying his uncompleted work, of a life left unfulfilled. Leland's interests were broad. He produced a work called *Assertio inclytissimi Arturii regis Britanniae* (Assertion of the most famous Arthur King

of Britain) in 1544. In it he attempted to establish the validity of King Arthur's historical existence, using place names, arte-facts, texts, and landscape features to bolster his arguments. It reflects Leland's interest in the material and textual remains of the past as well as topography. The fact that he describes Arthur as "King of Britain" shows he believed it was an im-portant national story that he was determined to upgrade from its status as dubious myth.[16] The work also shows that Leland was concerned with distilling a national history, which gives a particular edge to his concern for how English books were be-ing taken oversees and heralded as German "Monuments." And his interests were not simply antiquarian and poetic. Sometime in the second half of 1546, Leland was dispatched to France to gather trees, grafts, and seeds, including one hundred pear and apple trees from Rouen.

Leland, however, died leaving a wealth of manuscripts of notes but only a handful of printed texts. He had hoped to com-plete a number of ambitious but ultimately unrealisable schol-arly projects. In the *Laboryouse journey*, Bale writes that Leland had promised Henry four volumes on the biographies of great British writers. They were to be titled *De viris illustribus* (Of distinguished men). The four books already contained almost six hundred entries, arranged in chronological order, when he went insane. He also wanted to produce an account of Britain's topography, as well as a history of Britain (which he thought might encompass "fyfty bokes"). And just to make sure that every aspect of Britain's history was covered, he also wanted to undertake a work on the noble families of the realm. Un-surprisingly, none of these expansive projects were completed. The overwhelming idea of getting them all done may indeed have contributed to his decline. The king's death may also have weighed heavily on Leland, especially as his career was contin-

gent on Henry's patronage. But it's hard not to wonder whether the destruction of the libraries that he witnessed did not also contribute, in part, to his mental deterioration.

The destruction of the monastic libraries had another important effect, however, on those whom it did not drive mad. The iconoclasm of Henry's age and its desire to erase the past generated a nostalgia for what had come before. And this nostalgia was a catalyst for the emergence of many an antiquarian.[17] Viewed in this way, we might see antiquarianism as something that arose, phoenix-like, from the ruins of destruction. Leland was the first to use the title "antiquarius," and the word "antiquary" entered the English language not long after. But it feels as though this self-styled epithet grew amid the ruins of his own mind. Leland gives human shape to a tragedy of destruction.

Leland was one of the first of a generation of antiquarians who set about gathering up the scattered remnants of the nation's medieval past in order to preserve and organize them according to their own vision.[18] These antiquarians collected or investigated the past for all kinds of reasons. John Stow (1524/1525–1605), a London antiquarian, was a young man when Leland lost his mind. He has been called the "most prolific historical writer of the sixteenth century."[19] An avid reader, he had a magpie-like desire to collect and preserve fragments of the past. He said of himself, "I had bene a serchar of antiquities . . . of divinite sorencys [astrology] & poetrye."[20] His interests were diverse: he collected a wealth of rolls, wills, indentures, coins, and monumental inscriptions, and he discussed many of these finds in his lengthy 1580 *Chronicles of England*. His *Survey of London* (1598) is a ward-by-ward picture of the city interweaving classical and medieval literature, civic records, historical information, and personal reflection. It's one of the most

complete descriptions of the city to survive from before the Great Fire of 1666. Stow was also greatly interested in literature and collected countless literary manuscripts, some of which he used for editions of Chaucer and Spenser.

Stow's work, however, shows the dangers inherent in the use of the past in the sixteenth century. Because of his interest in the remains of the monastic libraries, the ecclesiastical authorities investigated him in 1569. Whether he was a Catholic sympathiser, as was alleged, is hard to make out, especially as he was part of a circle of notable Protestant thinkers. But Stow's legacy is clear. A monument to him dating from 1605, the year of his death, stands in the church of St Andrew Undershaft in Aldgate in the City of London. "Aut scribenda agere, aut legenda scriber" (Either perform deeds to be written about, or write things to be read). The words were appropriate for Stow, who performed deeds of lasting significance and wrote much that is still read to this day.

John Stow presented Matthew Parker, Archbishop of Canterbury (1504–1575), with a copy of his new edition, *The workes of Geffrey Chaucer, Newly Printed, with Divers Addicions Whiche Were Never in Printe Before*, in 1561. The gift coincided with something of an antiquarian turn in Parker's life in his declining years. He increasingly devoted himself to collecting and investigating Protestantism in the British past. Parker amassed one of the most important collections of early English manuscripts, mainly gathered from the remnants of monastic libraries. The collection included the St Augustine Gospels (the gospels brought by St Augustine to Canterbury in 597, when he came to convert those living in the south of England to Christianity), the A-version of the *Anglo-Saxon Chronicle*, a beautiful copy of Chaucer's *Troilus and Criseyde*, an early copy of the *Ancrene*

Wisse, and two giant Bibles made for Bury St Edmund's in the twelfth century (in scope and style similar to the Winchester Bible discussed in Chapter 4). He gave his collection to Corpus Christi College in Cambridge in 1574 with strict instructions that it should be cared for judiciously. Parker's gift was not the first major gift of a private collection to a nonmonastic institution: notably, Humphrey, Duke of Gloucester, had donated 280 manuscripts to Oxford University, many of which reflected his interest in humanism, in the fifteenth century. But Parker's bequest illustrates how collections that come to shape our modern understanding of the past were shaped in turn by personal biases in earlier ages. With his collecting efforts Parker aimed to create a particular narrative about the English church, which he sought to demonstrate was historically independent from Rome. He was a leading proponent of Anglican doctrine: the Thirty-Nine Articles—the defining statements on the doctrines and practices of the Church of England—were produced under his direction. Indeed, for Parker and his circle, the act of collecting was motivated by political and religious ideologies and aligned with a project of nation-building.[21]

The events of the 1530s remind us that what was saved was sometimes the result of chance. Many of the manuscripts discussed in *The Gilded Page* had an uncertain fate after the Reformation. For a large number of them, we simply do not know where they were in the period after the Dissolution—this is true, for example, of the Cuthbert Gospel (Chapter 1), the Sherborne Missal (Chapter 4), and the Lindisfarne Gospels (Chapter 5). From a broader perspective, the events of the Reformation and post-Reformation period also remind us that the past has always been susceptible to misuse. The way we understand history has been shaped by the agendas of kings, collectors, antiquarians,

and historians. But the past asks us again and again to view it with fresh eyes.

———

At some point before his death in 1345, Richard de Bury, Bishop of Durham (1287–1345), composed his *Philobiblon* (Love of Books), in which he set out to "clear the love we have had for books from the charge of excess."[22] I love de Bury's treatise: it is a battle hymn for the value of books and learning: "In books we climb mountains and scan the deepest gulfs of the abyss," he wrote.[23] Undoubtedly the *Philobiblon* is a product of its time, containing criticisms of contemporary ecclesiastical and scholarly practices, and yet in spite of this, and in spite of the gap of time that separates de Bury's age from our own, many of his concerns are those of today's bibliophiles, scholars, and librarians. The work is veined with a deep love for both texts and the material artefacts that contain them, and as such, it touches on many of the themes of *The Gilded Page*.

In one chapter, de Bury castigates those who treat books carelessly, criticising the "headstrong youth lazily lounging over his studies"—his nose running from the winter's frost—who allows his nose to drip onto the book in front of him. This dastardly youth, de Bury continues, does not think to clean his nails, which are "stuffed with fetid filth," and thereby leaves marks on the book; or, if he is wearing gloves, "his finger clad in long-used leather will hunt line by line through the page."[24] The lazy youth also eats fruit or cheese over the open pages, marks his place with straws, keeps pressed flowers between the folios, and thinks nothing of using the open book as a pillow when taking a nap. This youth is still the stuff of librarians' and curators' nightmares.

But de Bury's horror also reminds us of what is magical about the oldest books—that they have been handled and mishandled by so many people in their history that they are smudged with human stories. Although he is incensed that someone would mark the pages of a book with annotations, those very annotations are the bread and butter of book historians. If we didn't have the annotations of Aldred in the Lindisfarne Gospels (the incomparable eighth-century Northumbrian manuscript from Chapter 5), we wouldn't know the names of Eadfrið the scribe, or Æthelwald and Billfrið, who made its cover. Nor would we have the little messages Aldred left for us. On the final folio he describes how he "made a home for himself" amongst the four gospels, referring to the tiny vernacular glosses he added between the lines of the scriptural text, as if he imagined himself tucked cosily in between the lines. On the final folio he added a coda in the margin: "I am called Aldred, born [son of] Ælfred; I speak as the distinguished son of a good woman," and we hear him, centuries hence.

Richard de Bury's horror at the way books are mistreated extends beyond the individual crimes of careless readers to encompass the assaults of war and other disasters, which he addresses in Chapter 7 of the work. We need only think of the singed edges of the only manuscript containing *Beowulf*, which nearly perished in the fire at Ashburnham House in 1731, to be reminded of the preciousness of the manuscripts that have survived into the modern day. "All things are corrupted and decay in time," de Bury wrote, and "all the glory of the world would be buried in oblivion," were it not for books.[25] De Bury notes the "feebleness of human memory."[26] He thought books conferred immortality on figures from the past. He said of authors that, "so long as the book survives its author remains immortal and cannot die."[27] Yet de Bury seems to have known that if authors

did find immortality, it was contingent on the whims of scribes, the biases of collectors, and the vagaries of chance. As we have seen, authors are sometimes the constructions of later ages. De Bury condemned the work of "worthless compilers, translators and transformers" as well as "treacherous copyists" who would "shamefully mutilate . . . the meaning of the author."[28] But for all de Bury's ire, this is one of the most intriguing aspects of manuscript study—that texts are malleable and each version is unique. Each new form of an author's work creates a new set of meanings in different ages and cultural contexts.

It was not only authors whom de Bury thought were made immortal by books. He cited a host of venerable figures from the past, including Julius Caesar and Alexander the Great, whose stories would not have survived without books. He wrote that no "pope or king" could "find any means of more easily conferring the privilege of perpetuity than by books." This phrase— "the privilege of perpetuity"—is an apt one. It reminds us that how we understand the past is susceptible to bias: perpetuity is not a privilege that is universally conferred. Manuscripts hold stories and snapshots of the lives of people we otherwise might not encounter—anonymous scribes, artists, and writers; people of a different social status than ourselves; people of different ethnicities and genders. And through manuscripts, we can try to access something of their lives. As de Bury wrote, "in books I find the dead as if they were alive," and in this I could not agree with him more.[29]

Acknowledgments

A lot of people have not laughed at me when I said I wanted to write a book about medieval manuscripts (or if they did, they did so kindly). I am so grateful to all of those people, beginning with Henry Hitchings, who chose not to laugh about a decade ago. Consequently, I carried the germ of an idea around for years. Inigo Thomas also chose not to laugh, and chose also to be encouraging and interested and always keen to eat sushi at lunchtime. Dan Jones has mainly distracted me with stupid stuff in text messages, so I'm actually not sure why I'm thanking him, except that he suggested I meet George Capel. Thank you, George, for helping this idea about why material books are so precious become an actual, material book. I can't believe it. Thank you also to Irene Baldolini and Rachel Conway.

My editors at Quercus and Basic Books have been wonderful. Jon Riley has quietly piloted this book through the choppy waters of a global pandemic and a rather monumentally distracting life-change. I could not have asked for a kinder and more thoughtful hand at the tiller. He read multiple drafts of chapters with patience and precision. Huge thanks also to Jasmine Palmer for many kindnesses; to Nick de Somogyi, into whose capable hands I placed my book-baby as I waited for my human-baby; to Wilf Dickies for beautiful designs; and to

Cathie Arrington for picture help. Thank you, Claire Potter, for understanding what this book is about and knowing exactly when I needed to hear words of encouragement. Kathy Streckfus copyedited the book with such care and I am grateful for every improvement, right down to the commas. Thanks also to Lara Heimert, Abby Mohr, Liz Wetzel, Jessica Breen, Melissa Raymond, Olivia Loperfido, and Chin-Yee Lai.

Many other people have helped in direct and indirect ways. Several people read sections of this book, made wise suggestions, and gently pointed out examples of my idiocy. Kathleen Doyle read two different versions of a chapter, which is quite beyond the call of duty. Julian Harrison read two different chapters. Thank you also to Andrea Clarke, Alison Hudson, Amy Jeffs, Cathryn Charnel-White, Amia Srinivasan, and my mother. Tony Edwards is the harshest of critics, but also a great ally. Thank you for reading such a chunk of this book. Any remaining errors are entirely my own. As the (probably female) author(s) of the *Earliest Life of St Gregory* wrote, "[Do not] nibble with critical teeth at this work of ours which has been diligently twisted into shape by love rather than knowledge."[1]

Other people answered queries and talked over points with me. Thank you so much to Claire Breay, Anne Marie D'Arcy, Lloyd de Beer, Julian Harrison, Matthew Lampitt, and Hussein Omar. Colleen Curran shared PDFs of two much-needed resources. Ellie Jackson sent images. Andy O'Hagan cheered from the sidelines.

Most of this book was written in the reading rooms of the British Library. I'm so grateful to all the staff on the reference and issue desks of the rooms I haunted daily. And grateful to my library-wife, Amina Diab, for a thousand unnecessary coffees and Tupperware lunches and stupid jokes. It has been an endless pleasure to talk about so many of the manuscripts in

this book with students on the British Library's adult learning courses. Working in the Department of Ancient, Medieval and Early Modern Manuscripts at the British Library furnished me with dear friends and so much invaluable experience. Thank you to everyone in the section and in the Learning Department for the opportunity to work on the Discovering Literature web-space. Working as a writer on that project and writing posts for the section blog was excellent training, and I thank Julian Harrison, in particular, for editing so many blog posts.

Tom Jones, editor of the LRB blog, has been Marie Kondo-ing my prose for a while, and every time he makes me realise what needs to be there and what doesn't. Without knowing it, he also made me think I could write a book. I'm incredibly sorry about all the horrid adjectives in this book.

Kate Rundell is my writing partner in crime. I'll never write as well as you, Kate, but I could not have survived without you and Mirra and Alice and Kathryn and Amia and Molly. Amy Jeffs is the best reader and an unfailing friend and she never thinks anything is too weird and medieval.

A global pandemic made the completion of this book tougher than normal and I called in a lot of favours. Amanda Herries provided Wi-Fi and lunch in the Scottish wilds over several days. Thank you for those days of peace and seamless Internet surfing. Mirra and Alice both collected and posted books for me when I wasn't able to get them for myself. Richard Espley and a kind receptionist whose name I did not catch opened up the Senate House "Click and Collect" office when I turned up late and fretful. Cathryn Charnell-White looked up some page references for me. Amy Plewis helped me to check references when time in the library was severely restricted: thank you so much.

To my brothers and sisters: you are the only people I ever want to hang out with. None of you gives a toss about manuscripts,

and that is just fine by me. Thank you also to all my in-laws for tolerating me over many months of lockdown and for looking after me when I was so green about the gills.

Huge thanks to my mother, who took me to see the Ruthwell Cross when I was a teenager and so made me the monster I am today. Nobody writes or talks the way you do, with such a sense of the anarchic possibility of words. What a thrill to have learnt words and the love of them from you. And also to learn new words all the time which you appear to have invented. Thank you for reading so much of this book and pointing out many places where I was abusing my reader's goodwill. Thank you to my father, who somehow pronounces it "manna-scripts," and I agree: they are manna from heaven. What a good day we had going to visit the Winchester Bible.

Lastly, thank you to Fred, who laughs always, mainly at me. You remind me daily that there is more to life than manuscripts, but have helped me create a life where I get to think about them a lot of the time. Thank you for the jokes, but also for the peace that makes writing possible. And thank you to my tiny Elfrieda, who gestated alongside the final chapters and gurgled through the copyedit. I hope one day you will read this book and find something in it that you like.

Notes

All hyperlinks are correct as of December 2020. All quotations from the Bible are from the Douay-Rheims translation (made directly from the Latin Vulgate—the version that would have been used by medieval readers); psalm numbering in the Vulgate differs from modern psalm numbering. I have not followed the transcription convention of italicising expanded abbreviations in quotations from manuscripts.

Abbreviations

Add	Additional
BL	British Library, London
Bodl.	Bodleian Library, Oxford
EETS	Early English Text Society
ES	Extra Series (1867–1920)
ODNB	*Oxford Dictionary of National Biography*
OED	*Oxford English Dictionary*
OS	Original Series (1864–)
r	recto
SS	Supplementary Series (1970–)
v	verso

Introduction

1. In John Lydgate, *Life of Our Lady* (fifteenth century), BL Harley MS 5272, fol. 42r. Here, as elsewhere, uncited translations are my own.

See British Library, Digitised Manuscripts, www.bl.uk/manuscripts/Full Display.aspx?ref=Harley_MS_5272.

2. Christine Franzen, *The Tremulous Hand of Worcester: A Study of Old English in the Thirteenth Century* (Oxford: Clarendon Press, 1991), 1.

3. *Domesday Abbreviatio* (c. 1241), National Archives, ref: E 36/284.

4. See Michael Ohajuru, "An African Presence in Thirteenth-Century Britain," Our Migration Story, www.ourmigrationstory.org.uk/oms/an-african-presence-in-the-thirteenth-century.

5. From both archaeological evidence and written sources, we know there was trade and travel between Britain and the wider world even in the period before the Crusades. Bede tells us, for example, that Hadrian of Canterbury (c. 630/637–709), abbot of St Peter's and St Paul's, was "a man of the African race." See Bede, *Bede's Ecclesiastical History of the English People*, ed. and trans. Bertram Colgrave and R. A. B. Mynors (Oxford: Clarendon Press, 1969), 25. On Hadrian, see Michael Lapidge, "Hadrian (630x37–709), abbot of St Peter's and St Paul's, Canterbury," in *Oxford Dictionary of National Biography* (*ODNB* hereafter), www.oxforddnb.com/view/10.1093/ref:odnb/9780198614128.001.0001/odnb-9780198614128-e-39256. Bede also tells us that Archbishop Theodore of Kent was not from Kent, but Cilicia in modern-day Turkey. Bede, *Ecclesiastical History*, 330–331 (iv.1–2; 5.20). See also Michael Lapidge, "Theodore of Tarsus [St Theodore of Tarsus] (602–690), Archbishop of Canterbury and Biblical Scholar," in *ODNB*, www.oxforddnb.com/view/10.1093/ref:odnb/9780198614128.001.0001/odnb-9780198614128-e-27170.

6. For the "Ipswich Man," a man of North African origin buried in Ipswich in the thirteenth century, see Onyeka Nubia, "Who Was the Ipswich Man?," Our Migration Story, www.ourmigrationstory.org.uk/oms/the-ipswich-man.

7. The charter only survives in later copies, some only in Latin. The vernacular text is from Brussels, Bibliothèque Royale, 7965–73 (3723), fols. 165r–v. Translation from the Electronic Sawyer, Online Catalogue of Anglo-Saxon Charters, https://esawyer.lib.cam.ac.uk/charter/1228.html.

8. In a similar vein, it is hard to know what to make of the name "Maurus," which sometimes turns up in documents of the period. It can mean "Moor" or might also be a reference to St Maurice. Examples include Wulfsige Maurus, who was a Mercian thegn. See Charles Insley, "The Family of Wulfric Spotte: An Anglo-Saxon Mercian Marcher Dynasty?," in *The English and Their Legacy, 900–1200: Essays in Honour of*

Ann Williams, ed. David Roffe, 115–128 (Woodbridge, UK: Boydell Press, 2012), 122–123. On "golden" or "red," see Gillian Fellows-Jensen, "By-names," in *Wiley-Blackwell Encyclopedia of Anglo-Saxon England*, 2nd ed., ed. Michael Lapidge, John Blair, Simon Keynes, and Donald Scragg (Chichester, UK: Wiley Blackwell, 2014), 80–81.

9. An African girl was buried in North Elmham near Norwich in about 1000, on which see Peter Fryer, *Staying Power: The History of Black People in Britain* (London: Pluto, 1984), 1–2; David Olusoga, *Black and British: A Forgotten History* (London: Pan Macmillan, 2016), 18, 29–32. There is also archaeological evidence of a multiethnic presence in Roman Britain. On the "Beachy Head Lady," see Olusoga, *Black and British*, 33. For a more general discussion, see David Clark, "Race/Ethnicity and the Other in *Beowulf: Return to the Shieldlands*," in *Beowulf in Contemporary Culture*, ed. David Clark (Newcastle: Cambridge Scholars, 2020), 44–45.

10. Golden Book of St Albans (1380–c. 1540), BL Cotton MS Nero D VII, fol. 89v, British Library, Digitised Manuscripts, www.bl.uk /manuscripts/FullDisplay.aspx?ref=Cotton_MS_Nero_D_VII. Strayler depicts himself on fol. 108r.

11. The history of people of colour in medieval England specifically is gaining increasing attention. For a brief discussion, see Fryer, *Staying Power*, 2–3, and Olusoga, *Black and British*, esp. 33–40. For suggested reading on race and the Middle Ages, see Mary Rambaran-Olm and Erik Wade, "Recommended Readings for Early Medieval Studies," M. Rambaran-Olm, July 18, 2020, https://mrambaranolm.medium .com/race-101-for-early-medieval-studies-selected-readings-77be815 f8d0f.

12. Meir ben Elijah of Norwich, "Put a Curse on My Enemy," MS ebr. 402, translation by Susan Einbinder, in Anthony Bale, "Poems of Protest: Meir ben Elijah and the Jewish People of Early Britain," Our Migration Story, www.ourmigrationstory.org.uk/oms/put-a-curse-on-my -enemies-meir-ben-elijah-and-the-jews-of-early-norwich. An alternative edition and translation appears in Meir of Norwich, *Into the Light: The Medieval Hebrew Poetry of Meir of Norwich*, ed. and trans. Ellman Crasnow and Bente Elsworth (Norwich, UK: East Publishing, 2013), 30–37. See also *Hebrew Manuscripts in the Vatican Library*, ed. Benjamin Richler (Vatican: Biblioteca Apostolica Vaticana, 2008), 348–350.

13. For further context see Vivian David Lipman, *The Jews of Medieval Norwich, with an Appendix of Latin Documents from the Westminster*

Abbey Muniment Room; and the Hebrew Poems of Meir of Norwich, ed. A. M. Habermann (London: Jewish Historical Society of England, 1967), 157–159 and appendix. On the backdrop of persecution, see Susan L. Einbinder, "Meir b. Elijah of Norwich: Persecution and Poetry Among Medieval English Jews," *Journal of Medieval History* 26 (2000): 145–162.

14. *Into the Light*, ed. and trans. Crasnow and Elsworth, 10.

15. Francis Blomefield, *An Essay Towards a Topographical History of the County of Norfolk*, vol. 3 of 10, *The History of Norwich* (London: William Miller, 1806), 64; Lipman, *Jews of Medieval Norwich*, 177.

16. Michael Camille, *Mirror in Parchment: The Luttrell Psalter and the Making of Medieval England* (London: Reaktion Books), 9.

17. Beatus of Liébana, Commentary on the Apocalypse (c. 1091–1109), BL Add MS 11695, fol. 278r, quoted and translated in Marc Drogin, *Anathema! Medieval Scribes and the History of Book Curses* (Totowa, NJ: Allanheld and Schram, 1983), 19.

18. In the twelfth century, Hervey, the sacrist of Bury St Edmunds Abbey, commissioned a spectacular Bible (now Corpus Christi College MS 2) for his brother. The right materials were hard to come by and the artist and bookmaker, Master Hugo, "was unable to find any suitable calf-hide in these parts" and had to purchase parchment from Scotland. "Gesta sacristarum," *Memorials of St Edmund's Abbey*, ed. Thomas Arnold, 2, Rolls Series, 96 (1892), 289–296.

19. Bodl. Tanner MS 407, in *The Commonplace Book of Robert Reynes of Acle: An Edition of Tanner MS 407*, ed. Cameron Louis (New York: Garland, 1980), 29–30 (fols. 15v–16r).

20. Michael Gullick, "How Fast Did Scribes Write? Evidence from Romanesque Manuscripts," in *Making the Medieval Book: Techniques of Production*, ed. Linda L. Brownrigg, Proceedings of the Fourth Conference of the Seminar in the History of the Book to 1500, Oxford, July 1992, 39–58 (Los Altos Hills, CA: Anderson-Lovelace; London: Red Gull Press, 1995).

21. Manuscript scholars become very exercised about "collation," which means working out how many folded pieces there are in each booklet and how many booklets there are in a manuscript. This tells us how a manuscript was put together and how well planned it was. When we marry the collation information with what we know about the text, we can begin to establish a clearer picture about the process of creation. It helps to know, for example, that an artist created a particular image

on a separate sheet and then sewed it into a booklet, or that a scribe wished to squeeze one more text into a manuscript and had to resort to sewing a single sheet into a booklet.

22. Élodie Lévêque and Claire Chahine, "Liber Pilosus: Les reliures cisterciennes de Clairvaux recouvertes de peau de phoque" [Liber Pilosus: Cistercian bindings from Clairvaux Abbey bound in seal skin], *The Notebook of the Institute for Research and History of Texts*, June 2017, updated January 2018, https://irht.hypotheses.org/3003.

23. Richard Gameson, "Material Fabric of Early English Books," in *The Cambridge History of the Book in Britain*, vol. 1, *c. 400–1100*, ed. Richard Gameson, 13–93 (Cambridge: Cambridge University Press, 2011), 13–14; Michael Gullick and Nicholas Hadgraft, "Bookbindings," in *The Cambridge History of the Book in Britain*, vol. 2, *c. 1100–1400*, ed. Nigel Morgan and Rodney M. Thomson, 95–109 (Cambridge: Cambridge University Press, 1998), 105–106.

24. The jewelled binding made for Judith, Countess of Flanders (d. 1094), c. 1051–1064, is the Morgan Library's MS M. 708.

25. "Chemise Binding," Glossary, British Library, Catalogue of Illuminated Manuscripts, www.bl.uk/catalogues/illuminatedmanuscripts /GlossC.asp.

26. John Croke, trans., *Psalms in English Verse* (girdle book) (c. 1540), BL Stowe MS 956, British Library, Catalogue of Illuminated Manuscripts, www.bl.uk/catalogues/illuminatedmanuscripts/record.asp?MSID =7213.

27. Roy M. Liuzza, "Introduction," in *Old English Literature: Critical Essays*, ed. Roy M. Liuzza (New Haven, CT: Yale University Press, 2008), xi.

Prologue

1. Keith Houston, *The Book: A Cover-to-Cover Exploration of the Most Powerful Object of Our Time* (New York: W. W. Norton, 2016), 19.

2. Harley MS 2346, fol. 52r, in *The Middle English Charters of Christ*, Mary Caroline Spalding, 18–44 (Bryn Mawr, PA: Bryn Mawr College, 1914), 27.

3. De Mure and Langland both quoted in George Kane, "Word Games: Glossing *Piers Plowman*," in *New Perspectives on Middle English Texts: A Festschrift for R. A. Waldron*, ed. Susan Powell and Jeremy J. Smith, 43–54 (Cambridge: D. S. Brewer, 2000), 50–51.

Chapter One: Discoveries

1. Flinders Petrie, *Seventy Years in Archaeology* (London: Sampson Low, Marston and Co., 1931), 36.

2. Walter Oakeshott, "The Finding of the Manuscript," in *Essays on Malory*, ed. J. A. W. Bennett, 1–6 (Oxford: Clarendon Press, 1963), 5–6.

3. The description of the discovery of the Cuthbert Gospel is taken from *The Relics of Saint Cuthbert: Studies by Various Authors*, collected and edited with an introduction by C. F. Battiscombe (Oxford: Oxford University Press, 1956), Appendix to Introduction, p. 101. The original Latin can be found as cap. xvii in the *Historia Translationum Sancti Cuthberti auctore anonymo* in the Surtees Society edition of *Symeonis Dunelmensis Opera et Collectanea*, ed. I. Hodgson-Hinde, vol. 1 of 2 (Durham, UK: Andrews and Co., 1868), 188–197. An alternative edition made from different manuscript sources appears in the Bollandist *Acta Sanctorum Martii Tomus*, vol. 3 (Antwerp: Jacobum Meursium, 1668), 138–142.

4. Simeon of Durham, "History of the Kings of England," in *The Church Historians of England Containing the Historical Works of Simeon of Durham*, translated from the original Latin with preface and notes by the Rev. Joseph Stevenson, Church Historians of England, vol. 3 (London: Seeleys, 1855), 457.

5. Symeon of Durham, "History of the Church of Durham," in Stevenson, trans., *Historical Works of Simeon of Durham*, 671.

6. A church made "of boughs of trees" was built, to be followed by a stone church, which was subsequently replaced by a Romanesque cathedral begun in 1093. Simeon of Durham, "History of the Church of Durham," 671–673.

7. The manuscript's post-medieval history is explained in Arnold Hunt, "Post-Medieval Movements of the Manuscript," in *The St Cuthbert Gospel: Studies on the Insular Manuscript of the Gospel of Saint John (BL, Additional MS 89000)*, ed. Claire Breay and Bernard Meehan (London: British Library, 2015), 137–145.

8. *Rites of Durham, Being a Description or Brief Declaration of All the Ancient Monuments, Rites & Customs Belonging or Being Within the Monastical Church of Durham Before the Suppression, Written 1593*, ed. Joseph T. Fowler, Surtees Society 107 (Durham: Andrews, 1903), 61.

9. *Lady Louisa Stuart: Selections from Her Manuscripts*, ed. James Home (Edinburgh: David Douglas, 1899), 26–27.

10. John Milner, "Account of an Ancient Manuscript of St. John's Gospel by Rev. John Milner, F.A.S., in a Letter to the Rev. John Brand, Secretary," *Archaeologia* 16 (1812): 12–21 (esp. 19–20).

11. Hunt, "Post-Medieval Movements of the Manuscript," 142.

12. "The St Cuthbert Gospel: Add. MS 89000, Early 8th Century," British Library, Explore Archives and Manuscripts, http://searcharchives .bl.uk/IAMS_VU2:IAMS032-002226193.

13. Kurt Weitzmann, *Age of Spirituality: Late Antique and Early Christian Art, Third to Seventh Century* (New York: Metropolitan Museum of Art in association with Princeton University Press, 1979), image 495, 550–551.

14. John 1:1.

15. Richard Gameson, "Materials, Text, Layout and Script," in Breay and Meehan, *St Cuthbert Gospel*, 22.

16. Malcom Parkes, the great palaeographer, wrote that the Wearmouth-Jarrow script was characterized by "concern for calligraphy, increased discipline in the writing and the control of variant forms." *The Scriptorium of Wearmouth-Jarrow*, Jarrow Lecture (Jarrow: St Paul's Church, 1982), 11.

17. Bede was commissioned to write a life of St Cuthbert in about 720.

18. "Bede's Life of Saint Cuthbert," in *Two Lives of Saint Cuthbert*, ed. and trans. Bertram Colgrave (Cambridge: Cambridge University Press, 1940), 215.

19. "Bede's Life of Saint Cuthbert," 217.

20. A slightly different account of the manuscript's discovery is given by Lieutenant Colonel William Butler Bowdon in *The Times* (London), September 30, 1936, 13. He wrote that "the manuscript has lain on a bookshelf in the library of Pleasington Old Hall, Lancashire, next to a missal of 1340 in the rite of York, ever since I can remember." Both properties were owned by the family, and it is unclear which account— that of the father or the son—is most trustworthy. The father's was written closer to the time of the event, but he might not have wanted to admit to the fact that he nearly threw the book on the bonfire.

21. The letter was written in 1970 to a friend, Mrs D. Winifred Tuck. See Hilton Kelliher, "The Rediscovery of Margery Kempe: A Footnote," *Electronic British Library Journal* 23 (1997): 259–263, www.bl.uk/eblj /1997articles/pdf/article19.pdf, 260. All subsequent quotations from the letter are from this article.

22. A slightly modernised version of the original text may be found in Margery Kempe, *The Book of Margery Kempe*, ed. Barry Windeatt (2000; repr., Cambridge: D. S. Brewer, 2004). An excellent translation is available in Margery Kempe, *The Book of Margery Kempe*, trans. Anthony Bale (Oxford: Oxford University Press, 2015). A transcription of the original manuscript appears in Margery Kempe, *The Book of Margery Kempe*, ed. Sanford Brown Meech and Hope Emily Allen, Early English Text Society (EETS hereafter) OS 212 (London: Humphrey Milford, Oxford University Press, 1940). All quotations from *The Book of Margery Kempe* are taken from the Meech/Allen transcription and the translations are my own.

23. *Book of Margery Kempe*, ed. Meech and Allen, 7.

24. *Book of Margery Kempe*, ed. Meech and Allen, 8.

25. *Book of Margery Kempe*, ed. Meech and Allen, 8.

26. *Book of Margery Kempe*, ed. Meech and Allen, 8.

27. *The Book of Margery Kempe: A Modern Version*, ed. W. Butler-Bowdon, Life and Letters 103 (London: Jonathan Cape, 1936).

28. *Book of Margery Kempe*, ed. Meech and Allen, 19.

29. *Book of Margery Kempe*, ed. Meech and Allen, 177–178.

30. *Book of Margery Kempe*, ed. Meech and Allen, 178.

31. *Book of Margery Kempe*, ed. Meech and Allen, 181.

32. *Book of Margery Kempe*, ed. Meech and Allen, 4.

33. Margery Kempe, *The Book of Margery Kempe* (c. 1440), BL Add MS 61823, fol. 123r, British Library, Digitised Manuscripts, www.bl .uk/manuscripts/FullDisplay.aspx?ref=Add_MS_61823.

34. *Book of Margery Kempe*, ed. Meech and Allen, xxxiv.

35. It's possible that it was made earlier but unbound, but in that case we might expect the first and last pages or the outer leaves of each booklet to look grubby, which they do not.

36. Appears on fol. iv verso. The manuscript may have been acquired by the Carthusian author, prior, and mystic John Norton (d. 1521/1522), as there are two references to him in red ink in the margins (fols. 33v and 51v).

37. Julie A. Chappell, *Perilous Passages: The Book of Margery Kempe, 1534–1934* (Basingstoke, UK: Palgrave, 2013), 65–67.

38. Technically she took her PhD from Radcliffe College—attached to, but not part of, Harvard at the time. Radcliffe women were forbidden from attending lectures with Harvard men and had to wait for the same

lecture to be repeated by graduate students or younger members of the faculty.

39. John C. Hirsch, "Hope Emily Allen (1883–1960): An Independent Scholar," in *Women Medievalists and the Academy*, ed. Jane Chance, 227–238 (Madison: University of Wisconsin Press, 2005), 235.

40. *The Times* (London), December 27, 1934, 15.

41. Hirsch, "Hope Emily Allen," 235.

42. *Book of Margery Kempe*, ed. Meech and Allen, 1.

43. Adrienne Rich, *Of Woman Born: Motherhood as Experience and Institution* (1986; repr., New York: W. W. Norton, 1995), 16.

44. Oakeshott, "Finding of the Manuscript," 1.

45. Oakeshott, "Finding of the Manuscript," 2–3.

46. Oakeshott, "Finding of the Manuscript," 3.

47. "Malory Find at Winchester," *Daily Telegraph*, June 25, 1934. See also "A 'Morte Darthur' Manuscript," *The Times* (London), June 26, 1934, which suggests that the find was made as the library's contents were in "the process of being rehoused." It does not mention Oakeshott. Oakeshott wrote a longer piece describing the manuscript and its divergences from the Caxton print in *The Times Literary Supplement*, September 27, 1935, no. 1704, 650.

48. On the history of this edition, see A. S. G. Edwards, "Editing Malory: Eugène Vinaver and the Clarendon Edition," *Leeds Studies in English*, n.s. 41 (2010): 76–81.

49. Thomas Malory, *Le Morte Darthur*, ed. Stephen A. Shepherd (New York: W. W. Norton, 2004), 819.

50. "Explicit" is a scribal abbreviation of *Explicitus est* (It is finished /completed).

51. *Le Morte Darthur*, ed. Shepherd, 112.

52. Oakeshott, "Finding of the Manuscript," 5–6.

53. *Le Morte Darthur*, ed. Shepherd, 62.

54. The original article appeared in the Autumn 1977 issue of the *British Library Journal* and was subsequently expanded in Lotte Hellinga, "The Malory Manuscript and Caxton," in *Aspects of Malory*, ed. Derek Brewer and Toshiyuki Takamiya, Arthurian Studies I (Cambridge: D. S. Brewer, 1981), 127–142.

55. Hellinga, "The Malory Manuscript and Caxton," 128.

56. On fol. 314v in the top left-hand corner of the page there is an obvious smudge. Elsewhere to the trained eye, you can see, on fol. 159r,

line 13, a capital F; on fol. 186v, line 7, a capital B; on fol. 407r, line 4, a lowercase y, on fol. 187v, line 6, a capital I. "Sir Thomas Malory, Le Morte Darthur: Add MS 59678, c. 1471–1483," British Library, Explore Archives and Manuscripts, http://searcharchives.bl.uk/IAMS_VU2 :IAMS032-001998125.

57. Oakeshott, "Finding of the Manuscript," 6.

58. The Winchester College library catalogue made reference to a 1634 version of the *Morte*: Thomas Malory, *Most Ancient and Famous History of Prince Arthur* (London: Printed by William Stansby for Iacob Bloome, 1634).

59. Oakeshott, "Finding of the Manuscript," 6.

60. *The Times* (London), September 30, 1936, 13.

Chapter Two: Near Disasters

1. From *Almansor* (1823), l. 245. See "Heinrich Heine," *Oxford Dictionary of Quotations*, ed. Elizabeth Knowles (Oxford: Oxford University Press, 2009), www.oxfordreference.com/view/10.1093/acref/9780199237 173.001.0001/q-author-00001-00001597.

2. Library and Information Commission, "New Library: The People's Network," commissioned by the UK Department for Culture, Media, and Sport, 1997, available from UK Office for Library Information Networking (UKOLN), www.ukoln.ac.uk/services/lic/newlibrary.

3. Edward Miller, *That Noble Cabinet: A History of the British Museum* (London: Andre Deutsch, 1973), 32.

4. *A Report from the Committee Appointed to View the Cottonian Library* (London: R. Williamson, 1732), 4.

5. Simon Keynes, "The Reconstruction of a Burnt Cottonian Manuscript: The Case of Cotton MS Otho A. I," *British Library Journal* 22 (1996): 113–160 (esp. 113).

6. The two collections had been housed together since 1707. Miller, *Noble Cabinet*, 32.

7. William Bogdani to Maurice Johnson, October 30, 1731, printed in Adam Fox, *John Mill and Richard Bentley: A Study of the Textual Criticism of the New Testament, 1675–1729* (Oxford: Basil Blackwell, 1954), 150.

8. *Report from the Committee Appointed to View the Cottonian Library*, Appendix, 11.

9. This account of the library describes the collection as it was in Cotton House, but it is likely that the furniture was reinstalled at Ashburnham House. Colin Tite, *The Manuscript Library of Sir Robert Cotton*, Panizzi Lectures, 1993 (London: British Library, 1994), 95.

10. I am indebted to Rosemary Hill for the observation that the moon's phase is important in understanding the events of that night.

11. Tite, *Manuscript Library of Sir Robert Cotton*, 95.

12. Bogdani to Johnson, in Fox, *John Mill and Richard Bentley*, 150.

13. Keynes, "Reconstruction of a Burnt Cottonian Manuscript," 143n14.

14. Andrew Prescott, "Their Present Miserable State of Cremation: The Restoration of the Cotton Library," in *Sir Robert Cotton as Collector: Essays on an Early Stuart Courtier and His Legacy*, ed. C. J. Wright, 391–454 (London: British Library, 1997), 392.

15. Simon Keynes and Michael Lapidge, eds. and trans., *Alfred the Great: Asser's Life of King Alfred and Other Contemporary Sources* (Harmondsworth, UK: Penguin, 1983), 225.

16. Prescott, "Their Present Miserable State," 393.

17. William Bowyer, *Literary Anecdotes of the Eighteenth Century: Comprising Biographical Memoirs of William Bowyer, Printer, F.S.A*, vol. 9 of 9 (London: Printed for the author by Nichols, Son and Bentley, 1815), 592. It should be noted that this account calls Ashburnham House "Abingdon House," so it may not stand on rock-solid foundations.

18. Thomas Fitzgerald, *Poems on Several Occasions by the Late Reverend Thomas Fitzgerald* (London and Oxford: Printed for the editor, sold by J. and J. Fletcher, 1781), 72.

19. The manuscript as it was is described in a letter written by Humfrey Wanley in 1721, reprinted in Kenneth Sisam, *Studies in the History of Old English Literature* (Oxford: Clarendon Press, 1953), 148n3.

20. It was in the hands of John Leland, Matthew Parker, and William Camden. The work of early antiquarians is briefly explored in the Afterword.

21. The editions were the work of William Camden and Francis Wise, respectively. For a summary of the textual history, see *Asser's* Life of King Alfred *Together with the* Annals of St Neots *Erroneously Ascribed to Asser, with an Article on Recent Work by Dorothy Whitelock*, ed. William Henry Stevenson (Oxford: Clarendon Press, 1959), xi–xxxii.

22. All quotations here are from Keynes and Lapidge, *Alfred the Great*, 66–110.

23. Keynes and Lapidge, *Alfred the Great*, 75.

24. Keynes and Lapidge, *Alfred the Great*, 91.

25. Keynes and Lapidge, *Alfred the Great*, 92.

26. Keynes and Lapidge, *Alfred the Great*, 74.

27. Alfred P. Smyth, *King Alfred the Great* (Oxford: Oxford University Press, 1995), and also *The Medieval Life of King Alfred the Great: A Translation and Commentary on the Text Attributed to Asser* (Basingstoke, UK: Palgrave, 2002).

28. On the problems caused by lost manuscripts, see Andrew Prescott, "The Ghost of Asser," in *Anglo-Saxon Manuscripts and Their Heritage*, ed. Philip Pulsiano and Elaine M. Treharne (Aldershot, UK: Ashgate, 1998), 255–292.

29. The singed pages of *Beowulf* can be seen at British Library, Digitised Manuscripts, BL Cotton MS Vitellius A XV, www.bl.uk/manuscripts/FullDisplay.aspx?ref=cotton_ms_vitellius_a_xv.

30. *Beowulf*, ed. and trans. Michael Swanton, rev. ed. (Manchester: Manchester University Press, 1997), 186 (ll. 3178–3182) (my translation).

31. *Beowulf*, trans. Seamus Heaney (London: Faber and Faber, 1999), xiii–xiv.

32. My translation, ll. 2450–2451. The Father's Lament is found in ll. 2444–2462.

33. *Beowulf*, trans. Heaney, xiii.

34. Anglistica XXV, in Kevin S. Kiernan, *The Thorkelin Transcripts of Beowulf* (Copenhagen: Rosenkilde and Bagger, 1986), 4.

35. BL Add MS 46513, fols. 120v–121v (Reading Room Register of MSS, September 1784 to October 24, 1788).

36. "In hoc libro, qui Poesos Anglo-Saxonicæ egregium est exemplum, descripta videntur bella quæ Beowulfus quidam Danus, ex Regio Scyldingorum stirpe Ortus, gessit contra Sueciæ Regulos," *Antiquæ Literaturæ Septemtrionalis liber alter . . . Catalogus historico-criticus* (1705), reproduced in facsimile as no. 248 in the series *English Linguistics, 1500–1800* (Menston, UK: Scolar Press, 1970), 219.

37. Robert E. Bjork, "Grímur Jónsson Thorkelin's Preface to the First Edition of *Beowulf*, 1815," *Scandinavian Studies* 68 (1996): 291–320 (esp. 311).

38. Bjork, "Grímur Jónsson Thorkelin's Preface," 300–303.

39. Bjork, "Grímur Jónsson Thorkelin's Preface," 303.

40. Bjork, "Grímur Jónsson Thorkelin's Preface," 297.

41. Horace, *Odes*, 3, 30, quoted in Bjork, "Grímur Jónsson Thorkelin's Preface," 304–305.

42. Exeter Cathedral Library MS 3501, in *The Exeter Anthology of Old English Poetry: An Edition of Exeter Dean and Chapter MS 3501*, 2nd ed., vol. 1 of 2, ed. Bernard J. Muir, Exeter Medieval English Texts and Studies (Exeter, UK: University of Exeter Press, 2000), 2.

43. Muir, *Exeter Anthology*, 1:357 (ll. 1–11).

44. Muir, *Exeter Anthology*, 357 (ll. 12–20).

45. Muir, *Exeter Anthology*, 320 (ll. 1–6).

46. Unpublished journal of Sir Frederic Madden, July 10, 1865. Photocopies of Madden's journal are available on open shelf in the Manuscripts Reading Room of the British Library. The originals are held by the Bodleian Library in Oxford. Further information on the extent of the damage in the bindery fire can be found in Prescott, "Their Present Miserable State," 450n236.

47. Prescott, "Ghost of Asser," 270.

Chapter Three: Patrons

1. Transcribed from the manuscript, fol. 40r. See Thomas Hoccleve, *Regiment of Princes* (fifteenth century), Royal MS 17 D VI, British Library, Digitised Manuscripts, www.bl.uk/manuscripts/FullDisplay.aspx ?ref=Royal_MS_17_d_vi. An edition can also be found in Thomas Hoccleve, *The Regiment of Princes*, ed. Charles R. Blyth, TEAMS Middle English Texts Series (Kalamazoo, MI: Medieval Institute Publications, 1999), https://d.lib.rochester.edu/teams/publication/blyth-hoccleve-the -regiment-of-princes (ll. 2017–2023).

2. This was actually a common name for the *Encomium* in the late Middle Ages. It wasn't called the *Encomium* until Duchesne's edition, *Emmæ Anglorum Reginæ Richardi I: Ducis Normannorum filiæ Encomium, incerto authore, sed coætaneo* (London: 1619). See Pauline Stafford, "Emma: The Powers of the Queen in the Eleventh Century," in *Queens and Queenship in Medieval Europe*, ed. Anne J. Duggan, Proceedings of a Conference Held at King's College, London, April 1995 (Woodbridge, UK: Boydell Press, 1997), 44n7. See *Encomium Emmæ Reginæ* (eleventh century), BL Add MS 33241, British Library, Digitised Manuscripts, www.bl.uk/manuscripts/FullDisplay.aspx?ref=Add_MS_33241.

3. Pauline Stafford, *Queen Emma and Queen Edith: Queenship and Women's Power in Eleventh Century England* (Oxford: Blackwell, 1997), 29.

4. See *Encomium Emmae Reginae*, BL Add MS 33241, fol. 1v.

5. *Encomium Emmae Reginae*, ed. Alistair Campbell, with supplementary introduction by Simon Keynes, Camden Classic Reprints 4 (Cambridge: Cambridge University Press, 1998), xiv. I have Latinised Campbell and Keynes's Norse spellings, such as "Knútr," to prevent confusion.

6. Discussion of her age at the time of marriage can be found in Stafford, *Queen Emma*, 211.

7. *The Anglo-Saxon Chronicle: A Collaborative Edition*, vol. 6 (MS D), ed. G. P. Cubbin (Cambridge: D. S. Brewer, 1996), 51.

8. William of Malmesbury, *The Deeds of the English Kings (Gesta regum Anglorum)*, ed. and trans. R. A. B. Mynors, completed by R. M. Thomson and M. Winterbottom (London: Folio Society, 2014), 169.

9. Simon Keynes, "Emma [Ælfgifu] (d. 1052), Queen of England, Second Consort of Æthelred II, and Second Consort of King Cnut," *ODNB*, www.oxforddnb.com/view/10.1093/ref:odnb/9780198614128.

10. Stafford, *Queen Emma*, 221.

11. Simon Keynes, "Emma [Ælfgifu]."

12. Whitelock translates it as "widow," but the word *widuwe* is not used. *The Anglo-Saxon Chronicle*, ed. and rev. Dorothy Whitelock, with David C. Douglas and Susie I. Tucker (London: Eyre and Spottiswoode, 1961), 97.

13. Roberta Frank, "King Cnut in the Verse of His Skalds," in *The Reign of Cnut: King of England, Denmark and Norway*, ed. Alexander R. Rumble, 106–124 (1994; repr., London: Leicester University Press, 1999), 122.

14. Elizabeth M. Tyler, "Fictions of Family: *The Encomium Emmae Reginae* and Virgil's *Aeneid*," *Viator* 36 (2005): 149–180 (esp. 149).

15. *Encomium*, ed. Campbell, 5 (Prologue) (translation modified).

16. *Encomium*, ed. Campbell, 5 (Argument).

17. *Encomium*, ed. Campbell, 37 (2.19).

18. A full account of the literary analogues is mapped in Andy Orchard, "The Literary Background to the *Encomium Emmae Reginae*," *Journal of Medieval Latin* 11 (2001): 156–183.

19. Jacob Hobson, "National-Ethnic Narratives in Eleventh-Century Literary Representations of Cnut," *Anglo-Saxon England* 43 (2014): 267–295 (esp. 283).

20. The foregoing discussion is indebted to Tyler, "Fictions of Family," esp. 175–179.

21. *Encomium*, ed. Campbell, 13 (1.4).

22. William Shakespeare, *The Tragedy of Anthony and Cleopatra*, ed. Michael Neill (1994 [c. 1607]; repr., Oxford: Oxford University Press, 2000), 192 (Act II, scene 2, ll. 202–204).

23. *Encomium*, ed. Campbell, 33 (2.16).

24. See, especially, *Encomium*, ed. Campbell, 33–35 (2.16–18).

25. *Encomium*, ed. Campbell, 5 (Prologue).

26. *Encomium*, ed. Campbell, 25 (2.9).

27. *Encomium*, ed. Campbell, 53 (3.13–14).

28. Timothy Bolton, "A Newly Emergent Mediaeval Manuscript Containing *Encomium Emmae Reginae* with the Only Known Complete Text of the Recension Prepared for King Edward the Confessor," *Mediaeval Scandinavia* 19 (2009): 205–221.

29. Simon Keynes and Rosalind Love, "Earl Godwine's Ship," *Anglo-Saxon England* 38 (2010): 185–223 (esp. 195–196).

30. The following discussion is indebted to Kathryn Krakowka, "Unlocking the Secrets of the Winchester Cathedral Mortuary Chests," *Current Archaeology* 4 (2019), www.archaeology.co.uk/articles/unlocking -the-secrets-of-the-winchester-cathedral-mortuary-chests.htm; "Mortuary Chests Unlocked," Winchester Cathedral, May 16, 2019, www .winchester-cathedral.org.uk/mortuary-chests-unlocked._

31. Bruno Ryves, *Mercurius Rusticus; or, The Countries Complaint of the Barbarous Outrages Committed by the Sectaries of This Late Flourishing Kingdom* (n.p., 1646), 211–212.

32. There has been some debate about whether the image is an intentionally unflattering portrait or its awkwardness is the result of the artist adapting an existing standing portrait to a sitting one. Greg Walker has argued that it was intentional. See Greg Walker, *Persuasive Fictions: Faction, Faith and Political Culture in the Reign of Henry VIII* (Aldershot, UK: Scolar Press, 1996), 80. For the original manuscript, see Psalter (c. 1540–1541), Royal MS 2 A XVI, British Library, Digitised Manuscripts, www.bl.uk/manuscripts/FullDisplay.aspx?ref=Royal_MS_2_a_xvi. For the image of King Henry in his chamber, see fol. 3r

33. *The Inventory of King Henry VIII: The Transcript*, ed. David Starkey (London, 1998), no. 9042.

34. Not only does the psalter reflect Henry's tastes and fears in its images and annotation, but it may also, like the *Encomium Emmae Reginae*, contain some tactical omissions. Psalm 77 is missing a substantial section. For an argument that this is intentional, see Ian Christie-Miller, "Henry VIII and British Library, Royal MS. 2 A. XVI: Marginalia in

King Henry's Psalter," *Electronic British Library Journal* (2015), Article 8, www.bl.uk/eblj/2015articles/pdf/ebljarticle82015.pdf.

35. As in *Le Chemin de Paradis*, Bodleian. MS Bodl. 883.

36. From the preface to an edition of selected parts of the Bible in *Latin Sacrae Bibliae Tomus Primus*. See *King Henry's Prayer Book* (Facsimile Edition), with a commentary by James P. Carley (London: Folio Society, 2009), 70.

37. Psalter, Royal MS 2 A XVI, fol. 97r.

38. Psalter, Royal MS 2 A XVI, fols. 24r, 22r, 46r, 43r, 126v, and 82v.

39. Carley, *King Henry's Prayer Book*, 74.

40. On the annotation of books in this period, see William H. Sherman, *Used Books: Marking Readers in Renaissance England* (Philadelphia: University of Pennsylvania Press, 2008).

41. Carley, *King Henry's Prayer Book*, 74.

42. In a letter to Adrian VI, August 1, 1522. See *The Correspondence of Erasmus: Letters 1252 to 1355, 1522 to 1523*, vol. 9, trans. R. A. B. Mynors, annotated by James M. Estes (Toronto: University of Toronto Press, 1989), 152.

43. Act of Supremacy, 1534 (26 Henry VIII c. 1), in *Documents of the English Reformation*, ed. Gerald Bray (Cambridge: James Clarke and Co., 1994), 114.

44. Thomas Campbell, *Henry VIII and the Art of Majesty: Tapestries at the Tudor Court* (New Haven, CT: Yale University Press, 2007), 177–187.

45. In Henry Morley's *The Exposition and Declaration of the Psalme, Deus Ultionem Dominus* (London: Thomas Berthelet, 1539), Henry is described as "the royall king David . . . our prince woll not cesse to resist with all his power, the obstinate wylle & vsurped authorite of the proude byshop of Rome" (sig. A.7^{a-b}). Similarly, in a tract by Sir Richard Morison, Henry is compared to David, who—Morison contended—was protected above all others by God. See Carley, *King Henry's Prayerbook*, 72. Thomas Wyatt drew unflattering comparisons. See Greg Walker, *Writing Under Tyranny: English Literature and the Henrician Reformation* (Oxford: Oxford University Press, 2005), 351–376.

46. Psalter, Royal MS 2 A XVI, fol. 30r.

47. Psalter, Royal MS 2 A XVI, fols. 33v, 13r, 19v.

48. Psalter, Royal MS 2 A XVI, fols. 4v, 107v.

49. Psalter, Royal MS 2 A XVI, fol. 48r.

50. Psalter, Royal MS 2 A XVI, fol. 63r.

51. "The Family of Henry VIII, c. 1545," Royal Collection Inventory Number 405796, Royal Collection Trust, www.rct.uk/collection/405796/the-family-of-henry-viii. Sommers can be seen in the far-right doorway.

52. Psalter, Royal MS 2 A XVI, fol. 79r.

53. Psalter, Royal MS 2 A XVI, fol. 118r.

54. He wrote "nota de idolatria" (note concerning idolatry) next to Psalm 43 (fol. 55r) and "de confessione" (on confession) next to Psalm 94:2 (fol. 115r).

55. Psalter, Royal MS 2 A XVI, fol. 48v.

56. Psalter, Royal MS 2 A XVI, fol. 136v.

57. After this it was moved to the royal library at Westminster, where it was given an inventory number. James Carley, *The Libraries of King Henry VIII* (London: British Library in association with the British Academy, 2000), 277. The inventory is in two parts; the entry for the Psalter may be found in Inventory of King Henry VIII, 1547–1548, BL MS Harley 1419, fol. 206r, British Library, Digitised Manuscripts, www.bl.uk/manuscripts/FullDisplay.aspx?ref=Harley_MS_1419/2.

Chapter Four: Artists

1. Michael Camille notes the "socially marginal position of many medieval artists" in *Image on the Edge* (London: Reaktion Books, 1992), 147.

2. A. Radini, M. Tromp, A. Beach, E. Tong, C. Speller, M. McCormick, J. V. Dudgeon, et al., "Medieval Women's Early Involvement in Manuscript Production Suggested by Lapis Lazuli Identification in Dental Calculus," *Science Advances* 5 (2019), https://advances.science mag.org/content/5/1/eaau7126.

3. In researching the Winchester Bible, I have been hugely helped by the blog accompanying the Metropolitan Museum of Art's 2015 exhibition *The Winchester Bible: A Masterpiece of Medieval Art*. See www.metmuseum.org/exhibitions/listings/2014/winchester-bible/blog. Also useful is Andrew Honey, "Practice Makes Perfect? Lessons Learnt from the Binding of the Winchester Bible," paper presented at Care and Conservation of Manuscripts 17, University of Copenhagen, April 11–13, 2018, Oxford University Research Archive, https://ora.ox.ac.uk/objects/uuid:776ac48e-4504-4980-ab07-36f14c50abc7.

4. He used rather an old-fashioned script and ruling format, suggesting seniority. See Claire Donovan, *The Winchester Bible* (London: The British Library and Winchester Cathedral, 1993), 18.

5. Donovan, *Winchester Bible*, 20.

6. Walter Oakeshott, *Two Winchester Bibles* (Oxford: Clarendon Press, 1981), 15.

7. Donovan, *Winchester Bible*, 17.

8. "The Winchester Bible: Conservation in Action," Winchester Cathedral, www.winchester-cathedral.org.uk/conservation-action/the -winchester-bible.

9. Donovan, *Winchester Bible*, 5; Walter Oakeshott, *The Artists of the Winchester Bible* (London: Faber and Faber, 1945), 1.

10. Oakeshott, *Artists of the Winchester Bible*, 3–4.

11. These include the early medieval Benedictional of St Aethelwold (BL Add MS 49598), produced between 963 and 984, which contains twenty-eight magnificent images depicting figures in mauve, gold, blue, and emerald green. The Winchester Bible's immediate predecessor is the Winchester Psalter (BL Cotton MS Nero C IV), which contains thirty-eight full-page images illuminating the Old and New Testaments.

12. Roland Riem, *The Winchester Bible: The First 850 Years* (Stroud, UK: Pitkin Press, 2014), 5. The other Bible was Bodl. MS Auct. E inf. 2; see https://medieval.bodleian.ox.ac.uk/catalog/manuscript_520.

13. See, for example, a marginal note on p. 33 of An Leabhar Breac (The Speckled Book) (Royal Irish Academy MS 23 P 16), made in Duniry in about 1408–1411, in which the scribe wrote, "Fiche oidche ondiu co luan cásc, is am fuar toirsech, cen tene, cen tugaid" (Twenty nights from today till Easter Monday, and I am cold and weary, without fire or covering). See *Leabhar Breac, the Speckled Book*, ed. Joseph Ó Longáin and J. J. Gilbert (Dublin: Royal Irish Academy, 1876), 30. See also Michael Gullick, "How Fast Did Scribes Write? Evidence from Romanesque Manuscripts," in *Making the Medieval Book: Techniques of Production*, ed. Linda L. Brownrigg, Proceedings of the Fourth Conference of the Seminar in the History of the Book to 1500, Oxford, July 1992, 39–58 (Los Altos Hills, CA: Anderson-Lovelace; London: Red Gull Press, 1995), 43.

14. Donovan, *Winchester Bible*, 5.

15. Winchester Bible, fol. 303.

16. Winchester Bible, fol. 316; Donovan, *Winchester Bible*, 56. A later hand sought to overrule this instruction with a note, in different ink, that

begins with the word "Fac" (make) followed by some illegible words and then "in templo . . . et cum impetus" (in the temple . . . and with assault). Oakeshott, *Two Winchester Bibles*, 14.

17. Oakeshott, *Two Winchester Bibles*, 37.

18. These included vermillion for the reds, red lead for the oranges, copper-based verdigris or malachite for the greens, iron oxide for the yellows, carbon for the black, and white lead for the whites. Charles T. Little, "The Making of the Winchester Bible," The Met, January 21, 2015, www.metmuseum.org/exhibitions/listings/2014/winchester-bible /blog/posts/making-of-the-winchester-bible.

19. It is possible that the pigment may be azurite or woad, but as far as I am aware tests have not been carried out to determine which pigments were used.

20. Donovan, *Winchester Bible*, 28.

21. Nigel J. Morgan, "Winchester Bible" (2003), in *The Grove Encyclopedia of Medieval Art and Architecture*, ed. Colum P. Hourihane (Oxford: Oxford University Press, 2012).

22. Oakeshott, *Two Winchester Bibles*, 45.

23. Winchester Bible, fol. 21v.

24. Donovan, *Winchester Bible*, 24.

25. Donovan, *Winchester Bible*, 15.

26. Walter Oakeshott, *Sigena Romanesque Paintings in Spain and the Winchester Bible Artists* (London: Harvey Miller and Medcalf, 1972), 142.

27. Oakeshott, *Sigena Romanesque Paintings*, 116.

28. The leaf at the Pierpont Morgan Library is Morgan Library MS M. 619. Some other leaves were removed from the Bible when it was rebound in 1820. (Other leaves may have been removed at the same time and could still come to light.)

29. "The Morgan Leaf, from the Winchester Bible: Opening for the Book of 1 Samuel (r.); Frontispiece for 1 Samuel (?) with Life of David (v.), ca. 1150–80," The Met, www.metmuseum.org/art/collection/search /656524.

30. Donovan, *Winchester Bible*, 27.

31. Oakeshott suggests that "two [or] perhaps three" of the Winchester artists worked there. Oakeshott, *Sigena Romanesque Paintings*, 113.

32. Julia Perratore, "The Spanish Connection: The Winchester Bible and Spain," The Met, February 3, 2015, www.metmuseum.org /exhibitions/listings/2014/winchester-bible/blog/posts/the-spanish -connection.

33. Oakeshott argued that the frescoes came after the Bible in Oakeshott, *Sigena Romanesque Paintings*, 112.

34. Winchester Bible, fol. 99v.

35. Winchester Bible, fol. 5r.

36. R. W. L. Moberly, "Why Did Noah Send out a Raven?," *Vetus Testamentum* 50 (2000): 345–356 (esp. 346).

37. Oakeshott, *Artists of the Winchester Bible*, 3.

38. Riem, *Winchester Bible*, 24.

39. Riem, *Winchester Bible*, 24.

40. See "Luttrell Psalter" (c. 1325–1340), British Library, Collection Items, www.bl.uk/collection-items/the-luttrell-psalter; Luttrell Psalter (1324–1340), and BL Add MS 42130, British Library, Digitised Manuscripts, www.bl.uk/manuscripts/FullDisplay.aspx?ref=Add_MS_42130.

41. In his will Geoffrey Luttrell made provision for twenty chaplains to recite Masses for his soul over a five-year period. Michelle P. Brown, *The World of the Luttrell Psalter* (London: British Library, 2006), 24.

42. Luttrell Psalter, BL Add MS 42130, fols. 70v, 79v, 84v, 176r.

43. For a discussion of the origin and development of these kinds of border images, see Paul Binski, *Gothic Wonder: Art, Artifice and the Decorated Style, 1290–1350* (New Haven, CT: Yale University Press, 2014), 293–298.

44. Luttrell Psalter, BL Add MS 42130, fol. 54v.

45. This legend is from Osbern's late eleventh-century *Life and Miracles of St Dunstan*. See *Memorials of Saint Dunstan, Archbishop of Canterbury*, ed. William Stubbs (London: Longman and Company, 1874), 329.

46. Binski, *Gothic Wonder*, 286 and discussion, 299–305.

47. Michael Camille, *Mirror in Parchment: The Luttrell Psalter and the Making of Medieval England* (London: Reaktion Books), 318. Lucy Freeman Sandler noted that the calendar and litany have "a Lincoln 'flavour'" in *Gothic Manuscripts, 1285–1385*, A Survey of Manuscripts Illuminated in the British Isles V, vol. 2 of 2 (London: Harvey Millar; Oxford: Oxford University Press, 1986), 119.

48. Camille, *Image on the Edge*, 156.

49. Camille, *Mirror in Parchment*, 316.

50. Camille says "at least six" (Camille, *Mirror in Parchment*, 52), while Sandler says "a least five individuals" (Sandler, *Gothic Manuscripts*, 2:120).

51. Janet Backhouse, *The Luttrell Psalter* (London: British Library, 1989), 13.

52. Camille, *Mirror in Parchment*, 232. Camille argued that the image of a man's face next to an illuminated initial on fol. 177v was a self-portrait of this artist.

53. Backhouse, *Luttrell Psalter*, 14.

54. Camille, *Mirror in Parchment*, 232.

55. Sandler, *Gothic Manuscripts*, 2:120.

56. Luttrell Psalter, BL Add MS 42130, fol. 181r.

57. Luttrell Psalter, BL Add MS 42130, fols. 181v–182r.

58. Luttrell Psalter, BL Add MS 42130, fol. 173v.

59. Luttrell Psalter, BL Add MS 42130, fol. 170v.

60. Luttrell Psalter, BL Add MS 42130, fol. 158v.

61. Luttrell Psalter, BL Add MS 42130, fols. 172v–173r.

62. Luttrell Psalter, BL Add MS 42130, fol. 202v.

63. Michelle P. Brown, *The Luttrell Psalter: A Facsimile* (London: British Library, 2006), 4.

64. Backhouse, *Luttrell Psalter*, 57.

65. Luttrell Psalter, BL Add MS 42130, fols. 207v–208r.

66. Camille, *Mirror in Parchment*, 327.

67. Backhouse, *Luttrell Psalter*, 14.

68. Luttrell Psalter, BL Add MS 42130, fols. 23r, fol.196v. On the symbolism of the cherry from medieval art to the present day, see Amy Jeffs and Mary Wellesley, "Sexing Up the Cherry," *Apollo* 659 (2017): 76–78.

69. Luttrell Psalter, BL Add MS 42130, fol. 157v.

70. Luttrell Psalter, BL Add MS 42130, fol. 162r.

71. Luttrell Psalter, BL Add MS 42130, fol. 185r.

72. Luttrell Psalter, BL Add MS 42130, fol. 59v.

73. Luttrell Psalter, BL Add MS 42130, fol. 170v–171r, 172v.

74. Luttrell Psalter, BL Add MS 42130, fol. 157v.

75. Kathleen Scott, *Later Gothic Manuscripts, 1390–1490*, A Survey of Manuscripts Illuminated in the British Isles VI, vol. 2 of 2 (London: Harvey Millar, 1996), 52.

76. Sherborne Missal (c. 1399–1407), BL Add MS 74236, British Library, Viewer, http://access.bl.uk/item/viewer/ark:/81055/vdc_100104 060212.0x000001. See also J. A. Herbert, *The Sherborne Missal: Reproduction of Full Pages and Details of Ornament from the Missal Executed Between the Years 1396 and 1407 for Sherborne Abbey Church and Now Preserved in the Library of the Duke of Northumberland at Alnwick Castle* (Oxford: Roxburghe Club, 1920).

77. We cannot be sure, because specific records for the Sherborne Missal do not survive, but the book is very similar in size and scope to the Litlyngton Missal, which took two years just for the text to be copied, let alone decorated. See Janet Backhouse, *The Sherborne Missal* (London: British Library, 1999), 9–12.

78. Scott, *Later Gothic Manuscripts*, 2:52.

79. It had to have been produced before Mitford died in 1407, after 1399 when Henry V became Prince of Wales (his arms appear on p. 81). On the different artists, see Scott, *Later Gothic Manuscripts*, 2:53–55.

80. Scott, *Later Gothic Manuscripts*, 2:53–56.

81. Scott, *Later Gothic Manuscripts*, 2:55.

82. Scott, *Later Gothic Manuscripts*, 2:53.

83. Brunyng and Mitford appear side by side in eight places including the four major festivals of Christmas, Easter, Pentecost, and Trinity Sunday.

84. Sherborne Missal, BL Add MS 74236, 81.

85. Sherborne Missal, BL Add MS 74236, 225.

86. A Pentateuch commentary from Glastonbury Abbey, at Trinity College, Cambridge (MS B.3.7) and the fragmentary Lovell Lectionary (BL Harley MS 7026).

87. Timothy Graham, "Siferwas, John (fl. 1380–1421), Manuscript Artist," *ODNB*, www.oxforddnb.com/view/10.1093/ref:odnb/9780198 614128.001.0001/odnb-9780198614128-e-37958.

88. Graham, "Siferwas, John."

89. Scott summarises the arguments in *Later Gothic Manuscripts*, 2:54.

90. Sherborne Missal, BL Add MS 74236, 380a.

91. The independent bifolio might have been unintentional. Siferwas may have intended to add another image onto the opposite page, or simply preferred to work on an independent sheet, but this feels unlikely for such a meticulously planned manuscript.

92. Sherborne Missal, BL Add MS 74236, 573.

93. Scott, *Later Gothic Manuscripts*, 2:55.

94. Scott believes it may have been Siferwas. See Scott, *Later Gothic Manuscripts*, 2:55.

95. Janet Backhouse, *Medieval Birds in the Sherborne Missal* (London: British Library, 2001), 5.

96. Sherborne Missal, BL Add MS 74236, 382.

97. Backhouse, *Medieval Birds*, 33.

98. Sherborne Missal, BL Add MS 74236, 364.

99. Sherborne Missal, BL Add MS 74236, 369.

100. Sherborne Missal, BL Add MS 74236, 369, 375.

101. Brunsdon Yapp, *Birds in Medieval Manuscripts* (London: British Library, 1981), 152.

102. Sherborne Missal, BL Add MS 74236, 373, 393.

103. Shelduck appears on p. 370, the Shrike, p. 367. Backhouse, *Medieval Birds*, 33.

104. Sherborne Missal, BL Add MS 74236, 36.

105. As on, for example, p. 364, where the goldfinch in the lower left-hand side of the folio sits on top of the decorative devices of the border, unlike the dragon on the lower right-hand side, which is plaited into the border design.

106. Giovanni Boccaccio, *De Mulieribus Claris* (On famous women), Bibliothèque nationale de France, MS Français 12420, fol. 86r, digitised at BnF Gallica, https://gallica.bnf.fr/ark:/12148/btv1b10509080f/f18 1.item.

107. Giovanni Boccaccio, *On Famous Women*, ed. and trans. Virginia Brown (Cambridge, MA: Harvard University Press, 2001), 231.

Chapter Five: Scribes

1. Flavius Magnus Aurelius Cassiodorus, *Institutiones*, ed. R. A. B. Mynors (Oxford: Clarendon Press, 1937), 75; *Cassiodorus: Institutions of Divine and Secular Learning and On the Soul*, ed. and trans. James W. Halporn, with an introduction by Mark Vessey (Liverpool: Liverpool University Press, 2004), 163.

2. The case for Pinkhurst as Chaucer's scribe was laid out by Linne R. Mooney in "Chaucer's Scribe," *Speculum* 81 (2006): 91–138. This theory has been disputed, most notably by Lawrence Warner, *Chaucer's Scribes: London Textual Production, 1384–1432* (Cambridge: Cambridge University Press, 2018).

3. Geoffrey Chaucer, *The Riverside Chaucer*, 3rd, ed., ed. Larry D. Benson (gen. ed.) (Oxford: Oxford University Press, 1988), 650. Corrected against Cambridge Trinity College MS R. 3. 20, p. 367.

4. Lindisfarne Gospels, BL Cotton MS Nero D IV (c. tenth century), fol. 259r, British Library, Digitised Manuscripts, www.bl.uk/manuscripts /FullDisplay.aspx?ref=cotton_ms_nero_d_iv; Michelle Brown, *The Lindisfarne Gospels and the Early Medieval World* (London: British Library, 2011), 66.

5. Brown, *The Lindisfarne Gospels and the Early Medieval World*, 35, 67.

6. Aldred's note is treated with a degree of scepticism by some scholars, but the rough date range it proposes tallies with the stylistic and historical context. It is clear that the manuscript was made by one scribe-artist, and it is reasonable to assume that that scribe was Eadfrith, who took a strong interest in the promotion of Cuthbert's cult. Some of the debate is summarized in Richard Gameson, "Northumbrian Books in the Seventh and Eighth Centuries," in *The Lindisfarne Gospels: New Perspectives*, ed. Richard Gameson, Library of the Written Word, vol. 57, The Manuscript World, vol. 9, 43–83 (Leiden: Brill, 2017), 61–63n118. Some have argued that Eadfrith merely commissioned the book. See Janet Backhouse, *The Lindisfarne Gospels* (Oxford: Phaidon, 1981), 13.

7. See *Two Lives of Saint Cuthbert: A Life by an Anonymous Monk of Lindisfarne and Bede's Prose Life*, ed. and trans. Bertram Colgrave (Cambridge: Cambridge University Press, 1940). For the reference to the hermitage, see esp. pp. 302–305.

8. Æthelwulf, *De abbatibus* (Oxford: Clarendon Press, 1967), 18.

9. Brown, *The Lindisfarne Gospels and the Early Medieval World*, 38.

10. Alan Thacker, "Eadfrith [Eadfrid] (d. 721?), Bishop of Lindisfarne," *ODNB*, www.oxforddnb.com/view/10.1093/ref:odnb/9780198614128.001.0001/odnb-9780198614128-e-8381.

11. Michelle P. Brown, "Reading the Lindisfarne Gospels: Text, Image, Context," in Gameson, *Lindisfarne Gospels: New Perspectives*, 84–95 (p. 84).

12. Brown, *The Lindisfarne Gospels and the Early Medieval World*, 38.

13. Lindisfarne Gospels, BL Cotton MS Nero D IV, fol. 2v. There are four more after this one: fols. 26v, 94v, 138v, and 210v.

14. Lindisfarne Gospels, BL Cotton MS Nero D IV, fol. 3r. There are four more after this one: fols. 27r, 95r, 139r, and 211r.

15. Lindisfarne Gospels, BL Cotton MS Nero D IV, fols. 10r–17v.

16. Backhouse, *Lindisfarne Gospels*, 44.

17. Lindisfarne Gospels, BL Cotton MS Nero D IV, fol. 29r.

18. Janet Backhouse, "Birds, Beasts and Initials in Lindisfarne's Gospel Books," in *St Cuthbert, His Cult and His Community to AD 1200*, ed. Gerald Bonner, David Rollason, and Clare Stancliffe, 165–174 (Woodbridge, UK: Boydell Press, 1989), 166.

19. See Lindisfarne Gospels, BL Cotton MS Nero D IV, fols. 25v, 93v, 137v, and 209v, for the evangelist images.

20. Brown, *The Lindisfarne Gospels and the Early Medieval World*, 37.

21. Backhouse, *Lindisfarne Gospels*, 22.

22. Backhouse, *Lindisfarne Gospels*, 28.

23. The orpiment can be identified because it contains arsenic trisulfide (As_2S_3). Christina Duffy, "Under the Microscope with the Lindisfarne Gospels," *British Library Collection Care Blog*, July 29, 2013, https://blogs.bl.uk/collectioncare/2013/07/under-the-microscope-with-the-lindisfarne-gospels.html.

24. Duffy, "Under the Microscope."

25. The Lindisfarne Gospels Tour, "Chemistry," British Library, www.bl.uk/onlinegallery/features/lindisfarne/chemistry.html. See also Michelle P. Brown, *The Lindisfarne Gospels: Society, Spirituality and the Scribe* (London: British Library, 2003), 430–451.

26. Backhouse, *Lindisfarne Gospels*, 28.

27. *The Letters of Saint Boniface*, ed. and trans. E. Emerton (New York: W. W. Norton, 1976), 60. The manuscript containing this letter is a later copy from the second half of the ninth century, so, as is so often the case with women's writing from the period, we are left with later texts, reports of work, traces, and suggestions. I discuss this at length in the final chapter. See Diane Watt, *Women, Writing and Religion in England and Beyond, 650–1100*, Studies in Early Medieval History (London: Bloomsbury Academic, 2020), 69.

28. Although most scholars identify her as the abbess of Thanet, Barbara Yorke makes a case for her being the abbess of Wimbourne. See "Eadburh [Eadburga] (fl. c. 716–c. 746), Abbess (probably of Wimborne)," *ODNB*, www.oxforddnb.com/view/10.1093/ref:odnb/97801986 14128.001.0001/odnb-9780198614128-e-50659.

29. There was a decline in learning amongst nuns in England during the Benedictine Reform. See Watt, *Women, Writing and Religion*, 13. But it is clear that the level of literacy amongst nuns throughout the medieval period was good. See David N. Bell, *What Nuns Read: Books and Libraries in Medieval English Nunneries*, Cistercian Studies 158 (Kalamazoo, MI: Cistercian Publications, 1995).

30. Christine E. Fell summarises the evidence in *Women in Anglo Saxon England and the Impact of 1066* (London: British Museum Publications, 1984), 113–114.

31. *Letters of Saint Boniface*, 64–65.

32. P. R. Robinson, "A Twelfth-Century *Scriptrix* from Nunnaminster," in *Of the Making of Books: Medieval Manuscripts, Their Scribes and*

Readers: Essays Presented to M. B. Parkes, ed. P. R. Robinson and Rivkah Zim, 72–93 (Aldershot, UK: Scolar Press, 1997), 83.

33. Christine E. Fell, "Some Implications of the Boniface Correspondence," in *New Readings on Women in Old English Literature*, ed. Helen Damico and Alexandra Hennessey Olsen (Bloomington: Indiana University Press, 1990), 29. On the continental evidence, see, for example, Alison I. Beach, *Women as Scribes: Book Production and Monastic Reform in Twelfth-Century Bavaria* (Cambridge: Cambridge University Press, 2004).

34. Book of Nunnaminster (c. eighth to tenth centuries), BL Harley MS 2965, British Library, Digitised Manuscripts, www.bl.uk/manuscripts /FullDisplay.aspx?ref=Harley_MS_2965&index=0.

35. Book of Nunnaminster, BL Harley MS 2965, fol. 37r.

36. Book of Nunnaminster, BL Harley MS 2965, fols. 37v–38.

37. An edition and translation of a different manuscript version can be found in *Anglo-Saxon Remedies, Charms and Prayers from British Library MS Harley 585: The Lacnunga*, vol. 1, ed. and trans. Edward Pettit, Mellen Critical Editions and Translations, vol. 6a (Lewiston, NY; Lampeter, UK: Edward Mellen Press, 2001), 40–57.

38. As in *peccatrice* (ablative singular of *peccatrix*, meaning "female sinner"—literally translated as "with/by/from female sinner"). Book of Nunnaminster, BL Harley MS 2965, fol. 41r. Another, possibly contemporary, hand also added masculine forms. Book of Nunnaminster, BL Harley MS 2965, fol. 41r.

39. Book of Nunnaminster, BL Harley MS 2965, fol. 40v. Diane Watt discusses the importance of recording land grants for institutional memory in *Women, Writing and Religion*, esp. 58–67.

40. Simon Keynes and Michael Lapidge, ed. and trans., *Alfred the Great: Asser's Life of King Alfred and Other Contemporary Sources* (Harmondsworth, UK: Penguin, 1983), 91.

41. Robinson, "Twelfth-Century *Scriptrix*," 74.

42. Malcolm Parkes identified a group of early tenth-century manuscripts copied there. See M. B. Parkes, "The Palaeography of the Parker Manuscript of the *Chronicle*, Laws and Sedulius and Historiography at Winchester in the Late Ninth and Tenth Centuries" (1976), and "A Fragment of an Early Tenth-Century Anglo-Saxon Manuscript and Its Significance" (1983), both reprinted in M. B. Parkes, *Scribes, Scripts and Readers: Studies in the Communication, Presentation and Dissemination of Medieval Texts* (London: Hambledon Press, 1991), 143–169, 171–185.

43. Katie Ann-Marie Bugyis, *The Care of Nuns: The Ministries of Benedictine Women in England During the Central Middle Ages* (Oxford: Oxford University Press, 2019), 120.

44. Bugyis, *The Care of Nuns*, 123–124.

45. Smaragdus, Bodleian Library MS Bodl. 451 (c. 1100), fol. ii, Bodleian Library, Viewer, https://iiif.bodleian.ox.ac.uk/iiif/viewer/5dbb 4f95-5c18-4cef-aa52-74b0a1651e86#?c=0&m=0&s=0&cv=0&r=0& xywh=-2472%2C-232%2C7748%2C4622.

46. Bugyis, *The Care of Nuns*, 120–121. See also Susan J. Ridyard, *The Royal Saints of Anglo-Saxon England: A Study of West Saxon and East Anglian Cults* (Cambridge: Cambridge University Press, 1988), 28–29. See also Laurel Braswell, "Saint Edburga of Winchester: A Study of Her Cult, A.D. 950–1500, with an Edition of the Fourteenth-Century Middle English and Latin Lives," *Mediaeval Studies* 33 (1971): 292–333 (esp. 304).

47. These include (on fol. 119v of Smaragdus, Bodleian Library MS Bodl. 451), the famous motto, "Amor vincit omnia" (Love conquers all), which appears on the brooch of Chaucer's Prioress in the "General Prologue" of *The Canterbury Tales*.

48. Robinson, "Twelfth-Century *Scriptrix*," 92.

49. Colin Richmond, "Paston Family (per. c. 1420–1504), Gentry," *ODNB*, www.oxforddnb.com/view/10.1093/ref:odnb/9780198614128 .001.0001/odnb-9780198614128-e-52791.

50. *Paston Letters and Papers of the Fifteenth Century*, ed. Norman Davis, 2 vols. (Oxford: Clarendon Press, 1971), 1:226–227 [no. 130]; Paston Letters and Papers (fifteenth century), BL Add MS 34888, fol. 29, British Library, Digitised Manuscripts, www.bl.uk/manuscripts/FullDisplay.aspx?ref=Add_MS_34888.

51. The dispute over Gresham is eloquently explained in Helen Castor, *Blood and Roses: The Paston Family in the Fifteenth Century* (London: Faber and Faber, 2004), 42–49.

52. Davis, *Paston Letters*, 1:662–663 [no. 415]; Paston Letters and Papers (1440–1489), BL Add MS 43490, fol. 23, British Library, Digitised Manuscripts, www.bl.uk/manuscripts/FullDisplay.aspx?ref=Add_MS_43490. The identity of the hand has been disputed by Colin Richmond in *The Paston Family in the Fifteenth Century: Endings* (Manchester: Manchester University Press, 2000), 52n135; see counterclaim by Diane Watt, *The Paston Women: Selected Letters*, ed. and trans. Diane Watt (Woodbridge, UK: Boydell and Brewer, 2004), 137.

53. Joel T. Rosenthal, *Telling Tales: Sources and Narration in Late Medieval England* (University Park: Pennsylvania State University Press, 2003), 100; Watt, *Paston Women*, 134.

54. Davis, *Paston Letters*, 1:170 [no. 93]; Paston Letters and Papers (fifteenth century), BL Add MS 34889, fol. 215, British Library, Digitised Manuscripts, www.bl.uk/manuscripts/FullDisplay.aspx?ref=Add_MS_34889.

55. Davis, *Paston Letters*, 2:387 [no. 751]; Paston Letters and Papers (1440–1489), BL Add MS 43491, fol. 12, British Library, Digitised Manuscripts, www.bl.uk/manuscripts/FullDisplay.aspx?ref=Add_MS_43491.

56. See G. A. Lester, *Sir John Paston's "Grete Boke": A Descriptive Catalogue, with an Introduction of British Library MS Lansdowne 285* (Cambridge: D. S. Brewer, 1984), 7.

57. Michael Gullick, "How Fast Did Scribes Write? Evidence from Romanesque Manuscripts," in *Making the Medieval Book: Techniques of Production*, ed. Linda L. Brownrigg, Proceedings of the Fourth Conference of the Seminar in the History of the Book to 1500, Oxford, July 1992, 39–58 (Los Altos Hills, CA: Anderson-Lovelace; London: Red Gull Press, 1995), 41.

58. Davis, *Paston Letters*, 1:26 [no. 13]; Paston Letters and Papers (1440–1478), BL Add MS 43488, fol. 4, British Library, Digitised Manuscripts, www.bl.uk/manuscripts/FullDisplay.aspx?ref=Add_MS_43488.

59. As Helen Castor notes, she was educated, but "education did not necessarily imply literacy." Castor, *Blood and Roses*, 28.

60. Christiane Klapish-Zuber, "Women and the Family," in *Medieval Callings*, ed. Jacques Le Goff, trans. Lydia G. Cochrane, 285–311 (Chicago: University of Chicago Press, 1990), 302 (originally published as *L'uomo medieval*, 1987).

61. John Myrc, *Instructions for Parish Priests*, ed. Edward Peacock, original series 31 (London: Kegan, Trench, Trübner and Co. for the Early English Text Society, 1868), 3–4.

62. Davis, *Paston Letters*, 1:216–217 [no. 125]; Paston Letters and Papers, BL Add MS 43490, fol. 34.

63. Don C. Skemer, "Amulet Rolls and Female Devotion in the Late Middle Ages," *Scriptorium* 55 (2001): 197–227 (esp. 201–205).

64. Davis, *Paston Letters*, 1:lxxix.

65. Davis, *Paston Letters*, 1:576 [no. 353]; Paston Letters and Papers (1445–1500), BL Add MS 27445, fol. 59, British Library, Digitised Manuscripts, www.bl.uk/manuscripts/FullDisplay.aspx?ref=Add_MS_27445.

66. Paston Letters and Papers (1440–1489), BL Add MS 43489, fol. 52, www.bl.uk/manuscripts/FullDisplay.aspx?ref=Add_MS_43489.

67. Davis, *Paston Letters*, 1:582 [no. 355]; Paston Letters and Papers, BL Add MS 27445, fol. 60.

68. He did not write the entirety of all six. Davis, *Paston Letters*, 1:lxxv.

69. Davis, *Paston Letters*, 1:322 [no. 193]; Paston Letters and Papers, BL Add MS 27445, fol. 9.

70. Davis, *Paston Letters*, 1:9392 [no. 56]; Paston Letters and Papers, BL Add MS 34888, fol. 150.

71. Davis, *Paston Letters*, 1:339 [no. 201]; Paston Letters and Papers, BL Add MS 34889, fol. 74.

72. Davis, *Paston Letters*, 1:541 [no. 332]; Paston Letters and Papers, BL Add MS 34889, fol. 77.

73. On this technicality, see Castor, *Blood and Roses*, 216–217.

74. Caston, *Blood and Roses*, 220–224.

75. Davis, *Paston Letters*, 1:33–34 [no. 203]; Paston Letters and Papers, BL Add MS 34889, fols. 83v–84r.

76. "Brethel (n.)," Middle English Compendium, https://quod.lib.umich.edu/m/middle-english-dictionary/dictionary/MED5962. See also the entry for "brothel" in the *Oxford English Dictionary*.

77. Davis, *Paston Letters*, 2:498–500 [no. 861]; Paston Letters and Papers, BL Add MS 34889, fols. 78–79.

78. Davis, *Paston Letters*, 1:lxxvi.

79. Richmond, "Paston Family," *ODNB*.

80. Davis, *Paston Letters*, 1:472 [no. 282]; Paston Letters and Papers, BL Add MS 27445, fol. 73.

81. Davis, *Paston Letters*, 1:lxxvii.

82. Davis, *Paston Letters*, 1:473 [no. 283]; Paston Letters and Papers, BL Add MS 27445, fol. 74.

83. Lindisfarne Gospels, BL Cotton MS Nero D IV, fol. 89v.

84. Lindisfarne Gospels, BL Cotton MS Nero D IV, fol. 295r; Brown, *The Lindisfarne Gospels and the Early Medieval World*, 66.

Chapter Six: Authors and Scribes

1. Thomas Hoccleve, *La Mâle Règle* (1406), Huntington Library MS HM 111, fols. 19r, 20r, Huntington Library, Digital Library, https://hdl.huntington.org/digital/collection/p15150coll7/id/9873;

Hoccleve's Works, ed. Frederick J. Furnivall, EETS ES 73, 2 vols., reprinted from ES 61 (1892) (Oxford: Oxford University Press, 1970), 1:29–30, ll. 121–128, 161–168, translated by Jenni Nuttall for the Hoccleve Society at "Hoccleve's Male Regle," https://hocclevesociety.org/texts-and-resources/hoccleves-male-regle.

2. See *Thomas Hoccleve: A Facsimile of the Autograph Verse Manuscripts*, ed. J. A. Burrow and A. I. Doyle, EETS SS 19 (Oxford: Oxford University Press, 2002).

3. As Ardis Butterfield noted, recent decades have seen "an effort by a number of scholars to reconstitute the page of the scribal manuscript as an authentic object in its own right." See Ardis Butterfield, "*Mis-en-page* in the *Troilus* Manuscripts: Chaucer and French Manuscript Culture," *Huntington Library Quarterly* 58 (1995): 49–80 (esp. 49).

4. Cædmon's "Hymn," in Bede, *Historia ecclesiastica gentis Anglorum* (Moore Bede, c. 737), Cambridge University Library MS Kk.5.16, fol. 128v, University of Cambridge Digital Library, https://cudl.lib.cam.ac.uk/view/MS-KK-00005-00016/1, fol. 128r.

5. It should be noted that almost all Old English verse looks like prose in its manuscript witnesses.

6. Cædmon's "Hymn," in Moore Bede, 128v.

7. See, for example, the *Norton Anthology of English Literature*, ed. M. H. Abrams, 6th ed. (New York: W. W. Norton, 1993), 17. Kevin Kiernan has written brilliantly about the disparities between the medieval and modern texts. See his "Reading Cædmon's 'Hymn' with Someone Else's Glosses," in *Old English Literature: Critical Essays*, ed. Roy Liuzza (New Haven, CT: Yale University Press, 2002), 103–124.

8. Moore Bede, fols. 90v–92r.

9. Bede describes him as a lay brother, but the story makes clear that he was responsible for caring for the livestock.

10. Bede, *Bede's Ecclesiastical History of the English People*, ed. and trans. Bertram Colgrave and R. A. B. Mynors (Oxford: Clarendon Press, 1969), 417.

11. See Lees and Overing's productive discussion of Hild's role in the Cædmon story in Clare A. Lees and Gillian R. Overing, *Double Agents: Women and Clerical Culture in Anglo-Saxon England*, Religion and Culture in the Middle Ages (Cardiff: University of Wales Press, 2009), 19–45, esp. 30, 32, 35. See also Diane Watt's discussion of how Bede overwrote female authored sources in *Women, Writing and Religion in*

England and Beyond, 650–1100, Studies in Early Medieval History (London: Bloomsbury Academic, 2020), esp. 14–18, 21–39.

12. Bede, *Bede's Ecclesiastical History*, 415.

13. The idea of the "clean animal" is from Leviticus 11:3 and Deuteronomy 14:6.

14. Lees and Overing, *Double Agents*, 22.

15. Cædmon's "Hymn," in Bede, *Historia ecclesiastica gentis Anglorum* (Saint Petersburg Bede), National Library of Russia, lat. Q. v. I. 18, fol. 107r, at Daniel Paul O'Donnell, *Cædmon's Hymn: A Multimedia Study, Edition and Archive*, http://people.uleth.ca/~daniel.odonnell/caedmon /html/htm/transcription/l/facsimile.htm.

16. For a full explanation, see Daniel Paul O'Donnell, "Filiation and Transmission," in *Cædmon's Hymn: A Multimedia Study, Edition and Archive* (Cambridge: D. S. Brewer, 2005), chap. 5, http://people.uleth.ca /~daniel.odonnell/caedmon/html/htm/introduction/ch5.htm#CH5. The text was also given currency around 150 years after Bede's death, when, under the rule of King Alfred (r. 886–899), a large number of Latin texts were translated into Old English as part of a programme to promote learning. Alfred wrote that he wished to render books "ða ðe niedbeðearfosta sien eallum monnum to wiotonne, ðæt we ða on ðæt geðiode wenden ðe we ealle gecnawan mægen" (most needful for all men to know, into that language that we all can understand). Alfred, "Preface to the Translation of Gregory the Great's 'Pastoral Care,'" in *Old and Middle English, c. 890–1450: An Anthology*, ed. Elaine Treharne, 3rd ed. (Oxford: Wiley Blackwell, 2010), 12–13. One of these books "most needful for all men to know" was Bede's *Ecclesiastical History*. When the translator came to Bede's description of the cattle byre, he inserted a version of the "Hymn" that was very similar to that which appears in the edges of early copies of the *Ecclesiastical History*, rather than providing a new translation from Bede's Latin version of the text. (The translator also removed Bede's reference to translating from the original.)

17. Kiernan, "Reading Cædmon's 'Hymn,'" 108n18.

18. BL Harley MS 978, British Library, Digitised Manuscripts, www .bl.uk/manuscripts/FullDisplay.aspx?ref=Harley_MS_978. A list of contents and folio references in the manuscript are listed on this website.

19. BL Harley MS 978, fol. 40r.

20. BL Harley MS 978, fol. 67r; Marie de France, *Fables of Marie de France*, ed. and trans. Harriet Spiegel, Toronto Medieval Texts and Translations 5 (Toronto: University of Toronto Press, 1987), 256.

21. R. Howard Bloch, *The Anonymous Marie de France* (Chicago: University of Chicago Press, 2003), 25–50.

22. "E compassa les vers de lais / Ke ne sunt pas del tut verais." Denis Piramus, *La vie seint Edmund le rei, poème anglo-normand du XII^e siècle*, ed. Hilding Kjellman, Göteborgs Kungl. Vetenskaps-och Vitterhets-Samhälles handlingar, följd 5, ser. A, bd. 4, no. 3 (Götebord, 1935), 4.

23. Marie de France, *Lais*, ed. Alfred Ewert, with an introduction and bibliography by Glyn S. Burgess (London: Bristol Classical, 1995), 2.

24. Such as Phaedrus's first-century collection, as well as the *Romulus* and the so-called *Romuli Anglici Cunctis*. See Karen Jambeck, "Reclaiming the Woman in the Book: Marie de France and the *Fables*," in *Women, the Book and the Worldly: Selected Proceedings of the St Hilda's Conference, 1993*, vol. 2, ed. L. Smith and J. H. M. Taylor, 119–137 (Cambridge: D. S. Brewer, 1995), 122. The following discussion is indebted to Jambeck's fascinating work.

25. Jambeck, "Reclaiming the Woman in the Book," 121.

26. "The Wolf and the Sow," in *Fables of Marie de France*, ed. and trans. Spiegel, 82–85.

27. "The Wolf and the Sow," in *Fables of Marie de France*, ed. and trans. Spiegel, 84. Literal translation from Jambeck, "Reclaiming the Woman in the Book," 135.

28. Cambridge MS Ee 6.11. See *Catalogue of the Manuscripts Preserved in the Library of the University of Cambridge*, vol. 2 of 5 (Cambridge: Cambridge University Press, 1858), 260–261; Jambeck, "Reclaiming the Woman in the Book," 135.

29. See Jambeck, "Reclaiming the Woman in the Book."

30. *Fables of Marie de France*, ed. and trans. Spiegel, 256 (my translation).

31. This was the suggestion of Andrew Taylor. See his *Textual Situations: Three Medieval Manuscripts and Their Readers* (Philadelphia: University of Pennsylvania Press, 2002), esp. 99 and, more generally, 76–136. But Rupert T. Pickens suggested it originated in Herefordshire. See his "Reading Harley 978: Marie de France in Context," in *Courtly Arts and the Art of Courtliness: Selected Papers from the Eleventh Triennial Congress of the International Courtly Literature Society, University of Wisconsin–Madison, 29 July–4 August*, ed. Keith Busby and Christopher Kleinhenz (Cambridge: D. S. Brewer, 2006), 527–542.

32. BL Harley MS 978, fol. 160r.

33. Abbot Simon on February 13, 1226, and Abbot John de Fornsett on January 19, 1261. BL Harley MS 978, fols. 15v–16r.

34. Ernest H. Sanders, "Wycombe [Wicumbe, Whichbury, Winchecumbe], W. de.," in *Grove Music Online* (2001), Oxford University Press, www.oxfordmusiconline.com/grovemusic/view/10.1093/gmo/978 1561592630.001.0001/omo-9781561592630-e-0000030632.

35. Taylor, *Textual Situations*, esp. 76–136, figs. 8, 11–14; Nicky Losseff, "Wycombe, W. of (fl. c. 1275)," *ODNB*, www.oxforddnb.com/view /article/60119.

36. Keith Busby, "The Manuscripts of Marie de France," in *A Companion to Marie de France*, ed. Logan E. Whalen, 302–317 (Leiden: Brill, 2011), 305–306.

37. Marie de France, *Lais*, ed. Ewert, 1.

38. John Lydgate, Troy Book and Siege of Thebes (1457–c. 1530), BL Royal MS 18 D II, fol. 148r, British Library, Digitised Manuscripts, www.bl.uk/manuscripts/FullDisplay.aspx?ref=Royal_MS_18_D_II.

39. Seth Lerer, *Chaucer and His Readers: Imagining the Author in Late Medieval England* (Princeton, NJ: Princeton University Press, 1993), 23. And Lydgate was central to this—as Larry Scanlon observes: "Chaucer's initial installment at the head of the English canon owes a great deal to Lydgate's systematic efforts on his behalf." Larry Scanlon, *Narrative, Authority and Power: The Medieval Exemplum and the Chaucerian Tradition* (Cambridge: Cambridge University Press, 1994), 322.

40. Some scholars believe three early manuscripts may have been started before Chaucer's death. See *The Norton Chaucer*, ed. David Lawton (New York: W. W. Norton, 2019), 31.

41. Lerer, *Chaucer and His Readers*, 8.

42. Richard Firth Green, *Poets and Princepleasers: Literature and the English Court in the Late Middle Ages* (Toronto: University of Toronto Press, 1980), 6.

43. His *House of Fame* (a dream-vision), the *Legend of Good Women*, and, most probably, *The Canterbury Tales*, are all unfinished. And it seems likely that Chaucer also wrote texts that have now been lost. Recently, two scholars have suggested that perhaps the poem was left intentionally, jokily, in this state—as the number of tales that would be required for each pilgrim to tell one there and one on the way back would make a vast and cumbersome poem. See A. S. G. Edwards, "To Speken Short and Pleyn," *Times Literary Supplement*, no. 6013 (2018), www .the-tls.co.uk/articles/to-speken-short-and-pleyn; Geoffrey Chaucer, *The*

Canterbury Tales, ed. Julia Boffey and A. S. G. Edwards (Cambridge: Cambridge University Press, forthcoming).

44. Alexandra Gillespie, *Print Culture and the Medieval Author: Chaucer, Lydgate and Their Books, 1473–1557* (Oxford: Oxford University Press, 2006), 35.

45. Anne Ferry, "Anonymity: The Literary History of a Word," *New Literary History* 33 (2000): 193–214.

46. Julia Boffey and A. S. G. Edwards, *New Index of Middle English Verse* (London: British Library, 2005), no. 4019.

47. It has been claimed that the manuscript was written by a particular scribe whom Chaucer knew. See Linne R. Mooney, "Chaucer's Scribe," *Speculum* 81 (2006): 91–138. This has been disputed, most notably by Lawrence Warner, *Chaucer's Scribes: London Textual Production, 1384–1432* (Cambridge: Cambridge University Press, 2018).

48. *Marie de France: Seven of Her Lays Done into English by Edith Rickert* (London: David Nutt, 1901).

49. "John M. Manly and Edith Rickert," University of Chicago Faculty: A Centennial View, www.lib.uchicago.edu/projects/centcat/cent cats/fac/facch16_01.html.

50. Peter M. W. Robinson, "New Methods of Editing, Exploring, and Reading *The Canterbury Tales*," *Le médiéviste et l'ordinateur* 38 (1999): 19–28 (esp. 19).

51. John Manly and Edith Rickert, eds., *The Text of the Canterbury Tales Studied on the Basis of All Known Manuscripts*, vol. 1 of 8 (Chicago: University of Chicago Press, 1940), viii. See also William Snell, "A Woman Medievalist Much Maligned: A Note in Defense of Edith Rickert (1871–1938)," *Philologie im Netz*, Supplement 4 (2009): 41–54.

52. BL Harley MS 2382 (1475–1500), British Library, Digitised Manuscripts, www.bl.uk/manuscripts/FullDisplay.aspx?ref=Harley_MS_2382.

53. Anthony Bale suggests the texts were intentionally split up. He contends that the *Prioress's Tale* has been "reformatted as part of Lydgate's *Testament*." The Chaucerian text, he notes, "interrupts the *Testament* at the point at which 'Lydgate' the narrator, has detailed his youthful excesses." Anthony Bale, *The Jew in the Medieval Book: English Anti-Semitisms, 1350–1500* (Cambridge: Cambridge University Press, 2006), 96.

54. Manly and Rickert, *Text of the Canterbury Tales*, 1:248.

55. Charles Owen, *The Manuscripts of the Canterbury Tales* (Woodbridge, UK: D. S. Brewer, 1991), 115.

56. BL Harley MS 2382, fol. 97r ("Prioress") and fol. 100 ("Second Nun").

57. Not attributing authorship to Chaucer is not in itself unusual, but in this case I think it was strategic and deliberate. See Mary Wellesley, "John Lydgate's *Life of Our Lady*: Form and Transmission" (PhD diss., University College London, 2017), 193–203.

58. Geoffrey Chaucer, *The Riverside Chaucer*, 3rd ed., ed. Larry D. Benson (gen. ed.) (Oxford: Oxford University Press, 1988), 210 (l. 559).

59. From the thirteenth century onwards, the compilation and glossing of textual material was seen as a literary activity in itself. See Neil Hathaway, "*Compilatio*: From Plagiarism to Compiling," *Viator* 20 (1989): 19–44 (esp. 19–22).

60. Michael Johnson, "Constantinian Christianity in the London Manuscript: The Codicological and Linguistic Evidence of Thornton's Intentions," in *Robert Thornton and His Books*, ed. Susanna Fein and Michael Johnston, 177–204 (York, UK: York Medieval Press, 2014), 177.

61. *Riverside Chaucer*, ed. Benson, 650, corrected against John Lydgate, Poems, Cambridge Trinity College MS R.3.20, p. 367, Trinity College Cambridge, Wren Digital Library, https://mss-cat.trin.cam.ac .uk/manuscripts/uv/view.php?n=R.3.20.

62. I take the "a" to be a contracted form of the pronoun "he." See "Forms 1η," in "he, pron., n.1, and adj.," *OED*, oed.com/view/Entry/84893.

63. Doubt has been cast on the poem by two scholars who looked at the manuscript evidence and the meter. See A. S. G. Edwards, "Chaucer and 'Adam Scriveyn,'" *Medium Ævum* 82 (2012): 135–138; Eric Weiskott, "'Adam Scriveyn' and Chaucer's Metrical Practice," *Medium Ævum* 86 (2017): 147–151.

64. *Riverside Chaucer*, ed. Benson, 357, 355 (ll. 729, 574).

65. *Riverside Chaucer*, ed. Benson, 356 (ll. 652–660).

66. *Riverside Chaucer*, ed. Benson, 362 (l. 1146).

67. *Lydgate's Fall of Princes*, ed. Henry Bergen (Washington, DC: Carnegie Institute of Washington, 1923), 7 (ll. 246–247), 8 (ll. 279–280).

Chapter Seven: Authors Hidden

1. *Aldhelm: The Prose Works*, trans. Michael Lapidge and Michael Herren (1979; repr., Cambridge: D. S. Brewer, 2009), 61–62.

2. Hugeburc, Munich Bayerische Staatsbibliotek, Clm 1086, fol. 71v (p. 146), Biblissima, IIIF Collections—Manuscripts and Rare Books,

https://iiif.biblissima.fr/collections/manifest/ddbc5b54f8357800d8f433 c6311effe54b16e214.

3. I am indebted to Thijs Porck's excellent blog post "Anglo-Saxon Cryptography," https://thijsporck.com/2017/05/15/anglo-saxon-cryptography.

4. Christine Fell argues that the fact that this manuscript is held in a German collection may be a reason it has survived. Manuscripts in Britain often failed to survive "Viking raids, the Norman Conquest, or the Dissolution of the Monasteries and related hazards." Christine E. Fell, "Some Implications of the Boniface Correspondence," in *New Readings on Women in Old English Literature*, ed. Helen Damico and Alexandra Hennessey Olsen (Bloomington: Indiana University Press, 1990), 29. On the continental evidence, see, for example, Alison I. Beach, *Women As Scribes: Book Production and Monastic Reform in Twelfth-Century Bavaria* (Cambridge: Cambridge University Press, 2004).

5. Diane Watt, *Women, Writing and Religion in England and Beyond, 650–1100*, Studies in Early Medieval History (London: Bloomsbury Academic, 2020), 2–3.

6. Alistair Minnis, *Medieval Theory of Authorship: Scholastic Literary Attitudes in the Later Middle Ages* (1984; repr., Aldershot, UK: Scolar Press, 1988), 10. See, more generally, Anthony Bale, "From Translator to Laureate: Imagining the Medieval Author," *Literature Compass* 5 (2008): 918–934.

7. Carolyne Larrington, "Hugeburc [Huneburc] (fl. 760–780), Benedictine Nun and Hagiographer," *ODNB*, www.oxforddnb.com/view/10 .1093/ref:odnb/9780198614128.001.0001/odnb-9780198614128 -e-49413.

8. *The Exeter Anthology of Old English Poetry: An Edition of Exeter Dean and Chapter MS 3501*, 2nd ed., vol. 1 of 2, ed. Bernard J. Muir, Exeter Medieval English Texts and Studies (Exeter, UK: University of Exeter Press, 2000), 284, 328–330.

9. "Þe Wohunge of Ure Lauerd" (The Wooing of Our Lord), BL Cotton MS Titus D XVIII, fols. 127r–133r, British Library, www.bl.uk /manuscripts/Viewer.aspx?ref=cotton_ms_titus_d_xviii_f014r. See also *Middle English Religious Prose*, ed. N. F. Blake, 61–72 (London: Edward Arnold, 1972), 61–62. Translations from or based on Anne Savage and Nicholas Watson, *Anchoritic Spirituality: "Ancrene Wisse" and Associated Works* (Mahwah, NY: Paulist Press, 1991), 245–258.

10. Blake, *Middle English Religious Prose*, 62; Savage and Watson, *Anchoritic Spirituality*, 248.

11. Blake, *Middle English Religious Prose*, 66; Savage and Watson, *Anchoritic Spirituality*, 251.

12. For example, Blake, *Middle English Religious Prose*, 63; Savage and Watson, *Anchoritic Spirituality*, 249.

13. Blake, *Middle English Religious Prose*, 71; Savage and Watson, *Anchoritic Spirituality*, 255.

14. Blake, *Middle English Religious Prose*, 67; Savage and Watson, *Anchoritic Spirituality*, 252–253.

15. Blake, *Middle English Religious Prose*, 70; Savage and Watson, *Anchoritic Spirituality*, 255.

16. Blake, *Middle English Religious Prose*, 71; Savage and Watson, *Anchoritic Spirituality*, 256.

17. Blake, *Middle English Religious Prose*, 71–72; Savage and Watson, *Anchoritic Spirituality*, 256.

18. Ann K. Warren, *Anchorites and Their Patrons in Medieval England* (Berkeley: University of California Press, 1985), 20.

19. *Ancrene Wisse: A Corrected Edition of the Texts in CCCC MS 402, with Variants from Other Manuscripts*, ed. Bella Millett, EETS OS 325 (Oxford: Oxford University Press, 2005). The work is translated in *Ancrene Wisse: Guide for Anchoresses*, trans. Bella Millett (Exeter, UK: University of Exeter Press, 2009). The pages of both the edition and translation of the text by Millett correspond. All subsequent references will note the page reference once when referring to both works.

20. "Muche word is of ou, hu gentile wummen ȝe beoð, vor godleic and for ureoleic iȝirned of monie, and sustren of one ueder and of one moder, ine blostme of ower ȝuweðe uorheten alle wor[l]des blissen and bicomen ancren." Millett 2005 and 2009, 73.

21. Description drawn from E. A. Jones, "Ceremonies of Enclosure," *Rhetoric of the Anchorhold: Space, Place and Body with the Discourse of Enclosure*, ed. Liz Herbert McAvoy, 34–49 (Cardiff: University of Wales Press, 2008), esp. 40–41.

22. E. A. Jones, *Hermit and Anchorites in England, 1200–1550* (Manchester: Manchester University Press, 2019), 57.

23. "Schrapien euche dei þe eorðe up of hare put þet ha schulen rotien in." Millett 2005 and 2009, 46.

24. Millett 2005 and 2009, 43 (translation modified).

25. Roberta Gilchrist, *Contemplation and Action: The Other Monasticism* (London: Leicester University Press, 1995), 192.

26. Warren, *Anchorites and Their Patrons*.

27. Jones, *Hermit and Anchorites*, 62.

28. Jones, *Hermit and Anchorites*, 62.

29. Jones, *Hermit and Anchorites*, 81.

30. Jones, *Hermit and Anchorites*, 83.

31. Millett 2005 and 2009, 158.

32. Millett 2009, ix.

33. Millett 2005 and 2009, 48.

34. Millett 2005 and 2009, 56.

35. Millett 2005 and 2009, 48.

36. Millett 2005 and 2009, 78, and animal images, 76–79.

37. Millett 2005 and 2009, 46 (translation modified).

38. For example, Blake, *Middle English Religious Prose*, 63; Savage and Watson, *Anchoritic Spirituality*, 249.

39. Millett 2005 and 2009, 147.

40. *Þe Wohunge of Ure Lauerd*, ed. W. Meredith Thompson, EETS, OS 241 (London: Oxford University Press, 1958), xxi–xxii.

41. Savage and Watson, *Anchoritic Spirituality*, 418–419.

42. Jones, *Hermit and Anchorites*, 77.

43. E. A. Jones, "A Mirror for Recluses: A New Manuscript, New Information and Some New Hypotheses," *The Library* 15 (2014): 424–431 (esp. 427).

44. Millett 2005 and 2009, 73.

45. Catherine Innes-Parker, "Medieval Widowhood and Textual Guidance: The Corpus Revisions of *Ancrene Wisse* and the de Braose Anchoresses," *Florilegium* 28 (2011): 95–124.

46. Millett 2005 and 2009, 96.

47. Millett 2005 and 2009, 160. Two women shared a cell at Worcester Priory, and Christina of Markyate dwelt with a female recluse named Alfwen, and then Roger the hermit. See Robert Mills, "Gender, Sodomy, Friendship and the Medieval Anchorhold," *Journal of Medieval Religious Cultures*, 36 (2010): 1–27 (esp. 6).

48. Anneke B. Mulder-Bakker, foreword to *Anchorites, Wombs and Tombs: Intersections of Gender and Enclosure in the Middle Ages*, ed. Liz Herbert McAvoy and Mari Hughes-Edwards (Cardiff: University of Wales Press, 2005), 1.

49. St Julian's Church in Conesford, where Julian was enclosed, was destroyed by bombing in the Second World War. Its exact original layout is unclear. Margery may have been able to eat with Julian in a parlour adjoining the cell, or she may simply have sought her counsel at the

window of the cell. On the architecture of cells, see "Introduction," in *Ancrene Wisse*, ed. Robert Hasenfratz, TEAMS Middle English Texts Series (Kalamazoo, MI: Medieval Institute Publications, 2001), https://d.lib.rochester.edu/teams/text/hasenfratz-ancrene-wisse-introduction.

50. Some manuscripts say May 13.

51. Julian of Norwich, *Revelations of Divine Love: The Short and the Long Text*, ed. Barry Windeatt (Oxford: Oxford University Press, 2016), 31.

52. The title of the text is a matter of scholarly debate. Some term it *A Revelation of Love*, some the *Shewings*, but most modern editions call it the *Revelations of Divine Love*.

53. Julian of Norwich, *Revelations of Divine Love (Short Text and Long Text)*, trans. Elizabeth Spearing, with an introduction by A. C. Spearing (London: Penguin, 1998), xii.

54. *Revelations*, ed. Windeatt, 10.

55. Vincent Gillespie, "'She Do the Police in Different Voices': Pastiche, Ventriloquism and Parody in Julian of Norwich," in *A Companion to Julian of Norwich*, ed. Liz Herbert McAvoy, 192–207 (Woodbridge, UK: Boydell and Brewer, 2008), p. 196.

56. The first bequest made to her as an anchoress is from 1394, but she may have been enclosed for a long time before this.

57. *Revelations*, ed. Windeatt, 39.

58. *Revelations*, ed. Windeatt, 137.

59. Carole Hill, *Women and Religion in Medieval Norwich* (Woodbridge, UK: Boydell and Brewer, 2010), 14.

60. *Revelations*, ed. Windeatt, 35.

61. *Revelations*, ed. Windeatt, 35 (quotation from "Long Text").

62. Felicity Riddy, "'Women Talking About the Things of God': A Late Medieval Sub-culture," in *Women and Literature in Britain, 1150–1500*, ed. Carol M. Meale, 104–127 (Cambridge: Cambridge University Press, 1993), 114.

63. Vincent Gillespie and Maggie Ross, "The Apophatic Image: The Poetics of Effacement in Julian of Norwich's *Revelation of Love*," in *The Medieval Mystical Tradition in England*, ed. Marion Glasscoe, Exeter Symposium 5, 53–77 (Cambridge: D. S. Brewer, 1992).

64. *Revelations*, ed. Windeatt, 29.

65. *Revelations*, ed. Windeatt, 110.

66. *Revelations*, ed. Windeatt, xv.

67. *Revelations*, ed. Windeatt, 164.

68. *Revelations*, ed. Windeatt, xv.

69. Anna Maria Reynolds, "Some Literary Influences in the *Revelations* of Julian of Norwich (c 1342–post-1416)," *Leeds Studies in English* 7–8 (1952): 18–28, https://ludos.leeds.ac.uk:443/R/-?func=dbin-jumpfull &object_id=134449&silo_library=GEN01.

70. *Revelations*, ed. Windeatt, xv.

71. *Revelations*, ed. Windeatt, 154.

72. *Revelations*, ed. Windeatt, 44.

73. The "Short Text" version is slightly different. See *Revelations*, ed. Windeatt, 73.

74. Liz Herbert McAvoy, *A Revelation of Purgatory* (Cambridge: D. S. Brewer, 2017). For a discussion of the problems of attribution, see Clarck Drieshen, "English Nuns as 'Anchoritic Intercessors' for Souls in Purgatory: The Employment of *A Revelation of Purgatory* by Late Medieval English Nunneries for Their Lay Communities," in *Medieval Anchorites in Their Communities*, ed. Cate Gunn and Liz Herbert McAvoy, 85–100 (Woodbridge, UK: Boydell and Brewer, 2017).

75. *Revelations*, ed. Windeatt, 7.

76. "Introduction," in *The Shewings of Julian of Norwich*, ed. Georgia Ronan Crampton, TEAMS Middle English Texts Series (Kalamazoo, MI: Medieval Institute Publications, 1994), https://d.lib.rochester.edu /teams/text/the-shewings-of-julian-of-norwich-introduction.

77. Julian of Norwich, *Revelations of Divine Love*, "Short Text," in "Carthusian Anthology of Theological Works in English" (the "Amherst Manuscript," fifteenth century), BL Add MS 37790, British Library, Digitised Manuscripts, www.bl.uk/manuscripts/FullDisplay.aspx?ref= Add_MS_37790.

78. *Revelations*, in "Amherst Manuscript," BL Add MS 37790, fols. 96v, 226r, and repeated in black ink on fols. 1r and 226r.

79. *Revelations*, in "Amherst Manuscript," BL Add MS 37790, fols. 23r, 33r, 110v, 114r.

80. *XVI Revelations of Divine Love, Shewed to a Devout Servant of Our Lord, Called Mother Juliana, an Anchorete of Norwich: Who Lived in the Dayes of King Edward the Third*, published by Hugh (Serenus) Cressy (n.p., 1670).

81. Edward Stillingfleet, *A Discourse Concerning Idolatry Practised in the Church of Rome*, 2nd ed. (London: Robert White for Henry Mortlock, 1672), 226.

82. *Revelations of Divine Love . . . A version from the MS. in the British Museum*, ed. Grace Warrack (London: Methuen, 1901).

83. *The Works of Gwerful Mechain*, ed. and trans. Katie Gramich (Ontario: Broadview Press, 2018), 41. Gramich's work contains both literal and free translations. I have mainly chosen the literal ones, with a few exceptions.

84. Here she refers to the *descriptio pulcritudinis*—the bardic convention of praising a woman systematically. *Works of Gwerful Mechain*, ed. Gramich, 43. See also *Gwaith Gwerful Mechain ac Eraill*, ed. Nerys Ann Howells, Cyfres Beirdd yr Uchelwyr (Aberystwyth: Canolfan Uwchefrydiau Cymreig a Cheltaidd Prifysgol Cymru, 2001), 103–105.

85. *Gwaith Gwerful Mechain ac Eraill*, ed. Howells, 104. It is not her *most* popular. Her *cywydd* to Christ appears in sixty-nine manuscripts. See *Gwaith Gwerful Mechain ac Eraill*, ed. Howells, 51.

86. D. R. Johnston, "The Erotic Poetry of the Cywyddwyr," *Cambridge Medieval Celtic Studies* 22 (1991): 63–94 (esp. 82).

87. *Gwaith Gwerful Mechain ac Eraill*, ed. Howells, 2. She is described as Hywel Fychan's daughter in Aberystwyth, Llyfrgell Genedlaethol Cymru [National Library of Wales] MS 3057D, and this is supported by other evidence elsewhere. See *Works of Gwerful Mechain*, ed. Gramich, 7.

88. Ceridwen Lloyd-Morgan, "Women and Their Poetry in Medieval Wales," in *Women and Literature in Britain, 1150–1500*, ed. Carol M. Meale, Cambridge Studies in Medieval Literature 17, 183–201 (Cambridge: Cambridge University Press, 1993), 198.

89. *Gwaith Gwerful Mechain ac Eraill*, ed. Howells, 4.

90. M. Wynn Thomas, foreword to Meredid Hopwood, *Singing in Chains: Listening to Welsh Verse* (2004; repr., Ceredigion, Wales: Gomer Press, 2016), ix.

91. Thomas, foreword to Hopwood, *Singing in Chains*, xiv.

92. Gwyneth Lewis, "Extreme Welsh Meter," *Poetry Foundation Magazine*, November 3, 2014, www.poetryfoundation.org/poetrymagazine/articles/70172/extreme-welsh-meter. This form is slightly easier to achieve in Welsh than English because in Welsh the first letter of a word changes according to gender, place, and function.

93. Lewis, "Extreme Welsh Meter."

94. This Bardic tradition was "the preserve of Wales's professional medieval poetic guild and its élite patrons: the indigenous princes of Wales

(c. 1137–1282) in the first instance and, in its latter stages, the Welsh nobility and clerics (1282–c. 1650). Rules surrounding membership of the guild were strict: like its Gaelic counterpart in Ireland, the guild also had a hereditary dimension and poetic families have been identified." See Cathryn A. Charnell-White, "Problems of Authorship and Attribution: The Welsh-Language Women's Canon Before 1800," *Women's Writing* 24 (2017): 398–417 (esp. 402).

95. See Nia Powell, "Women and Strict-Metre Poetry in Wales," in *Women and Gender in Early Modern Wales*, ed. Michael Roberts and Simone Clarke, 129–158 (Cardiff: University of Wales Press, 2000), 134–135, for a discussion of women who learned the art of strict-metre verse from male relatives.

96. Powell, "Women and Strict-Metre Poetry," 132.

97. *Works of Gwerful Mechain*, ed. Gramich, 46–53; *Gwaith Gwerful Mechain ac Eraill*, ed. Howells, 106–107.

98. D. R. Johnston, "The Erotic Poetry of the Cywyddwyr," 83.

99. Aberystwyth, Llyfrgell Genedlaethol Cymru [National Library of Wales] MS 3050D, p. 360 (*olim* Mostyn Hall MS 147).

100. *Works of Gwerful Mechain*, ed. Gramich, 64–73; *Gwaith Gwerful Mechain ac Eraill*, ed. Howells, 80–83.

101. *Works of Gwerful Mechain*, ed. Gramich, 111.

102. See Ceridwen Lloyd-Morgan, "The 'Querelle des femmes': A Continuing Tradition in Welsh Women's Literature," in *Medieval Women: Texts and Contexts in Late Medieval Britain. Essays for Felicity Riddy*, ed. Jocelyn Wogan-Browne, Rosalynn Voaden, Arlyn Diamond, Ann Hutchison, and Carol Meale, Medieval Women: Texts and Contexts 3 (Turnhout, Belgium: Brepols, 2000), 101–114.

103. *Works of Gwerful Mechain*, ed. Gramich, 67.

104. Lloyd-Morgan, "The 'Querelle des femmes,'" 107, citing Jane Cartwright, *Y Forwyn Fair, Santesau a Lleianod. Agweddau ar Wyryfdod a Diweirdeb yng Nyghymru'r Oesoedd Canol* (Cardiff: University of Wales Press, 1999), 33–34.

105. *Works of Gwerful Mechain*, ed. Gramich, 71–73.

106. Jane Cartwright, "Women Writers in Wales," in *The History of British Women's Writing, 700–1500*, vol. 1, ed. Liz Herbert McAvoy and Diane Watt, 60–71 (New York: Palgrave, 2012), 67, citing Llinos B. Smith, "Olrhain Anni Goch," *Llên Cymru* 19 (1993): 107–126.

107. *Works of Gwerful Mechain*, ed. Gramich, 111.

108. This is one of Gramich's freer translations. *Works of Gwerful Mechain*, ed. Gramich, 88.

109. *Works of Gwerful Mechain*, ed. Gramich, 89.

110. *Gwaith Gwerful Mechain ac Eraill*, ed. Howells, 123; *Works of Gwerful Mechain*, ed. Gramich, 104–105. Cathryn Charnell-White ascribes this poem to Gwerful Fychan in the anthology *Beirdd Ceridwen Blodeugerdd Barddas o Ganu Menywod hyd Tua 1800* (Swansea, Wales: Cyhoeddiadau Barddas, 2005).

111. Jane Cartwright, "Women Writers in Wales," 60. The manuscript is Aberystwyth, Llyfrgell Genedlaethol Cymru [National Library of Wales], Cwrtmawr MS 1491 (Llyfr Dolwar Fach).

112. Lloyd-Morgan, "Women and Their Poetry," 190.

113. Leslie Harries, "Barddoniaeth Huw Cae Llwyd, Ieuan ap Huw Cae Llwyd, Ieuan Dyfi, a Gwerful Mechain" (master's thesis, University College of Wales, Swansea, 1933), 26. English translation from Katie Gramich, "Orality and Morality: Early Welsh Women's Poetry," http://www2.lingue.unibo.it/acume/acumedvd/Essays%20ACUME/AcumeGramichfinal.pdf, 5.

114. Nerys Howells ascribed nineteen out of a possible forty poems to Mechain. See *Gwaith Gwerful Mechain ac Eraill*, ed. Howells, 31.

115. The earliest manuscript is BL Add MS 14967, which is dated to the second quarter of the sixteenth century. See *Gwaith Gwerful Mechain ac Eraill*, ed. Howells, 25.

116. Charnell-White, "Problems of Authorship," 401.

117. Lloyd-Morgan, "Women and Their Poetry," 190.

118. *Works of Gwerful Mechain*, ed. Gramich, 9.

119. Leslie Harries, *Gwaith Huw Cae Llwyd ac Eraill* (Caerdydd: Gwasg Prifysgol, 1953).

120. Nerys Ann Howells wittily called her 2001 edition of Gwerful's works *Gwaith Gwerful Mechain ac Eraill* (The work of Gwerful Mechain and others) as a rebuttal to Leslie Harries.

121. Meic Stephens, *The Oxford Companion to the Literature of Wales* (Oxford: Oxford University Press, 1986), 238. Stephens did soften his criticism by praising her devotional poetry and her "spirited response" to domestic violence, in *A New Companion to the Literature of Wales* (Cardiff: University of Wales Press, 1998), 294.

122. Derek Keene, *Survey of Medieval Winchester: I and II*, Winchester Studies 2 (Oxford: Clarendon Press, 1985), 128.

123. Clare M. Dowding, "'A Certain Tourelle on London Wall . . . Was Granted . . . for Him to Inhabit the Same': London Anchorites and the City Wall," special issue: Anchoritic Studies and Liminality, *Journal of Medieval Religious Cultures* 42, no. 1 (2016): 44–55 (esp. 44).

124. It was copied by Hugh Maurice under the direction of Owen Jones (1741–1814), a Welsh antiquary and the president of the society. The library's nineteenth-century catalogue reports that the manuscript contains verse "complimentary and abusive in regard to young women." *Catalogue of Additions to the Manuscripts in the British Museum in the Years MDCCCXLI–MDCCCXLV*, 59.

Epilogue

1. *The Gutenberg Bible of 1454*, ed. Stephan Füssel, 3 vols. (Cologne: Taschen, 2018), commentary volume, p. 9.

2. See A. S. G. Edwards, "William Caxton and the Introduction of Printing to England," British Library, Discovering Medieval Literature, January 31, 2018, www.bl.uk/medieval-literature/articles/william-caxton -and-the-introduction-of-printing-to-england; Lotte Hellinga, *William Caxton and Early Printing in England* (London: British Library, 2010); George Painter, *William Caxton* (London: Chatto and Windus, 1976).

3. Geoffrey Chaucer, *Canterbury Tales* (London: William Caxton, 1483), sig. A. 2^b^. A. W. Pollard and G. R. Redgrave, *A Short Title Catalogue of Books Printed in England, Scotland and Ireland, 1475–1640*, 2nd ed., revised and enlarged by W. A. Jackson, F. S. Ferguson, and Katherine E. Pantzer, 3 vols. (London: Bibliographical Society, 1986–1991), no. 5083.

4. Eleanor Prescott Hammond, "On the Order of the Canterbury Tales: Caxton's Two Editions," *Modern Philology* 3 (1905): 159–178.

5. M. R. James and Claude Jenkins, *A Descriptive Catalogue of the Manuscripts in the Library of Lambeth Palace*, 2 parts (Cambridge: Cambridge University Press, 1930), 412–414 (information revised by Richard Palmer, 2011; see https://archives.lambethpalacelibrary.org.uk/Calm View/Record.aspx?src=CalmView.Catalog&id=MSS%2F265). See also N. F. Blake, "Manuscript to Print," in *Book Production and Publishing in Britain, 1375–1475*, ed. Jeremy Griffiths and Derek Pearsall, 409–432 (Cambridge: Cambridge University Press, 1989), 413–414.

6. *Manuscripts after Print c. 1450–1550: Producing and Reading Books During Technological Change*, a research project funded by the Arts and

Humanities Research Council in the United Kingdom, is currently underway at the University of Newcastle. See "Manuscripts After Print," Newcastle University, https://research.ncl.ac.uk/mssafterprint/about.

7. Curt F. Bühler, *The Fifteenth Century Book: The Scribes, The Printers, The Decorators* (Philadelphia: University of Pennsylvania Press, 1960), 16.

Afterword

1. On the self-styled title "antiquarius," see Arnaldo Momigliano, "Ancient History and the Antiquarian," *Journal of the Warburg and Courtauld Institutes* 13 (1950): 285–315 (esp. 313–314). Bale's version of Leland's work is John Leland, *Laboryouse journey: Serche of Johan Leylande, for Englandes antiquitees, geven of hym as a newe yeares gyfte to kynge Henry the viij. in the xxxvij. yeare of his reygne, with declaracyons enlarged: by Johan Bale* (London: Johan Bale, 1549), sig. C 1b.

2. He seems to have made two or three trips there before the Dissolution and one or two afterwards. See James P. Carley, "John Leland and the Contents of English Pre-Dissolution Libraries: Lincolnshire," *Transactions of the Cambridge Bibliographical Society* 9 (1989): 330–357 (esp. 331).

3. James Carley, *The Books of King Henry VIII and His Wives* (London: British Library, 2004), 93–94.

4. See Alice Hunt, *The Drama of Coronation: Medieval Ceremony in Early Modern England* (Cambridge: Cambridge University Press, 2008), 39–76; Dana F. Sutton, "John Leland and Nicholas Udall, Poetry for the Coronation of Anne Boleyn (1533)," A Hypertext Critical Edition, Philological Museum, May 5, 2006, www.philological.bham.ac.uk/boleyn.

5. James Simpson, *The Oxford English Literary History*, vol. 2, *1350–1574: Reform and Cultural Revolution* (Oxford: Oxford University Press, 2002), 9.

6. David Knowles, *Religious Orders in England*, vol. 1 of 3 (Cambridge: Cambridge University Press, 1959), 363.

7. Tessa Beverley, "Portinari, Sir Giovanni (b. c. 1502x1508, d. in or after 1572), Military Engineer," *ODNB*, www.oxforddnb.com/view/10.1093/ref:odnb/9780198614128.001.0001/odnb-9780198614128-e-52154.

8. Margaret Aston, "English Ruins and English History: The Dissolution and the Sense of the Past," *Journal of the Warburg and Courtauld Institutes* 36 (1973): 231–255 (esp. 239).

9. See "Herb Garden," Lewes Priory, www.lewespriory.org.uk /domains/lewespriory.org.uk/local/media/images/medium/8.%20 Priory%20Panels-%20Small.pdf, 4.

10. Aston, "English Ruins," 245.

11. Leland, *Laboryouse journey*, sig. B1ᵃ.

12. See J. A. Herbert, *The Sherborne Missal: Reproduction of Full Pages and Details of Ornament from the Missal Executed Between the Years 1396 and 1407 for Sherborne Abbey Church and Now Preserved in the Library of the Duke of Northumberland at Alnwick Castle* (Oxford: Roxburghe Club, 1920), 9.

13. Jennifer Summit, *Memory's Library: Medieval Books in Early Modern England* (Chicago: University of Chicago Press, 2008), 102.

14. N. R. Ker, *Medieval Libraries of Great Britain: A List of Surviving Books* (London: Royal Historical Society, 1941), xi–xii; Andrew G. Watson, *Catalogue of Dated and Datable Manuscripts, c. 435–1600, in Oxford Libraries*, vol. 1 of 2 (Oxford: Clarendon Press, 1984), xi.

15. Anthony à Wood, *Athenae Oxonienses: An Exact History of All the Writers and Bishops Who Have Had Their Education in the University of Oxford*, vol. 1, new ed. Philip Bliss, contrib. (London: F. C. and J. Rivington, 1813), 197–198.

16. The presentation copy for Henry VIII, printed on parchment and containing a correction in Leland's own hand, is held by the British Library (shelfmark C.20.b.3).

17. Aston, "English Ruins," 255; Simpson, *Reform and Cultural Revolution*, 14.

18. For more on the collectors of this period, see Summit, *Memory's Library*.

19. Barrett L. Beer, "Stow [Stowe], John (1524/5–1605), Historian," *ODNB*, www.oxforddnb.com/view/10.1093/ref:odnb/9780198614128 .001.0001/odnb-9780198614128-e-26611.

20. On *sorencys*, see E. J. Devereux, "Empty Tuns and Unfruitful Grafts: Richard Grafton's Historical Publications," *Sixteenth Century Journal* 21 (1990): 33–56, 44n47.

21. Summit, *Memory's Library*, 103.

22. Richard de Bury, *The Philobiblon of Richard De Bury*, ed. and trans. Ernest C. Thomas (London: Kegan Paul, Trench and Co., 1888), 159.

23. De Bury, *Philobiblon*, 229.

24. De Bury, *Philobiblon*, 237–239.

25. De Bury, *Philobiblon*, 161–162.

26. De Bury, *Philobiblon*, 226.
27. De Bury, *Philobiblon*, 162.
28. De Bury, *Philobiblon*, 179–180.
29. De Bury, *Philobiblon*, 161.

Acknowledgments

1. *The Earliest Life of Gregory the Great by an Anonymous Monk of Whitby*, ed. and trans. Bertram Colgrave (Lawrence: University of Kansas Press, 1968), 129.

Glossary

This section provides brief explanations of terms you may find unfamiliar in this book. It is indebted to the Glossary page of the British Library's Catalogue of Illuminated Manuscripts (www.bl.uk/catalogues /illuminatedmanuscripts/glossary.asp) and the Glossary of the Medieval Manuscript Manual produced by the Department of Medieval Studies at Central European University, Budapest (http://web.ceu.hu/medstud /manual/MMM), both of which contain more extensive explanations of terms. Underlining signifies that a term used in a definition has a definition of its own in this glossary.

Amanuensis. A secretary or scribe employed to transcribe an author's words by dictation.

Apocrypha. Those books of the Old Testament of the Bible excluded as of doubtful or spurious authenticity during the Reformation and relegated to an appendix (including the Book of Susanna and the First and Second Book of Maccabees).

Ascender. The ascending stroke in those letters (*b*, *d*, *f*, *h*, and so on) that extend above the body of the letter. (See <u>descender</u>.)

Bas-de-page. Literally, "the bottom of the page." A decorative scene in the space at the bottom of a <u>folio</u>.

Benedictional. A book containing all the episcopal blessings (those said by bishops) to be said during the <u>Mass</u>, arranged according to the liturgical year.

Bifolium (pl. bifolia). A sheet of paper or parchment folded in two to create two <u>folios</u> or <u>leaves</u> and slotted together to form <u>booklets</u> or <u>quires</u>.

Booklet. A collection of bifolia sewn together (also called a <u>quire</u> or <u>gathering</u>).

Border. The area around a text that might be decorated with images or patterns or left blank.

Canon table. A table of information found at the beginning of a Bible or copy of the gospels detailing which events in the story of Christ's life are found in which gospel and where there is overlap in the events described.

Carpet page. A dense page of ornamental designs found in manuscripts of Insular origin. The pages contain no text and usually appear separating the four gospels.

Catchword. A word or phrase written at the bottom of the folio on the final leaf of a booklet/quire/gathering that is repeated as the opening word or words on the following leaf. They were used to ensure that booklets/quires/gatherings were sewn together in the right order.

Chemise binding. A sort of coat (the ancestor of the book jacket) for a manuscript, protecting its binding. Often they were made of leather or textile. They could be simple affairs, such as a parchment wrapper, or something more elaborate—for example, they could be decorated with beads or jewels.

Chi-Rho. The Greek letters *XP*, which are an ancient symbol for Christ. They are a monogram of the first two letters of *ΧΡΙΣΤΟΣ* (*Christos*).

Codex. The Latin word for a manuscript, or handwritten book.

Codicology. The study of a book's (or codex's) physical structure.

Collation. A book's structure in terms of, for example, how many leaves there are in each booklet and how many booklets there are in the manuscript. Knowing a book's collation tells us how a manuscript was put together, which can reveal how well planned it was. When we marry the collation information with what we know about the text, we can begin to get a clearer picture of the process of creation. It helps to know, for example, that an artist created a particular image on a separate sheet and then sewed it into a booklet, or that a scribe wished to squeeze one more text into the manuscript, and had to resort to sewing single sheets into a booklet to have enough space for it.

Colophon. A note added at the end of a text in a manuscript or a printed book that supplies some information on the author, the title, or—in the case of printed books—the printer. From the Greek meaning "finishing touch."

Coptic binding. A method of book binding generally found in manuscripts of Egyptian or Eastern origin, but also found in the Cuthbert

Gospel (discussed in Chapter 1). The method, whereby the <u>booklets/quires</u> are sewn together by two needles working in a figure-eight pattern from booklet to booklet, allows the book to open easily.

Cords. Horizontal bands onto which <u>booklets/quires/gatherings</u> were sewn to create the <u>spine</u> of a book.

Dampfold. An artistic style, ultimately derived from Byzantine art, in which human figures appear in clothing that seems to stick to them as if they were wet. The folds of the drapery are sinuous and stylised.

Descender. The descending stroke in those letters (*g, j, f, p*, and so on) that extend below the body of the letter. (See <u>ascender</u>.)

Divine Office. A cycle of daily devotions performed by members of religious orders and the clergy. The cycle contained eight "canonical hours": *Matins* (approximately 2:30 a.m.), *Lauds* (approximately 5:00 a.m.), *Prime* (approximately 6:00 a.m.), *Terce* (approximately 9:00 a.m.), *Sext* (approximately 12:00 noon), *None* (approximately 3:00 p.m.), *Vespers* (approximately 4:30 p.m.), and *Compline* (approximately 6:00 p.m.).

Evangelist portrait. An image of one of the four evangelists—Matthew, Mark, Luke, or John—thought by Christians to be the authors of the Gospels. They often appear with their iconographical symbols (Matthew with a man, Mark with a lion, Luke with a bull, and John with an eagle). They are frequently depicted as scribes.

Explicit. A scribal abbreviation of "*explicitus est*," meaning "it is finished/completed." An explicit was often written in a different colour of ink from the rest of a manuscript and designated the end of the text.

Flyleaves. Blank leaves at the beginning or end of a manuscript used to protect a text (whether modern or medieval). They often contain ownership inscriptions, pen trials, or information on provenance.

Folio. From the Latin for "leaf," meaning half of a <u>bifolio</u>. Manuscripts, by and large, do not have "pages," but instead "<u>folios</u>" or "<u>leaves</u>." So you don't refer, for example, to "p. 2." but instead to "fol. 1v." A folio is a single sheet, so you refer to the <u>recto</u>—the front of the sheet—and the <u>verso</u>—the back of the sheet (abbreviated as "r" and "v," respectively). (Some manuscripts, such as the Sherborne Missal discussed in Chapter 4, are exceptions and contain pagination instead of foliation.)

Frontispiece. A decorative image facing a book's title page. These are generally a feature of printed books, not manuscripts, but sometimes the term is used to refer to an image at the opening of a particular book of

the Bible, as in the frontispiece for the opening of the Book of Samuel on the Morgan Leaf of the Winchester Bible (discussed in Chapter 4).

Gall/gallnut. Round, apple-like growths on an oak tree that develop when gall wasps (from the family *Cynipidae*) lay their eggs in the tree's developing leaf buds. The galls were ground and mixed with iron salts and tannic acids to make ink.

Gathering. A collection of bifolia sewn together (also called a quire or booklet).

Gesso. A thick white substance, usually made from chalk or plaster mixed with an adhesive, used to create a raised surface onto which gold leaf could be applied. Sometimes it was coloured red so that a warm red glow showed through the gold.

Girdle book. Small manuscripts that could be attached to a belt by a chain or rope. The format was popular for prayerbooks made for wealthy women in the fifteenth and sixteenth centuries.

Gospel/gospel-book. The gospels are the four accounts of the life of Christ, attributed to the evangelists, Matthew, Mark, Luke, and John, in the New Testament. The Cuthbert Gospel (discussed in Chapter 1) is a copy of the Gospel of Saint John, while the Lindisfarne Gospels (Chapter 5) contain all four accounts. Copies of all four tended to contain canon tables at their start.

Gothic. A period of Western art from about 1100 to 1300. Gothic manuscripts are generally characterized by their more naturalistic depictions of the human figure, decorated initials and frames, increased use of gilding, and the appearance of hybrid monsters (sometimes called "grotesques").

Gutter. The groove where two pages meet in the middle of a double-page spread along the spine of a book.

Half-uncial. A script used in antiquity and the early Middle Ages. It is similar in appearance to uncial, except that it is a minuscule script (i.e., akin to modern lowercase letters).

Incipit. The introductory words of a text, from the Latin *incipere*, meaning "to begin." These words might appear in a different colour of ink from the rest of the text, could be decorated, and might contain a title.

Incunable. A printed book created before 1501, when printing was still a novel technology. From the Latin *in cunabula*, meaning "in the cradle."

Insular. Of or relating to the art and culture of Britain and Ireland from about 550 to 900, especially a style characterised by its mixture of Celtic and Germanic motifs.

Interlace. A type of decoration that appears to depict interwoven ribbons or straps. A common feature of <u>Insular</u> art, it appears in manuscript decoration as well as jewellery design.

Lacuna (pl. lacunae). A missing section in a text; a hiatus, a blank.

Lay. An adjective describing secular society, as opposed to members of the clergy or a religious order.

Lead point. A piece of lead alloy used for drawing images, or sometimes for ruling the writing space (also known as a *plummet*). Sometimes the lead had a holder, a bit like a pencil. Scribes and artists would later fill in the lead lines with ink.

Leaf. Another word for a <u>folio</u>. A leaf or a folio is different from a "page," which is only one side of a leaf or folio.

Lection mark. Mark added to a text (often a liturgical text) to aid in its recitation or performance.

Line filler. A decorative feature that fills the remainder of a line that is not occupied by a section of script. For example, in a copy of the Psalms, when verses do not fill an entire line of text, a scribe or artist might add a line filler to enhance the appearance of the page.

Liturgy. The ceremonies of public worship. The central parts of the liturgy were the celebration of the <u>Mass</u> and the <u>Divine Office</u>.

Manuscript. A handwritten book.

Mass. The performance of the Christian <u>liturgy</u>.

Middle English. The form of the English language that evolved from Old English. It contains a high proportion of French vocabulary because of the many words that arrived in Britain after the Norman Conquest. It is generally dated to the twelfth to fifteenth centuries.

Mise-en-page. The layout of a page.

Missal. A service book containing the texts used in the performance of the <u>Mass</u>.

Old English. A Germanic language spoken in early medieval, pre-Conquest Britain, brought by northern European settlers. Generally dated to the seventh to early twelfth centuries.

Palaeography. From the Greek *palaeo*, meaning old or ancient, and *graphy*, meaning writing—thus literally the study of old writing. More precisely, palaeography is the study of scripts. Script styles are informative about a manuscript's date and place of production.

Palimpsest. A parchment or other writing surface that once contained text that is now erased and contains an overwritten text in place of the original.

Paper. Medieval paper was made from cotton or linen rags that were soaked and pulverized into a pulp. This pulp was placed into a vat of water and *size* (a glutinous substance). Into the vat a sieve-like wooden frame set with wires was placed to bring the pulp fibres to the surface. The film of sodden fibres was lifted out of the vat and then pressed between sheets of felt. The wires of the frame gave the finished paper ghostly lines in its surface that are only visible when the paper is held up to the light. From around 1300, European papermakers began twisting patterns into the wire to identify the paper as their own. These patterns—little designs like the head of a bull or a bunch of grapes—are known as *watermarks* and give scholars clues about the origins of particular paper stocks. Medieval and early modern paper made from rags is pretty durable, unlike modern paper made from wood pulp, which tends to wither, discolour, and crumble over time.

Papyrus. A writing material made from the papyrus plant, which is commonly found in ancient Egypt. It was replaced by parchment (see Prologue).

Parchment. The prepared skin of an animal, often a calf, used for making the pages of manuscripts (see Prologue).

Patron. A person who commissions a text or manuscript.

Pen trial. The scribbling or doodling, usually made by later owners of manuscripts, to test their pens.

Pigment. The colouring agent in paint. Pigments might have a vegetable, mineral, or animal origin and might have been derived from native sources or imported.

Plummet. See lead point.

Pricking. Piercing a folio or bifolio with tiny holes at even intervals to make it easier to rule lines for the text to be written on. This was done with a knife, a sharpened tool called an awl, or a "pricking wheel."

Psalter. A copy of the biblical Book of Psalms, which formed much of the basis of the <u>Divine Office</u>.

Quire. A <u>booklet</u> made from <u>bifolia</u> slotted and sewn together. Booklets, or quires, were then attached to one another to form a manuscript.

Recto. The front of a <u>leaf</u> or <u>folio</u>.

Rubrication. The coloured ink titles, rubrics, or headings added to a manuscript, often after the text was copied. The word literally means "red ink," but could be in different colours.

Rubricator. A person employed to add sections of text in ink of a different colour to the main text.

Running title. A section of text at the top of a folio or leaf that gives the title of a book or a discrete section within, such as the name of a particular book of the Bible.

Sanctorale. The celebration of saints' feast days; also the name given to a section in a liturgical book containing all the texts to be said or sung on those feast days.

Scribe. A person employed to copy a manuscript or transcribe it by dictation (see <u>amanuensis</u> and <u>scriptrix</u>).

Script. The type of hand or handwriting used.

Scriptorium (pl. scriptoria). A dedicated room in a monastery for copying and decorating manuscripts. Later replaced by the secular, professional workshop.

Scriptrix. A female scribe (from Latin).

Service book. A book used for the performance of the <u>liturgy</u>.

Sewing stations. The little places in the groove of a <u>bifolio</u> where a sewing needle attaches thread to the outer edge of the spine, in order to attach a <u>booklet/quire/gathering</u> to another <u>booklet/quire/gathering</u> or to the <u>cords</u>.

Spine. The edge of a book, where the <u>booklets/quires/gatherings</u> are sewn together.

Titulus. Latin for "title" or "label." The *tituli Psalmorum*—the titles of the psalms—for example, are a series of titles that appear at the start of each of the psalms in manuscripts and printed books. They summarise the content of each psalm and appear in different forms. The earliest form of the *tituli Psalmorum* dates back to the third century.

Treasure binding. An elaborate book cover made from metalwork in gold or silver or from ivory, and often studded with jewels.

Uncial. A majuscule handwriting <u>script</u> (equivalent to modern upper-case or capital letters) used in antiquity and the early Middle Ages. The script's individual letters have large, rounded forms, and each is written separately (as we might say, "printed"), as opposed to being linked to-gether, or "joined up." Uncial first appeared around the second century but reached the peak of its popularity between the fifth and eighth cen-turies. It was brought to Britain by the Christian mission of Gregory the Great in the late sixth century. (See also <u>cursive</u> and <u>half-uncial</u>.)

Vernacular. The "native" or "indigenous" language or dialect of a country or district. In Britain in the medieval period, there were multiple ver-nacular languages, including Cornish, Welsh, Gaelic, and English (<u>Old English</u> and latterly <u>Middle English</u>). Vernacular is a term usually used in this context in opposition to Latin, which was the language of the church and—at different points in the period—of law and government.

Verso. The back of a <u>leaf</u> or <u>folio</u>.

Workshop. A place where manuscripts were made. The term usually designates secular places of manuscript production (as opposed to the term <u>scriptorium (pl. scriptoria)</u>, which is used for the monastic setting). As the medieval period progressed, book production increasingly moved out of the monastery and into the <u>lay</u> world. The rise of universities in England from around the twelfth century created a demand for books outside of religious institutions.

Zoomorphic. A design containing animal forms.

A Note on Unfamiliar Letter Forms

Æ, æ. The letter "ash" (makes the sound of the "a" in "ash").

Ð, ð. The letter "eth" (makes a "th" sound).

Þ, þ. The letter "thorn," originally a runic letter (also makes a "th" sound).

Ȝ, ȝ. The letter "yogh" (pronounced in different ways depending on its position in a word—at the start of a word it was pronounced like the "y" in Modern English's "yet"; in the middle or the end of a word it was pronounced like the "ch" in the Scottish "loch").

Index

Mary Wellesley is a former research affiliate at the British Library, where she still teaches courses on medieval language and literature. Previously, she worked in the library's Department of Ancient, Medieval and Early Modern Manuscripts. A graduate of Oxford University, she completed her PhD at University College London. She has written for a number of academic journals. Her work has appeared in the *London Review of Books* and *New York Review of Books* and she also writes for *The Sunday Times*, *The Guardian*, *The Daily Telegraph*, and the *Times Literary Supplement*.